THE
QUITE NICE AND
FAIRLY ACCURATE

GOOD
OMENS

SCRIPT BOOK

Also by Neil Gaiman

NOVELS

The Ocean at the End of the Lane
Graveyard Book
Anansi Boys
Coraline
American Gods
Stardust
Neverwhere
Good Omens (with Terry Pratchett)

COLLECTIONS

Trigger Warning
Fragile Things
Smoke and Mirrors

ILLUSTRATED STORIES

The Truth Is a Cave in the Black Mountains
(illustrated by Eddie Campbell)
The Sleeper and the Spindle (illustrated by Chris Riddell)

FOR YOUNGER READERS

Fortunately, the Milk (illustrated by Skottie Young)
Hansel and Gretel (illustrated by Lorenzo Mattotti)
Instructions (illustrated by Charles Vess)
Odd and the Frost Giants (illustrated by Brett Helquist)
Crazy Hair (illustrated by Dave McKean)
Blueberry Girl (illustrated by Charles Vess)
The Dangerous Alphabet (illustrated by Gris Grimly)
M Is for Magic (illustrated by Teddy Kristiansen)

NONFICTION

Art Matters (illustrated by Chris Riddell)
Make Good Art
The View from the Cheap Seats

NEIL GAIMAN

THE
QUITE NICE AND
FAIRLY ACCURATE

GOOD
OMeNs

SCRIPT BOOK

wm

WILLIAM MORROW
An Imprint of HarperCollins*Publishers*

"A Nightingale Sang in Berkeley Square,"
Words and Music by Eric Maschwitz and Manning Sherwin © 1940.
Reproduced by permission of Peter Maurice Music Co Ltd/
EMI Music Publishing Ltd, London W1F 9LD.

THE QUITE NICE AND FAIRLY ACCURATE GOOD OMENS SCRIPT BOOK. Copyright © 2019 by BBC 2019. Introduction copyright © 2019 by Neil Gaiman. All rights reserved. Printed in the United States of America. No part of this book may be used or reproduced in any manner whatsoever without written permission except in the case of brief quotations embodied in critical articles and reviews. For information, address HarperCollins Publishers, 195 Broadway, New York, NY 10007.

HarperCollins books may be purchased for educational, business, or sales promotional use. For information, please email the Special Markets Department at SPsales@harpercollins.com.

FIRST U.S. EDITION

Library of Congress Cataloging-in-Publication Data has been applied for.

ISBN 978-0-06-289690-2

19 20 21 22 23 LSC 10 9 8 7 6 5 4 3 2 1

For Terry

CONTENTS

AN INTRODUCTION

I am writing this in December of 2018. The world is in its Christmas plumage, and I'm living in a hotel. Today, for the first time, when I told someone when I thought *Good Omens* would probably air, the reply was, 'That's soon.' I'm so used to people saying, 'That's such a long way away.' We've handed in Episodes One and Two, and tomorrow we'll do the final tweaks and polishes, spit-on-a-tissue-and-scrub-its-face things, and send Episode Three out for quality-control checks, because the last graphic we were waiting for – Famine's name, with a skeletal horse moving behind it – came in this afternoon. And tomorrow afternoon we have dubbing sessions for Madame Tracy and the International Express man, and the unfortunately named Disposable Demon (there was a draft of the script in which we learned his name was Eric), and a fragment of radio to record, and then we will be done with Episode Four's sound, if you don't count the animated bunny-rabbit noises. (I will, I have been told, be making the bunny noises in Bang Post Production in Cardiff on Thursday.) So many tiny details that need to be in place to take our six-hour story over the finish line.

So, when I look at the scripts now, they seem familiar, but half-remembered things – like places I lived a long time ago. And I suppose, in a way, they are exactly that. The people who

are making *Good Omens* are building a glorious edifice, a huge and unlikely place, part temple and part nightclub and a great deal of it is bookshop, and the six scripts are our original architectural diagrams: much-thumbed and creased, with grease-pencil marks on them to show wherever the builders had needed to change things. But they didn't give you any idea of the splendour of the building, or the colours it would be painted.

Terry Pratchett asked me to make a *Good Omens* television series in August 2014. He wrote, 'I know, Neil, that you're very, very busy, but no one else could ever do it with the passion that we share for the old girl. I wish I could be more involved, and I will help in any way I can.' It was a pragmatic letter: he knew that the Alzheimer's was taking its toll on him. He had never asked me for anything before. He told me he wanted me to make it because he wanted to see it. I agreed. I'd make it so that he could see it. And then, in March 2015, Terry died. I flew home from the funeral and I started writing the first episode. Sixteen months later, in a house on the Isle of Skye, I finished writing the last episode.

Only I didn't finish writing it. If you are writing television, you keep writing it. You write draft after draft. And then it's a week before the read-through and Douglas Mackinnon, our director, and I sat across from each other in a Camden kitchen, and rolled up our sleeves, and did a draft that acknowledged the realities of our budget. Scenes and characters went away (we had already cast the other Four Horsepeople of the Apocalypse, and lor' were they scary and funny, but they went, and so did some of the rain of fish, and Aziraphale setting up his bookshop in the late eighteenth century and being given a medal. His medal was never given to him, but it was still in the bookshop). Scenes went because they would cost us too much (hint: avoid scenes on motorways).

And then we shot it.

And then we edited together what we had shot, and we learned things, and we didn't stop learning them.

We learned, for example, that even though we had shot our scenes showing Aziraphale in his Soho bookshop doing

surreptitious miracles, and Crowley's rat-led invasion of the BT Tower and his taking all the mobile phones in London off-line, the present-day story started exactly where it starts in the book: in a ruined graveyard, with the arrival of Hastur and Ligur. Somewhere, when we learned this, I knew, a twenty-seven-year-old me was smiling smugly.

Those scenes are still in this script book. That's part of the fun, isn't it? A script book like this is, or it should be, a tour behind the scenes of the scenes, the ones that made it into the final edit and the ones that didn't.

It exists because I always loved script books: they gave you the missing bits and the cut scenes. As a boy and then as a teenager who wanted to, one day, make television and movies, script books were the only gateway I had to explain how the magical things that happened on the screen got there.

There are secrets in this book, and there are spoilers in the end, even for those who have read the original novel.

The angels, for example. They weren't in the novel. They were going to be in the next *Good Omens* book we wrote, only we never wrote it. We knew what they were going to be like. A version of them showed up in a *Good Omens* film script Terry and I wrote in 1991, although that was mostly interesting, if I remember correctly, for the angels using their haloes as glowing killer discuses in the British Museum. (At the insistence of the film company, who knew that people weren't interested in used bookshops, Aziraphale worked for the British Museum. Crowley owned a nightclub, although I cannot for the life of me remember why the film people thought this was a wise thing for him to do.) I was delighted to be able to bring the angels in now, the way Terry and I had originally talked about them.

If you break *Good Omens*, the novel, down into six roughly equal parts, you will be surprised to discover an almost complete absence of Crowley and Aziraphale in part three. (It is almost as if we had written the novel like madmen, discovering it as we went, and then patched it into one story at the end.) This seemed like a problem in making it into television, as I knew from the start that our stars would be Crowley and

Aziraphale, and I wanted them in each episode of the story. The way I fixed it was with the pre-credits sequence, which tells you a lot about the history of Crowley and Aziraphale on Earth over the last 6,000 years (although it omits more than it tells: I think it's fair to assume that if, at any time in the last 6,000 years, anything interesting happened anywhere on Earth, Crowley and Aziraphale were probably there, not doing whatever it is they were actually sent there to do).

If any of you are hoping to learn anything about scriptwriting from this book, I should warn you that there are jokes in the stage directions, and there shouldn't be. The people who know about these things will tell you not to do this. But I like putting jokes into scripts: they tell everyone reading what kind of a thing this is, they keep me awake while I'm writing, and sometimes they are a way of acknowledging that what I'm asking for is impossible, but I'm still asking for it.

In the scripts, Buddy Holly's song 'Every Day' runs through the whole like a thread. It was something that Terry had suggested in 1991, and it was there in the edit. Our composer, David Arnold, created several different versions of 'Every Day' to run over the end credits. And then he sent us his *Good Omens* theme, and it *was* the *Good Omens* theme. Then Peter Anderson made the most remarkable animated opening credits to the *Good Omens* theme, and we realised that 'Every Day' didn't really make any sense any longer, and, reluctantly, let it go. It's here, though. You can hum it.

I've left the scripts more or less as they were when we were done shooting. Things changed, as I said, when we started editing. Scenes went away, they split apart, they joined up, they moved around, they did things that were nothing like what I had planned for them to do. If you compare what we did to what I wrote, you'll get an idea of the editing adventure we went on. The editing room is its own strange space, one in which we were always prepared to try things, to move them, to break them until they worked. And in the end, it seemed, they always worked, even if Episode One closes, and Episode Two begins, with two halves of a scene from later in Episode Two that was

written to neither open nor close anything.

Episode Six was too long when we edited it, and Episode Five was too short, and didn't quite work, so we moved scenes from the beginning of Episode Six to the end of Episode Five, and then both episodes worked delightfully.

Nobody's seen the whole thing actually finished yet, not even me. It won't be done for another five or six weeks. I can't wait to find out what we've done.

Whatever it is we've made, we couldn't have done it without Douglas Mackinnon, our very brilliant director, who kept going when moving forward seemed impossible. Many of the best ideas and things on the screen aren't really Neil things and they aren't really Douglas things. One of us said or suggested something, and the other said, 'No, but . . .' or 'Yes, and . . .' and suddenly a shot or a scene or a concept that had been limping along started to fly. I suppose they were spawned by a two-headed beast called NeilandDouglas, just as, long ago, when a book was written, it wasn't by Neil Gaiman and it wasn't by Terry Pratchett, but by a rare two-headed TerryandNeil.

My friend Rob Wilkins, Terry's representative on Earth, has been a staunch companion on this journey. He represented Terry, and represented him well. It was Rob who brought Terry's hat and scarf to the set of Aziraphale's bookshop and who spirited them away before they could be burned.

Thank you to the BBC for putting up with me, and to Amazon for embracing the madness.

The words of a script don't mean much until the words are spoken: I'm grateful to all our remarkable actors for letting me put words into your mouths and for saying them so much better than I ever could. And most of all, thank you to the (literally) thousands of people in front of the cameras or behind them or thousands of miles away from them who, in any way, had anything to do with bringing Good Omens to the screen. We couldn't have done it without you.

Now, welcome backstage . . .

NEIL GAIMAN

THE
QUITE NICE AND
FAIRLY ACCURATE

GOOD
OMENS

SCRIPT BOOK

EPISODE ONE
IN THE BEGINNING

FADE IN:

101 TITLE CARD: **WARNING: CAUSING ARMAGEDDON CAN BE
 DANGEROUS**

 TITLE CARD: **DO NOT ATTEMPT IT IN YOUR OWN HOME**

102 GOD VOICE-OVER SEQUENCE

*A simple animation. We see, first, the Big Bang, and
SCIENTISTS. The CERN particle accelerator. Over this we
hear the Narrator, wise and sensible. Could this be the voice
of GOD?*

GOD (V.O.)
 Current theories on the creation of the Universe state
 that, if it were created at all and didn't just start, as it
 were, unofficially, it came into being about fourteen
 billion years ago. The earth is generally supposed to be
 about four and a half billion years old.
 (beat)
 These dates are incorrect.

*Now we see ancient scholars, working with abacuses, scrolls
and scraps of parchment . . .*

GOD (CONT'D)

> Medieval scholars put the date of the Creation at 3760
> BC. Others put Creation as far back as 5508 BC.
> *(beat)*
> Also incorrect.

*Now, USSHER and his ASSISTANTS, with a huge
genealogical list of the line of Adam, and how long everyone
lived . . .*

GOD (CONT'D)

> Archbishop James Ussher claimed that the Heaven and
> the Earth were created on Sunday the 21st of October,
> 4004 BC, at 9:00 a.m. This too was incorrect. By
> almost a quarter of an hour. It was created at 9:13 in
> the morning, which was correct. The whole business
> with the fossilised dinosaur skeletons was a joke the
> paleontologists haven't seen yet.

*The glorious universe: Hubble Telescope-like shots of the vast
and beautiful stars . . .*

GOD (CONT'D)

> This proves two things: firstly, that God does not play
> dice with the universe; I play an ineffable game of my
> own devising. For everyone else it's like playing poker in
> a pitch-dark room, for infinite stakes, with a dealer who
> won't tell you the rules, and who smiles all the time.
> *(beat)*
> Secondly, the Earth's a Libra.

We zoom in on a copy of the Tadfield Advertiser, *a smalltown
newspaper. And we end on the YOUR STARS TODAY
column, as God reads us the Libra entry.*

GOD (CONT'D)

> The entry for Libra in the *Tadfield Advertiser* on the
> night our history begins reads as follows: *You may be
> feeling run down and always in the same daily round. A
> friend is important to you. You may be vulnerable to a*

*stomach upset today, so avoid salads. Help could come
from an unexpected quarter.*
> *(beat)*

This was perfectly correct on every count except for the
bit about salads.

103 EXT. THE GARDEN OF EDEN – DAY – 4004 BC

GOD (V.O.)
> To understand the true significance of what that
> means, we need to begin earlier. A little more than
> 6000 years earlier, to be precise, just after the
> beginning. It starts, as it will end, with a garden. In
> this case, the Garden of Eden. And with an apple.

And then over the Garden of Eden:

TITLE CARD: **THE BEGINNING**

Almost a montage:

A huge black SNAKE slips along a tree branch.

The Snake's head whispers into EVE's ear.

*A hand, Eve's, picks an apple from a tree. She takes a bite.
Grins. Passes it to ADAM. (They are both tastefully naked.
I would not make them white people.) Adam also takes a
bite . . .*

*And then Adam grins lecherously at Eve. Tasteful blackout . . .
Time lapse . . .*

A rumble of supernatural thunder!

*An angel in white robes, whom we will come to know as
AZIRAPHALE (pronounced AzEERafail), holding a flaming
sword, gestures impressively towards an exit gate: they have
to leave . . .*

*Eve is pregnant. Adam looks miserable. They are wearing
fig-leaf-based clothes.*

Aziraphale looks conflicted. We HOLD on him for a moment, then he runs after them, and hands Eve the sword.

104 EXT. OUTSIDE THE GARDEN OF EDEN – DAY – 4004 BC

The Garden is walled. Inside, a perfect oasis of greenery. Outside, something more like a desert or an African plain.

GOD (V.O.)
 It was a nice day. All the days had been nice. There
 had been rather more than seven of them so far,
 and rain hadn't been invented yet. But the storm
 clouds gathering east of Eden suggested that the first
 thunderstorm was on its way, and it was going to be a
 big one.

Adam and Eve are running, desperately, away from the Garden. Adam is holding the sword. Eve is pregnant and sad.

Outside the garden animals roar, and Adam brings up the sword to protect himself.

105 EXT. ON THE WALL OF THE GARDEN OF EDEN – DAY – 4004 BC

Watching Adam and Eve leave are the angel, AZIRAPHALE, and beside him, on a tree, a very, very large black snake. The snake hisses loudly.

AZIRAPHALE
 Sorry. What was that?

The snake transmutes into a male demon whom we will come to know as CROWLEY. He's dressed in black robes, as opposed to the angel's white robes, and his eyes look like the eyes of a snake. Crowley's wing feathers are grey; Aziraphale's are white.

CROWLEY
 I *said*, 'Well, that one went down like a lead balloon'.

AZIRAPHALE

Oh. Yes, it did, rather.

CROWLEY

Bit of an overreaction, if you ask me. First offence and everything. And I can't see what's so bad about knowing the difference between good and evil, anyway.

AZIRAPHALE

It must BE bad, Crawley. Otherwise you wouldn't have tempted them into it.

CROWLEY

They just said, 'Get up there and make some trouble'.

AZIRAPHALE

Obviously. You're a demon. It's what you do.

CROWLEY

Not very subtle of the Almighty, though. Fruit tree in the middle of a garden, with a 'don't touch' sign. I mean, why not put it on top of a high mountain or on the moon? Makes you wonder what God's really planning.

AZIRAPHALE

Best not to speculate. It's all part of the Great Plan. It's not for us to understand. It's ineffable.

CROWLEY

The Great Plan's ineffable?

AZIRAPHALE

Exactly. And you can't second-guess ineffability. There's Right and there's Wrong. If you do Wrong when you're told to do Right, you deserve to be punished. Er.

(pause)

I don't like the look of that weather.

Low rumble of non-supernatural thunder on the horizon.

CROWLEY

Didn't you have a flaming sword?

AZIRAPHALE

Er . . .

CROWLEY

You did. It was flaming like anything. What happened to it?

AZIRAPHALE

Er . . .

CROWLEY

Lost it already, have you?

AZIRAPHALE

(mutters inaudibly)
I gave it away.

CROWLEY

You what?

AZIRAPHALE

I gave it away! They looked so miserable. And there are vicious animals, and it's going to be cold out there, and she's expecting already, and I said, here you go, flaming sword, don't thank me, and don't let the sun go down on you here . . . I do hope I didn't do the wrong thing.

CROWLEY

(drily)
You're an angel. I don't think you *can* do the wrong thing.

Aziraphale does not notice the sarcasm.

AZIRAPHALE

Oh. Thank you. It's been bothering me.

In the distance, Adam uses the flaming sword on some poor lion. Aziraphale winces.

CROWLEY
>I've been worrying too. What if I did the right thing,
>with the whole eat-the-apple business? A demon can
>get into a lot of trouble for doing the right thing. Funny
>if we both got it wrong, eh? If I did the good thing and
>you did the bad one.

AZIRAPHALE
>No. Not funny at all.

The thunderstorm begins in earnest.

*Buddy Holly's song 'Everyday' plays, beginning with a tick
tick tick and . . .* Every day, it's a-getting closer . . .

106 EXT. SOHO, LONDON – AFTERNOON – 2007

TITLE CARD: **ELEVEN YEARS AGO**

Establishing shot of Aziraphale's bookshop A. Z. Fell &
Co., Booksellers. *It's a run-down secondhand/antiquarian
bookshop of the kind you used to see lots of in London . . .*

107 INT. AZIRAPHALE'S BOOKSHOP – AFTERNOON – 2007

*Aziraphale is answering the phone. He has not changed since
we saw him as an angel. He looks like a happy, affluent,
used-book dealer. He's a kind-looking gentleman whose
sartorial style runs to bow-ties. He thinks a little tartan
is nifty, and would use the word* nifty *with pride. His
bookshop is chaotic, crowded, glorious, dusty. He is sitting
at a desk piled high with books.*

AZIRAPHALE
>. . . I would need to check the shelves, but I know
>I have a first edition, 1740, of *Past, Present and to
>Come*, Mother Shipton's Yorkshire prophecies. Red
>Morocco binding, only slightly foxed. I think I've
>priced it at about four hundred pounds. I also have
>several later, less desirable editions. I'll set it aside for

you. Well, we do specialise in early editions of books of prophecy. Is there anything else you're looking for?

Aziraphale looks through the window. (The phone conversation continues over this.)

Outside on the street, a MOTHER, holding too many bags and dealing with the meltdown of a SMALL CHILD, lets go of the stroller her BABY is in.

The stroller is rolling towards the street and the cars.

Aziraphale, irritated, concentrates. The stroller loops around and miraculously rolls away from the traffic and back into the hand of the mother, who doesn't notice anything. Aziraphale looks pleased with himself.

AZIRAPHALE (CONT'D)
> *The Nice and Accurate Prophecies of Agnes Nutter?*
> I'm so sorry, I can't help you. Of course I know who
> she was: born 1600, exploded 1656. But there are no
> copies of her book available. I'm not holding out on
> you. You could name your own price for a copy . . .
> No, I can't name my price, I don't have it. Nobody
> has it.

He writes down a phone number.

AZIRAPHALE (CONT'D)
> There really is no need for that kind of language.

108 EXT. BT TOWER, LONDON – EVENING – 2007

It's 7:30 p.m. in midsummer; the streetlights are going on, and people are leaving their offices. One person is going to work: Crowley is wearing stylish, very black sunglasses and a very nice suit. He is carrying a clipboard and a Thermos flask. His hairstyle is perfect for somewhere around a decade ago. He glances around a little theatrically. He puts on a day-glow orange donkey jacket.

He hangs an identity card on a lanyard around his neck.
Then he walks in to the BT Tower building lobby.

109 INT. BT TOWER, LONDON. LOBBY – EVENING – 2007

A security desk. Behind it, a bored female SECURITY
GUARD does a crossword.

CROWLEY
 Rataway Pest Control.

SECURITY GUARD
 I thought your lot weren't due in until tomorrow
 morning.

CROWLEY
 Preliminary inspection. Traps go down tomorrow. My
 job's to tell them where to put them.

SECURITY GUARD
 I'll take you up there.

She gets up from the desk.

SECURITY GUARD (CONT'D)
 Don't touch anything you don't have to. Lot of
 important stuff, that floor. Mobile phone services, that
 sort of thing.

110 INT. BT TOWER, LONDON. LIFT – EVENING – 2007

Crowley and the security guard are in the lift.

SECURITY GUARD
 It's terrifying. I put down a tuna sandwich yesterday,
 never saw it again. Health and safety closed off the top
 floors as a health hazard until you lot get here.

CROWLEY
 We'll soon see them off.

SECURITY GUARD
Sunglasses?

CROWLEY
It's my eyes.

111 INT. TOP FLOOR BT TOWER, LONDON. LIFT – EVENING – 2007

*The lift dings, and Crowley steps out. The floor is empty.
Night lighting. But we hear a SCRATCHING.*

Crowley looks around.

*Every surface is alive. A nose. Sharp teeth. A twitch of a tail.
RATS. Hundreds of them! Tiny sinister red eyes glowing at
us from all over. A beat, then they move – they are coming
towards us!*

*Crowley walks forward. He takes out his Thermos, unscrews
the top, pours himself a cup of steaming tea.*

And Crowley . . . smiles.

CROWLEY
Beautiful job! Thank you all so much, men!

A lady rat chirps angrily.

CROWLEY (CONT'D)
And, yes, obviously, ladies too. Nice job! You can all
go home. And, yeah, stay cool.

112 INT. COMPUTER ROOM – EVENING – 2007

*He walks into a room filled with computer and BT
equipment. All of it old-fashioned and out-dated: the
computers of yesteryear, and some cables.*

Lots of green and red lights flashing.

*Crowley pours his tea onto the unit. Then he pours the rest
of the tea from the Thermos.*

All around the room CONSOLE lights start to flicker.
Something electronic buzzes.

113 INT. COMPUTER ROOM – EVENING – 2007

Console lights flickering. And then they start to GO OUT.

114 INT. BT TOWER, LONDON. LOBBY – EVENING – 2007

Crowley exits the lift. The security guard is back at her desk.

SECURITY GUARD
That was quick.

CROWLEY
Left something back in the van.

115 EXT. BT TOWER STREET – EVENING – 2007

Crowley walks out of the lobby. Quick cuts: on the pavement
is a BUSINESSMAN on an old-fashioned pre-smartphone
phone.

BUSINESSMAN
No, I understand. That's why we have to close this
now. So. Seventy grand. Our final offer. What do you
say?

And then he shakes the phone. Tries redialling, and we follow
Crowley, who is taking off his jacket, past people on the
pavement: a WOMAN . . .

WOMAN
No, Gavin, you can pick me up here. I'm on the corner
of . . . can you hear me? Hello?

. . . and a TEENAGE BOY.

TEENAGE BOY
Look, I know I kissed her at the party. But I mean, that

doesn't mean I wanted to dump you. I'm really sorry. I'm really . . . hello? Hello?

Over this we can hear a telecom voice saying, 'We are sorry. All circuits are busy.'

And Crowley is smiling. What a wonderful day.

He reaches his car, a beautiful vintage Bentley sports car, and sees a note – ancient brown paper under the windscreen wiper. Puzzled, he opens it and reads.

He looks at his watch. He's late. It's no longer a beautiful day.

He drives away, at speed, leaving the crumpled note in the gutter, where it begins to burn.

116 INT. CROWLEY'S BENTLEY – EVENING – 2007

He reaches down and finds a CD. We can see the CD label: it's Mozart. Slams it into the CD deck in the car. A driving song by Queen begins to play . . .

And as he drives, we see a TITLE CARD *with* **GOOD OMENS** *on it, and hear our GOD:*

GOD (V.O.)
> *Good Omens.* Being a Narrative of Certain Events occurring in the last eleven years of human history, in strict accordance, as shall be shown, with *The Nice and Accurate Prophecies of Agnes Nutter.*

TITLES SEQUENCE

117 EXT. A WOOD – NIGHT – 2007

A small wood, near a church.

GOD (V.O.)
> It wasn't a dark and stormy night, but don't let the weather fool you. Just because it's a mild night doesn't

mean that the forces of evil aren't abroad. They are.
They are everywhere.

*Rising from the ground are two very evil-looking gentlemen:
one squat and monstrous, LIGUR; one tall, thin and no less
monstrous, HASTUR.*

*They reach down, and, carefully, pick up a wicker picnic
hamper. And head for . . .*

118 EXT. A GRAVEYARD – NIGHT – 2007

*A small country churchyard. Possibly ruined. Rather creepy.
We move through it slowly . . .*

It's misty, and brrr.

GOD (V.O.)
Two demons lurk at the edge of the graveyard. They're
pacing themselves, and can lurk for the rest of the
night if necessary, with still enough sullen menace left
for a final burst of lurking around dawn.

*Hastur has been hand-rolling a tobacco cigarette. He puts it
in his mouth, lights it with a flame from his fingertip. In the
flame's light, we get a good look at them.*

*They don't have horns, they wear vintage suits and shabby
raincoats, but they aren't human. Weird eyes. Skin like frogs,
or pitted with terrible acne. They are trying hard to pass for
human, but not even the fog is helping.*

LIGUR
Gissa drag.

Hastur hands him the cigarette.

HASTUR
Bugger this for a lark. He should have been waiting for
us.

LIGUR
> You trust him?

Ligur gives the cigarette back.

HASTUR
> Nope.

LIGUR
> Good. Be a funny old world if demons went around trusting each other. What's he calling himself these days?

HASTUR
> Crowley.

119 EXT. ROAD – NIGHT – 2007

Crowley, still speeding, looks in his rear-view mirror. A police car, behind him, turns on its blue light.

CROWLEY
> No.

And now the siren starts.

CROWLEY (CONT'D)
> I do not have time for this.

120 EXT. POLICE CAR – NIGHT – 2007

Two POLICE OFFICERS are thrilled to be doing a high-speed chase in the fog. No, really they are.

OFFICER FRED
> The nutter's doing a hundred and ten. In the fog. You know what this means?

OFFICER JULIA
> We get to do a hundred and fifteen. Brilliant. What the hell kind of car *is* that?

OFFICER FRED
Vintage Bentley, I think. Come on, nutter. Pull over.

CUT TO:

121 INT. CROWLEY'S BENTLEY – NIGHT – 2007

The noise of the siren is starting to get to him. Crowley, irritated, snaps his fingers.

CUT TO:

122 INT. POLICE CAR – NIGHT – 2007

OFFICER JULIA
(into police radio)
In pursuit of a speeding vehicle. Vintage Bentley. And we're . . .

The police car engine makes a whining sound, and then it slows down and stops.

OFFICER JULIA (CONT'D)
We're having mechanical problems. Over.

CUT TO:

123 EXT. POLICE CAR – NIGHT – 2007

The police car, on the side of the road. Fog. The car's steaming. They open the bonnet.

We move from Officer Julia to Officer Fred: they look horrified and confused. And now we look at the engine.

Where the engine ought to be is . . . staring up at us . . . RATS?

124 EXT. A GRAVEYARD – NIGHT – 2007

Ligur and Hastur, still lurking. Hastur crushes the dog-end

under his foot. We can see a little more of the object behind him.

A car's headlights approach in the fog.

HASTUR
Here he comes now, the flash bastard.

LIGUR
What's that he's drivin'?

HASTUR
It's a car. A horseless carriage. Didn't they have them last time you was up here?

LIGUR
They had a man walking in front with a red flag.

HASTUR
They've come on a bit since then.

A car door slams.

HASTUR (CONT'D)
You ask me, he's been up here too long. And he wears sunglasses, even when he dunt need to.

We look from Hastur's TOAD-LIKE eyes to Ligur's FROG-EYES, and we suspect why Crowley might want to wear sunglasses.

Crowley is sauntering up the path. He stops. They stare at him.

HASTUR (CONT'D)
All hail Satan.

LIGUR
All hail Satan.

CROWLEY
Er. Hi guys. Sorry I'm late, but, well, you know how it is on the A40 at Denham, and then I tried to cut up towards Chorleywood—

Hastur interrupts him.

HASTUR

Now we art all here, we must recount the Deeds of the Day.

CROWLEY

('We do'? Oh, I remember this.)
Of course. Deeds. Yeah.

HASTUR

I have tempted a priest. As he walked down the street and saw the pretty girls in the sun, I put Doubt into his mind. He would have been a saint, but now, within a decade, we shall have him.

Ligur makes approving guttural throaty noises, as if this is the best thing he's ever heard.

CROWLEY
 (politely)
Nice one.

LIGUR

I have corrupted a politician. I let him think a tiny bribe would not hurt. Within a year we shall have him.

Hastur hisses approval. They stare at Crowley. Him next. But that's good, because he has the BEST one . . .

CROWLEY

You'll like this.

We look at their faces and know that they won't.

CROWLEY (CONT'D)

I brought down every London-area mobile phone network tonight.

There is a baffled silence.

HASTUR

Yes?

CROWLEY

It wasn't easy. I had to send rats into the BT Tower, and I had to pour tea into the network controller, while the backup system was offline for maintenance . . .

HASTUR

And what exactly has that done to secure souls for our master?

CROWLEY

Oh come on! Think about it! Fifteen million pissed-off people? Who take it out on each other? Who take it out on everyone else? Ruined days. Ruined nights. The knock-on effects are incalculable . . .

LIGUR

It's not exactly . . . craftsmanship.

CROWLEY

Head office don't seem to mind. They love me down there. Guys, times are changing. So, what's up?

Hastur reaches down and picks up the object at his feet. Some kind of wicker basket. He hands it to Ligur, who grins unpleasantly . . .

HASTUR

This is.

CROWLEY

No.

LIGUR

Yes.

CROWLEY

Already?

HASTUR

Yes.

CROWLEY

And it's up to me to . . . ?

LIGUR
Yes.

CROWLEY
You know. This sort of . . . well, it really isn't my scene.

LIGUR
Your scene. Your starring role. Take it.

HASTUR
Like you said. Times are changing.

LIGUR
They're coming to an end, for a start.

CROWLEY
Why me?

HASTUR
'They love you down there.' And what an opportunity. Ligur here would give his right arm to be you tonight.

LIGUR
Somebody's right arm, anyway.

Hastur has produced a clipboard.

HASTUR
Sign here.

Crowley writes A. J. Crowley *on the clipboard.*

LIGUR
No. Your real name.

Crowley uses the tip of his finger, and writes a sigil which burns where he's touched it. The entire sheet of paper goes up like flash paper.

Ligur holds out the large wicker basket. It could be a dog-basket, but it's the wrong shape . . . Crowley looks dejected.

CROWLEY

Now what?

HASTUR

You will receive instructions. Why so glum? The moment we have been working for all these centuries is at hand!

CROWLEY
(dully)
Centuries.

LIGUR

Our moment of eternal triumph awaits!

Crowley is forcing a smile. It does not convince anyone.

CROWLEY
(dully)
Triumph.

HASTUR

And you will be a tool of that glorious destiny!

CROWLEY
(dully)
Glorious. Tool. Yeah.

He takes the basket from Ligur.

CROWLEY (CONT'D)

Okay. I'll, er, be off then. Get it over with. Not that I want to get it over with. Obviously. But you know me. Keen.

Two implacable demon faces. Crowley backs away down the path.

CROWLEY (CONT'D)

So I'll be popping along. See you guys ar— see you. Er. Great. Fine. *Ciao.*

In the mist. We hear the Bentley car door slam.

LIGUR
Wossat mean, 'Ciao'?

HASTUR
It's Italian. It means 'food'.

125 INT. AZIRAPHALE'S BOOKSHOP – NIGHT – 2007

*A CLOSED sign is on the door. A glass of wine is poured.
Now we see an antique gramophone needle descend onto a
record.*

*Aziraphale settles himself incredibly comfortably into a chair
as the music begins: Schubert's* String Quintet.

*A huge, happy smile crosses Aziraphale's face as the melodies
wash over him.*

This is a man at peace.

126 INT. CROWLEY'S BENTLEY – NIGHT – 2007

GOD (V.O.)
Crowley was all in favour of Armageddon in general
terms, but it was one thing to work to bring it about
and quite another for it to actually happen.

*Crowley is driving. He looks miserable, stressed and upset.
The mystery basket is on the back seat. He turns on the
radio.*

CROWLEY
Oh. Shit . . .

NEWSREADER (V.O.)
And the FT index finished up five points today, after
vigorous trading.

CROWLEY
. . . Ohshitohshitohshit. Why me?

And the voice of the newsreader becomes the voice of
SATAN . . .

NEWSREADER (V.O.)

> *Because you earned it, Crowley. Didn't you? What you*
> *did to the M25 was a stroke of demonic genius, darling.*

127 INT. HELL, ROOM 515 – 1973

Flashback. A very dark room where several demons
(including, if possible, BEELZEBUB and Ligur) are sat,
watching a presentation by Crowley. Hastur is in the front
row and the most unimpressed. Crowley's in 1973 clothes,
giant flared trousers and boots, possibly with a mullet and
sideburns, standing in front of a screen.

We are looking from their point of view:

A big drawing of the M25. Crowley is making changes on it
with a pen as he talks.

CROWLEY

> So thanks to three computer hacks, selective bribery,
> and me moving some markers across a field one night,
> the M25 London Orbital Motorway, which was meant
> to look like this, will, when it opens in 1986, actually
> look like this, and represent . . .

And he replaces the slightly amended M25 picture with the
Odegra *symbol . . .*

CROWLEY (CONT'D)

> . . . the dread sigil *Odegra* in the language of the
> Dark Priesthood of Ancient Mu. *Odegra* means 'Hail
> the Great Beast, Devourer of Worlds!' Can I hear a
> wahoo?

EVERYBODY

> *(dutifully)*
> Hail the Great Beast, Devourer of Worlds.

And now we see a map of the South of England with Odegra *around London, where the M25 is.*

CROWLEY

Once it's built, the millions of motorists grumbling their way around it are going to be like water on a prayer wheel. They'll grind out an endless fog of low-grade evil that will encircle the whole of London. Yes, Duke Hastur?

Hastur has his hand up.

HASTUR

What's a computer?

128 INT. CROWLEY'S BENTLEY – NIGHT – 2007

And the conversation continues.

CROWLEY

The M25. Yes. Well, glad it went down so well. Yup. Leave it to me.

SATAN (V.O.)

That is what we are doing, Crowley. But if anything goes wrong, then those involved will suffer greatly. Even you, Crowley. Especially you.

Crowley nods. He's terrified.

SATAN (CONT'D)

Here are your instructions. This is the big one, Crowley.

And Crowley FREEZES for a moment, as information is downloaded directly into his brain. (Perhaps, from behind the dark glasses, his eyes could glow for a moment.)

A bad idea to do this while he's driving, because a lorry is heading towards him in the fog.

At the last moment, he gets his brain back, and twists the

steering wheel hard, slamming out of the lorry's way, a manoeuvre that throws the wicker basket across the back seat.

And now, for the first time, we can see what it is: a wicker bassinet. And the sleeping NEWBORN BABY inside it opens its eyes, and it wails . . .

129 INT. JAPANESE RESTAURANT – NIGHT – 2007

Aziraphale walks in. The SUSHI CHEF points to his favourite table, kept free for him.

SUSHI CHEF
 Here is a selection of your favourite rolls, Honoured
 Aziraphale-San.
 (Aziraphale-san no sukina makizushi o tokubetsu ni
 torisoroete oki mashita . . .)

The chef, who puts them, along with a cup of steaming tea, on the table, bows. Aziraphale bows back.

AZIRAPHALE
 Thank you, chef, that's very kind of you.
 (Taisho, sore wa wazawaza)

He sits at his empty table. Smiles as he eats his first nibble. Life is good.

And then his smile vanishes. He looks up: in the mirror on the wall, there is someone standing beside him. And we pull back off the mirror to see . . .

. . . the angel GABRIEL is indeed now miraculously standing next to Aziraphale. He is tall, fit, handsome and charismatic: a leader of angels, and he smiles angelically at Aziraphale.

GABRIEL
 Mind if I join you?

Aziraphale obviously minds, but he smiles, and says:

AZIRAPHALE
Gabriel. What an unexpected pleasure. It's been—

GABRIEL
Quite a while, now.

He picks up a piece of sushi, examines it, unimpressed.

GABRIEL (CONT'D)
Why do you consume that? You're an angel.

AZIRAPHALE
It's sushi. It's nice. You dip it in soy sauce and . . . it's
what humans do, and if I am going to be living here
among them . . . well, keeping up appearances . . . tea?

GABRIEL
I do not sully the temple of my celestial body with
gross matter.

AZIRAPHALE
Obviously not. Nice suit.

GABRIEL
Yes. I like the clothes. Pity they won't be around for
much longer.

AZIRAPHALE
They won't?

GABRIEL
We have reliable information that things are afoot.

AZIRAPHALE
They are?

GABRIEL
My informants suggest that the demon Crowley may
be involved. You need to keep him under observation,
without, of course, letting him know that's what you're
doing . . .

AZIRAPHALE

> I do know. I've been on Earth doing this since the
> beginning.

GABRIEL

> So has Crowley. It's a miracle he hasn't spotted you,
> yet.
>> *(a beautiful smile)*
> I know. Miracles are what we do.

130 EXT. HOSPITAL – NIGHT – 2007

*A green Morris Traveller is driving cautiously along the road
outside the hospital. Inside the car are DEIRDRE YOUNG
and her husband, ARTHUR YOUNG. He is in his forties;
she is in her late thirties and hugely pregnant. This is her first
child. But everything's very normal . . .*

GOD (V.O.)

> Meet Deirdre and Arthur Young. They live in the
> Oxfordshire village of Tadfield.

DEIRDRE

> Are we there yet? Arthur? Four minutes apart.

MR YOUNG

> It's definitely this way. It's just the roads look all
> different in the dark . . .

DEIRDRE

> The nuns said to come in when they were four to five
> minutes apart.

MR YOUNG

> It's a bit, um. Well. Nuns.

DEIRDRE

> Do we have any egg and cress sandwiches?

*Deirdre reaches for a sandwich, and as she does so, has a
contraction . . .*

A sirening motorcade zooms past them – an ambulance,
followed by three black cars.

DEIRDRE (CONT'D)
 Arthur. Just follow them.

131 INT. AMBULANCE – NIGHT – 2007

Suddenly RAPID-CUTTING, ultra-adrenaline: the
ambulance is going at speed. In it is HARRIET DOWLING,
the movie-star beautiful wife of the American Cultural
Attaché to London. Very pregnant. Standing near her,
and being thrown around, are TWO SECRET SERVICE
AGENTS. Holding a video screen, and a video camera. It's a
pre-Skype video hookup from the old days.

GOD (V.O.)
 Meet Harriet Dowling and her husband, American
 diplomat Thaddeus Dowling.

On the video screen we can see TAD (THADDEUS J.)
DOWLING, cultural attaché, back in the US, soon to be
presidential hopeful, in a White House meeting. He's talking
to her:

TAD DOWLING
 Breathe, honey. Just breathe.

HARRIET
 I am breathing, goddammit, Tad. Why aren't you here?

TAD DOWLING
 Honey. I'm with you. I'm just also here with the
 President.

PRESIDENT BUSH
 Hey, Harriet. Sorry we had to borrow your husband.

TAD DOWLING
 Hon, I'd better get back to the strategy conference.

HARRIET

> You are meant to be with me, you useless sonofabitch.
> *(contraction)*

TAD DOWLING

> Honey, you're going to the best place we could find at
> short notice. The, uh . . .

SECRET SERVICE #1

> St Beryl's Convent Birthing Hospital, sir.

TAD DOWLING

> St Beryl's. Right. Honey, you just keep on having the
> baby. They're recording the whole thing. Birth is the
> single most joyous co-experience that two human beings
> can share, and I'm not going to miss a second of it.

PRESIDENT BUSH

> Tad. If we can return to the matter in hand?

TAD DOWLING

> I'll get back to you, honey.

*And the screen goes blank. Mrs Dowling bites back some
really impressive swearing.*

132 INT. ST BERYL'S CONVENT MAIN HALL – NIGHT – 2007

*An old convent, part of which has been converted into a
small birthing hospital. We are looking at a dozen NUNS.
The MOTHER SUPERIOR is facing them, with charts
behind her. The SATANIC nature of the place is given away
by the upside-down cross on the wall beside the Mother
Superior, who holds a pointer.*

On the chart: a stylised mother.

MOTHER SUPERIOR

> At some point this evening, Mrs Dowling will arrive.
> She will undoubtedly have secret service agents with
> her; you will all ensure they see nothing untoward.

She sticks a stylised baby on the sheet beside the mother.

MOTHER SUPERIOR (CONT'D)
Sister Theresa and I will deliver the Dowlings' child in
Room Four. Once he has been born, we will remove
the baby boy from the mother, and give her back our
master's child.

*She moves the baby to the far side of the sheet, swaps it with an
identical baby but with horns, who is now beside the mother.*

MOTHER SUPERIOR (CONT'D)
Any questions?

*SISTER MARY LOQUACIOUS begins, hesitating, to raise
a hand. A sharp look from SISTER GRACE VOLUBLE and
she lowers her hand.*

MOTHER SUPERIOR (CONT'D)
Very good. Everything is ready. Tonight, it begins.

But now SISTER MARY has raised her hand . . .

MOTHER SUPERIOR (CONT'D)
Sister Mary Loquacious. You have a question?

SISTER MARY LOQUACIOUS
Yes, excuse me, Mother Superior, but I was wondering
where the other baby was going to come from, not the
American baby, I mean that's obvious, that's just the
birds and the bees, but the, you know—

MOTHER SUPERIOR
Master Crowley is on his way with our dark Lord to
be, Sister Mary. We do not need to know more than
that. We are Satanic Nuns of the Chattering Order
of Saint Beryl. And tonight is what our order was
created for. Sister Grace, you're on duty reception.
Sisters Maria Verbose and Katherine Prolix, you are
there to assist Sister Theresa, the rest of you know
your duties.

We can hear the ambulance siren drawing up outside.

MOTHER SUPERIOR (CONT'D)
Places!

And the nuns begin to move, and as they do, they begin to chat to each other, each one saying whatever's on her mind.

SISTER MARY LOQUACIOUS
Excuse me. Mother Superior. I didn't get a job. Probably an oversight.

MOTHER SUPERIOR
Yes. Yes, of course. You could make sure that there are biscuits. The kind with pink icing. I think we had a tin in the convent larder.

Mother Superior reaches out and tips the upside-down cross the right-way up. And she SMILES.

133 EXT. ST BERYL'S CONVENT – NIGHT – 2007

Behind the ambulance and the motorcade of black cars, we see a green Morris Traveller.

DEIRDRE
Right.

134 INT. ST BERYL'S CONVENT RECEPTION – NIGHT – 2007

We watch as two things are happening at the same time.

Harriet Dowling is wheeled in, followed by a Secret Service man with a video camera, OTHER SECRET SERVICE MEN saying things like 'Clear!' into their earpieces, and all is commotion . . .

Meanwhile Mr and Mrs Young walk up to the front desk. He's carrying a little suitcase. Sister Grace Voluble is at the desk.

DEIRDRE

Excuse me. Deirdre Young. Contractions now four minutes apart.

SISTER GRACE VOLUBLE

Welcome to St Beryl's, Mrs Young. We weren't expecting you until next week.

Deirdre turns to Mr Young, takes the suitcase.

DEIRDRE

Now Arthur will be with me, while I'm in labour . . .

SISTER GRACE VOLUBLE

I'm afraid not. We believe fathers just . . . complicate the process for everybody. We'll let him know when to come up . . .

DEIRDRE

But—

Mr Young looks relieved.

MR YOUNG

Not going to argue with nuns. Nurses. Know what they're doing, Deirdre. I'll see you when it's . . .

Deirdre glares at him as she is taken away by several nuns. An ELDERLY NUN looks at Mr Young as he walks out of the door and says,

ELDERLY NUN

She'll be in Room Three.

CUT TO:

135 EXT. ST BERYL'S CONVENT – NIGHT – 2007

A vintage Bentley pulls up. Crowley gets out, grabs the hamper with the baby in it and heads towards the cloisters, leaving the car's lights on, a demon in a hurry with a lot on his mind.

GOD (V.O.)

It may help to understand human affairs to know that most of the great triumphs and tragedies of history are caused, not by people being fundamentally good or fundamentally bad, but by people being fundamentally people.

He spots Mr Young loitering by a black motorcade car and assumes he is something to do with the US embassy business . . .

MR YOUNG

You left your lights on.

Crowley snaps his fingers. The lights go out.

MR YOUNG (CONT'D)

Oh. That's clever. Is it infra-red?

CROWLEY

Has it started yet?

MR YOUNG

They made me go out.

CROWLEY

Any idea how long we've got?

MR YOUNG

I think we were, er, getting on with it, doctor.

CROWLEY

Got it. What room is she in?

MR YOUNG

We're in Room Three.

And Crowley nods.

CROWLEY

Room Three. Got it.

GOD (V.O.)

There's a trick they do with one pea and three shells,

or with playing cards, which is very hard to follow, and something like it, for greater stakes than a handful of loose change, is about to take place.

136 INT. CARD TRICK – NIGHT

We are looking from above at a green baize table. A hand puts down three cards, face down.

137 INT. DELIVERY ROOM THREE – NIGHT

Looking at Mrs Young's face, giving birth . . . She's smiling, looking proud and exhausted . . .

GOD (V.O.)
 Deirdre Young is in Delivery Room Three. She is having a golden-haired male baby we will call Baby A.

138 INT. CARD TRICK

The first card is flipped. It has a picture of a baby on it, with a blue blanket.

139 INT. DELIVERY ROOM FOUR

Mrs Dowling, giving birth angry and screaming. Secret Service Men filming. Mother Superior and SISTER THERESA GARRULOUS are in there.

GOD (V.O.)
 Harriet Dowling is giving birth in Delivery Room Four. She is having a golden-haired male baby we will call Baby B.

140 INT. CARD TRICK

A second card is turned over. It has an identical baby on it, but with a cream blanket.

141 INT. ST BERYL'S CONVENT CORRIDOR – NIGHT – 2007

*Crowley comes up some back stairs, and out into a corridor.
He's looking around, trying to find a nun. And he sees one
from behind.*

CROWLEY
 Psst!

142 INT. CARD TRICK

*The third card is turned face up: a third identical baby,
but with a red blanket. It's flipped face down, or a hand is
passed over it. Now when we see the face of the card, it has a
drawing on it of something monstrous.*

GOD (V.O.)
 Sister Mary Loquacious is about to be handed a
 golden-haired male baby we will call the Adversary,
 Destroyer of Kings, Angel of the Bottomless Pit, Prince
 of This World, and Lord of Darkness.

143 INT. ST BERYL'S CONVENT CORRIDOR – NIGHT – 2007

*Sister Mary Loquacious, looking down into the picnic
hamper. She is carrying a vintage biscuit tin.*

SISTER MARY LOQUACIOUS
 Is that him?

CROWLEY
 Yup.

SISTER MARY LOQUACIOUS
 Only I'd expected funny eyes. Or teensy-weensy little
 hoofikins. Or a widdle tail.

*She's taken the baby out of the basket. It's wrapped in a
RED blanket . . .*

CROWLEY

It's definitely him.

SISTER MARY LOQUACIOUS

Fancy me holding the Antichrist. And counting his little toesy-wosies . . . Do you look like your daddy? I bet you do. I bet you look like your daddywaddykins . . .

CROWLEY

He doesn't. Take him up to Room Three.

SISTER MARY LOQUACIOUS

Room three . . . do you think he'll remember me when he grows up?

CROWLEY

Pray that he doesn't.

CUT TO:

144 INT. CARD TRICK

GOD (V.O.)

Three babies. Watch carefully. Round and round they go.

The playing cards are pushed around on the table, three-card-monte-style, until we cannot tell which is which.

CUT TO:

145 INT. ST BERYL'S CONVENT MAIN HALL – NIGHT 2007

Sister Mary Loquacious, carrying the baby. She puts it into a wheeled bassinet.

Sister Grace Voluble notices her.

SISTER GRACE VOLUBLE

Sister Mary, what are you doing here? Shouldn't you be taking biscuits to the refectory?

SISTER MARY LOQUACIOUS
Master Crowley said . . .

SISTER GRACE VOLUBLE
Have you seen the civilian husband anywhere? It's time
to send him up, and he's wandering about the building
unescorted . . .

SISTER MARY LOQUACIOUS
I've only seen Master Crowley, and he said take the
baby to Room Three . . .

SISTER GRACE VOLUBLE
Well, get on with it, then.

CUT TO:

146 INT. HOSPITAL ROOM THREE – NIGHT – 2007

Sister Mary goes in, with the ANTICHRIST BABY in a
hospital-style bassinet, to the room in which Deirdre Young
is asleep.

Mrs Young has BABY A in an identical bassinet sleeping
soundly beside her.

Sister Mary looks at the two babies. They look quite similar,
don't they? The one already there is in a BLUE blanket; the
one she brings in is in a RED one.

A hesitant knock on the door. Mr Young.

MR YOUNG
Has it happened yet? I'm the father. The husband. Both.

MARY
Ooh yes. Congratulations. Your lady wife's asleep,
poor pet.

Mr Young looks down at the babies. Baby A and
the Antichrist baby in their bassinets. He jumps to a
conclusion.

MR YOUNG
 Twins? Nobody said anything about twins.

MARY
 Oh, no! This one's yours. The other one's . . .
 someone else's. Just looking after him. No, this one's
 definitely yours, your ambassadorship. From the top
 of his head to the tips of his hoofywoofies – which he
 hasn't got.

MR YOUNG
 All, er, present and correct, is he?

MARY
 Oh, yes. Normal. Very, *very* normal.

 CUT TO:

147 INT. DELIVERY ROOM FOUR – NIGHT – 2007

*Everything in this delivery room is FAST-CUT, with
adventurous camera moves and pounding music: we see
the sweat on foreheads, sharp lighting. It is a much bigger
delivery room, which is good because it has to fit a lot of
people. We have our secret service men, one of them with
his video camera, one of them holding up a small screen, a
couple of MINOR US OFFICIALS, nurse nuns, and Harriet
Dowling, who has just given birth to BABY B, loudly and
angrily.*

SECRET SERVICE #1
 The Eagle has landed. Repeat. The Eagle has landed.

*The Mother Superior and Sister Theresa Garrulous give
each other SIGNIFICANT LOOKS. Mother Superior
moves in.*

MOTHER SUPERIOR
 A beautiful boy. Now we just have to take him away
 for a minute to weigh him, and, the usual . . .

And she goes to put the newborn Baby B in a bassinet . . .

TAD DOWLING
A boy. Mr President, I have the honour, sir, to report
myself the father of a regular Y-chromosomed son.

PRESIDENT BUSH
Yep. Now, about the trade agreement . . .

TAD DOWLING
Absolutely. Back to business. Right, Harriet? This
father-of-a-male-boy-son is all yours, Mr President.

*Sister Theresa Garrulous, unnoticed, leaves. More pounding
music.*

CUT TO:

148 INT. CORRIDOR – NIGHT – 2007

*As Sister Theresa leaves, two nuns wheel a bassinet away
containing Baby B . . . Theresa goes the other way down the
corridor . . .*

CUT TO:

149 INT. ROOM 2 – NIGHT – 2007

*Pounding music. In Room Two, two different Chattering
Nuns are playing cards, guarding an empty bassinet.*

Sister Theresa Garrulous bursts in.

SISTER THERESA GARRULOUS
Where's the baby?

Nuns look up from their card game. They look blank.

SISTER THERESA GARRULOUS (CONT'D)
Satan give me strength.

CUT TO:

150 INT. STAIRWELL – NIGHT – 2007

Sister Theresa is heading down a stairwell, as fast as she can. She's panicking.

CUT TO:

151 INT. ST BERYL'S CONVENT CORRIDOR – NIGHT – 2007

Sister Theresa comes down a corridor and encounters Sister Grace.

SISTER THERESA GARRULOUS
 Do you know where our master's child is?

SISTER GRACE VOLUBLE
 Sister Mary Loquacious has him. In Room Three.

And Sister Theresa is running in a most un-nun-like fashion . . .

CUT TO:

152 INT. ST BERYL'S CONVENT CORRIDOR – NIGHT – 2007

Pounding music. Now Sister Theresa Garrulous isn't actually running down the corridors, but she is moving as fast as she can, scanning every open room as she passes . . .

CUT TO:

153 INT. DELIVERY ROOM THREE – NIGHT – 2007

. . . and Sister Theresa pushes open the door to Room Three. Mrs Young is still asleep. Sister Mary and Mr Young are having a cup of tea each.

Sister Mary is presenting Mr Young with a selection of pink iced biscuits.

SISTER MARY LOQUACIOUS
 Now these are what we call *bis-cuits*, but you'll be
 looking at them and going

(*fingerquotes*)
'cookies'!

MR YOUNG
I call them biscuits.

And Sister Theresa spots the two babies. Sister Mary winks and points to one. Sister Theresa winks back.

Freeze frame . . .

GOD (V.O.)
As methods of human communication go, the human wink is quite versatile. For example, Sister Theresa's meant:

SISTER THERESA GARRULOUS
Where the hell have you been? We're ready to make the switch, and here's you in the wrong room with the Adversary, Destroyer of Kings, Angel of the Bottomless Pit, Prince of This World, and Lord of Darkness, drinking tea.

GOD (V.O.)
And, as far as she was concerned, Sister Mary's answering wink meant . . .

Sister Mary looks up from her tea, and says, sharp, sexy and out of character (the voice dubbed by Sister Theresa):

SISTER MARY LOQUACIOUS
This child is the Adversary, Destroyer of Kings, Angel of the Bottomless Pit, Prince of This World, and Lord of Darkness. But I can't talk now because there's this outsider here.

GOD (V.O.)
Sister Mary, on the other hand, had thought that Sister Theresa's wink was more on the lines of . . .

Sister Theresa is now dubbed by Sister Mary.

SISTER THERESA GARRULOUS
Well done, that Sister Mary – switched over the babies all by herself. Now indicate to me the superfluous child and I shall remove it and let you get on with your tea with his Royal Excellency the American Ambassador.

Back to reality.

SISTER THERESA GARRULOUS (CONT'D)
(to Mr Young)
Extra baby . . . removal . . .

She wheels Baby A out of the room, leaving the Antichrist baby behind.

SISTER MARY LOQUACIOUS
But I'm wittering on. So where were you before you took up this appointment?

MR YOUNG
Swindon.

CUT TO:

154 INT. DELIVERY ROOM FOUR – NIGHT – 2007

Sister Theresa takes Baby A out of the bassinet and hands him to Mrs Dowling.

SISTER THERESA GARRULOUS
Here's your little man back. All cleaned up and weighed.

The secret service men edge forward nervously. One is still filming: Mrs Dowling shows the baby to his camera.

MRS DOWLING
Look, honey. Our son.

TAD DOWLING
He's beautiful, hon. What a little tyke, huh? Seeing him makes me understand what's important in life. It's not work. I'm going to teach him to play baseball, and

on Sundays we'll go fishing and . . . sorry hon, I'll call you back.

The awkwardness of the moment is increased as the Mother Superior, whom we had not seen enter the room, says, ominously:

MOTHER SUPERIOR
You must name the child.

HARRIET
Well, we were going to name him Thaddeus, after his pop. And his pop's pop . . .

MOTHER SUPERIOR
Damien's an excellent name.

HARRIET
Damien Dowling? Too alliterative.

MOTHER SUPERIOR
Warlock, then. It's an old English name. A good name.

Harriet looks down at little Warlock.

HARRIET
Hello, Warlock.

CUT TO:

155 INT. ROOM THREE – NIGHT – 2007

Deirdre Young is still asleep, as is the Antichrist baby. Sister Mary is getting into the naming.

MR YOUNG
Damien? No, I had fancied something more, well, traditional. We've always gone in for good simple names in our family.

SISTER MARY LOQUACIOUS
Cain. Very modern sound, Cain, really.

MR YOUNG
 Hmm.

SISTER MARY LOQUACIOUS
 Or there's always . . . well, there's always Adam.

MR YOUNG
 Adam? Hmm. Adam . . .

*And at that moment the baby wakes, and opens its eyes,
and starts to cry . . . and the baby, waking, wakes Deirdre
Young.*

DEIRDRE
 Oh. Give him here, Arthur. Come on little one . . .

She reaches for the crying baby and prepares to breastfeed.

MR YOUNG
 You know, Deirdre, I think he looks like an Adam.

DEIRDRE
 Hello, Adam.

 CUT TO:

156 INT. THE CONVENT CORRIDOR – NIGHT – 2007

*Two nuns are coming towards us, wheeling a bassinet,
containing Baby B, the Dowling baby.*

GOD
 It would be nice to think that the nuns had the surplus
 baby – Baby B – discreetly adopted. That he grew to
 be a happy, normal child, and, then, grew further to
 become a normal, fairly contented adult. And perhaps
 that is what happened. He probably wins prizes for his
 tropical fish.

157 INT. CROWLEY'S BENTLEY – NIGHT – 2007

Crowley has a hands-free calling system: he's driving.

CROWLEY
Call Aziraphale.

CARPHONE SYSTEM
Calling Aziraphale.

PHONE SYSTEM
We are sorry. All circuits are busy. We are sorry. All circuits are . . .

158 INT. THE BOOKSHOP – NIGHT – 2007

Aziraphale enters, humming Schubert. Hangs up his coat.

The phone on the desk rings . . . Aziraphale glares at it. He wants to let it ring. Then he picks it up.

AZIRAPHALE
I'm afraid we're quite definitely closed.

159 INT. TADFIELD VILLAGE PHONE BOX – NIGHT – 2007

Crowley is standing in the last village phone box in England to have a working payphone in it.

CROWLEY
Aziraphale? It's me. We have to talk.

AZIRAPHALE
Yes. Yes, I rather think we do.

CROWLEY
Really? Okay. Usual place.

AZIRAPHALE
I, um . . . I assume this is about . . .

CROWLEY
Armageddon. Yes.

He breaks the connection.

160 EXT. ST JAMES'S PARK DUCK POND – MORNING – 2007

It's morning in St James's Park. It feels like a spy movie.

GOD (V.O.)
> Everyone knows the best place for a clandestine
> meeting in London is, and always has been, St James's
> Park. They say the ducks in St James's Park are so used
> to being fed by secret agents that they've developed
> Pavlovian reactions to them.

*There are people around the pond, all pretending that they
are not secret agents having clandestine meetings. We can
see a Russian and an American having a meeting, a British
agent and a Chinese, a French and a Brazilian. In each case,
they are actually eating sandwiches and pretending to feed
the ducks.*

RUSSIAN AGENT
> *(tossing black bread)*
> Rudnitsky's gone triple.

BRITISH AGENT
> *(cucumber sandwich)*
> If the treaty is signed, it will have global repercussions . . .

FRENCH AGENT
> *(baguette)*
> We will match their offer . . .

GOD (V.O.)
> The Russian cultural attaché's black bread is
> particularly sought after by the more discerning duck.
> Crowley and Aziraphale have been meeting here for
> quite some time.

*Crowley and Aziraphale have been talking for a while when
we reach them – talking like spies and feeding the ducks.*

AZIRAPHALE
> You're sure it was the Antichrist?

CROWLEY

 I should know. I delivered the baby. Not delivered-delivered it. You know. Handed it over.

Aziraphale is tossing a breadcrust to a drake. The drake pecks at it, then squawks, and dies.

AZIRAPHALE

 Really, my dear, was that necessary?

CROWLEY

 Sorry.

The drake returns to life, quacks and paddles off.

AZIRAPHALE

 We knew something was going on, of course. I've made enquiries. An American diplomat. Really? As if Armageddon were a cinematographic show you wished to sell in as many countries as possible.

CROWLEY

 The Earth and all the kingdoms thereof.

Aziraphale looks at Crowley for the first time.

AZIRAPHALE

 We will win, of course.

CROWLEY

 You really believe that?

AZIRAPHALE

 Obviously. Heaven will finally triumph over Hell. It's all going to be rather lovely.

Crowley starts walking through the park. Aziraphale reluctantly follows him.

CROWLEY

 Out of interest, how many first class composers do your lot have in Heaven? Because Mozart's one of ours. Beethoven. Schubert. All the Bachs . . .

AZIRAPHALE

They have already written their music . . .

CROWLEY

And you'll never hear it again. No more Albert Hall.
No more Glyndebourne. No more proms. No Compact
Discs. Just celestial harmonies.

AZIRAPHALE

Well . . .

CROWLEY

And that's just the start of what you'll lose if you win.
No more fascinating little restaurants where they
know you. No gravlax with dill sauce. No more old
bookshops. No more Regency silver snuffboxes.

AZIRAPHALE

But after we win, life will be better for everybody.

CROWLEY

You'll be about as happy with a harp as I'll be with a
pitchfork.

AZIRAPHALE

We don't play harps.

CROWLEY

And we don't use pitchforks. You know what I mean.

AZIRAPHALE

But it's part of the Divine Plan. The Four Horsemen
will ride out.

CROWLEY

Where do they ride out from?

AZIRAPHALE

What?

CROWLEY

The Four Horsemen of the Apocalypse. Their arrival
signals the end of days. War, Famine, Pestilence and

Death. Where do they ride from? Do they have a stables somewhere?

CROWLEY

AZIRAPHALE

You ought to know. They work for your lot, don't they?

CROWLEY

Not as far as I know. Independent contractors, I expect. Specialists. In business for themselves.

AZIRAPHALE

I heard Pestilence retired.

CROWLEY

Really?

AZIRAPHALE

Yes. It's Pollution, these days. I think this is a bit of a red herring. The point is, the Four Horsemen ride out. The seas will turn to blood . . .

CROWLEY

The seas are where your sushi comes from. And your herrings.

They've reached Crowley's Bentley. He's parked it on the Mall, somewhere you can't park.

It already has a wheel clamp on it, and a TRAFFIC WARDEN is walking around it, writing things down in his electronic notebook.

CROWLEY (CONT'D)

We've only got eleven years. Then it's all over. We have to work together

AZIRAPHALE

No.

CROWLEY

It's the end of the world we're talking about. Not some little temptation I've asked you to cover for me

while you're in Edinburgh for the festival. You can't say no.

AZIRAPHALE

No.

CROWLEY

We can do something. I've got an idea.

AZIRAPHALE

No. I. Am. Not. Interested.

A breath. Crowley is about to fall apart. But he pulls himself together.

CROWLEY

Let's have lunch. I still owe you one from . . .

Aziraphale glares at him. Then softens . . .

AZIRAPHALE

Paris. 1793.

CROWLEY

Oh, yes. The Reign of Terror. Was that one of yours or one of ours?

They get into the car . . .

The WHEEL CLAMPS FALL OFF.

AZIRAPHALE

Can't recall. We had crêpes.

The traffic warden, who is looking triumphant, is startled when his handheld computer fizzles and sparks as the Bentley drives away. And the clamps are in the road.

161 EXT. AFRICAN ROAD – DAY – 2007

A dusty red-painted truck rumbles along a dusty road that's little more than a track. African music, African animals. A beautiful establishing shot.

GOD (V.O.)

At that time she was selling weapons. She never stuck at one job for very long. Three, four hundred years at the outside. You didn't want to get in a rut.

162 EXT. AFRICAN VILLAGE – DAY – 2007

A quiet, perfect village. Children run, laughing, through the streets. A woman sits beside her wares in the market. We see a truck stop in the street.

The DRIVER gets out and lifts the bonnet: thick smoke comes out. An African PASSER-BY walks over.

PASSER-BY

That does not look good.

The driver looks up, and we discover that she is a poised woman with the most amazing flame-red hair. She is WAR.

163 INT. AFRICAN BAR – DAY – 2007

War opens a bottle of beer by casually slamming it and her hand against the counter, and drains it. The BARTENDER is a bored African woman in her mid 30s.

WAR

I got a truck. The Engine's shot. Anyone around here repair trucks?

BARTENDER

Only Nathan. But he's gone back to Kaounda to his father-in-law's farm.

WAR

When's he coming back?

BARTENDER

A week. Perhaps two weeks.

164 EXT. AFRICAN ROAD – 2007

The passer-by walks around the truck. Then he peeks inside . . .

There are a lot of boxes in there. And the boxes are all stencilled with WARNINGS. High explosive. Ammunition. Guns. Rocket launchers . . .

165 INT. AFRICAN BAR – DAY – 2007

An elderly payphone in the corner. War is talking.

WAR
> Shipment's delayed. You'll just have to wait another two weeks to start your war.

There are TWO MEN sitting at a corner table, having an easy-going conversation, drinking and laughing.

WAR (CONT'D)
> No, you listen to me. No. You may have bought the equipment, but it begins when I get there . . . Really? REALLY?

She puts down the phone, sits down at the table with the men.

WAR (CONT'D)
> Hey. When was the last war in these parts?

The two men look at each other.

BAR CUSTOMER 1
> I don't think we've ever had one.

BAR CUSTOMER 2
> We don't go in for things like that here.

166 EXT. AFRICAN ROAD – DAY – 2007

War looks out at the lazy African paradise.

WAR
> Oh, what the hell. I needed a holiday anyway.

TIME SHIFT:

167 EXT. AFRICAN ROAD – EVENING – 2007

It's 24 hours later. An explosion rocks the street. A GROUP OF MEN in improvised uniforms come charging down the street. A rattling of sub-machine gun fire takes them out. They fall.

We follow a grenade behind improvised sandbags. The PEOPLE BACK THERE see the grenade, and look horrified, as it blows up . . .

We look at the corpses on the street.

And then we see the (now very empty) truck.

Several women, one of them the bartender, are up on the truck. They have a rocket launcher.

BARTENDER
 (fiercely)
 If they want war, we will give them war, my sisters . . .

They fire the rocket launcher.

War strides down the street towards us. Explosions behind her. Nothing's going to hurt her.

She smiles. Something goes BOOM.

168 INT. THE RITZ – DAY

Aziraphale and Crowley are sitting at a table. They are concluding dessert, and Aziraphale is finishing his last bite with enthusiasm.

AZIRAPHALE
 That was scrumptious. So, what are you in the mood for now?

CROWLEY
 Alcohol. Quite extraordinary amounts of alcohol.

AZIRAPHALE
> Is that wise? I suppose it is. But let's have it back at my
> place. Waiter!

169 GOD VOICE-OVER SEQUENCE

A shot of New York . . .

GOD (V.O.)
> This is bestselling author of diet books Doctor Raven
> Sable. He never actually earned the medical degree he
> claims, since there hadn't been any universities in those
> days.

170 EXT. NEW YORK – DAY – 2007

*We are on Fifth Avenue: we zoom in on 666 Fifth Avenue,
on the big 666 on the side of the building. And move through
the window at the top of the building into . . .*

171 INT. NEW YORK, FANCY RESTAURANT – DAY – 2007

*We pan across a restaurant. It's a fancy restaurant. Dry ice
and liquid nitrogen at tables. Molecular gastronomy. It's very
fancy . . .*

*RAVEN SABLE is dressed in black, and has a slightly sinister
beard. He looks rich, classy and clever. He is FAMINE.*

*Sable looks on with approval as a WAITER brings his dining
partner, FRANNIE, his accountant and financial manager, a
nearly empty but beautiful plate . . .*

WAITER
> Your main course, madam. Chicken froth, on a
> reduction of broccoli gel, with a mushroom foam. And
> the chef recommends this, first . . .

He hands her a balloon.

FRANNIE

What is it? It looks like a balloon.

WAITER

A balloon filled with lavender-scented air. It is the first course. Let it waft about you, as you eat your dinner.

FRANNIE

I need another glass of wine.

WAITER

Of course.

They are interrupted by SHERRYL, a fashion model. Horrendously underweight. Beautiful but dear god how can a human being be that thin . . . ?

SHERRYL

Uh. Dr Sable. I hope you don't mind me interrupting you. But your book. It changed my life . . . Sherryl. Two Rs. And a Y.

She puts the book down on the table. Sable's photo is on the cover: THE D-PLAN DIET. *And the subtitle: 'SLIM YOURSELF BEAUTIFUL – TERMINALLY!'*

He signs, saying:

SABLE

There. A quote from the Book of the Revelation of St John.

SHERRYL

You don't know how much this means to me.

She backs away.

FRANNIE

That girl looks like she's starving to death.

SABLE

She is. She's dying of hunger right now. *Bon appetit.* So. You saw the latest royalty statement?

Frannie is hungry. The molecular gastronomy is lost on her . . .

FRANNIE

Twelve million copies sold, Dr Sable.

SABLE

C'mon. Eat up. Molecular gastronomy. Amazing, huh?

FRANNIE

That's a lot of copies . . .

SABLE

Now it's time to go corporate. A chain of fast food outlets. Factories. The whole schmear.

Frannie has an ultra-thin, ultra-light black laptop. She's stabbing at it . . .

FRANNIE

Already on it. We use the Cayman Islands as a . . . Dr Sable? Are you listening?

SABLE

Sorry – it just occurred to me. I've never seen a room full of rich people so hungry . . .

And he smiles.

172 EXT. SOHO, AZIRAPHALE'S BOOKSHOP – EVENING – 2007

Crowley and Aziraphale are heading down the Soho pavement to the bookshop. They have eaten, and spent a very pleasant day together.

AZIRAPHALE

I have several very nice bottles of Châteauneuf-du-Pape in the back. I picked up a dozen cases of them in 1921, and I still have some left, for special occasions.

CROWLEY

Lovely. Not very big on wine in Heaven, are they, though? Not going to get any more nice little

Châteauneuf-du-Papes in Heaven. Or single malt
scotch. Or little frou-frou cocktails with umbrellas.

AZIRAPHALE
I told you, Crowley. I'm not helping you. I'm not
interested. This is purely social. I'm an angel. You're a
demon. We're hereditary enemies. Get thee behind me,
foul fiend!

He unlocks the door to the bookshop.

AZIRAPHALE (CONT'D)
After you.

173 EXT. OIL TANKER – DAY – 2007

*WHITE is in their twenties. They are beautiful, in a dirty sort
of way. Everything about them, overalls, face, hair, is slightly
grimy . . . They are mopping a deck of an oil tanker . . . This is
POLLUTION. FREEZE on their face.*

GOD (V.O.)
This one is called White, or Albus, or Chalky, or
Snowy. White's had lots of interesting jobs in lots of
interesting places . . . helped design the petrol engine,
plastics and the ring-pull can . . . they can turn their
hand to anything, White.

174 EXT. OIL TANKER – DAY – 2007

A shot from above: the oil tanker on a blue sea . . .

GOD (V.O.)
The tanker is almost entirely automated. There's
almost nothing left that a person can do.

175 INT. RESTRICTED AREA – DAY – 2007

WHITE walks to the Emergency Cargo Release switch. It

says EMERGENCY OIL RELEASE, and it's in the 'off' position. There are red lights on it.

White touches fingers to lips, as if blowing a kiss to the switch. The lights turn green.

White flicks the Cargo Release switch into the RELEASE position.

WHITE
> (*gently, wistfully.*)
> Oops.

176 BIRD'S EYE VIEW: THE TANKER – DAY – 2007

We see the tanker below us, and, all around it, a huge black oil spill spreading out across the blue of the sea.

GOD (V.O.)
> Afterwards, there was a huge amount of discussion as to whose fault it was. None of the ship's officers ever worked again . . .

177 EXT. TANKER DECK – DAY – 2007

A tiny ship, a little steamer, as different as can possibly be from the gleaming huge tanker, is passing in the background.

GOD (V.O.)
> But no one gave any thought to Able Seaman White . . .

178 EXT. SMALL SHIP – DAY

And there is White, eating crisps on the deck of the steamer. They toss the empty crisp packet overboard. Behind them, we pan up to see, are rusting barrels each stencilled with WEEDKILLER – TOXIC – EXTREMELY DANGEROUS and skull and crossbones . . .

GOD (V.O.)
 Nobody ever does.

179 EXT. HOSPITAL – NIGHT – 2007

Mr Young drives the car up to the main door. Deirdre comes out, with the baby. A bunch of Chattering Nuns wave goodbye, still chattering.

GOD (V.O.)
 That night, Arthur and Deirdre Young proudly took the baby they believed was theirs home to the quiet English village of Tadfield. The Antichrist had been on Earth for twenty-four hours.

180 EXT. AZIRAPHALE'S BOOKSHOP – NIGHT – 2007

Establishing shot of the outside of the shop. Soho. A CLOSED sign on the door.

GOD (V.O.)
 While in London, Soho, an angel and a demon had been drinking solidly for the last six of them.

181 INT. AZIRAPHALE'S BOOKSHOP, BACK ROOM – NIGHT – 2007

We move through the bookshop, listening to their conversation, until we reach the back room. There are a LOT of bottles of wines and spirits on the various surfaces, along with the teetering piles of books and the Regency snuff box display.

Crowley is drunker than Aziraphale, but they are both drunk.

AZIRAPHALE
 So what. Exactly. Is. Your. Point?

CROWLEY
 My point is. My point is. The point I'm trying to make is . . . the dolphins. That's my point.

AZIRAPHALE

Kind of fish.

CROWLEY

Nononono, 's mammal. Your actual mammal. Difference is . . .

Neither of them are very clear on the differences.

AZIRAPHALE

Mate out of water?

CROWLEY

Don't think so. Something about their young. Not the point. The point is. Their brains.

He pours himself a huge glass of wine. It takes a lot to get supernatural beings drunk.

AZIRAPHALE

What about their brains?

CROWLEY

Big brains. That's my point. Size of. Size of. Size of damn big brains. Not to mention whales. Brain city, whales, take it from me.

AZIRAPHALE

Kraken. Great big bugger. Supposed to rise to the surface right at the end, when the sea boils.

CROWLEY

That's my point, whole sea bubbling, dolphins, whales, everybody turning into bouillab, bouillab . . . fish soup. Not their fault. Same with gorillas. Whoops, they say, sky gone all red, stars crashing to ground, what they putting in the bananas these days?

AZIRAPHALE

All creatures great and small. Poor little, big . . .

CROWLEY

And you know what makes it worse? When it's

all over. You are going to have to deal with . . .
ETERNITY!

Crowley makes a huge gesture and sends a glass and contents flying. It smashes, loudly. Aziraphale gestures, and it reforms, slightly drunkenly.

AZIRAPHALE
Eternity?

Crowley has found Aziraphale's collection of theatre programmes.

CROWLEY
It won't be so bad at first. No more Stephen Sondheim first nights in eternity, I'm afraid. But I've heard rumours that your boss *really* loves *The Sound of Music*. Fancy spending eternity watching that? You could literally climb every mountain over and over and over . . .

Crowley walks around the back room . . .

AZIRAPHALE
I don't like it any more than you, but I told you. I can't disod – not do what I'm told. 'M anangel. I . . .
(*pause*)
I can't cope with this while 'm drunk. I'm going to sober up.

CROWLEY
Me too.

He closes his eyes, and jerks. We watch all the bottles around the room refill with alcohol.

Crowley and Aziraphale look like people who have just become un-drunk and don't like it.

182 EXT. A HILLSIDE ABOVE THE HOSPITAL – NIGHT – 2007

A storm has begun. There's a motorcade, ready to take the

Dowling baby away. Mrs Dowling comes out of the door, with the baby.

GOD (V.O.)

Harriet Dowling took baby Warlock to his new home, an official London residence.

We pull back. From the top of a nearby hill, Hastur steps from the shadows. The Mother Superior and Sister Theresa Garrulous kneel before him, their faces wet from rain.

MOTHER SUPERIOR

Our mission is done, Lord Hastur. The baby is in place, and his parents are none the wiser.

HASTUR

No need for the convent any longer, then.

MOTHER SUPERIOR

I'm afraid I—

HASTUR

Your order is dissolved.

MOTHER SUPERIOR

We're what?

SISTER THERESA GARRULOUS

Now hang on a moment. We did everything that was asked of us. What about our rewards?

HASTUR

You irritate me. You never shut up, do you?

SISTER THERESA GARRULOUS

We are a Chattering order. We say what is on our minds, and right now, what's on my mind is that you can't treat us like—

Hastur reaches out and puts his hand over Sister Theresa's mouth, and squeezes. She dies. Hastur looks at the Mother Superior.

HASTUR

> Do *you* want to tell them the order is dissolved? Or do
> you want them all to perish in the fire?

MOTHER SUPERIOR
> *(shaken)*
> What fire?

*Hastur gestures. Lightning strikes the roof of the hospital.
Now the roof begins to burn . . .*

*The Mother Superior looks at Hastur, and then runs back
down the hill. Hastur begins to laugh, and it's absorbed by
the thunder.*

DISSOLVE TO:

183 MONTAGE:

*We move from the fallen body of the late Sister Theresa
Garrulous, to the fallen bodies in the African village square.*

*From there to Sherryl, the supermodel from the restaurant,
on the floor of her apartment bathroom, dead.*

*From there to the ocean and dead fish, floating in an oil
spill . . .*

*And we finish looking back to the weedkiller boat, and we
close in on the death's head on the poison signs.*

Over all this:

GOD (V.O.)

> And there's a Fourth. He's everywhere, and what he
> does is what he is. He isn't waiting. He's working.
> Although in a manner of speaking, he's waiting for
> everybody.

*The sign of the grinning skull on the poison sign. We are
looking at an image of DEATH.*

184 INT. AZIRAPHALE'S BOOKSHOP, BACK ROOM – NIGHT – 2007

Crowley is pacing, impatiently. Putting corks back into wine bottles, perhaps. Aziraphale is agitated. They are both sober. And Aziraphale is coming over to the dark side.

AZIRAPHALE

Look! It's not that I disagree with you. But I'm an angel. I'm not *allowed* to disobey.

CROWLEY

You think I am? My people are only into disobedience in general terms. Not when it applies to them.

AZIRAPHALE

Even if I wanted to help, I couldn't! I can't interfere with the divine plan.

Crowley gets an idea . . .

CROWLEY

What about diabolical plans? My lot have put the baby in play, after all. You can interfere with that!

AZIRAPHALE

But . . . It's still part of the overall divine plan.

CROWLEY

Then you can't be certain that thwarting me isn't part of the divine plan too. I mean, you're supposed to thwart the wiles of the Evil One at every turn, aren't you?

AZIRAPHALE

Well . . .

CROWLEY

You see a wile, you thwart. Am I right?

AZIRAPHALE

Broadly. Actually I encourage humans to do the actual—

CROWLEY

The Antichrist has been born. But it's the upbringing

that's important. Influences. And the evil influences – that's all going to be me! It would be too bad if someone made sure that I failed.

A dawning light of comprehension in Aziraphale's eyes . . .

AZIRAPHALE

If you put it that way, Heaven couldn't actually object to me thwarting you . . .

CROWLEY

It'd be a real feather in your wing.

Aziraphale looks at him, doubtfully. Then he reaches out a hand, and Crowley and Aziraphale shake hands on it.

CROWLEY (CONT'D)

We could be godfathers, sort of. Overseeing his upbringing. If we do it right, he won't be evil. Or good. He'll be normal.

AZIRAPHALE

It might work. Godfathers. Well, I'll be damned.

CROWLEY

It's not that bad. Once you get used to it.

We hear a crack of thunder . . .

CUT TO:

185 EXT. WARLOCK'S RESIDENCE – DAY – 2012

TITLE CARD: **FIVE YEARS LATER**

It's fancy, and there are SECRET SERVICE MEN outside. We see a Mary-Poppins-style NANNY walking towards the house, with her back to us.

The doorbell is pressed. A BUTLER opens the door and Mrs Dowling is watching from the hall. The nanny, wearing dark glasses, reminds us of Crowley. She's sexy and domineering.

NANNY

 I understand you need a nanny.

Warlock peers past his mother at Nanny.

NANNY (CONT'D)

 What a delightful child.

186 EXT. WARLOCK'S BACK DOOR – DAY – 2012

The back door is opened. A saintly friar-like GARDENER, big Victorian gaffer sideburns, angelic, with a spade, who perhaps reminds us a little of Aziraphale, possibly chewing a grass-blade, raises his hat and says,

GARDENER

 They do say as you moight be lookin' for a gardener.

187 EXT. WARLOCK'S RESIDENCE, GARDEN – DAY – 2012

A small boy in a garden. Brother Francis, the gardener, is feeding the birds . . .

YOUNG WARLOCK, *aged about 5, wanders over.*

YOUNG WARLOCK

 Hello, Brother Francis.

GARDENER

 Hello, Young Warlock. My, you're growing fast. You must be all of . . .

YOUNG WARLOCK

 Five. I'm five. What's that?

GARDENER

 Brother Pigeon. And here's Brother Snail . . . Sister Slug. Remember, Warlock, as you grow, to have love and reverence for all living things.

YOUNG WARLOCK

 Nanny says living things are only fit to be ground

under my heels, Brother Francis.

GARDENER
Don't listen to her. Listen to me.

188 INT. WARLOCK'S BEDROOM – NIGHT – 2012

Nanny has wound up the spooky music box and the thing that casts scary shadows on the wall. Young Warlock is in bed.

YOUNG WARLOCK
Will you sing me a lullaby, Nanny?

NANNY
Of course, dear.
(*sings*)
Go to sleep and dream of pain
Doom and darkness, blood and brains
Sleep so sweet, my darling boy
You will rule, when Earth's destroyed.

YOUNG WARLOCK
The gardener says that I must be kind and nice to everybody. And hug them. Even Sister Slug. And not ever destroy the earth.

NANNY
Don't listen to him. Listen to me.

189 INT. THE LOBBY OF HELL AND HEAVEN – DAY – AFTER 2012

The lobby of a large London skyscraper. Crowley and Aziraphale both walk into the lobby. They ignore each other. Aziraphale takes the up escalator; Crowley takes the down.

GOD (V.O.)
There are many doors that will take you to Heaven or to Hell, but when Crowley and Aziraphale report in an official capacity to each of their respective head offices, they take the main entrance.

190 INT. DOOR 312 – NO DAYLIGHT – AFTER 2012

It's a grubby office. It's shadowy, which is good, as we do not want to see the entities to whom Crowley is reporting in too much detail. But in the foreground are Beelzebub, Lord of the Flies, who in his body language and with subtle make-up effects reminds us of a fly, and Hastur and Ligur.

In my mind, the demons in Hell are more demonic, less human than the versions we see when they are up above. But they are still basically human . . .

BEELZEBUB
 Tell us about the boy Warlock.

CROWLEY
 He's a remarkable child, Lord Beelzebub.

HASTUR
 Is he evil?

CROWLEY
 Fantastically evil.

LIGUR
 Killed anyone yet?

CROWLEY
 Not yet. But there's more to evil than just killing people.

Vague noises of agreement from hellish entities: Crowley has a point.

LIGUR
 I s'pose. But it's fun.

BEELZEBUB
 Have you encountered any trouble from the . . . opposition?

CROWLEY
 They don't suspect a thing.

191 INT. HEAVENLY OFFICE – DAY – AFTER 2012

We're at the top of a skyscraper, looking out over London. Aziraphale's meeting is very similar. Nicer decor.

The incredibly well-dressed people he's talking to have faces that seem slightly burned out by light. They include Gabriel, a beautiful, fit and rich archangel, MICHAEL, a slightly more studious archangel, URIEL, a hanger-on, and SANDALPHON, an angelic enforcer. They could be at a conference table or just standing around. (There is a similarity to the angels, although they cross all races and do not necessarily have obvious genders. They all like wearing nice suits.)

AZIRAPHALE

I am proud to say that, on a very real level, the Antichrist child is now being influenced towards the light.

Gabriel claps, politely. The other angels copy him, moments later.

GABRIEL

Very commendable. Excellent work, Aziraphale. As usual.

MICHAEL

Yes. But Aziraphale. We will be most understanding when you fail. After all, wars are to be won.

URIEL

Not avoided.

AZIRAPHALE

But I won't fail. I mean, that would be bad. If I did.

GABRIEL

Aziraphale. What you're doing is praiseworthy, but obviously doomed to failure. Still, as the Almighty likes to say. Climb every mountain.

SANDALPHON

Ford every stream.

And we finish on Aziraphale's face, as he winces.

192 EXT. LONDON BUS – DAY – AFTER 2012

The top deck of a bus. Aziraphale is reading a paper. Crowley sits down next to him.

CROWLEY
 The boy's too normal.

AZIRAPHALE
 Excellent. It's working. The heavenly influences are balancing out the hellish. A no-score draw.

CROWLEY
 I hope you're right. Six years left to go.

AZIRAPHALE
 Crowley?

CROWLEY
 Yes.

AZIRAPHALE
 What happens if we fail? I mean, if he comes into his full power? How do we stop him then?

CROWLEY
 I'm sure it won't come to that.

Aziraphale shakes his head.

193 TITLE CARD: **THE PRESENT**

TITLE CARD: **MONDAY**

194 INT. HELL, DOG HANGAR

Hastur and Ligur. They are standing in a huge aircraft-hangar-like building in Hell. A huge portcullis-like gate behind them. We can't see the animal in there, but it would appear to be about thirty feet high and terrifying. It growls.

They are eyeing it nervously. A JUNIOR DEMON near them eyes it with stark terror.

HASTUR

That's . . . that's a hell-hound all right.

LIGUR

It's big.

HASTUR

It'll be what he wants it to be. His mind will shape it. You! Get in there. Open the gate!

JUNIOR DEMON

Me?

HASTUR

You. Yeah. Watch out for his teeth.

Hastur and Ligur watch, as the demon vanishes off. Hell-hound growls. The sound of a winching gate lifting . . .

Then a scream from the junior demon. Hastur and Ligur wince. Sound of a junior demon being eaten.

LIGUR

It's not like you didn't tell him to look out for the teeth.

HASTUR

I think he was hungry.

195 INT. HELL, DOG HANGAR

LIGUR

The time is upon us. As soon as the boy names the hound, Armageddon will begin. Go! Find your master!

They back against the wall, scared, as the shadow of something huge goes past them . . .

196 INT. DINOSAUR PARK – DAY

WARLOCK, a couple of days before his eleventh birthday,
is being taken around Crystal Palace Dinosaur Park by
his mother. There are a number of rather questionable
prehistoric creatures dotted around a lake. A secret service
man follows them at a discreet distance.

MRS DOWLING
Honey. Look what they used to think dinosaurs looked
like. They're old. And educational.

WARLOCK
It's dumb.

MRS DOWLING
It's not dumb, sweetie. It's a dinosaur.

WARLOCK
A dumbasaur more like. Can we talk about my birthday
party? Why can't we have my party in an escape room?

Mrs Dowling drags him over to the next dinosaur. We pull
back to see that Crowley and Aziraphale were both watching.

CROWLEY
Dinosaurs! What normal kid doesn't like monsters?

AZIRAPHALE
But it's *good* he's not interested in flesh-tearing giant
lizards! Isn't it?

CROWLEY
I don't know . . . You know, I still don't understand
the point of creating a world complete with ancient
dinosaur skeletons.

AZIRAPHALE
Just one of God's many little jokes. One that the
paleontologists can't appreciate.

CROWLEY
Doesn't exactly have a punch line, either.

AZIRAPHALE

When's his eleventh birthday?

CROWLEY

Wednesday. That's when it begins. Or, if we've done our job right, it doesn't. The hell-hound will be the key. It'll show up at three on Wednesday.

AZIRAPHALE

You haven't actually mentioned a hell-hound before.

CROWLEY

Well, they're sending him a hell-hound, to pad by his side and guard him from all harm. Biggest one they've got.

AZIRAPHALE

Won't people remark on the sudden appearance of a huge black dog? His parents, for a start.

CROWLEY

Nobody's going to notice anything. It's reality, angel. And young Warlock can do what he wants, whether he knows it or not.

While they are talking, the camera wanders over various stone shapes: the faces of our Victorian dinosaur monsters.

CROWLEY (CONT'D)

It's the start of it all. The boy's meant to name it: Stalks By Night, or Throat-Ripper or something like that. But if you and I have done our job, properly, he'll send it away, unnamed.

AZIRAPHALE

And if he *does* name it?

CROWLEY

Then you and I have lost. He'll have all his powers, and Armageddon will be days away.

AZIRAPHALE

There must be some way of stopping it.

CROWLEY

If there's no boy, then the process would stop.

AZIRAPHALE

Yes, but there IS a boy. He's over there writing a rude word on a Victorian dinosaur.

CROWLEY

There is a boy, now. But that could change.
 (he waits for the penny to drop)
Something could happen to him.
 (another beat)
I'm saying you could kill him.

There's a pause. Then . . .

AZIRAPHALE

I've never actually killed anything. I don't think I could.

CROWLEY

Not even to save . . . everything? One life against the universe?

Aziraphale is not convinced. He changes the subject . . .

AZIRAPHALE

This hell-hound. It will show up at his birthday party?

CROWLEY

Yes.

AZIRAPHALE

We should be there. Maybe I can stop the dog. In fact . . .
 (he's just had an idea)
I could . . . Entertain.

CROWLEY

No. Please, no.

AZIRAPHALE

 (wiggling his fingers)
I'd just need to get back in practice.

Shows a coin. Attempts a French Drop with coin. Drops it. Fumbles around to pick it up.

CROWLEY

Don't do your magic act. Please. I am actually begging you, and you have no idea how demeaning that is. Please.

Aziraphale reaches behind Crowley's ear.

CROWLEY (CONT'D)

It was in your finger.

AZIRAPHALE

No, it was in your ear.

CROWLEY

It was in your pocket and then . . .

AZIRAPHALE

It was close to your ear . . .

CROWLEY

It was never anywhere near my ear.

AZIRAPHALE

You are no fun.

CROWLEY

Fun? It's humiliating. You can do proper magic, you can make things disappear.

AZIRAPHALE

But it's not as fun.

CROWLEY

I'll make you disappear.

197 EXT. WARLOCK'S PARTY – DAY

TITLE CARD: **WEDNESDAY**

We are in a huge tent in Warlock's back garden. It's a party! Birthday balloons. We have a couple of dozen

ELEVEN-YEAR-OLDS, all very well dressed. Warlock is wearing an 11 badge, the kind you get off a birthday card.

We also have some secret service officers. The same ones we saw eleven years ago, just a little older.

We have CATERERS, all wearing white food-serving jackets, even Crowley, who seems to be in charge of them, and is waiting by the cake. There are trifles and jellies and such.

Crowley looks down in embarrassment.

The kids all look bewildered – horrified – saddened. Because, up on a little stage . . .

It's Aziraphale! Dressed in the style of a Victorian conjurer, top hat and tails and all, in clothes he bought a hundred and fifty years ago and has not worn for fifty, and has never dry-cleaned. Proud as punch.

THE AMAZING MISTER FELL AND HIS REMARKABLE FEATS OF PRESTIDIGITATION is painted, Victorian-style, on a peeling old canvas in front of him. He has a little collapsible table, a magic wand, and he's in heaven. Right now, he's showing them his ancient top hat.

AZIRAPHALE
Now you sees my old top hat? 'Where did you get that hat?' as you young 'uns do say? Well, you also see that there is nothing inside my perfectly normal top hat such as any of you might wear on a trip to the confectioners. But wait! What is this? Could it be our furry friend, Harry the Rabbit?

A rabbit is produced from the hat. The kids are unimpressed.

WARLOCK
It was in the table.

TRIXIE
You said there were going to be a celebrity magician.

I had Penn and Teller at my party. An' I had a silent disco an' I got a . . .

WARLOCK

You're rubbish.

TARQUIN

Excuse me. Excuse me. He's right, you know. You are actually rubbish.

Crowley is looking around for the black hound. He looks at the clock – two minutes to three. Checks his watch: almost three . . .

AZIRAPHALE

(pressing on)

Do any of you young 'uns have such a thing as a thrupenny bit about your persons? No? Well, what's that behind your ear?

Crowley is counting the seconds now. Five, four, three, two . . .

198 INT. ADAM'S HOUSE – DAY

A kitchen. A cake is being iced by Deirdre Young, now eleven years older. The message says HAPPY BIRTHDAY ADAM.

Around the kitchen are all the signs of an eleven-year-old boy in occupation. A drawing on the fridge of aliens attacking, for example. Some toys on a windowsill.

Mr Young, also older and balder, puts his head around the door.

MR YOUNG

He's not back yet?

DEIRDRE

He's down in Hogback Wood, playing with his friends. I told him to be home by teatime.

MR YOUNG
> Right. Well, give me a shout when he gets back, and we can light the candles.

199 INT. WARLOCK'S PARTY – DAY

Crowley's watch says three p.m. Crowley looks around. Nothing.

AZIRAPHALE
> For my next remarkable illusion, I will need a pocket handkerchief. Does anyone have a pocket handkerchief?

Blank kids. They don't care. Some of them have pulled out their phones and are playing video games.

AZIRAPHALE (CONT'D)
> I really *will* need a handkerchief. I . . .

He blinks and performs a miracle. Ping! Turns to a secret service agent.

AZIRAPHALE (CONT'D)
> You, my fine young jack-sauce. If you look in your pocket, I have no doubt you will find a handkerchief.

SECRET SERVICE AGENT
> M'afraid not, sir.

AZIRAPHALE
> Actually. You *do*. Just look. Please look.

The agent reaches into his inside pocket, and looks puzzled. Then pulls out an ENORMOUS lace-edged hankie . . .

Which, as he pulls it out, snags his shoulder-holstered gun, sending it flying out of the holster.

The gun arcs slowly and gracefully and in slow motion through the air. It splashes down in a bowl of trifle near Warlock.

The kids applaud. This is more like it!

TRIXIE

Not bad.

Warlock grabs the gun. Covers the room.

WARLOCK

Hands up, scumbuckets! I got a gun.

A beat. The guards look around, panicky, and aren't sure what to do . . .

TARQUIN throws a lump of cake at Warlock, who whirls around, and reflexively, squeezes the trigger . . .

FREEZE IMAGE.

GOD (V.O.)

A .357 hollow point cartridge, shot from a Secret Service Sig Sauer P229 at 1,430 feet per second, will normally leave behind a red mist in the air and a certain amount of Secret Service paperwork.

1100 INT. WARLOCK'S PARTY – DAY

CLOSE UP on Aziraphale's face. He does a miracle blink, and . . .

A stream of water comes from the nozzle of Warlock's gun, and soaks Tarquin. The gun is now a water pistol.

Aziraphale looks rather proud of himself.

And then a huge lump of birthday trifle hits him in the face. Guards are (puzzled) firing water pistol guns. Kids are (enthusiastically) firing water pistol guns.

Perfectly timed lumps of jelly and trifle and cake are being thrown around. IT'S A FOOD FIGHT!

WARLOCK

Best Eleventh Birthday Ever!

1101 EXT. WARLOCK'S RESIDENCE – DAY

The street outside. Crowley is standing, looking worried. Aziraphale joins him. He's reaching into his sleeve.

AZIRAPHALE
 It was all a bit of a disaster, I'm afraid.

CROWLEY
 Nonsense. You gave them all a party to remember. Last one any of them will ever have, mind . . .

Aziraphale has removed a dove from his sleeve. He's prodding it, but it's dead.

AZIRAPHALE
 It's late.

CROWLEY
 Comes of putting it up your sleeve.

AZIRAPHALE
 No. The hell-hound. It's late.

Crowley irritably snaps his fingers at the dead dove, which flutters and flies off. He reaches into the Bentley and turns on the radio. It's Just a Minute . . .

NICHOLAS PARSONS (V.O.)
 And you have just a minute to tell us all about fish fingers, starting – *Hello Crowley. Is something wrong?*

CROWLEY
 Um. Hi. Who's this?

NICHOLAS PARSONS
 Dagon. Lord of the Files. Master of Torments.

CROWLEY
 Yeah. Just checking in about the hell-hound . . .

NICHOLAS PARSONS
 He was released minutes ago. He should be with you by now. Why? Has something gone wrong, Crowley?

CROWLEY

> Wrong? No . . . Nothing's wrong. What could be wrong? I can see it now. What a lovely big helly hellhound. Hey, great talking to you.

He turns off the radio.

AZIRAPHALE

> No dog.

CROWLEY

> No dog.

AZIRAPHALE

> Wrong boy.

CROWLEY

> Wrong boy.

There's a gunshot.

AZIRAPHALE

> *(not swearing)*
> Oh *sugar*! I must have missed one.

CROWLEY

> Armageddon is days away. And we've lost the Antichrist. Get in.

Aziraphale just stands there, shocked.

AZIRAPHALE

> I don't understand. How could we lose the Antichrist?

1102 EXT. TADFIELD – DAY

Still a beautiful little village in England. We are moving through it. The clock on the village steeple is striking three.

1103 EXT. TADFIELD: THE ROAD TO HOGBACK WOOD – DAY

Look! This is Hogback Wood. It's a perfect place for kids to

play. An area of natural beauty that adults have forgotten. And there's a lane above it.

Birds are singing. A lazy bumble bee buzzes in the flowers at the side of the lane.

Down in the wood we can see CHILDREN, four of them, all about eleven, playing.

They are a gang of four. They look harmless and sweet and VULNERABLE . . .

PEPPER, a girl, has a wooden sword, and is battling BRIAN, a grubby boy with a toy crown.

WENSLEYDALE, a thoughtful, bespectacled boy, has a battered book of 1001 Scientific Things a Boy Can Do. *He is weighing a potato against a stone on an improvised scales, adding stones to the pan to get them to balance . . .*

And one of them, who has been up in a tree, comes down a rope: golden-haired, glorious, the ultimate eleven-year-old. It MUST be ADAM.

GOD (V.O.)

The right boy was playing in the woods with his friends. After all, it was his birthday. Hogback Wood was their Eden where they could play unbothered by adults. The children called themselves The Them. Pepper and Brian. Wensleydale. And the birthday boy, their leader, who found their den and invented the best games of all: Adam.

And now we hear something, as the last of the bell chimes fades away. Something metallic and disturbing, rumbling and nightmarish.

A ripping, rumbling noise, and now, LOOK! There's a beat, and in front of us, on the lane, appears, from Hell . . .

The HELL-HOUND.

It's huge: a terrifying monster of a dog. The Hound of the Baskervilles would take one look at this brute and flee, whimpering.

It looks at the kids in the woods below, hungrily and evilly . . .

And it opens its mouth and growls terrifyingly, showing huge and awful teeth.

We want to shoot this sequence like a horror movie, from the point of view of the monster: we KNOW these kids are soon going to be munchies . . .

We slowly hear their conversation, as if it's been going for a while, and the hell-hound is listening.

ADAM

It's my birthday, of course I'm going to get a dog.

PEPPER

Nobody actually said you were going to get a dog, Adam.
(to Brian)
Have at thee alien fiend!

BRIAN

Your dad'd be complaining about buying dogfood.
(to Pepper)
I'm not an alien. I'm a barbarian.

WENSLEYDALE

(without looking up)
They eat privet.

BRIAN

Dogs don't eat privet, Wensley.

WENSLEYDALE

Stick insects do. They're very interesting, actually.
They eat each other when they're mating.

PEPPER

That's praying mantises.

ADAM

What're they praying for?

PEPPER

Praying they don't get married, I expect.

Pepper strikes, and Brian falls back. He drops.

BRIAN

You win, Pepper, oh mighty warrior. I give you my crown.

PEPPER

So are you a barbarian king or an alien one?

And now the hell-hound is padding down into Hogback Wood. The kids are getting up from whatever they've been doing around the wood, and are getting ready to go home . . .

The hell-hound! Its eyes are red. Saliva slathers down from its jaws and burns the leaf mould.

PEPPER (CONT'D)

They never get you what you want. I wanted a bike, and I asked for it, and I told them I wanted a razorblade saddle and twelve gears and everything, and do you know what they got me? A girls' bike. With a basket.

WENSLEYDALE

But you are actually a girl, Pepper.

PEPPER

That's just sexist. Giving people girly presents, because they're girls.

She waves her sword to make her point. Adam now looks intent, almost preternatural, as he says, with conviction:

ADAM

I want. A dog.

Hell-hound's POV: Adam. Only Adam is important. We hear a back-of-the-throat growling. And it's coming closer.

PEPPER

Oh, right. And your mum and dad are going to get you a big old rottenwiler then, Adam?

ADAM

I don't want a big dog.

CLOSE UP on the hell-hound. It tips its monstrous head on one side, and looks puzzled . . .

ADAM (CONT'D)

I want the kind of dog you can have fun with. A little dog.

From the hell-hound's POV, a sudden lurch DOWNWARDS. As if something huge has shrunk.

ADAM (CONT'D)

I want a dog that's brilliantly intelligent and can go down rabbit holes, and I can teach it tricks.

A rumble of thunder. Our view is obscured . . .

ADAM (CONT'D)

And it has to have one funny ear that always looks inside out.

CLOSE UP on former hell-hound: now a small black-and-white mongrel with a comically puzzled expression. There's a POP, and its ear turns inside out.

ADAM (CONT'D)
And I'll call him . . .

The former hell-hound looks dangerous. Its eyes glow red. It dribbles onto the ground, and the dribble steams.

GOD (V.O.)

And this is the moment. The naming. This will give it its purpose, its function, its identity. This is the moment that sets Armageddon in motion.

The hell-hound growls, the sort of growl that starts in the back of one's throat and ends up in someone else's.

ADAM

I think I'll call him Dog. Saves a lot of trouble, a name like that.

The red glow in the dog's eyes goes out. And the tail starts slowly to wag.

PEPPER

And what, this Dog's just going to turn up?

ADAM

Maybe. Here boy! Come on!

And bounding out of the trees, happy and obedient, tail wagging, yipping with delight, comes Dog. And Adam is in heaven . . .

1104 INT. AZIRAPHALE'S BOOKSHOP, BACK ROOM – DAY

In the back room: Crowley and Aziraphale are comparing notes. Aziraphale is pouring them whiskies.

CROWLEY

Armageddon is days away and we've lost the Antichrist. Why did the powers of Hell have to drag me into this anyway?

AZIRAPHALE

Don't quote me on this, but I'm pretty sure it's because you kept sending them all those memos saying how amazingly well you were doing.

CROWLEY

Is it my fault they never check up? I'm to blame they never check up? Everyone stretches the truth a bit in memos to head office, you know that.

AZIRAPHALE

Yes, but you told them you invented the Spanish Inquisition, and started the Second World War, and . . .

CROWLEY

So humans beat me to it. That's not my fault.

Crowley looks up, as if he's hearing something. Crowley looks startled. A spectral growl echoes through the bookshop.

CROWLEY (CONT'D)

Something's changed.

AZIRAPHALE

It's a new cologne. My barber suggested . . .

CROWLEY

Not you. I know what you smell like.

Crowley looks agitated.

CROWLEY (CONT'D)

The hell-hound has found its master.

AZIRAPHALE

You sure?

CROWLEY

I felt it. Would I lie to you?

AZIRAPHALE

Obviously. You're a demon. That's what you do.

CROWLEY

I'm not lying. The boy, wherever he is, has the dog. He's coming into his power. We're doomed.

Aziraphale lifts his glass.

AZIRAPHALE

Well then. Welcome to the end times.

And we . . .

FADE TO BLACK.

1105

Over end credits, Buddy Holly's 'Everyday', done by a boys' choir, in the style of Carmina Burana.

EPISODE TWO
THE BOOK

201 EXT. LONDON, SOHO – DAY

 TITLE CARD: **SOHO, LONDON**

 TITLE CARD: **THURSDAY**

 TITLE CARD: **TWO DAYS TO THE END OF THE WORLD**

Two people are walking through a Soho street towards Aziraphale's bookshop.

202 INT. AZIRAPHALE'S BOOKSHOP, MAIN SPACE – DAY – PRESENT DAY

There are a couple of browsing customers. And as Aziraphale comes in from the back, the doorbell dings.

AZIRAPHALE
 Can I help you?

It's Gabriel, and his thuggish angelic number two, Sandalphon.

GABRIEL
 (loudly)
 I would like to purchase one of your material objects.

Sandalphon corrects him.

SANDALPHON
 Books.

GABRIEL
Books. Let us discuss my purchase in a private place.
Because I am buying, er . . .

SANDALPHON
Pornography?

GABRIEL
(proudly and loudly)
Pornography.

*He picks up an (obviously not pornographic) vintage book.
Aziraphale sees Crowley through the window, out on the
pavement, heading for his car.*

AZIRAPHALE
Gabriel. Sandalphon. Please, come into my back room.

*Sandalphon adds, for the benefit of any customers who had
missed it . . .*

SANDALPHON
We humans are extremely easily embarrassed. We must
buy our pornography secretively.

203 INT. AZIRAPHALE'S BACK ROOM – DAY

*Sandalphon stands by the door, like a guard. Gabriel smiles
charmingly.*

GABRIEL
Human beings are so simple, and so easily fooled.

AZIRAPHALE
Yes. Good job. You fooled them all.

He looks at the copy of Mrs Beeton's Book of Household
Management *that Gabriel brought in and is unimpressed.*

GABRIEL
You remember Sandalphon?

AZIRAPHALE

> Sodom and Gomorrah. You were doing a lot of
> smiting, and turning people into salt. Hard to forget.

Sandalphon grins, pleased with itself. Then it sniffs the air.

SANDALPHON

> Something smells . . . evil . . .

AZIRAPHALE

> That'll be the Jeffrey Archer books, I'm afraid.

GABRIEL

> Just came by to talk about the status of the Antichrist . . .

AZIRAPHALE

> Why? What's wrong? I mean, if something's wrong I
> can put my people onto it—

GABRIEL

> Nothing's wrong. Everything's going perfectly. There's
> a lot happening. All good.

AZIRAPHALE

> All good?

GABRIEL

> It's all going according to the divine plan. The hell-
> hound was set loose. Now the Four Horsemen of
> the Apocalypse are being summoned. War, Famine,
> Pollution and Death.

AZIRAPHALE

> Oh. Right. Who exactly summons them?

GABRIEL

> Not my department. I believe that sort of thing is
> outsourced.

SANDALPHON

> About time. That's what I say. You can't have a war
> without War.

GABRIEL

I say, Sandalphon, that's rather good. You can't have
a war without War. I may use that. Anyway. No
problems? How was the hell-hound?

AZIRAPHALE

I didn't stick around to see.

But Gabriel is already bored. He gets up and opens the door.

GABRIEL
 (loudly)
Thank you so much for my pornography.
 (to Aziraphale)
Excellent job.
 (to Sandalphon)
'You can't have a war without WAR.' That's so clever.

204 INT. WAR ZONE HOTEL – DAY

*We are in a war-zone press conference space, looking at
hard-bitten war reporter ANFORTH, looking at a copy
of the* National World Weekly. *He snorts, passes it to
MURCHISON, who grins, shakes his head, passes it to Ms.
VAN HORNE.*

GOD (V.O.)

This is the *National World Weekly.* A typical issue
would tell the world how Elvis Presley was recently
sighted working in a Burger Lord in Des Moines; how
the spate of werewolves infesting the Midwest are the
offspring of noble pioneer women raped by Bigfoot;
and that Elvis Presley was taken by Space Aliens in
1976 because he was too good for this world. It does
not need a war correspondent. And yet it has one . . .

MURCHISON

How the hell does she do it? It's like she knows where
war's going to break out before any of us.

VAN HORNE

It's a good thing they never print her stories. She'd be a shoe-in for a Pulitzer if they had . . .

MURCHISON

I know. Her piece on the Sudan was amazing.

A male Western army OFFICER enters to brief everyone.

OFFICER

Thank you so much for waiting. Well, I don't think any of you need background on the conflict. For several years now, Masiwea has been the subject of an intense border conflict with the PLA on the one hand and the Delirian Homeland on the other. Thousands of people on all sides have lost their lives. Hundreds of thousands have lost their homes. And the United Nations, and the Pan-African Conference, have worked diligently to foster talks and a willingness to see the other side.

Everyone = half a dozen hardbitten war reporters, male and female. Everyone looks grungy, unwashed, seedy. It's hot and sweaty.

During the talk War walks in. Everybody looks up. She's more alive than anyone else, perfectly dressed and looking completely unaffected by the heat.

OFFICER (CONT'D)

So, informally, I'm very happy to be able to announce that the peace treaty will be signed in two weeks' time. Any questions?

War raises her hand. Everyone, male and female, is transfixed. Every tiny noise she makes is SUPER LOUD. She's the only thing that matters. Everyone there is very aware of her.

OFFICER (CONT'D)

Yes, Ms . . . you're from the . . .

WAR

Carmine Zingiber. *National World Weekly.* I was just wondering where the peace treaty is going to be signed?

OFFICER

Classified. We don't want anybody interfering with the peace process.

WAR

Well, of course not. You definitely wouldn't want that.

205 INT. CROWLEY'S FLAT – DAY

TITLE CARD: **THE PRESENT DAY.**

Crowley's flat is perfect. It's very white, and looks unlived in. Everything is perfect. The only things that seem even better than perfect are the potted plants, which are lush.

Crowley walks into the lounge. Elegant TV.

He nods and it turns on: morning television. A MAN and a WOMAN on a sofa, smiling at us.

MORNING TV PRESENTER

And after the news, the government's foreign affairs spokesman will be here to comment on the recent increase in international tension.
 (beat)
But first, do you know what's in your fridge?

And then there's a crackling, and now the couple on the sofa are Hastur and Ligur, broadcasting straight from Hell.

HASTUR

Morning, Crowley.

LIGUR

Just checking in. Nice sofa.

CROWLEY

Hi, guys.

LIGUR

It's about the Antichrist.

CROWLEY

Yeah. Great kid. Takes after his dad.

HASTUR

Our operatives in the state department have arranged for the child's family to be flown to the Middle East.

LIGUR

There he and the hell-hound will be taken to the valley of Megiddo.

HASTUR

The Four Horsemen will begin their final ride. Armageddon will begin.

CROWLEY

 (unenthusiastically)
Hurrah.

HASTUR

The final combat. It's what we have been working towards since we rebelled. We are the fallen. Never forget that.

CROWLEY

It's not the kind of thing that you forget.

HASTUR

. . . I don't trust you, Crowley.

CROWLEY

Well, obviously. We're demons.

LIGUR

I've been reading your report on CIA torture practices. And the one from the Spanish Inquisition. If anything goes wrong, it's going to be one from column A, one from column B, repeat until squishy.

CROWLEY

 Everything's going just fine.

Ligur and Hastur vanish, replaced by the TV hosts.

MORNING TV WOMAN

 And now, over to Jessica for this morning's weather.

Crowley makes the screen go blank.

CROWLEY

 I didn't fall. I didn't mean to fall. I just hung around
 the wrong people.

206 EXT. WAR ZONE – DAY

*A van drives up a dirt track towards a town somewhere in
North Africa.*

GOD (V.O.)

 Somebody has to summon the Four Horsemen of the
 Apocalypse. But they outsource that sort of thing these
 days.

*The van stops and we see THE INTERNATIONAL
EXPRESS MAN.*

GOD (V.O.)

 Meet the summoner. He has four items to deliver in his
 van. He works for the International Express Company,
 and he's about to make his first delivery in a former
 war zone.

207 INT. WAR-ZONE HOTEL CONFERENCE ROOM – DAY

*We are in a hotel conference room. Three long tables,
arranged in a triangle. There are three groups of people here.
Each table has three people at it: a MINISTER and two
ASSISTANTS. And behind the people, on chairs, are their
BODYGUARDS. Also a PHOTOGRAPHER. I'll call these
groups green, blue and brown. Also the army officer we saw*

at the press conference. One group might be Iraq, one Iran, one Saudi, or one Indian, one Burmese and one Chinese – it doesn't matter, as long as we feel they are from different neighbouring cultures, and we subtly colour-code them.

They look happy and at ease . . .

GOD (V.O.)
> Sometimes, despite everything, peace breaks out.
> People get tired of fighting and pain and death, and are willing to start all over again.

GREEN MINISTER
> And now?

OFFICER
> Now you just . . . sign the peace treaty.

Door opens, and War comes in. Bodyguard guns come out.

WAR
> Guys, please. I'm not dangerous . . .

Pats herself down. No weapons . . .

BROWN MINISTER
> Who are you?

WAR
> Carmine Zingiber. *National World Weekly.* War correspondent.

GREEN MINISTER
> The Bigfoot newspaper? Is that still in business?

BROWN MINISTER
> I read the story about Elvis Presley being taken by Space Aliens. I did not find it entirely credible.

BLUE MINISTER
> More credible than the one that said he was frying hamburgers in a diner.

OFFICER
>*(to War)*
>How did you find out this was here?

WAR
>I've been killing time. You learn things.

GREEN MINISTER
>It is good, my friend. Good that there is a member of
>the world's press to see us sign the peace accord. It
>has taken many years, but I believe that today will be
>remembered as the day that war between our countries
>ended for ever.

They all agree. War is suppressing a smile.

WAR
>Oh, I'm sorry. That's so sweet. Don't mind me. You
>just carry on.

OFFICER
>If you would like to sign it first, your Highness,
>then the Prime Minister, then the Supreme Leader,
>and then we'll get a photograph of the three of you
>together.

The Brown Minister picks up the pen and the accord . . .

GREEN MINISTER
>He signs first?

BROWN MINISTER
>It's just a formality who signs first.

GREEN MINISTER
>A formality? You make me a laughing stock in my
>country, and you call it a formality?

BROWN MINISTER
>*Somebody* has to sign the peace agreement first!

The Blue Minister grabs the pen . . .

BLUE MINISTER
They do. And it's going to be me.

The Brown Minister's gun comes out.

A beat. All the guns come out. In moments EVERYONE has a gun in each hand, and every hand is pointing at a different person. It's like Tarantino cubed.

In the background, Queen's song 'Crazy Little Thing Called Love' starts playing.

Eyes. Guns. Hands. And War sitting in the middle of it all, with nobody pointing a gun at her.

Door opens.

And, pushing his way through the knot of gunmen hanging around the door, comes the International Express Man, bespectacled and uniformed and inoffensive.

INTERNATIONAL EXPRESS MAN
Don't mind me, gents, what a day, eh? Nearly didn't find the place, someone doesn't believe in signposts. Still, found it in the end, finally asked at the post office, they always know at the post office, had to draw me a map though.

He looks around the room. People with guns are too baffled to do anything. He sees War, steps underneath a gun, and walks over to her. He's holding a long, thin, brown-paper-wrapped parcel.

INTERNATIONAL EXPRESS MAN (CONT'D)
Package for you, miss. You'll have to sign for it.

He hands her a clipboard. We see her write WAR, *in elegant handwriting, on the receipt.*

He takes the clipboard, hands her the large package, and walks out, through the gunmen.

INTERNATIONAL EXPRESS MAN (CONT'D)
What a lovely place you have here, always wanted to
come here on holidays . . .

And he's gone.

The people with guns are still pointing their guns at each other.

*War opens the parcel. In it, is a sword. Beautiful and very
dangerous-looking. She holds it by the hilt.*

WAR
Finally!

*The people with guns have her surrounded. The Blue
Minister points his gun at her.*

BLUE MINISTER
Put that down.

WAR
Oh, you sweet thing. That's not going to happen. Is it?
(to the room)
I'm sorry, folks. I'd love to stay and get to know you all
better. But duty calls.

208 INT. HOTEL CORRIDOR – DAY

*War comes towards us through the doors. A beat. 'Crazy
Little Thing Called Love' is playing quietly in the distance.
Then the shooting begins.*

GOD (V.O.)
She's the first of the four, and you can't have a war
without her. She's been killing time for so long now.
Time, and sometimes people. And now sixty centuries
of waiting are about to end.

*And we pull back . . . The tick-tick-tick of 'Everyday', our
THEME SONG, begins . . .*

TITLES SEQUENCE

209 EXT. LANCASHIRE VILLAGE – DAY – 1656

TITLE CARD: **LANCASHIRE, ENGLAND. 1656**

GOD (V.O.)

This is also the story of a witch, a witchfinder and a book. And that story starts about 360 years ago with the last witch burning in England.

Music: lute music becomes 'Everyday' by Buddy Holly, done as if it were a seventeenth century folk piece or chorale.

It's a damp, misty morning. Striding towards us comes a Witchfinder Major. He is dressed in a sober costume that is Hammer Horror Witchfinder General, only slightly more military and puritan. He is arrogant, and is called ADULTERY PULSIFER. A Witchfinder Private, MAGGS, comes running towards him. They talk while walking.

MAGGS

Major Pulsifer! The bone fire is built on the green. All is prepared.

PULSIFER

And where is the hag?

MAGGS

In her cottage. She suspects nothing.

PULSIFER

I thought you tested her with a pin.

Maggs produces a large ivory-handled hatpin.

MAGGS

We did. Regulation issue, Witchfinder's pin. Pricked her all over.

PULSIFER

What was the result?

MAGGS

She said it cured her arthritis.

PULSIFER

Hmm. Of what else is she accused?

MAGGS

Predicting the future, mostly. She told Mistress
Bulcock that Adultery would be coming to town.

PULSIFER

(cold)
Such nonsense.

MAGGS

That's you, isn't it?

PULSIFER

It is NOT me! My given name, Witchfinder Private
Maggs, is Thou-Shalt-not-Commit-Adultery. But you
can call me Witchfinder Major Pulsifer.

MAGGS

So, they don't call you Adultery Pulsifer?

PULSIFER

They do not.

MAGGS

Because children can be cruel, Witchfinder Major.

CUT TO:

210 INT. AGNES NUTTER'S COTTAGE – DAY – 1656

AGNES NUTTER *is standing by a table, writing a note.
On the table is a book — a brand NEW copy of* The Nice
and Accurate Prophecies. *Next to it is a locked box, with an
envelope. Next to that, another envelope, with* INNE YE
EVENTE OF MYE DEATHE *written on it.*

AGNES

(to herself as she writes)
Good milkman, bring no more milk, not this day or ever,

for today I am to die in flames. Yours, Agnes Nutter. PS my best wishes to your wife.

The note, which we do not linger on, says:

GOOD MILKMANNE, BRINGE NO MOAR MILK, NOT THIſſ DAY OR EVER, FOR TODAY I AM TO DYE IN FLAYMES. Yrs AGNES NUTTER. PS MY BEST WISHES TO YOUR WYFE

Agnes is a still-handsome woman in her middle years. She looks up, unimpressed.

AGNES (CONT'D)
They are late.

211 EXT. LANCASHIRE VILLAGE – DAY – 1656

Maggs has been joined by OLD GOODY LARMOUR, as they walk to Agnes's cottage.

PULSIFER
And she runs, you say. With no one pursuing her?

OLD GOODY LARMOUR
Aye! She says that running each morning in an unladylike manner around the village doth improve her health.

PULSIFER
Monstrous! Perhaps invisible demons pursue the witch as she runs.

OLD GOODY LARMOUR
She says it's good for you. She says we should get more fibre in our diet. I told her, it's hard enough picking out the gravel . . .

PULSIFER
She is mad, obviously. But how can we be certain she is a witch?

MAGGS

> She cured me of the howling pox.

OLD GOODY LARMOUR

> And cured my son of the bloody flux. Obviously a witch.

Everyone nods sagely, and goes, 'Witch.'

MORE VILLAGERS are collecting in their train, men and women. And at that Agnes's door is thrown open.

AGNES

> Adultery Pulsifer. Good people. Thou'rt tardy. I should have been aflame ten minutes since. Right . . .

And she strides off in the direction of the village green. Her skirts are huge and she is waddling slightly.

Agnes clambers, slightly awkwardly, onto the pyre, and puts her hands behind her, to be tied. Pulsifer ties them.

PULSIFER

> This is most irregular, Mistress Nutter.

The crowd is slightly nervous, and unsettled. Pulsifer takes a fiery brand from Maggs, and plunges it into the sticks upon which Agnes is standing. She seems entertained by this.

AGNES

> Gather ye right close, good people. Come close until the fire near scorch ye, for I charge ye that all must see how the last true witch in England dies. And let my death be a message to the world.

As she is talking the villagers gather in closer and closer. Adultery Pulsifer notices a trickle of sizzling powder, and a couple of nails, falling from inside Agnes's well-stuffed coat into the fire that is crackling around her feet. He is puzzled.

212 INT. AGNES NUTTER'S COTTAGE – DAY – 1656

Now we see the empty barrels by the table. One barrel says

GUNPOWDER, HANDEL WYTH CAUTION. *The other says* ROOFING NAILS.

213 EXT. LANCASHIRE VILLAGE – DAY – 1656

Back on the village green. The villagers are jostling to get a good view of the burning.

AGNES
Gather ye right close, I say, and mark well the fate of all who meddle with such as they do not understand!

Another nail falls. A moment of dawning comprehension on Adultery Pulsifer's face . . . but it's too late.

PULSIFER
Oh, bugger.

A grim smile on Agnes's face, a millisecond before . . . a huge explosion rips across the green.

We see only smoke and the hat that is blown into the air, far above the village green.

GOD (V.O.)
Among the folk from the next village there was much subsequent debate as to whether this disaster had been sent by God or by Satan.

Inside the hat is a tape with THIſſ HATTE BELONGETH TO WITCHFINDER MAJOR THOU-SHALT-NOT-COMMIT-ADULTERY PULSIFER *written on it.*

214 INT. AGNES NUTTER'S COTTAGE – DAY – 1656

JOHN DEVICE opens the Inne Ye Evente of Mye Deathe *envelope. Behind him are the tubs of gunpowder and roofing nails.*

GOD (V.O.)
However, a note found in Agnes's cottage suggested

that any divine or devilish intervention had been materially helped by Agnes's petticoats, in which she had concealed fifty pounds of gunpowder and thirty pounds of roofing nails.

John and VIRTUE DEVICE, Agnes's daughter, look with fear and awe at the book and the box on the table.

GOD (V.O.)
Agnes also left behind a box and a book. They were to be given to her daughter and her son-in-law, John and Virtue Device.

John and Virtue open the book.

We look at the book: brand new, more or less. John unfolds a note in it from Bilton and Scaggs, publishers, letting Agnes know this is her free (gratis) author's copy.

JOHN DEVICE
Dear Mistress Nutter, we take great pleasure in enclosing your author's copy of your book. We trust it will sell in huge numbers, yea, and be reprinted even unto a second printing. Yrs, Bilton and Scaggs, publishers.

And then he looks at the title page of the book, and we follow down the page with him.

JOHN DEVICE (CONT'D)
The Nice and Accurate Prophecies of Agnes Nutter . . .

VIRTUE DEVICE
'*Reminiscent of Nostradamus at his best*', Ursula Shipton. What does this mean, John?

He closes the book.

JOHN DEVICE
It means, Virtue, that although Agnes is dead, we must study her book. For your mother knew the future.

Virtue picks up the book. Flips to the middle, reads . . .

VIRTUE DEVICE

Prophecy 2214: '*In December 1980 an Apple will arise no man can eat. Invest thy money in Master Jobbes's machine and good fortune will tend thy days.*' This is balderdash.

215 EXT. ANATHEMA'S LOS ANGELES HOME – DAY – 2007

A beautiful house – practically a mansion – in LA.

TITLE CARD: ELEVEN YEARS AGO

TITLE CARD: MALIBU, CALIFORNIA

GOD (V.O.)

The book Agnes left behind her was the sole prophetic work in all human history to consist entirely of correct predictions concerning the following 350-odd years, being a precise and accurate description of the events that would culminate in Armageddon. It was on the money in every single detail. On the night the Antichrist was born, in a house in Malibu, Agnes Nutter's great-great-great-great-great-granddaughter was drawing on the title page and, metaphorically, the book had just begun to tick.

216 INT. ANATHEMA'S LOS ANGELES HOME – DAY – 2007

ANATHEMA, around ten years old, is sitting at the table. Her mother is bustling about, taking cookies out of the oven. On the table is a book. We look at the cover. It's the same copy of The Nice and Accurate Prophecies *that Agnes had sent to her relatives, but 350 years older.*

On the table is also a box of well-thumbed index cards. Anathema's mother takes out some cards, and turns one over. On it is a typed prophecy with handwritten notes.

ANATHEMA'S MOTHER
Prophecy 2214.

YOUNG ANATHEMA
This is boring.

ANATHEMA'S MOTHER
2214, sweet pea. And if you get it right, there's a
cookie for you.

YOUNG ANATHEMA
*In December 1980 an Apple will arise no man can
eat.* That one's stupid, mom. It doesn't mean anything.
Why do I have to learn this stuff?

Her mother gives her a cookie.

ANATHEMA'S MOTHER
My mom bought 5000 shares in Apple in 1980, sweet
pea. That's worth 40 million today. Okay. 2213? You
remember that one?

YOUNG ANATHEMA
(reciting from memory)
*Four shall ride, and Three shall ride the Sky as two,
and One shall ride in flames; and there shall be no
stopping them: not fish, nor rain, neither Deville nor
Angel. And ye shall be there also, Anathema.*

ANATHEMA'S MOTHER
See? She's got special plans for you, honey. Agnes gave
us the easy job. We just had to keep everything good
for the family. You're the one that's going to have to
save the world.

YOUNG ANATHEMA
(disgusted)
And I have to do *kissing.*
(defensively)
It's in prophecy 1401. I'm not stupid.

217 EXT. DORKING, NEWT'S HOUSE – NIGHT – 2007

TITLE CARD: **DORKING, UK**

A dull house on a dull street. We are zooming in to a bedroom window with the light on.

GOD (V.O.)
> Meanwhile, in Dorking, Surrey, Thou-Shalt-Not-Commit-Adultery Pulsifer's great-great-great-great-great-grandson should have been in bed hours ago.

MRS PULSIFER
> Newton? It's after your bedtime, dear.

218 INT. NEWT'S BEDROOM – NIGHT – 2007

Newton Pulsifer's bedroom is the bedroom of a boy who would love to be good at things electrical, but isn't. NEWT, aged twelve, is wearing pyjamas and a dressing gown. He has much-home-repaired glasses on. Everything about the bedroom tells us the boy in it likes doing things boys are meant to do, but does them really, really badly. The Airfix model airplanes are appalling.

He has a primitive 1980s computer in pieces in front of him, and is putting it back together, thoughtfully.

NEWT, AGE 12
> Just a few more minutes, Mum. I'm putting the old computer together.

MRS PULSIFER
> You young scientists and your experiments.

NEWT, AGE 12
> It's not really an experiment, Mum. I just changed the plug, and cleaned dust out of the expansion slots. It'll work now.

He plugs the computer in. Turns it on. The bedroom lights go out.

MRS PULSIFER
> I do hope the man from the electric isn't going to be upset again.

NEWT, AGE 12
> It's not fair. Computers hate me . . .

219 EXT. DORKING STREET – NIGHT – 2007

The street outside. In each house the lights go out.

MRS PULSIFER
> Don't worry, love. It's not as if it's the end of the world.

220 INT. ANATHEMA'S LOS ANGELES HOME – DAY

TITLE CARD: **TWO WEEKS AGO**

Same place. It's eleven years since we first met Anathema. Her mother's waiting at the bottom of the stairs.

Anathema comes downstairs carrying a small suitcase.

ANATHEMA'S MOTHER
> You've packed everything you need?

ANATHEMA
> Everything I could possibly need, Mom.

ANATHEMA'S MOTHER
> You'll need Band-Aids. A theodolite . . .

ANATHEMA
> I know the prophecies, Mom.

ANATHEMA'S MOTHER
> Do you have a breadknife? Agnes is very clear on bringing the breadknife.

ANATHEMA
> They have breadknives in England, Mom.

Her mother looks at her. Anathema takes a breadknife from

the sideboard, and puts it into the only open box.

We can see that the room is filled with boxes. Anathema has written what they contain and where they go on the side:

Magazines (assorted). Books (witchcraft). Books (prophecy). Towels and bedlinens (to pink bedroom). Implements (magical) goes to downstairs study. *And so on. There is even a nice old bicycle.*

Anathema tapes the box closed, decisively.

ANATHEMA'S MOTHER
I'll probably never see you again, honey.

Anathema is about to argue with her.

ANATHEMA'S MOTHER (CONT'D)
You know the prophecies as well as I do. Agnes is always very specific about family. Whether you succeed or fail, I won't see you again.

ANATHEMA
I won't fail, Mom.

ANATHEMA'S MOTHER
Make us proud of you, honey. Whatever the Beast is, I know you'll be a match for it. Just trust Agnes, and trust the book.

221 EXT. NEWT'S HOUSE – DAY

TITLE CARD: **THE PRESENT DAY**

Newt's house now. Newt's mother is ten years older than the last time we saw her . . . She's waiting at the door. Newt's car, Dick Turpin, is in the drive: small and ugly and klunky.

NEWT'S MOTHER
I just wanted to say . . . Well, good luck on the new job. I hope it works out this time.

NEWT

> I'm sure it will, Mum.

NEWT'S MOTHER

> You've just been unlucky. I made you sandwiches.

222 INT. OFFICE BUILDING – DAY

It's a big open-plan office. Lots of people around . . .
NEWTON PULSIFER aka NEWT, mid twenties, gawky
and awkward and potentially likable, is at his desk. (Photo of
Newt's mother on it.) LOUISA BLATT comes past. She has
a tablet, and is tapping off names on it as she goes . . .

LOUISA

> And you are?

NEWT

> Newton Pulsifer. Wages clerk. I'm new.

She taps his name off on the list on her screen.

NEWT (CONT'D)

> Excuse me, is there a way to do this without, you
> know, putting it into the computer?

LOUISA

> . . . Is there a way to access the wages database without
> using a computer?

NEWT

> Maybe someone could print it out for me, and I could
> do the sums on paper.

But NIGEL TOMPKINS has started his meeting, which,
in the middle of an open-plan office, he does by clinking a
spoon against a mug and saying:

TOMPKINS

> So who's excited about the training initiative? Let's see
> some hands up then.

He raises his hand. Around the office a variety of hands go up, enthusiastically or wearily . . . we pause as we go around to look at JANICE EVANSON, NORMAN WEATHERED, the three women of the Financial Planning Trio . . .

JANICE EVANSON

Just so you know, Norman, I've registered a complaint with HR about this whole training initiative nonsense. And I believe Financial Planning are with me on this.

The three silent women of Financial Planning nod, disapprovingly.

TOMPKINS

It's a team-building exercise, Janice. And you know what? There's no I in team.

NORMAN WEATHERED

But there's two I's in building, Nigel. And an I in exercise.

Newt has his opening screen. It's all going rather well. He starts to type in a number . . .

TOMPKINS

Norman. Please. Can I have everybody's attention? Who are you?

NEWT

Newt. Newton Pulsifer. Sorry. Just got to hit return and I'm with you . . .

He hits return. The screen of his computer flickers and then goes black. A beat, then other computers start turning off. As do the building lights . . .

NEWT (CONT'D)

Sorry. Just not very good at computers. Team building . . . ?

TOMPKINS

I'm afraid there's no U in team, Mr Pulsifer.

223 EXT. OFFICE CARPARK – DAY

At the back of the carpark, where the most junior of junior employees park, is an ugly car. It's Newt's Wasabi, it is painted green and on the back Newt has painted DICK TURPIN.

Newt reaches it, holding his cardboard box, and reaches down to open the car. A passing MS FROBISHER, from Internal Audits, says:

FROBISHER
 Need a hand, Dick?

She opens the door.

NEWT
 Thank you. But my name's not Dick. That's the car's name.

FROBISHER
 Oh. Right.

NEWT
 You can. You can ask me why, if you like.

FROBISHER
 No thanks.

224 INT. HEATHROW AIRPORT IMMIGRATION – DAY

A bored IMMIGRATION OFFICIAL waves a family on and Anathema steps up.

IMMIGRATION OFFICIAL
 AthanEema Device?

ANATHEMA
 AnATHema. Old family name.

IMMIGRATION OFFICIAL
 Purpose of your visit to the United Kingdom?

ANATHEMA

I'm commanded by an ancient family prophecy. I'm going to use all the witchcraft and wisdom at my disposal to hunt down the heart of darkness then do all I can to destroy it before it brings about the end of the world.

IMMIGRATION OFFICIAL

(tiny bit puzzled, 'did I just hear that?')
... I'm sorry?

ANATHEMA

Vacation.

She brings down the stamp.

225 EXT. A PARK – DAY

Newt is walking, lonely and sad and alone. He's on the phone.

NEWT

Hello, Mum. The job? Yeah. It's going really well. It's great. They love me.

He puts the phone in his pocket and realises he is standing in front of SERGEANT SHADWELL, who is standing on a box, painted black, and has a small board propped up beside him. The board looks like it was painted fifty years ago, and says on it, a word or a thought to a line, WITCHES/ BLIGHT CROPS/ CAST THE EVIL EYE / DANCE NAKED (an abomination) / WORSHIP THE DEVIL / HAVE TOO MANY NIPPLES/ CALL THEIR CATS FUNNY NAMES. Shadwell is giving it all he's got.

SHADWELL

Fear? There's only one thing we have to fear, ya sissies. It's not 'global warming'. It's not 'nuclear Armageddon'. Can anybody here tell me what it is?

Nobody is watching him. His audience consists of a bored pigeon.

SHADWELL (CONT'D)

> You don't answer. You don't answer because you know
> it's true. They are hidden in our midst.
> *(to a PASSER-BY)*
> They could be you!

PASSER-BY

> Oh. Thank you.

SHADWELL

> Don't thank me. I'm the thin red line that stands
> between humanity and the darkness, but don't thank
> me. I'm talking about . . .

NEWT

> Witches?

*And Shadwell looks down to see he now has an audience of
one person. It's Newt. Shadwell softens . . .*

SHADWELL

> Aye. Witches. They lurk behind a façade of
> righteousness. And there's nobody to stop them but me.

*Shadwell looks around. There's nobody watching him.
Nobody cares. He sighs. He gets off his soapbox, and picks it
and his board up. He walks to a coffee van.*

SHADWELL (CONT'D)

> In the old days witchfinders were respected. Matthew
> Hopkins, Witchfinder General, used to charge each
> town and village ninepence for every witch he found.
> And they paid!

NEWT

> Are you. Um. Witchfinder General?

SHADWELL

> I am not. There is no longer a Witchfinder General.
> Nor is there a Witchfinder Colonel, a Witchfinder
> Major, or even a Witchfinder Captain. There is,

however, a Witchfinder Sergeant. And you are looking at him.

Shadwell looks at Newt as if sizing him up.

Then he presents him with an elderly, stained business card.

NEWT
Pleased to meet you, Mister Shadwell.

They've reached the front of the line. Shadwell orders from the food van . . .

SHADWELL
Cup of tea. Nine sugars. And a packet of cheese-and-onion crisps.
(to Newt)
Get your wallet out, laddie. Bit of advice: You never want to appear tight-fisted on first acquaintance.

Newt realises that he's being told to pay for Shadwell's tea. He hands over a fiver and is given some change.

SHADWELL (CONT'D)
And it's not Mister Shadwell. It's sergeant. Witchfinder Sergeant Shadwell. What's your name, lad?

NEWT
Newton. Newton Pulsifer.

SHADWELL
Pulsifer. It's a familiar name, now you mention it. Hmm . . . Do you have your own teeth?

NEWT
Yes.

Shadwell slurps his tea.

SHADWELL
How many nipples have you got?

NEWT

What?

SHADWELL

Nipples! NIPPLES, laddie. How many?

NEWT

Just the usual two.

Shadwell seems satisfied. He thrusts a page of a local newspaper at Newt, who takes it reflexively. An advert has been circled.

SHADWELL

Be there tomorrow at eleven. Bring scissors.

Shadwell, carrying his board, has already headed off. He's taken the roll-up cigarette from behind his ear, and is paying Newt no mind. Newt reads the advert aloud.

NEWT

'JOIN THE PROFESSIONALS. ASSISTANT REQUIRED TO COMBAT THE FORCES OF DARKNESS. UNIFORM, BASIC TRAINING PROVIDED. FIELD PROMOTION CERTAIN. BE A MAN!'

CUT TO:

226 EXT. TADFIELD – DAY

TITLE CARD: **JASMINE COTTAGE, TADFIELD**

TITLE CARD: **THURSDAY**

TITLE CARD: **TWO DAYS TO THE END OF THE WORLD**

A small moving van is parked outside Jasmine Cottage. A DRIVER is carrying in boxes of stuff from the van, with Anathema Device, mid twenties, sparky and funny and sensible. It is the most rustic and beautiful cottage that the location manager can find.

227 INT./EXT. JASMINE COTTAGE – DAY

She is thanking the driver, as he deposits the last box of stuff in her house . . . empty bookcases, barely furnished . . .

ANATHEMA
Just put it there. Thanks so much. Here you go.

She gives him money. He wishes he had a line here. He doesn't.

ANATHEMA (CONT'D)
What a gorgeous village. It's like it ought to be on a postcard. Thank you . . .

The driver goes away, thinking, all these years acting and I don't even get a line of dialogue. Anathema opens the box that she brought, and takes out . . .

A theodolite – an odd one, with crystals and runic carvings attached to it. A pendulum, a breadknife, the copy of The Nice and Accurate Prophecies of Agnes Nutter *we've already seen.*

An ordnance survey map of Tadfield, which she pins to the wall, followed by a medieval woodcut-style illustration, cut from an old book, yellowing and scary, connected to the map with a strand of wool: it shows a demonic nightmarish monster, bigger than a house. And it is captioned, in old gothic lettering, Ye Adversarye, Destroyer of Kings, Angell of ye Bottomleſſ Pit, Prince of Thiſſe Worlde, & Lord of Darkneſſ.

ANATHEMA (CONT'D)
Right. To work.

228 INT. CROWLEY'S FLAT, OFFICE – DAY

In the office, a huge desk with an old-fashioned phone and an answering machine on it, and there's a cartoon of the Mona Lisa on the wall. Crowley picks up the plant mister, and walks out into the flat.

229 INT. CROWLEY'S FLAT – DAY

GOD (V.O.)

> The only things in the flat Crowley devotes any
> personal attention to are the house plants. He had
> heard about talking to plants in the early seventies
> and thought it an excellent idea. Although, talking is
> perhaps the wrong word for what Crowley does.

Crowley is misting the plants. And talking to them.

CROWLEY

> An easy job. Just deliver the Antichrist. And keep an eye
> on him. Nice, straightforward job. Eh? Not the kind of
> thing any demon is going to screw up. Right? . . . Is that
> a spot? Is it?

He examines a plant . . .

CROWLEY (CONT'D)

> Right! You know what I've told you all about leaf
> spots. I will not stand for them.
> > *(to the plant)*
> You know what you've done? You've disappointed me.
> Oh dear, oh dear.

He holds the plant up.

CROWLEY (CONT'D)

> Everyone, say goodbye to your friend. He just couldn't
> cut it.

*The plants are terrified. No, I don't know how we show this
on television either.*

He shakes his head.

CROWLEY (CONT'D)
> > *(to plant)*
> This is going to hurt you so much more than it will
> hurt me . . .
> > *(to other plants)*

And you guys, just, grow better.

GOD (V.O.)

What he does is put the fear of God into them. Or, more precisely, the fear of Crowley. The plants are the most luxurious, verdant and beautiful in London. Also the most terrified.

Crowley leaves the room, taking the offending plant with him. We stay with the terrified healthy ones, which tremble as . . .

We hear the sound of something like a shredder or even a woodchipper in the background. The plants stand up straighter, and do their best to make their leaves look greener and prettier.

Crowley returns with an empty plant pot, heading for his office.

230 EXT. SHADWELL'S FLAT – THE NEXT DAY

A corner newsagent. A seedy door next door, leading to the flat. Newt rings the doorbell.

A moment, then MADAME TRACY comes down the stairs. She's a medium, and a sex worker, and is not as young as she used to be. Today, she's dressed for sex work, rather than as a medium, which means a dressing gown and a little too much make-up.

NEWT

Um. Hello. I'm here about the advert. In the paper.

MADAME TRACY

Well, Madame Tracy Draws Aside the Veil every afternoon except Thursdays. Parties welcome. When would you be wanting to Explore the Mysteries, love?

NEWT

I think perhaps there must have been another advert.

MADAME TRACY

Oh, right. Well, I don't do anything kinky except by
prior agreement, and my knees aren't what they were.
Also, if it's strict discipline you're wanting, tell me now,
because it can take me half an hour to squeeze into the
leather pinny.

She and Newt start back up the stairs together.

NEWT

I'm sorry . . . ?

MADAME TRACY

You're not here for intimate personal relaxation and
stress relief for the discerning gentleman?

NEWT

No! I'm here to join the Witchfinder Army.

MADAME TRACY

Oh, Mister Shadwell said he had a visitor coming!
You're going to make him so happy! It's just been him
for so long. Can I make you a cup of tea?

*Newt is not quite certain what he's got himself into. But
Madame Tracy is already knocking on the door of Shadwell's
flat. A sign on the door in crabbed handwriting says DEFY
THE FOUL FIEND!*

Shadwell's unshaven face appears at the door. He's suspicious.

SHADWELL

Aye?

MADAME TRACY

It's your new recruit, Mister Shadwell. Look!

SHADWELL

Awa' wi' ye, HARLOT! SCARLET WOMAN!
JEZEBEL!

She's flattered.

MADAME TRACY

Oh, Mr Shadwell! I'll bring you both tea.
(to Newt)
Milk and sugar, dear?

SHADWELL

He's in the army now, Jezebel. He'll make his own tea.

231 INT. SHADWELL'S FLAT/HALLWAY/MADAME TRACY'S
BEDROOM – DAY

*Newt is looking around the flat, bewildered. It's a Witchfinder
Army museum, and a collection of books, and a filthy shambles.
Newt is standing by an ancient kettle on a gas hob, about to
make tea. The kettle begins to whistle as Shadwell talks.*

SHADWELL

Welcome to the Witchfinder Army, new recruit. You
are, as of right now, Witchfinder Private Pulsifer.
We used to be powerful. We used to be important.
Condensed milk, laddie. Pour it in. And I take . . .

NEWT

Nine sugars.

SHADWELL

Exactly. We were the line of fire between the darkness
and the poor unsuspecting folk who don't believe in
witches.

*There is a 200-year-old blunderbus hanging on the wall: the
Thundergun.*

NEWT

But, er, Sergeant, don't the churches do that, these
days?

SHADWELL

Nay, lad. It's up to us. Against the darkness. It's a war.
And you know what our first weapon is?

Newt looks around. He points to the Thundergun on the wall . . .

SHADWELL (CONT'D)
> The Thundergun of Witchfinder Lance Corporal
> 'Get 'em before they get you' Dalrymple? Nay, laddie.
> That'll never be used again. Not in this degenerate age.

Newt nervously displays his scissors.

SHADWELL (CONT'D)
> VERY GOOD! And you know what we do with them?

Newt makes a rather ineffectual stabbing motion with the scissors, as if attacking a foe.

SHADWELL (CONT'D)
> No, laddie.

And he drops a large pile of newspapers in front of Newt. He points to a handwritten yellowing sign he has sellotaped on the wall, or on the table in front of Newt. It says:
> 1) Witches.
> 2) Unexplainable Phenomenons. Phenomatrices.
> Phenomenice. Things, ye ken well what I mean.

SHADWELL (CONT'D)
> We read. And we cut.

We pull back and look down on the flat from above. Then move across the hall to see Madame Tracy's flat.

In the hallway, a very large GENTLEMAN CALLER is arriving. Madame Tracy is in her bedroom, laying out a pink frilly nightie and a large black whip on the pink and fluffy bed.

Her doorbell rings.

232 INT. CROWLEY'S FLAT, OFFICE – DAY

The phone begins to ring. On his desk. We see the answering

machine. If it's an old one, we can have a tape in it, but no real reason it can't be solid state.

CROWLEY (V.O.)

> *Hey, this is Anthony Crowley. You know what to do. Do it with style.*

AZIRAPHALE

> *(on answering machine)*
> Hello. Crowley? Is this on? It's me. No leads yet at my end. Anything at your end? Listen, I have a sort of an idea . . .

Crowley's hand snatches the phone from the cradle.

CROWLEY

> What?

AZIRAPHALE

> *(confidentially)*
> Well. I was just wondering . . . Could there *possibly* have been another baby?

CROWLEY

> *What?!?*

233 EXT. LONDON – DAY

Crowley is driving at impossible speeds through London. Aziraphale is not enjoying this at all.

AZIRAPHALE

> I brought a little something for the journey. In case we get peckish.

Crowley doesn't reply. Aziraphale turns and places a tin of shortbread on the back seat of the car.

AZIRAPHALE (CONT'D)

> You've lost the boy—

CROWLEY
—we've lost—

AZIRAPHALE
A child has been lost. But you still know—

CROWLEY
—we know—

AZIRAPHALE
His age. His birthday. He's eleven. There'll be records. There's always records. Everyone keeps records. You – all right, we – just have to look for them. You can remember the hospital?

CROWLEY
You make it sound easy.

AZIRAPHALE
How hard can it be? I just hope nothing's happened to him.

CROWLEY
Happened to him? Nothing happens to him! HE happens to everything!

AZIRAPHALE
So all we've got to do is find the birth records. Go through the hospital files.

CROWLEY
And then what?

AZIRAPHALE
And then we find the child.

Silence.

CROWLEY
 (meaningfully)
And then what?
 (pause)

I suppose – get off the road, you clown – your people wouldn't consider giving me asylum?

AZIRAPHALE

I was going to ask you the same thing . . . *watch out for that pedestrian!*

Crowley takes his hands off the wheel to remonstrate.

CROWLEY

She's on the street, she knows the risks she's taking!

AZIRAPHALE

Watch the road! Watch the road! Where is this hospital, anyway?

CROWLEY

A village near Oxford! Tadfield.

AZIRAPHALE

Crowley! You can't do ninety miles an hour in central London!

CROWLEY

Why not?

AZIRAPHALE

You'll get us killed! Inconveniently discorporated. MUSIC! Why don't I put on a little music . . . ?

He fumbles around in the CDs or cassettes beneath the seat.

AZIRAPHALE (CONT'D)

What's a Velvet Underground?

CROWLEY

You wouldn't like it.

AZIRAPHALE

Oh. Be-bop.

Crowley takes a deep breath, and drives faster.

234 EXT. TADFIELD, SOMEWHERE LOVELY AND VERY CHEAP – DAY

The kids come out of the village shop. Dog has been tied to the railing, and now Adam unties him.

Brian is wearing very clean clothes, and is unwrapping a chocolate ice-cream, which he will eat during the scene. Wensleydale eats fastidiously.

PEPPER

 I still can't believe your dad let you keep him, Adam.

WENSLEYDALE

 Actually, when I found a cat we had to put up a notice saying we had found a lost cat, and then we had to give her back.

ADAM

 It's my birthday. And he didn't have a collar. An' we asked. Nobody's reported a missing dog.

Brian is getting ice-cream on his face.

BRIAN

 Our dog doesn't like me. It pretends I'm not there.

A glob of Brian's ice-cream hits his shirt.

WENSLEYDALE

 Did you know, that my cousin Charlotte says that in America they have shops that sell thirty-nine different flavours of ice-cream.

FREEZE on Wensleydale.

GOD (V.O.)

 Wensleydale's first name is Jeremy, but nobody has ever used it, not even his parents, who call him Youngster.

A still photograph of the Wensleydale family. His parents and he look like they come from a matched set. Obviously he will grow up to be his father.

GOD (V.O.)

All that stands between Wensleydale and chartered
accountancy is time.

PEPPER

There aren't thirty-nine different flavours of ice-cream.
There aren't thirty-nine flavours of ice-cream in the
whole world.

FREEZE on Pepper.

*Still photographs: Bad Hippy Times on a field in Wales. A
sheep chews a tent.*

GOD (V.O.)

Pepper's given first names were Pippin Galadriel
Moonchild. She had been given them in a naming
ceremony in a muddy valley field that contained three
sheep and a number of leaky polythene tents. Six
months later, sick of the rain, the men, the sheep who
ate first their marijuana crop and then their tents,
Pepper's mother returned to Tadfield, and enrolled in a
sociology course.

*The action starts again. Brian's shirtfront and face is now
covered with chocolate ice-cream.*

BRIAN

There could be, if you mixed them up. You know.
Strawberry *and* chocolate.

FREEZE on Brian.

GOD (V.O.)

Every gang needs a Brian: always grimy, always
supportive of anything Adam invents or needs.

BRIAN

Chocolate *and* vanilla. Strawberry *and* vanilla *and*
chocolate.

Brian wipes his face with his sleeve, so he now looks generally grimy, face and clothes.

ADAM

Anyway. Nobody's going to take Dog away from me. We're together to the end. Aren't we, boy?

And Dog wags his tail.

235 EXT. TADFIELD LANE – DAY

On a narrow lane in Tadfield, we see Anathema. She's taking a siting down her theodolite, her bike propped up against a tree . . .

We move in on Anathema, who is now making notes on a map of the area on her iPad.

ANATHEMA

Eye of newt and tongue of dog, north by northwest . . . There. And it's . . . southwest . . .

236 EXT. HOGBACK WOOD – DAY

A sunny day. The THEM are sitting around in the Pit. Adam is playing with Dog; the other three are talking.

PEPPER

There's a witch moved in to Jasmine Cottage.

BRIAN

That's stupid.

PEPPER

It's not stupid, stupid. Mrs Henderson told my mother the lady there gets a witches' newspaper.

WENSLEYDALE

Excuse me. My father says there's no such thing as witches.

ADAM

> It makes sense witches would have their own
> newspaper. My dad gets the *Anglers' Times* and I bet
> there's loads more witches than anglers.

PEPPER

> Shut up, I'm trying to tell you things! It's called the
> *Psychic News*! She's a witch!

WENSLEYDALE

> Actually, there's no more witches, because we invented
> science and all the vicars set fire to the witches for their
> own good. It was called the Spanish Inquisition.

ADAM

> I don't reckon it's allowed, going round setting fire to
> people. Otherwise people'd be doin' it all the time.

Brian, grimy, is eating crisps . . .

BRIAN

> It's all right if you're a vicar. And it stops the witches
> from goin' to Hell, so I expect they'd be quite grateful
> if they understood it properly.

ADAM

> We could be the new Spanish Inquisition.

WENSLEYDALE

> Actually we can't be the Spanish Inquisition, because
> we are not actually Spanish.

BRIAN

> I've been to Barcelona. I can teach you Spanish. They
> say *Olé* a lot.

ADAM

> We should practise. Before we start burning witches.
> We should start small and work our way up.

*Pepper nods, decisively. She's an excellent second in
command.*

PEPPER

> Leave it to me.

237 INT. BENTLEY – DAY

Crowley is following the road signs to TADFIELD MANOR.

AZIRAPHALE

> This is the way to Tadfield Manor. Does it look
> familiar yet?

CROWLEY

> You know, it does. I think there was an airbase round
> here somewhere.

AZIRAPHALE

> Airbase?

CROWLEY

> You don't think American diplomats' wives usually
> give birth in little religious hospitals in the middle
> of nowhere, do you? It all had to seem to happen
> naturally. There's an airbase at Lower Tadfield,
> things started to happen, base hospital not ready,
> our man there said, 'There's a birthing hospital just
> down the road', and there we were. Rather good
> organisation.

*And by now he's going up the drive to the former Satanic
Hospital . . .*

AZIRAPHALE

> *(sarcastically)*
> Flawless.

CROWLEY

> It should have worked.

AZIRAPHALE

> Ah, but evil always contains the seeds of its own
> destruction. No matter how well-planned, how

foolproof an evil plan, no matter how apparently successful it may seem upon the way, in the end it will founder upon the rocks of iniquity and vanish.

CROWLEY
For my money, it was just an ordinary cock-up.

238 EXT. HOGBACK WOOD – DAY

Anathema wanders from the village green down the path to Hogback Wood. She's alternately scribbling in a notebook and waving a pendulum above a map of the village, covered in marks and crosses. She's depressed.

She sees the kids; they cheer her up a little. They wave.

Anathema marks off another square on her map.

Pepper and Wensleydale go past. Wensleydale is dressed as a witch. Or at least, he's wearing a pointy black hat made of paper, and he is carrying a broom.

ANATHEMA
Hi guys.

PEPPER
Hi.

ANATHEMA
Nice hat.

WENSLEYDALE
Actually, we made it out of cardboard. It's for our game.

ANATHEMA
Stylish. What are you playing?

WENSLEYDALE
The British inquisition.

PEPPER
Come *on*, Wensleydale.

Anathema is amused enough that she is following.

Adam is wearing his dressing gown. Brian is a guard. Pepper is wrangling Wensleydale. Anathema looks at Adam.

ANATHEMA
Looks like fun. So, how does this game work?

ADAM
I am Chief Inquisitor of the British Inquisition. Brian is the head torturer. And we're trying to find a witch.

ANATHEMA
That sounds . . . very sensible. How do you do that?

ADAM
Watch.
 (to Wensleydale)
Art thou a witch? *Olé?*

WENSLEYDALE
Yes.

PEPPER
You can't say yes. You've got to say no.

WENSLEYDALE
Then what?

ADAM
Then we torture you until you say yes.

ANATHEMA
You're going to torture him?

ADAM
We've built a torturing machine.

He points to a tractor tyre hanging from some ropes, as a swing.

ANATHEMA
It looks like a swing.

WENSLEYDALE

But obviously in this scenario I actually am a witch. I have a big pointy hat and we have a cat at home, and I borrowed mum's broom . . .

PEPPER

Look, no one's saying you can't *be* a witch, you jus' have to say you're not a witch. No point in us taking all this trouble if you're going to go round saying yes the minute we ask you. Say NO.

WENSLEYDALE

But . . .

Pepper looks serious.

ADAM

Art thou a witch, oh evil crone?

239 MOMENTS LATER

Cries of pure joy. Wensleydale is having the TIME OF HIS LIFE being swung backwards and forwards on the tyre.

Brian is doing the pushing, and he is getting a bit tired of it.

BRIAN

Excuse me, Adam, I don't see why I have to do all the work.

WENSLEYDALE

I am being tortured! Actually, this is very painful! I am thinking of admitting to being a witch.

Brian stops pushing.

BRIAN

I'm going to go home unless I can have a go. Don't see why evil witches should have all the fun.

WENSLEYDALE

You have to keep pushing.

Anathema is talking to Adam.

ANATHEMA
Hey. Kid. Can I ask you something?

ADAM
Yes.

ANATHEMA
Are there any . . . great beasts around here? Or strange things happening?

ADAM
There's Dog. He's a beast. Go on, Dog, shake hands.

Anathema looks at Adam's cute dog, and smiles. Dog offers her its paw.

ANATHEMA
Not really what I was looking for.

ADAM
Hold on. I have to tell them what to do. All right, evil Witch Wensleydale, don't do it again, and now you get off the torturing swing and let someone else have a turn.

Brian takes the pointy hat from Wensleydale and puts it on his own head as he gets into the swing.

Anathema grins at the display of sweetness in front of her.

ANATHEMA
You kids are hilarious. Okay. I'll keep looking.

240 EXT. TADFIELD MANOR – DAY

And the Bentley pulls up in front of somewhere that we recognise. It's the former Hospital of Satanic Nuns. Now it's a fancy manor house, with lots of nice cars in the carpark in front of the façade . . .

They get out of the Bentley. As they do we are looking at them through rifle-sights.

AZIRAPHALE

Um. Are you sure we're in the right place? This doesn't look like a hospital . . . And it feels loved.

POV shot: someone with a gun is looking at them down the barrel. Sighting on Crowley then Aziraphale.

CROWLEY

No. It's the right place. How do you mean? Loved?

POV shot: Aziraphale in the gunsights.

AZIRAPHALE

I mean, the opposite of when you say, 'I don't like this place. It feels spooky.'

CROWLEY

I don't ever say that. I like spooky. Big spooky fan, me. Let's go talk to some nuns.

Crowley and Aziraphale take a step towards the building, and we hear two muffled BANGS, as Crowley is shot in the chest and Aziraphale is shot in the back.

SLOW MOTION as they both crumple to the ground. Important: everything in Tadfield Manor from here to the end is shot like a war film, somewhere between Rambo: First Blood *and* Band of Brothers . . .

We can see that Crowley's shirtfront has turned red . . .

Crowley and Aziraphale are sprawled on the lawn. We nose in on them. Crowley touches the red on his shirt. Looks at the red on his fingers. Sniffs it. Licks it.

CROWLEY

Hmm.

Aziraphale raises his hand. The 'blood' on it is blue . . .

AZIRAPHALE

Blue?

CROWLEY

It's paint.

And as they get up, Nigel Tompkins comes charging out of the rhododendrons, paintball gun at the ready.

NIGEL TOMPKINS

Okay. You're both hit. I don't know what you think you're playing at but—

And we look at Nigel as Crowley transforms into something monstrous.

Nigel faints. We cut back as Crowley has transformed back . . .

CROWLEY

That was fun.

AZIRAPHALE

Yes. Fun for you. Just look at the state of this coat. I've kept it in tiptop condition for over a hundred and eighty years now. I'll never get this stain out.

CROWLEY

You could miracle it away.

AZIRAPHALE

Yes. But I'd always know the stain was there. Underneath, I mean.

Crowley gestures. The stain vanishes.

AZIRAPHALE (CONT'D)

Oh. Thank you. This gun. I've looked at it. It's not a proper gun at all. It just shoots paintballs.

CROWLEY

Don't your lot disapprove of guns?

AZIRAPHALE

> Unless they are in the right hands. Then they give
> weight to a moral argument. I think.

Crowley is amused by this. He takes the paint gun from Aziraphale . . .

CROWLEY

> A moral argument? Really? Come on . . .

He puts the paint gun down. Now it's a real gun.

241 INT. TADFIELD MANOR – RECEPTION

We follow Crowley and Aziraphale into the building. It's barely recognisable as the satanic convent from Episode One. Modernised tastefully into a place where retreats happen.

TADFIELD MANOR CONFERENCE AND MANAGEMENT TRAINING CENTRE: A PLACE TO INTEGRATE AND EXPAND *is on the wall, and beneath it a large photograph of* MARY HODGES.

Another sign tells us this is the UNITED WORLDWIDE HOLDINGS (HOLDINGS) COMBAT INITIATIVE COURSE.

Crowley picks up a leaflet from the reception desk, flicks through it, tosses it down.

CROWLEY

> This is definitely the place. I wonder where the nuns
> went.

FREEZE FRAME on the cover of the leaflet on Tadfield Manor.

GOD (V.O.)

> Management training no longer meant watching half
> a dozen unreliable PowerPoint presentations. Firms
> these days expected more than that. They wanted

to establish leadership potential, group cooperation and initiative, which allowed their employees to fire paintballs at any colleagues who had irritated them. The brochure for Tadfield Manor that Crowley is inspecting fails to contain any sentences along the lines of, 'until eleven years ago the Manor was used as a hospital by an order of Satanic Nuns who weren't actually very good at it . . .'

And now we can see the Tadfield Manor image darken and change: it becomes the hospital, eleven years ago in the rain.

242 EXT. TADFIELD MANOR – DAY

Nigel Tompkins comes to, a little blearily.

He looks down at the gun. We can hear Norman Weathered and Louisa Blatt heading towards us . . .

NORMAN WEATHERED
I'm pretty sure I heard someone around here . . .

And Nigel fires his gun. Only it's a real gun . . .

243 INT. TADFIELD MANOR – DAY

Crowley and Aziraphale are wandering through the building. Ms Frobisher, wearing desert camouflage and carrying a polystyrene cup, waves to them.

FROBISHER
Who's winning? Millie in Accounts caught me on the elbow.

CROWLEY
You're all going to lose.

And from outside, we hear gunfire . . .

AZIRAPHALE
What the Hell did you just do?

CROWLEY
Well, they wanted real guns. So I gave them what they wanted.

244 EXT. TADFIELD MANOR – DAY

The silent women from Financial Planning, led by Janice Evanson, are crawling through the grass. Everything is shot like a war film. Louisa crawls over to them.

LOUISA
I always said you couldn't trust those people from Purchasing. The bastards.

JANICE EVANSON
Why? Why would they do this?

LOUISA
That's the wrong question, Janice. The right question is, can we take them out, before they do it again?

She fires her gun. It's a semi-automatic weapon that blows a bush apart . . .

245 EXT. TADFIELD MANOR GROUNDS – DAY

Pull back. Someone from IT is crawling through the bushes, when an arm goes around his neck.

NIGEL TOMPKINS
You're from IT, aren't you?

The IT man nods.

NIGEL TOMPKINS (CONT'D)
Well. IT man. Down there, it's company law. But up here, it's me.

CUT TO:

246 EXT. TADFIELD MANOR GROUNDS – DAY

It's all getting very Apocalypse Now.

Norman Weathered is facing a bunch of middle-aged men and women, from the Internal Audits department. He's making a speech . . . they are moved, enthused and galvanised by it.

NORMAN WEATHERED
 I wanted to be a graphic designer, design LPs for The
 Rolling Stones, but the careers teacher said he hadn't
 heard of it. So I spent thirty-six years in the Internal
 Audits department of United Worldwide Holdings
 (Holdings). Thirty-six years of double-checking form
 BF18. And now this. Couldn't just say, 'Norman, we're
 giving you early retirement. Here's a watch, bugger off
 and tend your marigolds.' No. It's 'We're going to take
 you to bloody Oxfordshire and shoot at you.' We've all
 known we couldn't trust anyone in Forward Planning
 or Sales. We've all seen the Marketing department, and
 the way they look at us with their skinny lattes and
 their dry flat whites. These are people who talk about
 having a personal relationship with a Brand.

*Everyone nods. They all hate marketing. As Norman has
been talking he has taken off his tie. Now he ties it around his
forehead, as a bandana, for those of us who remember Rambo.*

NORMAN WEATHERED (CONT'D)
 They want war? We'll give them war. Okay, guys! Let's
 get the bastards!

 CUT TO:

247 INT. TADFIELD MANOR – EVENING

*Crowley and Aziraphale are wandering the empty corridors,
looking for something, pushing open doors at random . . .*

We can hear occasional stutters of gunfire.

AZIRAPHALE

There are people out there shooting at each other!

CROWLEY

It gives weight to their moral arguments. Everyone has free will, including the right to murder . . . Think of it as a microcosm of the universe. Ineffable, right?

AZIRAPHALE

(aghast)
They're murdering each other?

CROWLEY

(sighs, reluctant)
No. They aren't. No one's killing anyone. They are all having miraculous escapes. It wouldn't be any fun otherwise.

AZIRAPHALE

You know, Crowley, I've always said that, deep down, you are quite a nice—

But he doesn't get to finish it. Crowley has grabbed him by the shirt-collar, pushed him up against a wall. He pushes his face close to Aziraphale's and says:

CROWLEY

Just shut it! I'm a demon. I'm not nice. I'm never nice. Nice is a four letter word I will not—

And a voice from behind says,

MARY HODGES

Excuse me, gentlemen. I'm sorry if I'm breaking in on an . . . intimate moment, but . . . Can I help you?

Crowley turns around and sees Mary Hodges. She's Sister Mary Loquacious, ten years older, no longer a nun . . .

248 FLASHBACK – 2007

Crowley handing the baby to Sister Mary . . .

249 THE PRESENT:

Crowley walks towards her.

CROWLEY
 You!

MARY HODGES
 Saints and demons preserve us, it's Master Crowley!

She turns to flee. And Crowley snaps his finger. Mary FREEZES in place, her eyes blank.

AZIRAPHALE
 You didn't have to do that! You could have just asked her!

CROWLEY
 Of course. 'Excuse me, ma'am, we are two supernatural entities looking for the notorious Son of Satan, I wonder if you could help us with out enquiries?'

AZIRAPHALE
 Er. Look, hello, you weren't by any chance a nun here eleven years ago, were you?

MARY HODGES
 I was.

AZIRAPHALE
 Luck of the devil!

CROWLEY
 What happened to the baby I gave you?

MARY HODGES
 I swapped him with the son of the American Ambassador. Such a nice man. He used to be ambassador to Swindon. And then Sister Theresa Garrulous came and took the other baby away.

CROWLEY
 This 'American Ambassador'. What was his name?

Where did he come from? What did he do with the baby?

MARY HODGES
I don't know.

AZIRAPHALE
Records! There must have been records!

MARY HODGES
Yes. There were. We were very good at keeping records.

AZIRAPHALE
Well, where are they?

MARY HODGES
Burned in the fire.

AZIRAPHALE
Well, is there anything you can remember about the baby?

MARY HODGES
He had lovely little toesy-wosies.

The sound of police sirens is getting louder.

250 EXT. TADFIELD MANOR – EVENING

We see a couple of police cars, lights flashing, pulling up in the driveway outside.

251 INT. TADFIELD MANOR – EVENING

Crowley and Aziraphale can hear the sirens and shouted police orders . . .

POLICE LOUD HAILER
Come out with your hands up. Repeat, come out with your hands over your heads.

CROWLEY
Let's go.

AZIRAPHALE
>*(to Mary)*
>You will wake up having had a lovely dream about
>whatever you like best—

*And Crowley has grabbed Aziraphale and hauled him off
down the corridor.*

252 INT. TADFIELD MANOR – EVENING

*Now we follow Crowley and Aziraphale down the stairs and
out of the manor hallway: the attendees are being rounded
up by the police.*

*And Crowley and Aziraphale walk through it, never actually
running into the police, missing the trainees.*

253 EXT. TADFIELD MANOR – NIGHT

*All lit by police flashing lights. Crowley and Aziraphale are
talking as they walk past the police cars and the battles.*

AZIRAPHALE
>You'd think he'd show up, wouldn't you? You'd think
>we could detect him in some way.

CROWLEY
>He won't show up. Not to us. Protective camouflage.
>He won't even know it, but his powers will keep him
>hidden from prying occult forces.

AZIRAPHALE
>Occult forces?

CROWLEY
>You and me.

AZIRAPHALE
>I'm not occult. Angels aren't occult. We're ethereal.

CROWLEY
Whatever.

The cop looks down at what he's holding . . . does a double take. It's a paint gun.

254 EXT. TADFIELD LANE – NIGHT

Anathema. She's taking a siting down her theodolite, in the moonlight. She's lit by moonlight and iPad.

GOD (V.O.)
Most books on witchcraft will tell you that witches work naked. This is because most books on witchcraft are written by men.

ANATHEMA
Darksome night, / And shining Moon . . . Oh come on . . .

255 EXT. TADFIELD MANOR DRIVE – NIGHT

The Bentley drives casually past police cars with flashing blue lights. Nobody's noticed them . . .

AZIRAPHALE
Is there some other way of locating him?

CROWLEY
How the Heaven should I know? Armageddon only happens once, you know. They don't let you go around again until you get it right.

He puts his foot down and the car zooms off down the drive.

CROWLEY (CONT'D)
But I know one thing. If we don't find him. It won't be the war to end all wars. It'll be the war to end everything.

256 EXT. TADFIELD LANE – NIGHT

*Anathema on her bike, going down a hill, right to left, going
back the way she came . . .*

257 EXT. TADFIELD LANE – NIGHT

Aziraphale is puzzled in the extreme.

AZIRAPHALE
 There's a very peculiar feeling to this whole area. I'm
 astonished you can't feel it.

CROWLEY
 I don't feel anything out of the ordinary.

AZIRAPHALE
 But it's everywhere. All around here. Love. Flashes of
 love.

*Crowley is disappointed. He turns much too fast at an
intersection . . .*

CROWLEY
 You're being ridiculous. The last thing we need right
 now is—

*And there is a THUMP as he hits Anathema on her bike
with the car. The bike goes flying, as does the body. The car
stops.*

AZIRAPHALE
 You hit someone.

CROWLEY
 I didn't. Someone hit me.

258 EXT. TADFIELD LANE – NIGHT

*They get out to examine the damage. There's a twisted bike,
its front wheel bent out of shape, its back wheel still clicking
ominously. One Bentley headlight is out. It's dark.*

AZIRAPHALE

Let there be light.

And a beautiful glow suffuses the lane. Anathema, semi-unconscious in the ditch, says:

ANATHEMA

How the hell did you do that?

Light vanishes. Aziraphale looks guilty. The Bentley front headlight that was out pings on, throwing some more light around.

ANATHEMA (CONT'D)

Oh . . . I think I hit my head.

Crowley has no interest in a young lady in a ditch. He is dealing with the important stuff: walking around the car magically repairing the scrape down its side, the dimple in the bumper.

Aziraphale puts his hand on Anathema's arm, bent at a strange angle.

AZIRAPHALE

Up you get.
 (meaningfully)
No bones broken.

The arm is now at a normal angle. Anathema gets up, a bit shakily.

ANATHEMA

My bicycle.

Aziraphale picks it up and wheels it over to her.

AZIRAPHALE

Amazingly resilient, these old machines.

And it's as good as new. Or better. It has gears, for a start . . .

AZIRAPHALE (CONT'D)

Where do you need to go?

CROWLEY

Not giving her a lift. Out of the question. Nowhere to put the bike.

AZIRAPHALE

Except the bike rack. Get in, my dear.

Crowley looks and is pained to see that a tartan luggage rack has appeared miraculously on the back of his perfect car.

Anathema is in the back seat, and Aziraphale, who has gathered up the spilled contents of the bike's basket, dumps it all (including the BOOK) onto the back seat next to her. Then he hands her a slightly bent breadknife.

She holds it as a weapon.

They drive off, the bike miraculously fastened to the back of the car.

CROWLEY

So. Where are we taking you?

ANATHEMA

Back into the village. I'll give you directions.

259 EXT. TADFIELD VILLAGE – NIGHT

ANATHEMA

Listen. My bike. It didn't have gears. I know it didn't have gears. Make a left.

CROWLEY

(*sotto voce*)
'Oh Lord, heal this bike?'

AZIRAPHALE

I got carried away.

ANATHEMA

You can drop me off here.

The car stops outside Jasmine Cottage.

Aziraphale, beaming, helps Anathema out. She grabs her theodolite, basket, breadknife, etc. Gets out.

The Bike is already miraculously propped up against the garden gate. No gears.

AZIRAPHALE
Oh look. No gears. Just a perfectly normal velocipede.

CROWLEY
Bicycle. Can we get on? Get in, angel.

Anathema heads in to the house as the Bentley roars away.

260 INT. JASMINE COTTAGE – NIGHT

Anathema is in her kitchen, drawing on her map. All her things are laid out around her on the table. She's got the iPad in front of her. Taps her mother's icon.

Her mother appears on the screen.

ANATHEMA'S MOTHER
Hi, hon. How's it going?

ANATHEMA
Lousy, Mom. I just got hit by a car.

ANATHEMA'S MOTHER
Ow. Baby. Any progress in finding the . . . the whatever it is?

ANATHEMA
The 'young beast and the lesser beast'? It must be at the north end of the village. I'm certain of it. I just can't work out where.

ANATHEMA'S MOTHER
Have you used your pendulum?

ANATHEMA
Mom. I'm not a kid. Get too close, the signal swamps

me. Further away, I can't get an accurate fix.

She pours some coffee.

ANATHEMA'S MOTHER
 The answers are always in the book, honey. It's just
 sometimes you don't see them until afterward.

ANATHEMA
 I just have to think like a seventeenth-century witch
 with a mind like a crossword puzzle. Okay. I'll go back
 to the book . . .

*She looks down at the table, with the stuff she had in the bike
basket on it. And she realises . . .*

It's not there.

ANATHEMA (CONT'D)
 The book. Holy shit. Mom, I'll have to call you back—

She turns off the iPad and runs out into the street . . .

261 EXT. JASMINE COTTAGE – NIGHT

*Anathema stands, not knowing where Crowley and
Aziraphale are. Or where her book is.*

262 INT. GREASY SPOON CAFÉ – NIGHT

*A greasy spoon café. Crowley has a cup of tea. Aziraphale
has a cup of tea and a slice of cake, which he is enjoying.*

AZIRAPHALE
 . . . You know, we might be able to get another human
 to find him.

CROWLEY
 What?

AZIRAPHALE
 Humans are good at finding other humans. They've

been doing it for thousands of years. And the child is partly human. Other humans might be able to sense him, perhaps.

CROWLEY

He's the Antichrist! He's got an automatic defence thungummy. Suspicion will slide off him like, like . . . whatever it is water slides off of.

AZIRAPHALE

Got any better ideas? Got one single better idea?

Crowley glares at him, glarefully.

263 EXT. ADAM'S HOUSE – NIGHT

It's night time. A glow comes from Mr and Mrs Young's bedroom window.

264 INT. THE YOUNGS' BEDROOM – NIGHT

Mr and Mrs Young are in bed. He's reading a book. She's reading on her iPad.

DEIRDRE

I still don't know why you let him keep that dog.

MR YOUNG

I reported it as lost. But they said just to look after it, and if anyone came looking, they'd send them to us. It was his birthday. And, I don't know, the way he was looking at the dog. And the dog was looking at him. As if they were made for each other.

DEIRDRE

Arthur. You are a softy sometimes.

MR YOUNG

I resent that remark.

DEIRDRE

Where's the dog now?

MR YOUNG

Tied up outside. Adam asked if he could have him in his room, and I said, 'Absolutely not.' 'Absolutely not', I said.

Mrs Young gets out of bed.

MR YOUNG (CONT'D)

What are you doing?

DEIRDRE

Checking on something.

She walks out of their bedroom, across the hall. She knocks, then pushes open the door.

265 INT. ADAM'S BEDROOM – NIGHT

A typical eleven-year-old boy's bedroom, only not typical, because it's sort of perfect. Perfectly messy. Perfectly typically a boy's room – a football, toys, a mess of books and comics. Nothing that anchors it in time, though – no rock bands yet, no specific football posters.

Adam is in bed, sleeping convincingly. Dog is nowhere to be seen.

Deirdre looks at him. Smiles lovingly, closes the door.

266 INT. THE YOUNGS' BEDROOM – NIGHT

Mr Young looks up, quizzically.

MR YOUNG

What was that about?

DEIRDRE

Oh. Just checking on Adam. He's quite sweet, you know. When he's asleep.

MR YOUNG
When he's asleep, yes.

267 INT. ADAM'S BEDROOM – NIGHT

Adam opens an eye to check that his mum's gone. He whispers:

ADAM
Come on, Dog!

Dog puts its head out from under the bed, and jumps back onto the bed, next to Adam, who smiles, and genuinely closes his eyes to sleep.

His dog is asleep on the pillow beside him. And it's a heartwarming moment.

Except for the WHISPERS.

A low susurrus of whispering voices, of all kinds. We can't make out what they are saying. Not yet.

And we move slowly in to Adam's sleeping face, as the whispers surround him. We can't make out words yet. Just whispers.

268 INT. CROWLEY'S BENTLEY – NIGHT

Aziraphale is rather enjoying having the upper hand in the ideas department.

AZIRAPHALE
Look. There's something I should tell you. I have a . . . network of highly trained human agents, spread across the country. I could set them searching for the boy.

CROWLEY
You do? I actually have something similar. Human operatives.

AZIRAPHALE
Gosh. Do you think they ought to work together?

CROWLEY

I don't think that would be a good idea. My lot are not
very sophisticated, politically speaking.

AZIRAPHALE

No. Neither are mine. So we tell our respective
operatives to look for the boy? Unless you have a better
idea?

CROWLEY

(pause. Then:)
Ducks!

AZIRAPHALE

What about ducks?

CROWLEY

They're what water slides off.

AZIRAPHALE

Just drive the car, please.

269 EXT. TADFIELD LANE – NIGHT

GOD (V.O.)

The trouble with trying to find a brown-covered book
among brown leaves and brown water at the bottom of
a ditch of brown earth in the middle of the night is that
you can't.

Anathema, with her torch and bike, staring at the ditch, the
road, desperate to find the lost book. She is talking aloud to
the book.

ANATHEMA

You have to be here. There is no way I've lost you.
Agnes would have told me if I was going to lose you.
She was always very clear on things concerning you.
Oh god, I am talking to a book right now, I am talking
to a book that isn't even here.

There's a beat. And then she breaks.

ANATHEMA (CONT'D)
Okay. You're gone. I guess you must be in the back of
the car with those . . . men. But that's fine. I have the
annotated notecards. And I know you by heart. So, I
mean. I guess it'll be okay.
(beat)
It's not like they're ever going to figure out what
they've got.

CUT TO:

270 INT. CROWLEY'S BENTLEY – NIGHT

*They aren't talking. Appropriate music is coming out of the
Bentley's stereo. Queen, perhaps? And then Crowley says
something that's been bothering him for hours.*

CROWLEY
You know, if you lined up everyone in the whole world,
and asked them to describe the Velvet Underground,
nobody at all would say Be-bop.

*The Bentley draws up outside Aziraphale's Bookshop.
Aziraphale gets out, reaches into the back of the car to get his
box of shortbread, then notices a book . . .*

AZIRAPHALE
There's a book back there.

CROWLEY
It's not mine. I don't read books.

AZIRAPHALE
It has to belong to the young lady you hit with your
car. We really should have got her address . . .

CROWLEY
No, we really shouldn't. I'm in enough trouble as
it is. I'm not going to start returning lost property.

That's what your lot do. Why don't you send it to the Tadfield post office addressed to the mad American woman with the bicycle . . . ?

The last couple of sentences SOUND WEIRD, because our entire world is suddenly Aziraphale and the book. Aziraphale's glanced at the title page and if he had a heartbeat it would be loud enough to hear.

AZIRAPHALE
Oh. Jolly good, yes. Rather.

He heads for the door.

CROWLEY
Right. So we'll both contact our respective human operatives, then.

AZIRAPHALE
. . . Sorry?

CROWLEY
Are you all right?

AZIRAPHALE
Perfectly. Yes. Tip-top. Absolutely tickety-boo.

CROWLEY
'Tickety boo'?

AZIRAPHALE
Mind how you go!

And he goes into his bookshop and closes the door.

CROWLEY
(baffled)
Right. Well, that was a thing.

271 INT. AZIRAPHALE'S BACK ROOM – NIGHT

Aziraphale is making cocoa.

Having made the cocoa, he places it beside the book. He gets a pad of paper and a pen.

Then he takes white cotton gloves and puts them on. He takes a lamp and angles the light onto the book.

Finally he sits down at a chair in front of it.

While he's doing this, we linger on books in the glass cabinet above his head. We can see titles: these are famous books of prophecy.

And through this whole scene we hear . . .

GOD (V.O.)

> Aziraphale was particularly proud of his books of
> prophecy. First editions, usually. And every one was
> signed. He had Martha the Gypsy, and Ignatius Sybilla,
> and Ottwell Binns. Nostradamus had signed 'To myne
> olde friend Azerafel, with Beste wishes'; Mother Shipton
> had spilled drink on his copy of her book; he even owned
> an original scroll in the handwriting of St John the
> Divine of Patmos, whose 'Revelation' had been the all-
> time best seller. Aziraphale had found him a nice chap,
> if a bit too fond of funny mushrooms. But there was one
> book he didn't have. One book he had only heard of . . .

Aziraphale opens the book to the title page: it's the title page we saw in the seventeenth century, earlier in this episode, only it's ancient, and a decade ago a child drew on it in crayon. But yes, it is.

AZIRAPHALE

> *The Nice and Accurate Prophecies of Agnes Nutter.*

Then he opens the book at random. We see the prophecy over his shoulder.

AZIRAPHALE (CONT'D)

> *3008: When that the angel readeth these words of
> mine, in his shoppe of other menne's books, then*

*the final days are certes upon us. Open thine eyes
to understand. Open thine eyes and rede, I do say,
foolish principalitee, for thy cocoa doth grow cold.*

He creases his brow at this.

AZIRAPHALE (CONT'D)
Cocoa doth grow cold? What cocoa?

*He looks down at the mug of cocoa. Looks amazed and filled
with wonder and awe.*

And then he picks up the book and starts to read.

*Time lapse: in the background, we see the dawn and the day
begin and the day come up. And Aziraphale just reads and
turns the pages.*

The cocoa sits untouched beside him.

272 EXT. CROWLEY'S FLAT – MORNING

Mayfair. The world is coming to life.

273 INT. CROWLEY'S FLAT – MORNING

*The houseplants in Crowley's all-white, ultra-stylish flat. They
are looking at the door to Crowley's bedroom, nervously.*

We hear Crowley getting out of bed, coming to the door.

*As he approaches, the houseplants all stand to attention and
stick out their leaves.*

*Crowley looks a bleary mess as he walks past the camera one
way. We can see his snake-eyes, his messy hair.*

*He walks back past the camera fully dressed a second later
looking stylish, with not a hair out of place, and his dark
glasses on.*

274 INT. CROWLEY'S FLAT, OFFICE – MORNING

Crowley's at the desk.

*He picks up the phone (connected to answering machine).
Dials . . .*

CROWLEY
Any news? Found the Antichrist yet?

275 INT. AZIRAPHALE'S BACK ROOM – DAY

Aziraphale is on the phone.

AZIRAPHALE
No! No news. Nothing. Nothing at all. If I had
anything I'd tell you. Obviously. Immediately. We're
friends! Why would you even ask me?

CROWLEY
Dude. Chill. I was just asking. No news here either.
Well, they're taking the wrong boy to Megiddo. But
they'll find that out soon enough. Call if you find
anything.

AZIRAPHALE
Absolutely, why would you think I wouldn't?

He puts down the phone. We see The Nice and Accurate
Prophecies, *and a pad of paper, on which he's been doing
sums . . . A row of numbers. He looks at a prophecy,
checks . . . We see prophecy 3817:* 'The Number of the
Beast is in the Revelayting of Sainte John, call hym in
Taddes field. And ye will know hym by this sign, that when
ye do call to hym, the Lesser Beaste will walk upon his
hinde legs like unto a Dancing Bear.'

*Then he opens an ancient Bible. We look over his shoulder
– it's the Book of Revelation.*

AZIRAPHALE (CONT'D)
Hang on:
(reads)
Let him that hath understanding count the number
of the beast: for it is the number of a man; and his
number is six hundred threescore and six . . . It can't
be that simple . . .

Then he looks, doubtfully, at his piece of paper.

AZIRAPHALE (CONT'D)
I'd need to put the Tadfield area code first, of course . . .

Then he picks up the phone and dials . . .

276 INT. ADAM'S HOUSE – DAY

Adam and Dog are playing in the garden, visible through
the French doors. The phone rings. Mr and Mrs Young are
finishing breakfast.

Mr Young goes over to the phone.

MR YOUNG
Tadfield, oh four six triple six? Arthur Young here.

ADAM
Dad! Look! I got Dog to walk on his hind legs!

277 INT. AZIRAPHALE'S BACK ROOM – DAY

Aziraphale. We see the expression on his face . . . It's all true.
And that boy is the missing Antichrist.

AZIRAPHALE
Sorry. Right number.

And, shocked and stunned, he puts down the phone.
'Everyday' starts . . . and we . . .

FADE TO BLACK.

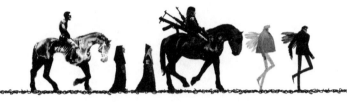

EPISODE THREE

HARD TIMES

301 EXT. THE GARDEN OF EDEN – DAY – 4004 BC

TITLE CARD: **THE GARDEN OF EDEN, 4004 BC**

A few minutes after the end of the Eden scene in Episode One. Aziraphale is locking up the gate to the Garden of Eden: we see the garden, still sunny, and then the gates swing closed, and we are out in the rain of an African plain.

Aziraphale pats his hands together in a 'job well done' gesture. Then a BLINDING LIGHT shines down on him. A rumble of thunder.

GOD (V.O.)
Aziraphale. Angel of the Eastern Gate.

AZIRAPHALE
Yes, Lord. Hello, Lord.

GOD (V.O.)
Where is the flaming sword I gave you, Aziraphale, to guard the Gate of Eden?

AZIRAPHALE
Sword? Right. Big sharp cutty thing. Yes. Must have put it down somewhere. Forget my own head next.

He looks around guiltily as he waits for a reply. But the light fades.

AZIRAPHALE (CONT'D)
 Oh dear.

302 EXT. THE ARK – DAY – 3004 BC

TITLE CARD: **MESOPOTAMIA, 3004 BC**

*It's classical Noah's Ark. Thunder rumbles but the rain
hasn't yet begun. Animals head past, two by two. . . SHEM,
HAM and JAPHETH are herding animals along, shouting at
them. This could be shot in a way that implies that we have
the budget to show it all if we wanted to, we just don't want
to. Mostly it's animal noises.*

*A CROWD has gathered to watch the animals go past.
MOTHERS with BABIES, some KIDS who laugh and
point.*

*Aziraphale, dressed as a local, but in white, is watching,
from the sidelines, looking, well, awkward and shifty. As if
he doesn't want to be there. Crowley, dressed similarly but in
black, sidles up next to him.*

CROWLEY
 Hello, Aziraphale.

AZIRAPHALE
 Crawley.

CROWLEY
 So. Giving the mortals the flaming sword. How did
 that work out for you?

AZIRAPHALE
 The Almighty has never actually mentioned it again.

CROWLEY
 Probably a good thing. What's all this about? Build a
 big boat and fill it with a travelling zoo?

It's been bothering Aziraphale. And he shouldn't tell, but . . .

AZIRAPHALE

I probably shouldn't be telling you. What with you
being a demon and all that. But . . . from what I hear,
God's a bit tetchy. Wiping out the human race. Big
storm.

CROWLEY

All of them?

AZIRAPHALE

Just the locals. I don't believe the Almighty's upset
with the Chinese. Or the Native Americans. Or the
Australians.

CROWLEY

Yet.

AZIRAPHALE

And God's not actually going to wipe out ALL the
locals. I mean, there's Noah up there, his family, his
sons, their wives, they'll all be fine.

CROWLEY

But they're drowning everybody else?

*Aziraphale nods. Children laugh at a couple of large animals
coming past.*

CROWLEY (CONT'D)

Not the kids? You can't kill kids.

Aziraphale nods again.

CROWLEY (CONT'D)

That's more the kind of thing that you'd expect my lot
to do.

AZIRAPHALE

I didn't get any say. But God's promised this will be the
last time. Oh, and when it's done, the Almighty's going
to put up a new thing called a rainbow, as a promise
not to drown everyone again.

CROWLEY

How kind.

AZIRAPHALE

You can't judge the Almighty, Crawley. God's plans are
. . .

CROWLEY

Are you going to say 'ineffable'?

AZIRAPHALE

Possibly.

*Crowley and Aziraphale watch the animals going past. A
boom of distant thunder. The first raindrops begin to fall.*

CROWLEY

(calls out)
Oy! Shem! That unicorn's going to make a run for it if
. . . oh, too late. Well, you've still got one of them.

303 EXT. GOLGOTHA – DAY – 33 AD

TITLE CARD: **GOLGOTHA, 33 AD**

*JESUS is being nailed to the cross by a CENTURION.
Aziraphale, in a white robe, is part of a small crowd
watching from below, and he's wincing at each hammer
blow . . .*

JESUS

(muttering through the pain)
Father, please . . . you have to forgive them . . . they
don't know what they are doing . . .

Crowley, in black, comes up next to Aziraphale.

CROWLEY

You've come to smirk at the poor bugger, have you?

AZIRAPHALE

Smirk? Me?

CROWLEY

Well, your lot put him on there.

AZIRAPHALE

I am not consulted on policy decisions, Crawley.

CROWLEY

I've changed it.

AZIRAPHALE

Changed what?

CROWLEY

My name. Crawley just wasn't doing it for me. A bit too squirming at your feet-ish.

AZIRAPHALE

Well, you *were* a snake. So what is it now? Mephistopheles? Asmodeus?

CROWLEY

Crawley.

More hammer blows. They wince.

AZIRAPHALE

Did you . . . ever meet him?

CROWLEY

Yes. Seemed a very bright young man. I showed him all the kingdoms of the world.

AZIRAPHALE

Why?

CROWLEY

This is first-century Palestine. Travel opportunities are limited.
 (he winces)
Ow. That's got to hurt. What was it he said that got everyone so upset again?

AZIRAPHALE
Be kind to each other.

CROWLEY
Yeah. That'll do it.

304 EXT. ANCIENT ROME – DAY – 41 AD

TITLE CARD: **ROME, 8 YEARS LATER**

Crowley, in a black toga, with sunglasses, sits down at a counter. A BARTENDER, female and black, with attitude.

CROWLEY
What have you got?

BARTENDER
It's all written up there. Two sesterces an amphora for everything except the Greek retsina.

CROWLEY
I'll have a jug of whatever you think is drinkable.

BARTENDER
Jug of house brown. Two sesterces.

Aziraphale, in a white toga, notices Crowley . . .

AZIRAPHALE
Crawley? Crowley? Fancy running into you here!

Aziraphale sits next to him.

AZIRAPHALE (CONT'D)
Still a demon, then?

CROWLEY
What kind of a stupid question is that? 'Still a demon?' What else am I going to be? An aardvark?

AZIRAPHALE
Just trying to make conversation.

CROWLEY

Well, don't.

They sit for a moment. Then Crowley sighs and:

CROWLEY (CONT'D)

Cup of wine? It's the house wine – dark.
(to bartender)
A cup for my acquaintance here.

She gives him an empty cup. Crowley pours wine from the jug into the cup, passes it to Aziraphale.

AZIRAPHALE

Salutaria! In Rome long?

CROWLEY

Just nipped in for a quick temptation.

AZIRAPHALE

Tempting anyone special?

CROWLEY

Emperor Caligula. Frankly, he doesn't actually need any tempting to be appalling. Going to report it back to head office as a flaming success. You?

AZIRAPHALE

They want me to influence a boy called Nero. I thought I'd get him interested in music. Improve him.

CROWLEY

Couldn't hurt. So, what else are you up to while you're in Rome?

AZIRAPHALE

I thought I'd go to Petronius's new restaurant. I hear he does remarkable things to oysters.

CROWLEY

I've never eaten an oyster.

AZIRAPHALE

Let me tempt you to . . . Oops. That's your job, isn't it?

305 EXT. ARTHURIAN BRITAIN – DAY – 537 AD

TITLE CARD: **THE KINGDOM OF WESSEX, 537 AD**

The fog is thick. Aziraphale is wearing armour, and walking up a hill, leading a white horse.

AZIRAPHALE

Hello? I, Sir Aziraphale of the Table Round, am here to speak to the Black Knight.

A small, shuffling figure dressed in rags appears and leads Aziraphale forward silently.

AZIRAPHALE (CONT'D)

Oh. Right. Hello. I was hoping to meet the Black Knight.

A knight in jet black armour steps out of the mist.

BLACK KNIGHT

You have sought the Black Knight, foolish one. But you have found your death.

There's a beat. Then:

AZIRAPHALE

Is that you under there, Crawley?

The black knight removes his helm.

CROWLEY

*Crow*ley.

AZIRAPHALE

What on earth are you playing at?

It's hard to see in the mist, but there are other figures present.

CROWLEY

(to the others)
It's all right, lads. I know him. He's all right.

(to Aziraphale)
I'm here spreading foment.

AZIRAPHALE

Is that a kind of porridge?

CROWLEY

No! I'm, you know, fomenting dissent and discord.
King Arthur's spread a bit too much peace and
tranquillity in the land. So I'm here, you know . . .
Fomenting.

AZIRAPHALE

I'm, er, meant to be fomenting peace.

CROWLEY

So, we're both working very hard in damp places and
just cancelling each other out?

AZIRAPHALE

You could put it like that. It is a bit damp.

Crowley has an idea. A life-changing idea . . .

CROWLEY

Be easier if we'd both stayed home, and just sent
messages back to our head offices saying we had done
everything they asked for, wouldn't it?

AZIRAPHALE

(shocked)
That would be lying!

CROWLEY

Possibly. But the end result would be the same. We
cancel each other out.

AZIRAPHALE

But my dear fellow . . . they'd check! Michael is a bit
of a stickler. And you do not want to get Gabriel upset
with you.

CROWLEY

My lot have more to do than verify compliance reports from Earth. As long as they get the paperwork, they seem happy enough. I mean, as long as you're being seen to be doing *something* now and again . . .

AZIRAPHALE

No! Absolutely not! I am shocked that you would even imply such a thing. We are not even having this conversation. Not another word.

CROWLEY
(*disappointed*)
Right.

AZIRAPHALE
Right.

306 INT. THE GLOBE THEATRE – NIGHT – 1601

TITLE CARD: **THE GLOBE THEATRE, LONDON, 1601**

A play is being performed at The Globe. The audience consists of a very depressed playwright, SHAKESPEARE, and Aziraphale. Perhaps THREE or FOUR PEOPLE are also in the audience, dozing or leaning or paying no attention. Also an OYSTER WOMAN with an ice-cream-vendor style tray of oranges, kippers, oysters and grapes. Aziraphale is buying grapes.

OYSTER WOMAN
Kippers! Grapes! Oysters! Oranges!

AZIRAPHALE
Some grapes, please. They do look scrummy.

Crowley comes in and sees Aziraphale. Edges his way over to him. On the stage HAMLET looks at the absent audience, in a disappointed way . . . and he stands and stares at them.

CROWLEY

I thought you said we'd be inconspicuous here. Blend into the crowds.

AZIRAPHALE

Well, that was the idea. Grape?

CROWLEY

Ah, hang on. It's not one of Shakespeare's gloomy ones, is it? No wonder nobody's here.

AZIRAPHALE

Shh. It's him.

Aziraphale shushes him, as Shakespeare is approaching.

SHAKESPEARE

Prithee, gentles. Might I request a small favour? Could you, in your role as the audience, give us more to work with?

AZIRAPHALE

You mean, like when the ghost of his father came on, and I shouted 'He's behind you!'

SHAKESPEARE

Just so! That was jolly helpful. Made everyone on the stage feel appreciated. A bit more of that.
 (to Hamlet)
Good Master Burbage, please. Speak the lines trippingly.

HAMLET

I'm wasting my time up here.

AZIRAPHALE

No, you're very good. I love all the, the talking.

HAMLET

And what does your friend think?

AZIRAPHALE

He's not my friend. We've never met before. We don't know each other.

CROWLEY
I think you should get on with the play.

SHAKESPEARE
Yes, Burbage. Please.

Hamlet hesitates, then . . .

HAMLET
To be – or not to be – that is the question . . .

Aziraphale takes it like a panto question . . .

AZIRAPHALE
To be! I mean, *Not to be!* Come on, Hamlet! Buck up!

Hamlet gives Aziraphale a grateful thumbs up, then continues the soliloquy. Shakespeare mouths along, like a proud parent.

AZIRAPHALE (CONT'D)
He's very good, isn't he?

CROWLEY
Age does not wither nor custom stale his infinite variety.

SHAKESPEARE
Oh, I like that.

And he pulls out a scrap of paper to write it down.

AZIRAPHALE
What do you want?

The soliloquy continues on the stage.

CROWLEY
Why ever would you insinuate that I might possibly
want something?

AZIRAPHALE
You are up to no good.

CROWLEY
Obviously. And you are up to good, I take it? Lots of
good deeds?

AZIRAPHALE

No rest for the, well, good. I have to be in Edinburgh
at the end of the week. A couple of blessings to do, and
a minor miracle to perform. Apparently, I have to ride
a horse to get there.

CROWLEY

Hard on the buttocks, horses. Major design flaw, if you
ask me. I'm always expected to ride those big black
jobs. With flashing eyes. Oddly enough, *I'm* meant to
be heading to Edinburgh too this week. Tempting a
clan leader to steal some cattle.

AZIRAPHALE

Doesn't sound like hard work.

CROWLEY

That was why I thought we should . . . well, bit of a
waste of effort. Both of us going all the way to Scotland.

AZIRAPHALE

You cannot actually be suggesting what I infer you are
implying.

CROWLEY

Which is?

AZIRAPHALE

That just one of us goes to Edinburgh and does . . .
both. The blessing and the tempting.

CROWLEY

We've done it before. Dozens of times now. The
arrangement.

AZIRAPHALE

Don't say that.

CROWLEY

Our respective head offices don't actually care how
things get done. They just want to know they can cross
it off the list.

AZIRAPHALE

If Hell found out, they wouldn't just be angry. They'd destroy you.

CROWLEY

Nobody ever has to know. Toss you for Edinburgh.

Aziraphale hesitates. For a moment his noble better nature rejects the idea out of hand. Then, he falls . . .

AZIRAPHALE

Fine. Heads.

An Elizabethan coin goes up, lands on the back of Crowley's hand.

CROWLEY

Tails, I'm afraid. You're going to Scotland.

In front of them, Shakespeare is talking to the oyster seller . . .

SHAKESPEARE

It's been like this every performance, Juliet. A complete dud. It'd take a miracle to get people to come and see *Hamlet.*

Crowley looks at Aziraphale.

CROWLEY

Yeah. All right. I'll do that one. My treat.

AZIRAPHALE

Oh, really?

CROWLEY

I still prefer the funny ones.

307 INT. DUNGEON – REVOLUTIONARY FRANCE – DAY – 1793

TITLE CARD: **PARIS, 1793**

A dank and unpleasant dungeon. From up high, light through a tiny, barred window.

Through the window we can see the top of a high guillotine . . . And the blade comes down . . .

We hear a CRASH, as of a guillotine blade landing, a head hitting a basket, and a French cheer from a crowd.

This makes Aziraphale, dressed as an upper-class English aristocrat, and chained to a wall, look distinctly uncomfortable.

We hear the guillotine blade being winched up, and the blade appears again in the window.

The door is thrown open. Two large GUARDS show a small EXECUTIONER in. The guards leave.

EXECUTIONER JEAN-CLAUDE
> *(in French)*
> Ah, the music of the blade, and the joy of the people. Beautiful, no? Now, let us inspect your neck.

The executioner starts checking out Aziraphale's neck, estimating the size as if fitting him for a collar.

AZIRAPHALE
> Um. Monsieur, *c'est une grande* mistake, um, *erreur.* Bit out of practice at French. *Je pense que quelquechose—*

EXECUTIONER JEAN-CLAUDE
> I speak English.

Another guillotine FALL and CRASH and THUMP . . .

EXECUTIONER JEAN-CLAUDE (CONT'D)
> Listen to that, the fall of the guillotine blade, is it not terrible?

AZIRAPHALE
> Yes. Cutting off that poor woman's head. Terrible.

EXECUTIONER JEAN-CLAUDE
> That is Pierre. An amateur. Always he lets go of the rope too soon. You are lucky that it is I, Jean-Claude,

who will remove your traitorous head from your
shoulders.

AZIRAPHALE

Look, this is all a terrible mistake. I don't think you
understand . . .

EXECUTIONER JEAN-CLAUDE

English aristo spy. You have perhaps half an hour to live,
until you receive the kiss on the neck from your new
lover, Madame Guillotine! But I have good news for
you: you are the nine hundred and ninety-ninth aristo to
die at the guillotine by my hand. But the first English.

*He starts loosening Aziraphale's collar to make sure the neck
is nice and available.*

*We hear the guillotine blade being winched up, and the blade
appears again in the window.*

Aziraphale pulls away.

AZIRAPHALE

Please, no, dreadful mistake discorporating me,
there's paperwork to fill out when I get back, it'll be a
complete nightmare . . .

Anticipatory cheers from the crowd.

*Aziraphale looks out of the window. We see and hear the
guillotine blade begin to fall once more, and Aziraphale
winces. And then the blade FREEZES . . .*

AZIRAPHALE (CONT'D)
Animals!

CROWLEY

Animals don't kill each other with clever machines,
angel. Only humans do that.

AZIRAPHALE
Crowley? Oh good Lord . . .

TIME HAS STOPPED: the executioner is FROZEN in place. Crowley, dressed as a French peasant, albeit a stylish one, is standing immediately behind him.

CROWLEY

>What the deuce are you doing locked up in the Bastille? I thought you were opening a bookshop.

AZIRAPHALE

>I was. I got peckish.

CROWLEY

>Peckish?

AZIRAPHALE

>If you must know, it was the crêpes. You can't get decent ones anywhere but Paris. And brioche . . .

CROWLEY

>So you just popped across the Channel during a revolution, because you wanted something to nibble? Dressed like that?

AZIRAPHALE

>I have standards. I had heard that they were getting a bit carried away here but . . .

CROWLEY

>This is not getting 'carried away'. This is cutting off lots of people's heads very efficiently with a big head-cutting machine. Why didn't you just perform another miracle and go home?

AZIRAPHALE

>I was reprimanded last month. They said I'd performed too many frivolous miracles. I got a strongly-worded note from Gabriel.

CROWLEY

>You were lucky I was in the area.

AZIRAPHALE

I suppose I am. Why are you here?

CROWLEY

My lot sent me a commendation for outstanding job performance. So I thought I should find out what they were commending me for.

AZIRAPHALE

So all this is your demonic work? I should have known!

CROWLEY

Nah. Humans thought it all up themselves. Nothing to do with me. Right.

The chains fall away.

AZIRAPHALE

I suppose I should say thank you. For the, er, rescue.

CROWLEY

Don't say that. If my people hear I rescued an angel, I'll be the one in trouble. And my lot don't send rude notes. They send Hastur. Or Ligur. If you're lucky.

AZIRAPHALE

Well, anyway, I'm very grateful. What about if I buy you lunch?

CROWLEY

Looking like that?

Aziraphale sighs, then flicks his fingers. Now he is dressed like the executioner, who is in Aziraphale's clothes.

AZIRAPHALE

Barely counts as a miracle, really.

TIME STARTS. The frozen guillotine blade CRASHES DOWN, a head-fall and a cheer.

The two guards re-enter, and drag the astonished executioner out to (I imagine) his death. Crowley shakes his head.

CROWLEY

Dressed like that, he's asking for trouble. So what's for lunch?

AZIRAPHALE

What would you say to some crêpes?

308 EXT. ST JAMES'S PARK – DAY – 1862

TITLE CARD: ST JAMES'S PARK, LONDON, 1862

Similar to the previous scene in St James's Park, but a hundred and fifty years earlier. Now we get Crowley in a tall black hat and huge black coat, tossing bread to the ducks. Aziraphale steps out beside him, looking like a character from Dickens, and tosses some breadcrumbs.

CROWLEY

Look, I've been thinking. What if it all goes wrong? We've got a lot in common, you and me . . .

AZIRAPHALE

We may both have started out as angels, but YOU are fallen.

CROWLEY

I didn't really fall. I just, you know, sauntered vaguely downwards. I need a favour.

AZIRAPHALE

We already have the agreement, Crowley. We stay out of each other's way. Lend a hand when needed . . .

CROWLEY

This is something else. For if it all goes pear-shaped.

AZIRAPHALE

I like pears.

CROWLEY

If it all goes wrong. I want insurance.

AZIRAPHALE

... What?

CROWLEY

I wrote it down. Walls have ears. Not walls. But trees
have ears. Ducks have ears. Do ducks have ears? Must
do. That's how they hear other ducks.

*He hands a slip of paper to Aziraphale. Aziraphale opens it,
looks down, then ...*

AZIRAPHALE

Out of the question.

CROWLEY

Why not?

AZIRAPHALE

It would destroy you. I'm not bringing you a suicide
pill, Crowley.

CROWLEY

That's not what I want it for. Just ... insurance ...

The paper says, in Crowley's handwriting, HOLY WATER.

AZIRAPHALE

I'm not an idiot, Crowley. Do you know what trouble
I'd get into if they knew I'd been fraternising? It's
completely out of the question.

CROWLEY

Fraternising?

AZIRAPHALE

Whatever you wish to call it. I do not think there is any
point in discussing it further.

CROWLEY

I have lots of other people to fraternise with, angel.

AZIRAPHALE

Of course you do.

CROWLEY
I don't need you.

AZIRAPHALE
The feeling is mutual. Obviously.

CROWLEY
Obviously.

Aziraphale flicks the paper into the pond. It bursts into flame as it hits the water.

309 EXT. A CHURCH – NIGHT – 1941

The church, an imposing Hawksmoor-type London church, has its windows blacked out.

Aziraphale, dressed 1941-style, hurries up the steps to the church, carrying a package. We hear an air raid siren start in the background.

310 INT. A CHURCH – NIGHT – 1941

TITLE CARD: **LONDON, 1941**

A church. Two men are waiting at a small card table set up at the end of the aisle, before we get up to the altar. We are in the final act of a spy drama, and we know these people already: GLOZIER, the pudgy fat-man-type, and HARMONY, the Peter Lorre-ish sidekick. Both very well dressed, both Nazi spies who speak English without an accent, but in the manner of people who learned it formally. Aziraphale comes down the aisle.

AZIRAPHALE
Mr Glozier? Mr Harmony?

GLOZIER
Mr Fell. You are late, but not to worry.

HARMONY

You have the books for the Führer?

AZIRAPHALE

I do, yes.

He puts the package down. Mr Harmony opens them, examines each book and puts it in front of Mr Glozier. As he does so, Aziraphale names the books . . .

AZIRAPHALE (CONT'D)

Books of Prophecy. Otwell Binns, Robert Nixon, Mother Shipton. First editions. As requested.

HARMONY

What about the other book we told you to bring us? The Führer was most definite that he needed it. It has the prophecies that are true. With the true prophecies book, the war is as good as won.

AZIRAPHALE

The Nice and Accurate Prophecies of Agnes Nutter, Witch. No luck. I'm afraid that's the Holy Grail of prophetic books.

GLOZIER

The Führer also wants the Holy Grail. And the Spear of Destiny. If you run across them.

HARMONY

Why are there no copies of Agnes Nutter's book? We have made it clear that money is no object. You will be a very rich man.

AZIRAPHALE

The unsold copies of *Nice and Accurate Prophecies* were destroyed by the publisher, which is, um, all of them. It never sold a single copy. But I found the publisher's catalogue for 1655, and it did list one of Agnes Nutter's prophecies.

HARMONY
What was it?

AZIRAPHALE
Her prophecy for 1972. 'Do not buy Betamacks.'

GLOZIER
Who is Peter Max?

AZIRAPHALE
I have no idea.

HARMONY
I will pass it on to the Führer.

GLOZIER
These volumes of prophecy will be in Berlin by the end of the week. The Führer will be most grateful.

HARMONY
You have been most helpful, Mr Fell. Here is your money. Count it. It is all there.

He pushes a paper bag across the table.

AZIRAPHALE
Jolly good.

But before Aziraphale can look in the bag, Glozier pulls a gun on him.

GLOZIER
Such a pity you must be eliminated, Mr Fell. But take heart. Just another death in the Blitz.

AZIRAPHALE
That's not very sporting.

GLOZIER
You do not appear worried, my friend.

The TIP TAP TIP TAP of high heeled shoes down the aisle. They all look up. A BEAUTIFUL WOMAN in 1940s clothes, holding a gun, is walking towards them.

WOMAN SPY
　　He's not worried.

HARMONY
　　Who is she?

Aziraphale is very proud of himself.

AZIRAPHALE
　　She, my double-dealing Nazi acquaintance, is the reason
　　why none of these books are ever going to Berlin, and
　　why your nasty little spy ring will be spending the rest
　　of the war behind bars. Let me introduce you to Captain
　　Rose Montgomery of British Military Intelligence.

ROSE
　　　(very English)
　　Thank you for the introduction.

AZIRAPHALE
　　Our side know all about you two. She recruited me
　　to 'work' for you. Now, she's going to tell you that
　　this building is surrounded by British agents, and
　　that you two have been – what's that lovely American
　　expression? Played for suckers.

ROSE
　　Yes, about that . . .

AZIRAPHALE
　　Right everyone! Come on! Round them up! Rose,
　　where exactly are your people?

HARMONY
　　We are all here.

GLOZIER
　　Allow *me* to introduce Fräulein Greta Kleinschmidt.
　　She works with us.
　　　(in German, to Greta)
　　You fooled the shithead bookseller. Good job, darling.

ROSE/GRETA
>*(in German)*
>It wasn't hard, darling. He's very gullible.

Harmony is putting the books into a large leather bag.

HARMONY
>*Played for a sucker.* I must remember that. *I am played for a sucker, you are played for a sucker, he, she or it will be played for a sucker . . .*

GLOZIER
>Where were we? Oh yes. Killing you.

AZIRAPHALE
>You can't kill me! There will be paperwork!

Greta raises her gun, points it dispassionately at Aziraphale. And then we HEAR CROWLEY'S VOICE. He's going, 'Ow!'

CROWLEY
>Ow! Ow! Ow! Ow-ow-ow! Ow!

They all turn around. Crowley is walking down the aisle towards them, walking amazingly gingerly. He has nice snakeskin shoes, but is still walking like a man in bare feet on very hot sand.

CROWLEY (CONT'D)
>Sorry! Ow! Consecrated ground! It's like being at the beach in bare feet.

AZIRAPHALE
>What are you doing here?

CROWLEY
>Stopping you getting into trouble. Ow!

AZIRAPHALE
>I should have known. Of course. These people are working for you.

CROWLEY

No! They're a bunch of half-witted Nazi spies running about London, blackmailing and murdering people. I just didn't want to see you embarrassed. Ow! Ow!

Crowley has now reached them, but he's doing a sort of a dance, standing in place.

GLOZIER

The mysterious Anthony J. Crowley. Your fame precedes you.

Aziraphale is softening. They haven't spoken in a hundred years: he's realising they are still friends.

AZIRAPHALE

Anthony?

CROWLEY

You don't like it?

AZIRAPHALE

No. I didn't say that. I'll get used to it.

GRETA/ROSE

The famous Mr Crowley? Such a pity you must both die.

AZIRAPHALE

What does the J stand for?

CROWLEY

It's just a J, really. Look at that. A whole font-full of holy water. It doesn't even have guards.

GLOZIER

Enough babbling! Kill them both.

CROWLEY

In about a minute a German bomber will release a bomb that will land right here. If you all run away very VERY fast, you might not die. You won't enjoy dying, and you definitely won't enjoy what comes after.

GLOZIER

You expect us to believe that? The bombs tonight will
fall on the East End.

CROWLEY

(hinting hard)

It would take a last-minute demonic intervention to
throw them off course, yes. You are wasting all your
valuable running-away time. But if, in thirty seconds,
a bomb does land here, it would take a real miracle for
my friend and I to survive it.

AZIRAPHALE

A real miracle?

CROWLEY

Yes.

HARMONY

Kill them! They are very irritating.

Greta raises her gun and is about to shoot Aziraphale when –
BOOM – HUGE EXPLOSION. FIRE AND LIGHT AND
THINGS BEING BLOWN AROUND. SO COOL AN
EXPLOSION THAT I AM TYPING IN CAPITALS.

They look up and the screen goes black.

311 EXT. THE RUBBLE – NIGHT – 1941

Smoke and dust blow away, to reveal . . . we're outside,
because the walls of the church have gone. There is dust in
the air. Crowley polishes his dark glasses with a handkerchief
and puts them back on.

AZIRAPHALE

That was very kind of you.

CROWLEY

Shut up.

AZIRAPHALE

Well, it was. No paperwork, for a start. The books! I forgot all the books! They'll have been be blown to . . .

Crowley reaches down, removes the leather bag from Harmony's dead hand, sticking out from the rubble. Hands it to Aziraphale.

CROWLEY

Little demonic miracle of my own. Lift home?

312 EXT. A PUB SIGN – NIGHT – 1967

TITLE CARD: **SOHO, LONDON, 1967**

A swinging pub sign for THE DIRTY DONKEY pub. It's 1967.

313 INT. PUB BACKROOM – NIGHT – 1967

Sixties music is playing. We open the door to the pub's backroom, to reveal a 1960s criminal gang: SALLY, the acrobat, has a beehive and white lipstick. DANGEROUS SPIKE is black, wearing very fancy clothes. Crowley is a sixties version of Crowley.

CROWLEY

So Spike, you're the muscle, and you'll be hauling the ropes.

SPIKE

And she'll be going down on the ropes then?

CROWLEY

Hang on. Who are you? Close that door.

YOUNG SHADWELL closes the door behind him.

YOUNG SHADWELL

I understand you need a locksman.

CROWLEY

I was expecting Mr Narker.

Young Shadwell will grow up to be Shadwell. He's now in his early twenties, and fresh out of prison.

YOUNG SHADWELL

Mr Narker's passed on to his reward. I've taken over the business. He was my cellmate. He taught me everything he knew. My name's Shadwell.

CROWLEY

Please, sit down, Mr Shadwell.

YOUNG SHADWELL

Lance Corporal Shadwell. If you don't mind.

SALLY

So what's so valuable that they're going to leave it in a church at night?

CROWLEY

We'll go over the exact details of what you're obtaining for me when we get there. You will all be very well compensated.

Young Shadwell puts up his hand.

CROWLEY (CONT'D)

Lance Corporal Shadwell? You have a question?

YOUNG SHADWELL

Stealing from a church. There's nae . . . Witchcraft involved here, is there?

CROWLEY

Nope. Completely witch-free robbery.

YOUNG SHADWELL

Pity.

CROWLEY

Any more questions?

YOUNG SHADWELL

You are not yourself a witch, a warlock or someone who calls your cat funny names?

CROWLEY

Not a witch. No pets. Anyone else?

SALLY

What are we getting paid?

CROWLEY

A hundred pounds now, and another hundred when the job is done. A hundred more to keep schtum.

SPIKE

Good money.

314 EXT. SOHO – NIGHT – 1967

Crowley is walking towards his Bentley. Young Shadwell is lurking in an alley, smoking a roll-up. Before Crowley reaches the car, Shadwell steps out of the shadows to intercept him.

YOUNG SHADWELL

Mr Crowley? May I have a moment of your time?

CROWLEY

Yes, Lance Corporal Shadwell. What are you a Lance Corporal in? You don't look like an army man.

YOUNG SHADWELL

That is precisely the matter upon which I planned to talk to you. You might remember that earlier this evening I asked a pointed question about witchcraft?

CROWLEY

Yes.

YOUNG SHADWELL

I am a proud member of an enormous organisation. Vast. A secret army that battles the forces of witchery. I was inducted into it.

CROWLEY
How nice for you.

YOUNG SHADWELL
The Witchfinder Army. Perhaps you've heard of it.

CROWLEY
I thought you said it was secret.

YOUNG SHADWELL
Ye never know when a gentleman such as yourself might have need of such an organisation. A man with hundreds of pounds to throw around. If you need us, the Witchfinder Army are here for you.

CROWLEY
A whole army?

YOUNG SHADWELL
We can be your eyes and ears. Think it over. You know where to find me.

He sidles off.

315 INT. CROWLEY'S BENTLEY – NIGHT – 1967

Crowley gets into the car. Then he does a double take. Aziraphale is sitting in the passenger seat.

CROWLEY
What are you doing here?

AZIRAPHALE
Needed a word with you.

CROWLEY
What?

AZIRAPHALE
I work in Soho, I hear things. I hear you are setting up a caper to rob a church. Crowley, it's too dangerous. Holy water wouldn't just kill your body. It would

destroy you completely.

CROWLEY

You've already told me what you think. A hundred and five years ago.

AZIRAPHALE

And I haven't changed my mind. But I won't have you risking your life. Not even for something dangerous. So you can call off the robbery.

He produces a nice old-fashioned tartan Thermos flask.

AZIRAPHALE (CONT'D)

Don't go unscrewing the top.

CROWLEY

It's the real thing?

AZIRAPHALE

The holiest.

CROWLEY

After everything you said?

Aziraphale nods.

CROWLEY (CONT'D)

Should I say thank you?

AZIRAPHALE

Better not.

CROWLEY

Can I drop you anywhere?

Aziraphale opens the door to the car.

AZIRAPHALE

No, thank you. Oh, don't look so disappointed. Perhaps one day we could . . . I don't know . . . Have a picnic. Or dine at the Ritz.

CROWLEY
I'll give you a lift. Anywhere you want to go.

AZIRAPHALE
You go too fast for me, Crowley.

Crowley holds up the Thermos, and he shivers. Then he puts it down on the seat.

316 EXT. SOHO – NIGHT – 1967

The Bentley drives away. Aziraphale stands looking at it go.

A neon sign is flashing on and off in a shop window, and from where we are looking, it could almost be a halo above his head, blinking on and blinking off again . . .

We hear a very 1960s-style cover of Buddy Holly's 'Everyday' begin, and we go into the TITLES.

TITLES SEQUENCE

317 EXT. AZIRAPHALE'S BOOKSHOP – DAY– PRESENT DAY

The present day. There is a CLOSED sign on the door.

318 INT. AZIRAPHALE'S BOOKSHOP – DAY

Through the bookshop into the back room. Aziraphale has been making charts which he's hung up on the wall.

On one of them we can see he's written TADFIELD. Beneath that, ADAM YOUNG. There are other notes: AIRFIELD and FOUR HORSEMEN and such, and arrows going around. Also mathematical notations. And now we spot a medal he was given, around the neck of a dusty Victorian bust.

Aziraphale is looking at the chart. He looks uncomfortable.

AZIRAPHALE

> Come on. Buck up. Worse things happen at sea. Right, you'll just go to head office, and explain it all.

TITLE CARD: **FRIDAY, ONE DAY TO THE END OF THE WORLD**

Aziraphale is psyching himself up to talk to Gabriel.

AZIRAPHALE (CONT'D)

> So. Gabriel. Ah, listen. Gabriel. Most holy Archangel Gabriel. Too formal. Hello, Gabriel, me old mate. There is a, a child, we have to deal with. And make everything okay again.

He takes a deep breath, and pretends he's talking to head office.

AZIRAPHALE (CONT'D)

> Hello, Gabriel. Just thought you ought to know, that due to an unfortunate mix-up in a hospital, the Antichrist has been mislaid. But it's all right because I've found him. He is living in the English village of Tadfield. And his eleventh birthday was the start of the end of things. Um, I have his address here, so if we eliminate him now, then everything could still be okay. He'll have an enormous hell-hound with him. He won't be hard to spot . . .

319 EXT. TADFIELD LANE – DAY

Adam is wandering the road to Tadfield, with Dog at his heels.

We HOLD on DOG.

GOD (V.O.)

> This wasn't, insofar as the hell-hound had any expectations, what he had imagined life would be like in the last days before Armageddon.

Home-movie style, an ENORMOUS, GRUMPY ORANGE CAT saunters in front of Dog.

GOD (V.O.)

 Form shapes nature. There are certain ways of
 behaviour appropriate to small dogs which are in fact
 welded into the genes.

Dog freezes. Eyes glow deep red.

GOD (V.O.)

 He'd surprised the huge ginger cat from next door and
 had attempted to reduce it to cowering jelly by means
 of the usual glowing stare and deep-throated growl. It
 had always worked in the past.

*The orange cat swipes angrily at Dog, raking claws across his
nose. He WHIMPERS. The cat saunters away.*

GOD (V.O.)

 Dog was looking forward to a further cat experiment,
 which would consist of jumping around and yapping
 excitedly at it.

*Back to the here and now. Dog has started growling. It's an
angry, deep growl for a small dog . . .*

ADAM

 What? What is it?

320 EXT. JASMINE COTTAGE LANE – DAY

*He stops. And he can hear something. It sounds like
someone tearfully angry . . . And he sees this is JASMINE
COTTAGE.*

ADAM

 Jasmine Cottage! Come on, Dog.

321 EXT. JASMINE COTTAGE – DAY

*Anathema is sitting in the garden, furious with herself. She's
breaking a flowerpot.*

ANATHEMA
So stupid. 350 years.

ADAM
Psst!

She looks up, puzzled to see Adam's face upside down: he's hanging from a tree, looking at her.

ADAM (CONT'D)
Did the witch catch you? Can I help you escape?

Anathema smiles, despite herself. She shakes her head.

ADAM (CONT'D)
But you were crying.

ANATHEMA
I know . . . Hello. You're the kid from Hogback Wood, aren't you? I'm okay. This sounds so dumb. I . . . lost a book. And it all got a bit much.

ADAM
I can help you look for it.

ANATHEMA
That's sweet of you. It's been in my family for a long time.

Adam clambers down from the tree.

ADAM
I wrote a book once. It was about this pirate who was a famous detective. I bet it was a lot more exciting than any book you've lost. Specially the bit in the spaceship where the dinosaur comes out and fights with the cowboys. I bet it'd cheer you up, my book. I'm Adam. I live in Hogback Lane.

ANATHEMA
Thank you, Adam. I'm Anathema.
 (shakes her head)
Are you from here?

ADAM

Yup. This is my world. From Hogback Wood to the
Dip and from the Old Quarry up to the pond.

ANATHEMA

You haven't seen two men in a big black vintage car?

ADAM

Did they steal it? Professional book thieves, probably
they go around in their car stealing books . . .

ANATHEMA

They didn't mean to steal it. They were looking for
the Manor, but I went up there and no one knows
anything about them.
 (remembering her manners)
Do you want some lemonade?

ADAM

Are we going to have to break into the cottage and
battle the witch for it?

ANATHEMA

It's my cottage. I'm renting it.

Adam looks her up and down. The penny drops . . .

ADAM

Look, 'scuse me for askin', if it's not a personal
question, but . . . are you a witch?

ANATHEMA

No. I'm an occultist.

ADAM

Oh. That's all right then.

They head in to get lemonade.

ANATHEMA

You're thinking, nothing wrong with my eyes, aren't
you?

HOLD on Dog. He's not following them in. He's in the garden, growling. We see what he's looking at.

It's a horseshoe, nailed above the door. It starts to glow red.

GOD (V.O.)
> There had been a horseshoe over the door of Jasmine Cottage for hundreds of years. It protected the inhabitants from evil, or so they believed.

Dog is crouched on the doorstep of Jasmine Cottage. He's growling.

ADAM
> Come on, you silly dog.
> (to Anathema)
> Normally he does everything I say, right off.

ANATHEMA
> You can leave him in the garden.

ADAM
> No, he's got to do what he's told. My father said I can only keep him if he's properly trained. Now, Dog. Go inside.

Dog whines, gives Adam a pleading look. Then, with extreme reluctance, as if making progress in the teeth of a gale, he slinks over the doorstep.

ADAM (CONT'D)
> Good boy! It wasn't that hard, was it?

Dog whimpers, then licks Adam's face. They follow Anathema into the kitchen. We pan up slowly to above the door.

GOD (V.O.)
> The hell-hound entered the cottage and a little bit more of Hell burned away.

The horseshoe over the door is now orange and smoking as it cools.

322 INT. SHADWELL'S FLAT – DAY

Newt is, bored, looking at newspapers. He creases his brow. Looks at a headline: A WHITE CHRISTMAS IN OXFORDSHIRE VILLAGE – AGAIN! *Smaller heading:* AGAINST ALL ODDS, TADFIELD HAS THREE INCHES OF SNOW. ONLY TOWN IN ENGLAND.

He cuts it out with the scissors.

The phone in the hallways starts ringing. Shadwell is nowhere to be seen.

323 INT. SHADWELL'S HALLWAY – DAY

Newt answers the phone. He listens to a voice . . .

NEWT
Um. Marks and Spencer cotton Y-fronts, if you must know.

Madame Tracy peers around her door.

NEWT (CONT'D)
I think it's for you. Oh. He hung up.

MADAME TRACY
Where's Mr Shadwell, then?

NEWT
The sergeant had to go out. Army business.

Madame Tracy looks at the press clipping he's holding.

MADAME TRACY
Wouldn't it be easier to get a computer, dear? It's all on the internet nowadays.

NEWT
I . . . you know. I'm meant to be a computer engineer. It's just, I can't make computers work.

MADAME TRACY

I just turn mine on, and it knows what to do. Oh, listen to me. I am naughty. I have clients, dear, who email me on the computer. I'm either Sexykittenboots or MysteriesRevealed.

NEWT

I once tried to build a joke circuit that was guaranteed not to do anything at all. It had diodes the wrong way round and . . .

MADAME TRACY

There's another email address, but it's a bit naughty. That's for the gentlemen who need a firm hand. What happened?

NEWT

It picked up Radio Moscow. I'm just not very good at electronics.

324 INT. THE CAFÉ – DAY

Crowley is half-hidden behind a newspaper. Shadwell sits down at the same table. He tips the contents of the sugar bowl into his tea. Crowley keeps pretending to read the paper during the conversation.

CROWLEY

Sergeant Shadwell.

SHADWELL

Mr Crowley. You're looking well.

CROWLEY

Clean living.

SHADWELL

Your father, how is he? You resemble him very much, you know . . .

CROWLEY

So they tell me. He's well.

Shadwell produces a greasy, well-thumbed accounts book.

SHADWELL

I've prepared the ledger. The men need paying, your honour. It's hard times for witchfinders in today's degenerate age.

He makes to slide it across, but Crowley makes a gesture: not necessary. Shadwell nods. The accounts vanish into Shadwell's mac.

CROWLEY

No need. Two hundred and fifty pounds. I'll drop off the money for you on Saturday.

SHADWELL

In cash, in an envelope. We don't take plastic.

CROWLEY

You astonish me.

Hold on Shadwell's accounts book.

SHADWELL

So.

CROWLEY

There's a village called Tadfield, in Oxfordshire. Send your best people down there. I'm looking for a boy. He's about eleven. I don't have anything more than that. But . . . Look for anything strange.

SHADWELL

This boy. He's a witch?

CROWLEY

Possibly. We'll have to find him first, won't we?

SHADWELL
My best operatives. That would be, Witchfinder
Lieutenant Table, and . . .

But Crowley's already on his way out.

CROWLEY
Call me if you find anything.

325 INT. JASMINE COTTAGE – DAY

*Adam and Anathema are in her kitchen. She's pouring them
both lemonade.*

ANATHEMA
All of my family have had occult powers, going all the
way back. We can find ley lines.

ADAM
Right. What's ley lines?

ANATHEMA
Invisible lines of force linking places of power.

ADAM
Amazin', there bein' all these invisible lines of force
around and me not seeing 'em.

ANATHEMA
And we can see auras.

ADAM
And they are . . . ?

ANATHEMA
A sort of coloured force field around someone.
Everyone's got one. I can look at its strength and
colour and tell you how you're feeling.

ADAM
That's brilliant. Why don't they teach us about them at
school?

ANATHEMA

 School is a repressive tool of the state.

ADAM

 Oh. So what colour's my aura then?

Anathema squints. We look at Adam in ANATHEMA VISION, but no aura manifests about him.

ANATHEMA

 I . . . Adam, I can't see your aura.

ADAM

 You said everybody's got one.

ANATHEMA

 I don't know, hon. It's an art, not a science. You're in great shape.

ADAM

 So what else don't they teach us at school?

A hasty montage, as Anathema starts to explain things to him, but we leave out all the explanations because we do not have time so we just fast forward through the conversation and cut in on significant words in her explanation. All the time she is talking, Adam is RAPT.

ANATHEMA

 Clubbing baby seals. // they are cutting down the rainforests so you can get cheap hamburgers. // don't get me started on global warming. // genetically modified food // whales have huge brains and we are hunting them for no reason// nuclear power stations . . .

And time is flowing again, as Adam interrupts her.

ADAM

 Nuclear power stations are rubbish!

ANATHEMA

 Yes! They are!

ADAM

> We went to see one on a school trip. Nothing was
> bubbling and there wasn't any green smoke and there
> weren't anyone wearing those space suits. It was so dull.

ANATHEMA

> Well, yes. But we need to get rid of them.

ADAM

> Serve them right for not bubbling.

Anathema notices the time . . .

ANATHEMA

> Adam, I have to get back to work. But if you're
> interested in any of this stuff, I've got some old
> magazines here. I mean, you don't have to read them . . .

She looks around, finds the stack of New Aquarian
*magazines. One step up from fanzines, the covers have things
like* CHARLES FORT, GENIUS OF THE UNEXPLAINED
and THE MYSTERIES OF THE TIBETAN SECRET
MASTERS *and* WHERE IS LOST ATLANTIS? *on them.*

ADAM

> Wicked!

326 EXT. JASMINE COTTAGE LANE – DAY

*Adam is walking home, with his stack of ancient magazines,
and his dog following happily at his heels.*

GOD (V.O.)

> It might have helped Anathema to understand what
> was going on, if she understood the very simple reason
> why she couldn't see Adam's aura.

*And now we FREEZE on Adam, then rapidly PULL BACK
from him. PULL BACK from the lane to the world from
above, the town, the county, England . . .*

GOD (V.O.)
 It's for the same reason that people in Times Square
 can't see America.

*And now we have pulled back far enough to see the curvature
of the Earth. And there's a pulsing, multicoloured light around
Oxfordshire that centres on Adam.*

327 EXT. ANGELIC SKYSCRAPER – EARLY EVENING

The sun is setting, glinting off the skyscraper.

328 INT. ANGELIC SKYSCRAPER – EARLY EVENING

*The room of angels in slick suits. There are four of them, male
and female, and of all skin shades, but they are all upper class
angels. Aziraphale is there to talk to them. He's nervous. The
senior angel is Gabriel – slick, buff, good-looking.*

GABRIEL
 So, Aziraphale. We got your message. You've got
 something big. Lay it on us.

AZIRAPHALE
 I'm sorry?

URIEL
 What's happening?

AZIRAPHALE
 Well. Okay. So. It's about the Antichrist.

URIEL
 Yes?

AZIRAPHALE
 I think that, um. Well, it's not impossible, considering
 all the alternatives, that the, the other side, might have
 lost track of him.

MICHAEL

The other side?

Aziraphale points downward.

GABRIEL

Lost track of him? He's the son of the US ambassador.
He's under constant observation..

MICHAEL

The other side are currently transporting him to the
plains of Megiddo. Apparently, that's the traditional
starting point.

GABRIEL

Middle Eastern unrest. Everything else follows. Four
Horsemen ride out. Last great battle between Heaven
and Hell.

AZIRAPHALE

Yes. Well, it's possible that the demon Crowley . . .
He's a wiley adversary. Keeps me on my toes, I can tell
you. But the um, American ambassador's son, well, it
may have been a ruse . . .

SANDALPHON

A ruse?

AZIRAPHALE

And the actual Antichrist might be, um, somewhere
else.

GABRIEL

Where?

AZIRAPHALE

Not sure. I mean . . . I could find out. I have my agents.
Dedicated team who could investigate the possibility.
Hypothetically speaking, if this were the case . . .

URIEL

It wouldn't change anything, Aziraphale.

GABRIEL

There was war in Heaven, long before the Earth was created. Crowley and the rest of them were cast out. But things were never really settled.

AZIRAPHALE

No. Right. I suppose they weren't. But there doesn't have to be another war, does there?

MICHAEL

When your cause is just you do not hesitate to smite the foe, Aziraphale.

SANDALPHON

We all look forward to a good foe-smiting.

GABRIEL

Much as we've enjoyed your hypotheticals, Aziraphale, I'm afraid we have things to get back to. The Earth isn't going to just end itself, you know.

AZIRAPHALE

No. Yes. Right. Sorry.

329 INT. LIFT – EARLY EVENING

Aziraphale is in one of those lifts that go down the side of buildings, with glass walls, so he can look out on all of London as he goes down.

He looks miserable.

330 INT. ANGELIC SKYSCRAPER – EARLY EVENING

The senior angels.

GABRIEL

What did you think of that then?

URIEL

That's an angel who has been down there too long.

SANDALPHON

 I don't trust him.

GABRIEL

 Hypotheticals, indeed.

331 EXT. JASMINE COTTAGE – DAY

We can see the sign on the cottage.

332 INT. JASMINE COTTAGE BEDROOM – DAY

Anathema's bedroom: the walls are covered with paper notes, and these are connected to a map of the area by wool and thumbtacks. There are magical symbols, notes and all sorts.

The map is Tadfield and surrounding area.

333 EXT. TADFELD VILLAGE GREEN – DAY

Anathema is walking through the village green, holding a map. She's looking at the map. Crossing off sections. She has a small pendulum which she's holding above the map — it seems to be swinging oddly.

We can see a few cheerful village types — A MILKMAN, a COURTING COUPLE, an OLD LADY AND HER GRANDSON. She smiles and nods at them.

Then we see them for a moment in ANATHEMA VISION: each of the people has an aura, a human-shaped coloured glow, around them. The milkman is violet, the courting couple both blue, the old lady green, and her grandson yellow.

R.P. TYLER and his dog SHUTZI go past. His aura is an angry red.

Anathema blinks and normal vision returns.

TYLER

> R. P. Tyler. Neighbourhood watch. I couldn't help but
> notice, young person, that you have a map. Casing the
> joint, are we?

ANATHEMA

> What?

TYLER

> We don't need your kind here.

ANATHEMA

> I'm renting Jasmine Cottage.

TYLER

> Oh good lord, you're an American tourist. Sorry.
> Thought you were a person of interest.

ANATHEMA

> I am. Listen. Eleven years ago, something came to
> this village. Some kind of beast, or creature. If you're
> neighbourhood watch, maybe you noticed.

TYLER

> Tadfield is a perfectly respectable village. If you're
> going to come here and smoke your fatty spliffers
> and bimble off to woo-woo land, I suggest you do it
> elsewhere. Like back in America.

ANATHEMA

> Fatty spliffers?

But he has stomped off.

334 INT. MADAME TRACY'S FLAT – DAY

*We hear a phone ringing. For the first time we get to look
around Madame Tracy's place. The sitting room is all set for
a seance. She's walking around, putting her seance things
away – the crystal ball, the occult candles and so on, and in
their place she's putting pink love candles.*

*She's making a slightly occult sitting room into a love den.
She could have two-sided paintings, with scary Victorian
black and white spirit photographs on one side, and with
sexy young women, or even sexy Madame Tracy paintings,
on the other, and turn them over.*

*She's made-up, but her hair is still in rollers, and she's
dressed for sexy times, but with a kimono over it.*

*We follow her into the hall, where she picks up the ancient
payphone on the wall.*

335 INT. MADAME TRACY'S FLAT HALLWAY – DAY

*If we are cutting backwards and forwards, Aziraphale is now
back in his bookshop.*

MADAME TRACY
 (sexy voice)
Hello.

AZIRAPHALE
Witchfinder Sergeant Shadwell, please. Or, um, one of
his officers.

MADAME TRACY
 (posh voice)
Ay shall endeavour to see if he is availi-able.
 (knocks)
Coo-ee, Mr Shadwell.

*Madame Tracy knocks on Shadwell's door, and opens it.
Through the open door, Newt is sitting cutting out articles . . .*

MADAME TRACY (CONT'D)
Hello, Newton.

NEWT
Hello, Madame Tracy.

Shadwell comes stomping up the stairs.

SHADWELL

Awa' wi' ye, harlot.

MADAME TRACY

A gentleman on the telephone for you. He sounds ever so refined. And I'll be getting us a nice bit of liver for Sunday.

SHADWELL

I'd sooner sup wi' the Devil.

MADAME TRACY

So if you'd let me have the plates back from last week, there's a love.

Shadwell ignores this and grabs the phone. Cut between Aziraphale in the bookshop and Shadwell.

AZIRAPHALE

Sergeant Shadwell. This is You Know Who.

SHADWELL

Who?

AZIRAPHALE

Me. Your, um, sponsor. Listen, do you have any men free? I need them to poke about a bit.

SHADWELL

Poke, eh? And where exactly do you want them poking?

AZIRAPHALE

Tadfield. It's a little town in Oxfordshire. There's a boy I need placed under observation. I need to know where he is at all times. I'll give you his address.

SHADWELL

I'll put a squad of my best men onto it.

AZIRAPHALE

Oh. Good. Thank you so much. So . . . How is Witchfinder Colonel Green? Is his leg any better?

SHADWELL

Clearing up nicely.

AZIRAPHALE

And I should have said Witchfinder Major Milkbottle.
I was so sorry to hear about his untimely end. I sent
flowers.

SHADWELL

Aye. The flowers were appreciated. And so was the
extra twenty pounds you sent for the family. He was a
brave man.

AZIRAPHALE

I was flabbergasted when you told me how he died.

SHADWELL

Aye. A brave man. I'll be by the bookshop next week
to collect your annual dues, then. And the expenses for
the keeping an eye on the young man.

AZIRAPHALE

Squad of best men to Tadfield, dear boy, and keep
them there until I give you orders. Now, the boy is
called Adam Young, and his address is four, Hogback
Lane, Tadfield. You've got that?

He writes it down on a notepad, by the phone.

SHADWELL

Absolutely, your honour. Tadfield it is.

AZIRAPHALE

Right. Pip-pip. Let me know when your men are in
position.

He puts down the phone.

SHADWELL

'Pip-pip'! Great southern pansy.

336 INT. SHADWELL'S FLAT – DAY

Newt is sitting cutting articles out of newspapers in Shadwell's unpleasant flat. He coughs. The air is thick. Tries to open a window. Fails.

He looks at the ancient hat of Thou-Shalt-not-Commit-Adultery Pulsifer in its glass case, and reads the label. Looks puzzled.

He looks at Shadwell's accounts book, filled with fictitious witchfinders . . .

Now a COMPLEX COMPUTER GRAPHIC of the Witchfinder Army organisational chart. People appear on it, multiply as they are named. The first few have different faces, and then they start looking identical. Beside each soldier we see how much they get paid. It appears to mostly be about a shilling, although the top officers are paid as much as three pounds a week.

GOD(V.O.)

Strictly speaking, Shadwell doesn't run the Witchfinder Army. According to Shadwell's pay ledgers it is run by Witchfinder General Smith. Under him are Witchfinder Colonels Green and Jones, and Witchfinder Majors Jackson, Robinson, and Smith (no relation). Then there are Witchfinder Majors Saucepan, Tin, Milkbottle (deceased), and Cupboard, because Shadwell's limited imagination had been beginning to struggle at this point. And Witchfinder Captains Smith, Smith, Smith, and Smythe and Ditto. And five hundred Witchfinder Privates and Corporals and Sergeants. Most of them are called Smith, but this doesn't matter because neither Crowley nor Aziraphale has ever bothered to read that far.

The hundreds of people on the organisational chart have started to vanish, leaving only drawings of Sergeant Shadwell and Witchfinder Private Newton Pulsifer.

GOD (V.O.)

> Crowley and Aziraphale simply hand over the pay.
> After all, both lots put together only come to around
> £500 a year.

TIME RESTARTS.

Shadwell has entered.

SHADWELL

> Find any witches yet, Witchfinder Private Pulsifer?

NEWT

> Even better than that. I found something really
> interesting. I've discovered some unusual weather
> patterns. There's a town in Oxfordshire with some very
> strange weather events.

SHADWELL

> Raining blood, is it? Or raining fish? Satanic frost in
> summer, witherin' the crops, after some hag got into
> an argument with a farmer?

NEWT

> No. It's just . . . it always has perfect weather for the
> time of year.

Shadwell is unimpressed . . .

SHADWELL

> Call that a phenomena?

NEWT

> Normal weather for the time of year isn't normal,
> Sergeant. Crisp autumns, and long hot Augusts? The
> kind of weather you used to dream of as a kid? It's
> snowed there every Christmas Eve for the last eleven
> years.

SHADWELL

> Not interested. Just look for witches, and witch-caused
> phenomenomenoms.

NEWT

Is this what the Witchfinder Army does? I just go through newspapers?

SHADWELL

It is.

NEWT

I thought maybe we'd go to training camps . . . It would be quicker with a search on the computer.

SHADWELL

Witch's tools, boxes of the devil!

NEWT

Tell me about it. I don't think they like me.

337 EXT. DES MOINES, IOWA – DAY

TITLE CARD: **IOWA, USA**

We are outside a Burger Lord Fast Food Restaurant in Des Moines, Iowa. A piece of paper blows past: it's a lonely and deserted place.

338 INT. BURGER LORD – DAY

It's a real diner. There's an old man flipping burgers. He's a bit corpulent, has a cowlick and is undoubtedly ELVIS PRESLEY. He's happy. He's humming to himself – an Elvis hit. Heartbreak Hotel *perhaps.*

Sable and Frannie stride in to the Burger Lord. He's holding a briefcase. Frannie shows ID to the waitress, who is vaguely baffled.

GOD (V.O.)

He's a businessman with a chain of restaurants. And he's about to launch something new.

*As he talks, Sable opens the briefcase to reveal a hamburger,
a bun, a pickle, a milkshake, and raw French fries.*

SABLE

Artificial bun. Artificial burger. Fries that have never
even seen a potato. Foodless sauces. And, we are rather
proud of this: a completely artificial dill pickle.

FRANNIE

The shake doesn't contain any actual food content
either.

SABLE

Nobody's shakes contain actual food content. Okay.
Let's try it out.

*Cut back as the food that the FRY COOK has been cooking
for us is pushed off the grill into the bin. Such a waste of
food! And Sable's new, brightly-coloured food goes onto the
grill, and the chips go into the oil . . .*

Frannie is telling the waitress how to present the food:

FRANNIE

Press this button as you hand over the Chow. And
don't call it food. It's Chow.

*She puts a tray of food down, presses the button. A very
rapid voice says:*

RAPID VOICE

CHOW™ brand unfood contains spun, plaited and
woven protein molecules, designed to be ignored
by your digestive enzymes, no-cal sweeteners, oil
replacements, fibrous materials, colorings, and
flavorings. Chow is an edible substance and must not
be confused with food. Eating Chow can help you to
lose weight, hair, and kidney functions. May cause
anal leakage. Enjoy your meal.

Elvis is troubled. He hums.

SABLE

 That man . . .

And now, coming into the diner, is the International Express man. He's carrying a package.

INTERNATIONAL EXPRESS MAN

 Party name of Sable?

SABLE

 Yes?

INTERNATIONAL EXPRESS MAN

 Thought it was you, looked around, thought, tall gent
 with a beard, nice suit. Package for you, sir.

Sable scribbles FAMINE on the clipboard and opens the package to reveal a little silver pair of antique scales.

SABLE

 Finally!

He gives $20 to the Express man. Turns to the female assistant.

SABLE (CONT'D)

 I'm flying to England.

FRANNIE

 I'll let the jet know. When are you returning?

SABLE

 Who knows? Cancel all my appointments.

FRANNIE

 For how long?

SABLE

 The foreseeable future.

Frannie's fingers start flying over the tablet screen.

Elvis is still singing.

ELVIS

 You ain't nothing but a hound dog . . .

SABLE

And fire that man. He irritates me.

The hokey Burger Lord sign is being taken down and replaced with a hipster CHOW! sign as he leaves.

339 INT. SHADWELL'S FLAT – DAY

Shadwell notices that Newt has managed to open a window, and immediately pulls it closed.

NEWT

Sergeant, the village I was telling you about with perfect weather. Well, it says in the manual that witches can influence the weather . . . What if I just sort of nipped over there tomorrow? And have a look around, you know. I'll pay my own petrol.

Shadwell ponders this. It's been an odd and coincidence-filled day, so he asks:

SHADWELL

This village. It wouldna be called Tadfield, would it?

NEWT

How did you know that?

SHADWELL

Aye. I suppose it can't do any harm. Be here at nine o' the clock in the morning, afore ye leave.

NEWT

What for?

SHADWELL

Yer armour of righteousness.

340 INT. CROWLEY'S FLAT, BEDROOM – EVENING

Crowley's bedroom. We see a MONTAGE of Crowley trying to get to sleep by lying on the bed, on the wall, then on the ceiling.

CLOSE UP on his open snake-eyes. He's wide awake. Then he puts on his dark glasses.

341 INT. CROWLEY'S FLAT – EVENING

He walks through the flat. Pauses to spray a houseplant with a plant mister.

342 INT. CROWLEY'S OFFICE – EVENING

Crowley picks up the landline. He dials a number.

343 INT. AZIRAPHALE'S BOOKSHOP – EVENING

Aziraphale is pacing around. He looks miserable. He jumps when the phone rings, and then picks it up. We cut between them.

CROWLEY
 It's me. Meet me at the third alternative rendezvous.

AZIRAPHALE
 Is that the old bandstand, the number 19 bus, or the British Museum café?

CROWLEY
 The bandstand. I'll be there in fifteen minutes.

344 EXT. THE YOUNG'S HOUSE – EVENING

It's night. The lights are mostly out, but downstairs people are watching TV.

345 INT. THE YOUNG'S HOUSE – EVENING

Adam's parents are watching TV. Adam is sitting in the corner, reading the pile of New Aquarian *magazines.*

ADAM

> Dad. Did you know there are ley lines everywhere?

MR YOUNG

> No, Adam. Ley lines are rubbish. You'll like this bit,
> Deirdre. He's taped a gun under the chair.

ADAM

> It's not rubbish. They wouldn't write about it in a
> magazine, if it was rubbish.

*Mr Young ignores Adam and watches a little more of the TV
show.*

ADAM (CONT'D)

> There's people from Tibet watching everything we do
> through hidden tunnels.

*His parents both look at him at the same time, with the same
expression.*

ADAM (CONT'D)

> I think I might go to bed early, actually.

He gets up and leaves.

DEIRDRE

> Do you think he's all right?

346 EXT. ST JAMES'S PARK – EVENING

*The duckpond at St James's Park. The park is locked.
Crowley is standing by the pond, waiting. He checks his
watch. Aziraphale hurries over.*

CROWLEY

> Any news?

AZIRAPHALE

> Um. What kind of news would that be?

CROWLEY

> Well? Do you have the missing Antichrist's name, address and shoe size yet?

AZIRAPHALE

> *(guiltily)*
> Shoe size? Why would I have his shoe size?

CROWLEY

> Joke. I've got nothing either.

AZIRAPHALE

> It's the Great Plan, Crowley.

CROWLEY

> For the record, great pustulent mangled bollocks to the Great Blasted Plan.

AZIRAPHALE

> May you be forgiven!

CROWLEY

> I won't be forgiven. Not ever. That's part of a demon's job description. *Unforgivable. That's what I am.*

AZIRAPHALE

> You were an angel once.

CROWLEY

> That was a long time ago. We find the boy. My agents can do it . . .

AZIRAPHALE

> And then what? We eliminate him?

CROWLEY

> Well . . . somebody does. I'm not personally up for killing kids.

AZIRAPHALE

> You're the demon. I'm the nice one. I don't have to kill children.

CROWLEY

Uh-uh.

AZIRAPHALE

If you kill him, then the world gets a reprieve. And
Heaven does not have blood on its hands.

CROWLEY

No blood on your hands? That's a bit holier than thou,
isn't it?

AZIRAPHALE

I am a great deal holier than thou. That's the whole
point.

CROWLEY

Then you should kill the boy yourself. Holi-ly.

AZIRAPHALE

I'm not killing anybody.

CROWLEY

This is ridiculous. You are ridiculous. I don't even
know why I'm still talking to you.

AZIRAPHALE

Frankly, neither do I.

CROWLEY

Enough. I'm leaving.

Aziraphale calls after him . . .

AZIRAPHALE

You can't leave, Crowley. There isn't anywhere to go.

*Crowley looks back. He looks at Aziraphale. Above them, a
beautiful starry sky. And Crowley softens.*

CROWLEY

Big universe. Even if this all ends up in a puddle of
burning goo, we could go off together.

AZIRAPHALE

'Go off together?' Listen to yourself.

CROWLEY

How long have we been friends? Six thousand years?

AZIRAPHALE

Friends? We aren't friends. We are an angel and a demon. We have nothing whatsoever in common. I don't even like you.

CROWLEY

You do.

AZIRAPHALE

(blurts out the truth)
Even if I did know where the Antichrist was, I wouldn't tell you. We are on opposite sides.

CROWLEY

We're on *our* side.

AZIRAPHALE

There isn't an 'our side', Crowley. Not any more. It's over.

Crowley takes a deep breath, as if he's going to keep talking. And then he lets it all go.

CROWLEY

Right. Well, then. Have a nice doomsday.

347 INT. ADAM'S BEDROOM – NIGHT

Adam's in bed, with a torch/flashlight, reading New Aquarian *magazines. He has a bag of sherbet lemons, which he is sucking. (The sherbet lemons, not the bag.)*

ADAM

Brilliant.

He picks up the next copy. The headline on the cover of this one is 'NUCLEAR POWER? NO THANKS! CAN WE MAKE PLANET EARTH A NUCLEAR-FREE ZONE?!'

Adam is getting sleepy. He puts down his sherbet lemons. He drops the magazine. Before he falls asleep he manages to turn out the light. And we hear WHISPERY VOICES. They are saying things like:

WHISPERY VOICES

You can do it. You can change it. Fix it, Adam. It's getting closer. It's getting stronger.

And Adam sleeps. A moment of perfect peace and then . . .

348 EXT. TURNING POINT NUCLEAR POWER STATION – NIGHT

We hear LOUD klaxons going off.

349 INT. TURNING POINT CONTROL ROOM – NIGHT

A nuclear power control room. SMYTHE is sleepily staring at the controls. He's baffled. HORTENSE GANDER, a Shift Charge Engineer, comes in. RED LIGHTS are flashing. The klaxon continues to sound. The huge room is filled with dials, and as we watch, swathes of the dials go down to zero, and areas of the wall of dials go completely dark.

HORTENSE

That's a bit impossible.

SMYTHE

Yeah. What do we do?

Hortense pulls out her phone. She thumbs it, and is apparently calling 'Mr Whippy'.

HORTENSE

You don't do anything. I'm going to wake up the station manager.

350 INT. STATION MANAGER'S BEDROOM – NIGHT

The STATION MANAGER's mobile phone starts playing a happy, inappropriate song like NELLIE THE ELEPHANT. *The screen on his phone says 'The Cornetto'. His hand fumbles for it, answers . . .*

STATION MANAGER
You want to what?

351 INT. TURNING POINT CONTROL ROOM – NIGHT

Hortense is looking at the dials. She's on the phone.

HORTENSE
I want to open the reactor.

352 INT. STATION MANAGER'S BEDROOM – NIGHT

The station manager turns on the light by his bed.

STATION MANAGER
Is this a joke?

353 INT. TURNING POINT CONTROL ROOM – NIGHT

Hortense seems unruffled.

HORTENSE
Two hundred and forty megawatts of power are currently being produced by this power station, Eric. It's just, according to our indicators, nothing's producing them.

STATION MANAGER
I can't just tell you to open up the reactor, Hortense.

HORTENSE
No Eric. Obviously not. But you can call someone who can.

354 INT. MINISTER'S BEDROOM – NIGHT

An important male middle-aged MINISTER is awake,
naked, sitting on the bed, and grumpy. Next to him is a
MALE SEX WORKER, who is sitting, grumpily mouthing,
'I'm on the clock, you know', and tapping his wrist . . .

MINISTER
What do you mean, I have to authorise it? Is there
anyone else? I KNOW I'm the minister. Well then, yes.
I authorise you to open the bloody thing up.

355 INT. NUCLEAR REACTOR – NIGHT

Hortense and the station manager are unscrewing a huge
screw-door. Smythe is checking the Geiger counter . . . it's
silent:

SMYTHE
Nothing. Not even the normal background radiation.

STATION MANAGER
How can we be putting out power with a dead reactor?

SMYTHE
Got me on that, chief.

Hortense throws open the door and looks down at the room.
It's a circular room the size of a grey squash court, with pipes
coming in . . . but not connecting to anything. The room is
utterly empty.

HORTENSE
Oh. There's something you don't see every day. An
enormous room without a nuclear reactor in it.

STATION MANAGER
But . . . There's nothing there.

SMYTHE
Not nothing, chief. Look . . . what's that?

And we move in on the only thing in the room . . . A
SHERBET LEMON.

HORTENSE
 It looks like a sherbet lemon.

CUT TO:

356 INT. ADAM'S BEDROOM – NIGHT

And Adam is blissfully asleep. The bag of sherbert lemons
spilled on his night table, on a pile of New Aquarians. *We*
hear the satanic whisper voices, but they are too quiet to
make out what they are whispering . . .

WHISPERY VOICES
 Mend it all. End it all . . .

And Buddy Holly's 'Everyday' starts, this time sounding
almost like a lullaby, as we . . .

FADE TO BLACK.

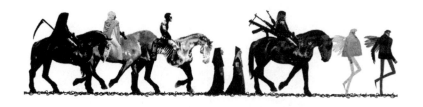

EPISODE FOUR

SATURDAY MORNING FUNTIME

401 EXT. MORBILLO DECK – DAY – PRESENT DAY

*Start on CAPTAIN VINCENT, played, if possible, by
WILLIAM SHATNER, talking into a dictaphone. Slow
pull back to reveal, first that the captain is on the bridge of
the* Morbillo, *a relatively small, high-tech very fancy luxury
cruise ship.*

CAPTAIN VINCENT (V.O.)
 Captain's log, pleasure cruiser *Morbillo*. Was sailing
 south-south-west on course for Hawaii when we
 realised that something was amiss.

402 EXT. MORBILLO DECK – NIGHT

*Earlier: the FIRST MATE is pointing down, towards the
ocean. The captain looks down and sounds like William
Shatner as Kirk when he says . . .*

CAPTAIN VINCENT
 But that's . . . impossible . . .

*And we pull back to see that the ship is not on the ocean. It's
aground, on a FANTASTIC LANDSCAPE OF PYRAMIDS
AND SUCHLIKE. The landscape is a seaweed-covered
mash-up of H. P. Lovecraft and Ancient Egypt.*

CAPTAIN VINCENT (V.O.)

It appears that a vast expanse of sea-bed has risen up beneath us in the night, revealing the sunken city of Atlantis.

Now we see the ATLANTEANS: they are all wearing old brass diving helmets, or things like fishbowls on their heads, and white robes. They are doing cruise-like things: shuffleboard and queueing for food and such . . .

CAPTAIN VINCENT (V.O.)

Old men in long robes and diving helmets have come aboard the ship and are mingling happily with the passengers, who think we organised this for their amusement. The High Priest has just won the quoits contest.

Final shot: our captain presenting the HIGH PRIEST with a tiny silver sports presentation award. They both smile for the camera. The High Priest is SO HAPPY.

403 EXT. TADFIELD LANE – MORNING

The Them are walking down the lane towards Hogback Wood, with Dog at their heels. Adam is talking. He's carrying a pile of dog-eared New Aquarian *magazines . . .*

ADAM

You have to read them too. I learned all this amazing stuff they don't teach us at school. There was a man called Charles Fort who could make it rain fish!

BRIAN

Cooked fish?

ADAM

Course not. That would be stupid. Live fish.

PEPPER

Adam, I still don't understand the thing you were telling us about alien spaceships. If I was an alien

I wouldn't go around giving people messages of
universal peace and goodwill. I'd say,
(Darth Vader)
'THISS IS A LASER BLASHTER. PREPARE TO DIE,
REBEL SWINE.'

WENSLEYDALE
I'd say that too, actually, if I was an alien in a flying
saucer.

BRIAN
Or 'Exterbinate'.

ADAM
Obviously the aliens used to do that. Now they give
messages of global peace and cosmic harmony, and the
government hushes it all up.

WESLEYDALE
Why?

ADAM
It's what they do. They hush up aliens and nuclear
reactors and, and they hush up the people from Tibet
who have secret tunnels and who are listening to
everything we say.

*They all look around as if they are looking for tunnels. Even
Dog. Pepper, who has her doubts about all this, finally says
them aloud.*

PEPPER
Adam, I don't think this stuff is, you know . . . Real.
It's made up.

*Adam gives her a sharp look. Dog looks at her and does a
small growl. A beat: is Adam going to get angry? Then he
grins and . . .*

ADAM
Things on the internet can be made up. But this

is magazines. Course it's real. Just like the city of
Atlantis.

WENSLEYDALE
　Actually, I don't think Atlantis is a thing.

ADAM
　It's under the sea. And people live there.

WENSLEYDALE
　How can they breathe?

BRIAN
　I bet they wear diving helmets.

ADAM
　Probably.

PEPPER
　Do you believe that's true?

And again Adam seems, well, spooky.

ADAM
　Of course it's true. What I say is true.

And he believes things, and they happen . . .

*By now they've reached their base in Hogback Wood. They
are getting ready to play.*

BRIAN
　Bags I be from Atlantis.

WENSLEYDALE
　Actually, I think we should play Tibetans in secret
　tunnels.

ADAM
　I want to play Charles Fort. He was . . .

BRIAN
　The one who made it rain fish.

WENSLEYDALE
> Excuse me. How? I mean, fish don't fall from the
> sky. Unless there's another sea up there which I don't
> actually think there is.

BRIAN
> Maybe the fish come from Atlantis and shoot up
> through the sky and then come down . . .

Adam wishes he'd thought of that.

PEPPER
> I think we should play Charles Fort making it rain fish.
> And we should play Atlantis. Is there anything else in
> those magazines, Adam?

ADAM
> *(beat)*
> Yeah. I know so much stuff now.

TITLES SEQUENCE

404 EXT. A PARK – DAY

TITLE CARD: **SATURDAY MORNING FUN TIME**

*Aziraphale is looking for someone. He spies a human statue
dressed as an angel, with wings. It's not him.*

*The archangel Gabriel, whom we have met before, is jogging
towards us. Aziraphale spots him, tries and fails to attract
his attention, then starts running awkwardly beside him.*

AZIRAPHALE
> It's me.

GABRIEL
> I know it's you, Aziraphale.

AZIRAPHALE
> Yes. Look. We have to get the word upstairs, to, to the
> Big Boss. There are prophecies.

GABRIEL

And what's in human prophecies that matters to us?

AZIRAPHALE

The kraken wakes and rises from the sea floor. So does Atlantis. The rain forests return. And that's just for starters. Armageddon is coming. I'm fairly certain it starts today. Just after teatime.

GABRIEL

Exactly. Right on schedule. I really don't see what the problem is.

AZIRAPHALE

Look, will you please slow down, just a minute!

Gabriel stops. Aziraphale is panting . . .

GABRIEL

Well?

AZIRAPHALE

I just . . . I just thought there was something we could do.

GABRIEL

There is. We can fight. And we can win!

AZIRAPHALE

But there doesn't have to be a war.

GABRIEL

Of course there does. Otherwise, how could we win it? Wrap up anything you have to wrap up down here. Report back to active service. And . . .

He reaches out and pats Aziraphale's stomach.

GABRIEL (CONT'D)

Lose the gut. You're a lean, mean, fighting machine. What are you?

AZIRAPHALE

Um. I'm . . .

But Gabriel has jogged off.

AZIRAPHALE (CONT'D)
(to himself)
I'm soft.

He looks at the world. GABRIEL (miraculously back) taps him on the shoulder. Aziraphale jumps.

GABRIEL
Nearly forgot. According to our records, you were issued with a flaming sword. You haven't lost it?

AZIRAPHALE
What, like I'm going to just give it away or something?

Gabriel gives him an approving look.

405 EXT. A ROAD NEAR A RIVER – EARLY MORNING

Sunrise. The sky is a vivid shade of red.

TITLE CARD: **SATURDAY**

Then a beat, then:

TITLE CARD: **THE LAST DAY OF THE WORLD**

We are on the outskirts of a town, or rather on the ring road that goes around it. Somewhere very rural with a big, bad road. Everything feels pretty and quiet until, with a ROAR—

A lorry comes barreling round the bend, speeding. Queen's 'Another One Bites the Dust' is playing on the radio. The unshaven DRIVER looks sleepy, and chugs a pill back with some coffee.

406 INT. INTERNATIONAL EXPRESS MAN'S BEDROOM – MORNING

A nice little suburban bedroom. The International Express man is getting dressed. From the bed, his wife stirs.

EXPRESS WIFE
Lesley? Come back to bed.

INTERNATIONAL EXPRESS MAN
Can't, love. Delivery to make.

EXPRESS WIFE
On a Saturday morning?

INTERNATIONAL EXPRESS MAN
At least it's local. Two deliveries and then I'm done.

EXPRESS WIFE
Lesley . . . Who are these deliveries for?

INTERNATIONAL EXPRESS MAN
I don't know, love. Someone important. Head office said
that the job was booked about six thousand years ago.

EXPRESS WIFE
They were joking.

INTERNATIONAL EXPRESS MAN
Well, the company's only eighty years old. But I saw
the paperwork . . . Anyway. Ours is not to reason why.
Ours is to deliver packages.

EXPRESS WIFE
Love you . . . tiger.

INTERNATIONAL EXPRESS MAN
Love you, Maud.

He puts on his cap, in front of the mirror.

407 EXT. INTERNATIONAL EXPRESS MAN'S HOUSE/INT. VAN
 – MORNING

*Inside the van. The door opens and the International
Express man looks in: nothing in there but a package and an
envelope. He ticks it off on his clipboard.*

Then he climbs into the driver's seat and heads off. It's early in the morning and nobody else is up.

408 INT. HEAVEN – DAY

Michael approaches Gabriel, who is sitting at a desk with a beautiful view.

GABRIEL
I still need the battle formation strategy.

MICHAEL
It's on the way. I may be out of line here, but I've been following up on Aziraphale's comments during our last meeting.

GABRIEL
I'm disappointed in him. Not thinking like an angel.

MICHAEL
I went back through the Earth observation files. There may be an explanation.

Michael puts some black-and-white photographs down in front of Gabriel.

Awkward, paparazzi-style photos of Aziraphale and Crowley in conversation – in Victorian days in St James's Park, eleven years ago in St James's Park, on a bus together . . .

GABRIEL
I'm sure there's a perfectly innocent explanation.

MICHAEL
Of course. Would you have any objection to me following this up, using backchannels?

GABRIEL
There are no backchannels, Michael.

MICHAEL
Obviously not.

409 INT. HEAVEN, A STAIRWELL – DAY

Even the stairwell has a view. Michael pulls out a communication device that looks expensive and advanced.

MICHAEL
>It's me. It's our man Aziraphale. Is there any possibility that he's working for you? No? Well, then, you might want to investigate the activities of the demon Crowley. Might be playing his own game. Word to the wise. No, I'm telling you that you can't trust him . . . Of course you can trust me. I'm an angel.

410 INT. HELL – AN OFFICE

Ligur is at his cramped desk, in a tiny office. He puts down an old, stained telephone from the 1960s.

LIGUR
>Oh Crowley, Crowley, Crowley. What have you been playing at?

And then he growls . . .

411 INT. CROWLEY'S OFFICE – NIGHT

A globe of the world. We're looking at the UK. Then it spins slowly. Then we see America go past, and we start to pull back.

CROWLEY
>England's out. America's out. Atlantis didn't exist yesterday, exists today, still out. Everywhere is going to burn.

Crowley has a globe in the corner of the office, and is pushing it with his finger.

He grabs a big book of astronomy, flips it open to a picture of the moon, then to beautiful Hubble-style photos of outer space . . .

CROWLEY (CONT'D)
 (to himself)
The moon? No atmosphere. No night life. Alpha
Centauri . . . That's always nice at this time of year . . .
if you can run far enough, you don't have to hide . . .
 (then, impressed in spite of himself)
Nice nebula. Look at that. I helped build that one . . .

He closes the book, and looks up, and talks to God, in the classical fashion.

CROWLEY (CONT'D)
 (to God)
I only ever asked questions. That's all it took to be a
demon in the old days. Great Plan? Hey! God! Are you
listening? Show me a Great Plan! Okay, I know you're
testing them, you said you were going to be testing
them. But you shouldn't test them to destruction . . .

Crowley stares down at the stars in the book, or out of the window at the stars above

CROWLEY (CONT'D)
 (quietly)
Not to the end of the world.

412 EXT. A BUSY ROAD NEAR A RIVER – MORNING

The International Express man parks his van on the verge.

Then he opens the back. Takes out the package, leaving the envelope behind.

He looks right, left, right again, and steps out into the road and as he starts to cross: VROOOOOM! A juggernaut lorry comes past.

A shot: the road's empty; what happened to him?

Ah. He was in the ditch by the side of the road. He threw himself on top of the package. Now he's getting up, putting

his glasses back on and his cap. He's muttering to himself.

INTERNATIONAL EXPRESS MAN
Shouldn't be allowed, bloody lorries, no respect for
other road users, what I always say, what I always
say is remember that without a car, son, you're just a
pedestrian too . . .

He brushes himself off, and walks down to the river bank.

413 EXT. THE RIVER BANK – MORNING

*White, last seen on a polluted ship, is sitting looking at the
water.*

*They are wistful and happy, and what they are looking at is
foam, sludge, plastic bags and ick of all kinds floating on top
of the water.*

WHITE
Look at it.

*The International Express man is walking along the bank.
His face is a study.*

GOD (V.O.)
In the old days, and it wasn't that long ago really, there
was an angler every dozen yards, children played here,
courting couples came here to hold hands, and to get
all lovey-dovey in the Sussex sunset. He did that with
Maud, before they were married. They came here to
spoon and, on one memorable occasion, fork.

The International Express man reaches White.

INTERNATIONAL EXPRESS MAN
Party name of Chalky, sir?

White nods listlessly, but doesn't look at him.

WHITE
Look at that river.

INTERNATIONAL EXPRESS MAN
Yes, sir. It's the pollution. Progress, you could call it.

WHITE
It's just so damned beautiful.

INTERNATIONAL EXPRESS MAN
Funny old world isn't it and no mistake. I mean you go all over the world delivering and then you wind up practically in your own back yard, so to speak. I've been to the Middle East, and to Dez Moines, and that's in America, sir, and now here I am, and here's your parcel, sir.

And he shows them the parcel. White seems in no hurry to take it.

INTERNATIONAL EXPRESS MAN (CONT'D)
You have to sign for it, sir.

He hands them a clipboard and pen. The moment White touches the pen, it starts to leak. We can see a P and then just a splodge. They hand back the pen.

INTERNATIONAL EXPRESS MAN (CONT'D)
Red sky in the morning, shepherd's warning. Or is it sailor's warning?

WHITE
Everybody's warning.

The International Express man has no idea what they are talking about.

INTERNATIONAL EXPRESS MAN
Very good, sir.

WHITE
Or very bad. Depends where you're standing. It's good if you're us.

The International Express man walks away. White rips off

*the packaging, brown paper and bubble wrap. They drop it
into the river.*

GOD (V.O.)

The third of the Four Horsemen took over when
Pestilence retired. They've killed as many people as
Famine or as War.

*White holds up a crown. It's beautiful and silver and it
shines. Black tarnish starts to grow on it where they touch it
and, in moments, it has turned black.*

Only then do they put it on.

*We cut away to see the paper and bubble wrap in the polluted
river. We look back. White has gone.*

We hear the sound of a motorbike in the background.

414 INT. INTERNATIONAL EXPRESS VAN – MORNING

*The International Express man gets his clipboard with the
instructions on it, and opens an envelope. He reads the note
inside.*

*He looks upset. Then he folds the instructions, puts them
in his pocket. We see the word EVERYWHERE on the
instructions before they go.*

*He looks at the leaky pen, drops it, picks up a nicer pen, and
a sheet of paper.*

*He writes 'Maud, I love you' on it. Puts the paper on his
dashboard.*

He gets out of the cab.

415 EXT. A BUSY ROAD NEAR A RIVER – MORNING

*He looks right. Looks left. Looks sad. And he walks across
the road.*

VROOM! A huge lorry goes past.

INTERNATIONAL EXPRESS MAN
 Whew! That one nearly had me.

And then he looks down. There's A BODY ON THE GROUND, AND IT'S HIS. It looks like it was hit by a truck. The note that he was meant to deliver is fluttering across the road . . .

INTERNATIONAL EXPRESS MAN (CONT'D)
 Oh.

And a voice, deep and dark and resonant, and not sounding overly voice-treated, says, conversationally,

DEATH
 I'M AFRAID SO.

Death's skeletal hand reaches out and catches the fluttering letter.

The International Express man looks up. DEATH is there. The trick in design is going to be not having Death look either comical or like a puppet. A grinning skull, with tiny blue dots like stars in the eyes. We don't talk in the book about how he's dressed, this first time, and I think this is the one time he should be in classical Grim Reaper robes, to make the biker costume later stand out, but I can be talked out of this by a designer or costume person with a brilliant alternative.

INTERNATIONAL EXPRESS MAN
 I've got something for you, sir. It's not a package. It's a message.

DEATH
 DELIVER IT, THEN.

INTERNATIONAL EXPRESS MAN
 It's just this. 'Come and see.'

DEATH
 FINALLY.

The background, of the bend in the road by the body, has been getting greyer and mistier through this. Now the International Express man is standing in a grey mist . . .

INTERNATIONAL EXPRESS MAN
 What does it mean, sir?

DEATH
 IT'S A CALL TO ACTION. WAR AND FAMINE, POLLUTION AND DEATH. TODAY WE RIDE. NOW . . .

Pull back. The grey mists are parting and there's nothing but darkness and stars.

DEATH (CONT'D)
 DON'T THINK OF IT AS DYING. THINK OF IT AS LEAVING EARLY TO AVOID THE RUSH.

416 EXT. ANATHEMA'S COTTAGE – DAY

Adam, with the Them behind him, knocking on Anathema's door.

Anathema opens the door. We can hear Radio Four playing in the background. She looks like she hasn't slept for a day or two.

She looks down. It's the kids. She smiles.

ANATHEMA
 Hello, Adam.

ADAM
 These're my friends. Pepper and Brian and Wensleydale.

ANATHEMA
 Um. Hello.

Adam nods.

ADAM
Have you got any more of the *New Aquariums*? Cos, we need to know everything.

ANATHEMA
You read the ones I gave you already?

ANATHEMA (CONT'D)
Um. Sure. Hold on. Would you like candy? It's carob, not chocolate, and—

BRIAN
We don't take sweets from—

PEPPER
Witches.

WENSLEYDALE
I do.

He takes a sweet. The other kids look at each other. They shrug. Then they put out their hands.

As Anathema gives them the carob sweets, we move over to the radio. We can hear an interview going on . . . The spokesperson is probably Hortense from the power station.

JAMES NAUGHTIE (V.O.)
And precisely how much nuclear material has escaped?

ELECTRIC SPOKESPERSON (V.O.)
We wouldn't say escaped. Temporarily mislaid.

JAMES NAUGHTIE (V.O.)
Surely you have considered that this has to be terrorist activity?

417 INT. NEWT'S CAR – DAY

Newt is driving his sad little car (with DICK TURPIN

hand-painted on the back) down Madame Tracy's road. We see how sad the car is. But Newt looks quite excited. He pulls up and parks around the back . . .

ELECTRIC SPOKESMAN (V.O.)
Yes. All we need to do is find some terrorists who are capable of taking an entire nuclear reactor out of its can while it's running and without anyone noticing.

JAMES NAUGHTIE (V.O.)
But you said the power station is still producing electricity . . .

And then Newt sits in the car, puzzled, listening to the radio.

ELECTRIC SPOKESMAN (V.O.)
It is.

JAMES NAUGHTIE (V.O.)
How can it still be doing that if it hasn't got any reactors?

ELECTRIC SPOKESMAN (V.O.)
We don't know. We were hoping you clever buggers at the BBC would have an idea.

Newt turns it off.

418 INT. MADAME TRACY'S FLAT HALLWAY – DAY

Newt knocks on the door. It's opened by Madame Tracy, dolled up as a medium, looking as mystic as she can.

MADAME TRACY
(spookily)
Enter of your own free will, and together we will part the veil between this world and the next.

NEWT
It's me, Newt.

MADAME TRACY
> *(normally)*
> Just getting into the mood, dear. I've got a seance this
> afternoon. I'm feeling very ectoplasmic already.

NEWT
> I'm sorry I'll have to miss it. I'm off on a mission.

*Newt glances at the scrap of paper by the phone in the
hallway.*

CLOSE UP on the paper, in Shadwell's handwriting: ADAM
YOUNG, 4 Hogback Lane, TADFIELD.

MADAME TRACY
> It's all a bit of fun, dear. But I do put on a remarkable
> show. I've got Mr Scroggie and Vera Ormerod coming
> in after lunch, so it's off with the frilly undies and
> back to polishing my crystal ball . . . That sounded
> somewhat ruder than I had intended.

She opens the door to Shadwell's flat.

MADAME TRACY (CONT'D)
> Cooo-eee! Mr Shadwell. Ooh. You're looking rather
> posh.

*For Shadwell is wearing his witchfinder's uniform. It's like
a misbegotten combination of the Salvation Army and a
Victorian Officer, with a Puritan aesthetic.*

SHADWELL
> Get out of here, Hoor of Babylon. This is army
> business.

She pointedly straightens Newt's collar before she goes.

SHADWELL (CONT'D)
> Ten-shun!

*Newt looks around to make sure Shadwell's talking to him,
then shuffles into attention.*

Behind Shadwell on the wall is an ancient, stained map of the UK. 'Jerusalem' is playing in the background.

SHADWELL (CONT'D)
> This is our country. It's under our protection. I wish I was goin' wi' ye. I'm too old now. No more lying in the bracken spying on their evil ways. It's all up to you, now, Witchfinder Private Pulsifer.

NEWT
> Shouldn't there be a few more of us? If we're protecting the whole country from witches?

Shadwell is opening a dusty glass display case.

SHADWELL
> Nobody ever said it would be easy, Private Pulsifer. Here. Put this on.

And from the display case he produces a dark jacket: it's very old, and is a lot like the one Shadwell is wearing. It has WA on the lapel, and tarnished gold buttons.

Newt hesitates. Shadwell growls.

SHADWELL (CONT'D)
> Put. It. On.

And, awkwardly, Newt does. Shadwell nods approvingly.

If Terry was still alive, he'd make a point of telling me that this should be shot like every war movie, where the weapons are getting checked, loaded, before our team head out to certain death. So I am writing it instead. Weapons porn. Shadwell is handing over things he is taking from the cabinet.

SHADWELL (CONT'D)
> Pendulum of discovery.

Newt takes it and pockets it while repeating:

NEWT
> Pendulum of discovery.

SHADWELL
Thumbscrew.

Newt does not like the thumbscrew . . .

NEWT
Um, I really don't think . . .

SHADWELL
THUMBSCREW.

NEWT
Thumbscrew.

A packet of firelighters.

SHADWELL
Firelighters.

NEWT
I'm not actually prepared to burn anybody—

SHADWELL
FIRELIGHTERS.

NEWT
Firelighters.

Shadwell produces a budgie bell, a birthday candle, and a dog-eared copy of Little Prayers for Tiny Hands.

SHADWELL
Bell, book and candle.

NEWT
Bell, book and candle. What are they for?

SHADWELL
You may need to exorcise a demon.

NEWT
How do I do that?

SHADWELL
Ring the bell. Light the candle.

NEWT
>Read the book?

SHADWELL
>There'll be no time for light reading when you're under
>demonic attack, laddie. Just wave it around a bit.

*Finally, the high point of the scene, in its presentation box,
Shadwell presents THE PIN.*

SHADWELL (CONT'D)
>And finally . . . PIN!

NEWT
>Pin?

*Shadwell takes the pin from its box and puts it into Newt's
lapel.*

SHADWELL
>It's the bayonet in your army of light.

NEWT
>Right. Well, off to Tadfield then.

SHADWELL
>Off ye go, Witchfinder Private Pulsifer. May the armies
>of glory march beside ye.

He salutes. Newt hesitates, then salutes him back.

419 EXT. STREET – DAY

*Newt is driving away. He turns on the radio. The music
begins . . .*

*He throws first the thumbscrew, then the firelighters out of
the window.*

A beat, and the car reverses.

*CLOSE UP as Newt drops the firelighters into a roadside
dustbin. He drives off . . .*

GOD (V.O.)

The world was changing. What Adam believed was true was beginning to happen in reality.

420 INT. TIBETAN TUNNEL – DAY

We see, in cross-section, like a glass-walled vivarium, a tunnel. A long tunnel, and then a space big enough for two people to sit.

The two people are Tibetan actors, speaking in Tibetan, with subtitles. A man and a woman, both middle aged. They have spades leaned against a wall. And they are on their tea break, drinking tea from bowls.

TIBETAN 2

We must tunnel and observe. We are secret masters.

TIBETAN 1

I run a nice radio repair shop in Lhasa. I just stopped for tea, and then I was here, dressed like this.

TIBETAN 2

Tell me about it. I was selling railway tickets in Shigatse . . . Oh! Tea break's over.

They pick up their shovels . . .

CUT TO:

421 EXT. TADFIELD VILLAGE – DAY

Newt is driving. He's heading into Tadfield, passing the village green . . .

As he drives he's talking to himself, doing different voices . . .

NEWT

Man with a pin. Nobody move, I've got a pin. I've got a pin, and I'm not afraid to use it . . . *Have Pin, Will Travel. The Pinslinger. The Man with the Golden Pin.*

The Pins of Navarone. Pins 'n' Roses . . .

And we pull back because, dear god, we are looking at a FLYING SAUCER, descending from the sky in front of us. It's a big silver classic saucer ship, like the Dalek saucers in Doctor Who.

Newt slams his foot down on the brakes. He looks up at the saucer. A door opens. Blue light floods out.

Three shadowy figures stand in the door. ALIEN TOAD. GREEN ALIEN. And THE PEPPERPOT, who looks like a cross between R2D2 and a Dalek.

A ramp comes down, and the Pepperpot waves its weapon arms, then zooms down it, and falls over at the bottom. It makes pissed-off beeping noises. The other two ignore it, and the alien toad steps over it. They walk like cops. In everything they do, they behave exactly like vaguely grumpy cops. NO VOICE TREATMENTS.

The toad raps on Newt's car window, and Newt winds it down. The green alien walks over to a tree. Kicks it. Takes a leaf and scans it with some alien complex gadget.

TOAD

Morning, sir, madam or neuter. This your planet, is it?

NEWT

Yes. I suppose so.

TOAD

Had it long, have we?

NEWT

Not personally. I mean, as a species, about half a million years. I think.

TOAD

Been letting the old acid rain build up, haven't we, sir? Been letting ourselves go a bit with the old hydrocarbons, perhaps?

NEWT

I'm sorry?

TOAD

Could you tell me your planet's albedo, sir?

NEWT

I don't know what that is.

TOAD

Well, I'm sorry to have to tell you, sir, that your polar ice caps are significantly below regulation size for a planet of this category, sir. We'll overlook it on this occasion, sir. The fact is, sir, that we have been asked to give you a message.

NEWT

Oh? Me?

TOAD

Message runs: 'We give you a message of universal peace and cosmic harmony an' suchlike.' Message ends.

NEWT

Oh. That's very kind.

TOAD

Have you got any idea why we have been asked to bring you this message, sir?

NEWT

Well, er, I suppose, what with Mankind's, er, harnessing of the atom and—

TOAD

Neither have we, sir. Neither have we.

He turns to go back to the saucer.

GREEN ALIEN

CO2 level up 0.5 percent. You do know you could find yourself charged with being a dominant species while

under the influence of impulse-driven consumerism, don't you?

NEWT

Sorry. Thank you! Sorry.

The aliens stop to pick up the fallen Pepperpot, and wheel him up the ramp.

Newt, stunned, dials Shadwell on his old mobile phone.

CUT TO:

422 INT. SHADWELL'S FLAT – DAY

Shadwell, baffled, on the phone in the hall.

SHADWELL

You what?

NEWT

I just got. Pulled over. By aliens.

SHADWELL

Did you count their nipples?

NEWT

I didn't think . . .

SHADWELL

You're a witchfinder. Not an alien . . . finder. But I'll . . . make a note of it.

423 EXT. TADFIELD LANE – DAY

Adam and co. are walking down the lane. They've bought ice lollies and such. Wensleydale is holding forth:

WENSLEYDALE

Actually, I don't know if this is in your *New Aquarium* magazines, but I was thinking, we ought to save the whales.

BRIAN

If we save enough do we get a badge?

PEPPER

That joke wasn't funny when your dad made it.

WENSLEYDALE

Whales can sing, actually. And they have big brains.
And there's hardly any of them left.

PEPPER

If they're so clever, what are they doing in the sea all
day, just swimming and eating things and singing and
oh my god I want to be a whale . . .

ADAM

Right. We'll save the whales, then.
(beat)
All of them.

424 EXT. THE WHALING SHIP KAPPAMAKI – DAY

A whaling ship goes past . . .

GOD (V.O.)

This is not a whaling ship. This is a scientific research
ship. Currently what it is researching is the question:
how many whales can it catch in a week?

*CLOSE UP: a ship's sonar or radar, green flashes, and the
numbers on it are changing . . .*

GOD (V.O.)

They are wondering about their instrument failure.
They've seen no whales on the radar, no tuna, nothing
bigger than an anchovy. And now the sea bottom
appears to be dropping . . .

425 INT. THE BRIDGE OF THE KAPPAMAKI – DAY

The captain is talking to the first mate in Japanese. (Subtitled.)

CAPTAIN
>It's impossible! It can't be dropping! The sea bottom cannot be 6000 metres, here.

We hear sonar pinging noise, slowly going crazy.

FIRST MATE
>No! It's an instrument error. It's rising again.
>>*(happily)*
>It's 1000 metres . . .
>>*(less happily)*
>500 metres . . . one hundred metres . . . thirty metres . . .

Everything in the bridge lurches, and the view out of the window rises, as if the ship is rising up into the air . . .

GOD (V.O.)
>Beneath the thunders of the upper deep, as Aziraphale and Tennyson both knew, *Far, far beneath in the abyssal sea, The kraken sleepeth.* And now it's waking up.

426 EXT. THE WHALING SHIP KAPPAMAKI – DAY

A long shot of the ocean, as if we are shooting it on a wobbly mobile phone: the kraken is rising, with the ship on top of it.

It's a mass of writhing tentacles and undulating hugeness, like some kind of enormous tentacled manta ray, and it keeps rising, and we realise how incredibly tiny the ship is in comparison . . .

GOD (V.O.)
>And a million sushi dinners cry out for vengeance.

427 INT. ADAM YOUNG'S HOME – DAY

Mr Young is watching the TV. The kraken shot that we've just seen is on it . . .

TV ANNOUNCER

Scientists have pronounced themselves baffled by the appearance of the enormous sea creature which the internet has begun to refer to as the kraken. It appears to be targeting whaling ships.

Mr Young looks at Mrs Young.

He looks down at the copy of New Aquarian *Adam left behind, with the kraken on the cover.*

428 INT. HELL – A ROOM

A basement office in Hell. It's a small, badly lit office with too many desks in it. We can't properly see the huddled figures at each desk.

Something disgusting and gelatinous is dripping from a broken pipe onto the desk in the foreground. It's collecting in a bucket on the desk.

Ligur lurks over to Hastur, who is standing at the desk, looking at the bucket.

LIGUR

I've been thinking. About Crowley. Something's not right.

HASTUR

Look at this. I'm meant to be getting ready to go to Megiddo to meet the boy. It all starts in the morning. Instead, I'm standing here with a bucket, waiting for maintenance to fix another bloody pipe.

LIGUR

If we win, we'll have the lovely view and the fancy offices, and the surviving angels can deal with the pipes and the buckets.

The bucket is full. Hastur tips the bucket out onto the ground. Green jelly drips out.

HASTUR

When we win. Not if. So. Crowley. What's Mister Slick done now?

LIGUR

Not sure. I know it's nothing good.

HASTUR

That's all right then. He's not meant to do good.

LIGUR

Figure of speech. Nothing bad, then.

Hastur is having trouble parsing this. He's still holding the bucket.

HASTUR

Nothing bad. So he's . . . not in trouble?

LIGUR

He's definitely in trouble. Or he will be.

HASTUR

We going in, then?

LIGUR

Not yet. We need proof. But as soon as we've got it, he's toast.

HASTUR

That's got to hurt.

LIGUR

Being toasted? Oh yes.

HASTUR

(satisfied)
Toast. Right. Back to Armageddon, then.

A glob of green jelly drips from a pipe onto his paperwork.

429 INT. JASMINE COTTAGE, KITCHEN – DAY

Anathema's phone alarm goes BING. She looks down at the reminder, checks a note card, then goes into the bathroom.

She comes back with bandages, a first-aid kit, and a bottle of aspirin. She lays them out on the table in an orderly fashion.

430 EXT. TADFIELD OUTSKIRTS – DAY

Newt has started driving again. He seems a bit shaken.

431 EXT. TADFIELD LANE – DAY

Newt is driving down the road, when . . .

CLOSE UP on Tibetan 1, whose head pops up out of a hole, and seems alarmed that something is heading for him.

432 EXT. TADFIELD LANE – DAY

Adam and the Them hear a screech and a CRASH.

Newt's Dick Turpin car is upside down. Wheels spinning.

The kids run to it. Adam pulls open the car door. Newt is hanging upside down . . .

Newt is semi-unconscious.

PEPPER
 We should call an ambulance.

WENSLEYDALE
 Actually, I think we shouldn't move him at all. Because of broken bones.

ADAM
 He's hurt. Come on. We should do something.

BRIAN

> We should get him away from the car. It might blow
> up. They do that on telly.

*Newt looks around blearily . . . Adam undoes the seat belt . . .
Newt gets out . . .*

NEWT

> Dick Turpin won't blow up. He's a good car. I bet
> you're wondering why I call my car Dick Turpin.

*And he woozily half-faints. The kids start to help him walk.
Adam glances over. The Tibetans look out of the hole at him,
catch his eye and then, embarrassed, lower themselves down
again.*

433 EXT. MEGIDDO – DAY

It's peaceful and beautiful. There's a jeep, or similar.

*Beside it, Hastur, smoking a roll-up. Several junior demons
behind him. One of them has a clipboard, and is trying to
brief Hastur. Two others are checking maps and tablets. The
same actor plays ALL the junior demons.*

JUNIOR DEMON

> The Four Horsemen of the Apocalypse will ride over
> the plain, towards us. And then our forces, I thought
> 'the Forces of Darkness' was a bit long, so I'm calling
> us 'Darkforce One', we rise up, pushing through the
> earth, while the opposition descend from above . . .

HASTUR

> *(unimpressed, ignoring the demon)*
> So this is Armageddon.

JUNIOR DEMON

> Well, that's the Greek name for it. Technically, the
> fields of Megiddo. Yes. Archeological excavations over
> there, avocado fields that way.

HASTUR
They grow avocados here?

JUNIOR DEMON
Yes.

HASTUR
And the end of the world.

JUNIOR DEMON
We have a joke. We say, that's going to be one big avocado.

Hastur grabs the junior demon by the throat. Crushing its windpipe.

HASTUR
I don't like jokes. I don't do jokes. And when people do jokes in my presence, they rapidly find themselves swallowing their tongues. No, tell a lie. It's mostly me that swallows their tongues. More fun that way.

The junior demon tries to speak but can't, just rolls on the ground, clutching its throat. Hastur looks at it, unimpressed. It vanishes, and its footprints are smoking.

HASTUR (CONT'D)
Next!

Another junior demon picks up the junior demon's fallen clipboard and steps forward.

HASTUR (CONT'D)
So what time do the boy and the hell-hound get here?

DEMON 2
About twenty minutes. The ambassador is here for a photo op with the ruins of the old temple. When they get here, our master's son will come into his own.

HASTUR
What's a photo op? Is it another joke?

DEMON 2
No, your disgrace. It's . . . Well, you know what a selfie is?

Hastur doesn't, and glares at him.

DEMON 2 (CONT'D)
I believe the demon Crowley invented them.

A beat, then Hastur is angry.

Where Demon 2 was is just a smoking torso and a fallen clipboard.

Demon 3 steps forward, hesitantly, picks up the clipboard.

DEMON 3
(gabbles a bit)
When all is ready, the boy and the dog and the Four Horsemen will converge here. And the boy will give the word. And Armageddon will begin.

HASTUR
One big avocado.
(He makes a terrible laughing noise)
Funny.

434 EXT. JASMINE COTTAGE – DAY

The Them are manhandling the semi-unconscious Newt up the garden path . . . Anathema comes out to watch them.

ADAM
Anathema! We found a man! He was in a car accident!

ANATHEMA
I know. Bring him inside.

The boys walk Newt into the house.

435 INT. JASMINE COTTAGE KITCHEN – DAY

Anathema picks up her first-aid kit. Pepper looks at Anathema, with all the bandages etc. laid out all ready. Pepper puts her head on one side. Dog is hanging around.

PEPPER

It's almost like you were expecting him.

ANATHEMA

I was. But I was hoping he'd be a bit more . . .

PEPPER

Hunky?

ANATHEMA

I think that's a bit sexist.

PEPPER

It's not sexist to describe our male oppressors as hunky . . . My mum says.

ANATHEMA

I was hoping he wouldn't come. If he didn't turn up . . . maybe none of it was real. But if he's here, then the Beast is real.

PEPPER

You mean Dog?

Anathema shakes her head and scratches Dog's ears. The boys come back . . .

BRIAN

He's asleep, Anathema.

Adam is looking around as if he can hear something. Anathema has some of her workings on the wall of the kitchen, and Adam finds himself staring at the picture of the Great Beast, the Antichrist, a demonic monster on Anathema's notice board.

ANATHEMA
> He won't wake up for half an hour. Would you kids like some sandwiches?

WENSLEYDALE
> I have a very nutritious lunch waiting at home. My mother likes me to come home with an appetite.

PEPPER
> Bye, Anathema. You coming Adam?

ADAM
> I didn't say you could go.

A beat. Everyone stares at him. Then he grins.

ADAM (CONT'D)
> See you after lunch.

The kids walk off.

436 EXT. TADFIELD LANE – DAY

Pepper, Brian and Wensley are walking down the lane.

BRIAN
> Adam's different.

PEPPER
> Don't be wet.

WENSLEYDALE
> Actually, that's why we like him. He's not boring.

BRIAN
> You know what I mean. You must do.

PEPPER
> He's Adam. He comes up with all the best games and the best ideas.

BRIAN
> But something's changed. He's not the same any more.

Can I say something stupid without you thinking it's
stupid . . . ?

PEPPER

No. If you say something stupid, I'll think it's stupid.

WENSLEYDALE

I won't think you're stupid, Brian.

BRIAN

I was scared he wouldn't let us go, just then.

PEPPER

That's stupid . . .

WENSLEYDALE

Actually, I felt that too. And I think you did as well,
Pepper.

They turn a corner.

*It ought to be innocent and sweet. Adam's waiting for them,
standing in the middle of the road, with Dog beside him.*

Then Adam smiles. And it's scary.

437 INT. JASMINE COTTAGE, BEDROOM

*Anathema steps into the bedroom, with a small tray, on it a
glass of water and some aspirin, and checks the clock. Looks
down at Newt and shakes her head a little. She'd been hoping
for something better. She's also counting down . . .*

*Newt is unconscious on the bed. He opens his eyes, groggily.
NEWT's POV – the room slides into focus. And there seems
to be someone at the end of the bed.*

ANATHEMA

How are we feeling?

Newt looks around the room, puzzled and dazed.

NEWT
Is my car all right?

ANATHEMA
Apparently. You banged your head. Nothing broken,
though.

NEWT
I swerved to avoid Tibetans in the road. At least, I
think I did. I've probably gone mad.

ANATHEMA
If you have, no one's going to notice. You're twenty
minutes late.

Newt raises his head, puzzled, then falls unconscious again.
Anathema shrugs.

438 EXT. MEGIDDO – DAY

A black limo draws up, with a jeep behind it with armed
soldiers in it.

The limo door opens: the American ambassador to the UK,
Mr Dowling, gets out, with Harriet, his wife, alongside a
GOVERNMENT GUIDE and, behind them, Warlock.
Warlock looks bored.

The Dowlings look around. An argument is still being
conducted sotto voce.

HARRIET DOWLING
Honey, I'm still not clear on what we're doing here.

TAD DOWLING
This is life as a diplomat. One moment you're in
London, the next, we're familially interfacing with Israeli
archaeological sites on a historical fact-finding vacation.

HARRIET DOWLING
But it doesn't make any sense.

TAD DOWLING

You don't argue with the State Department, hon.

HARRIET DOWLING

Is this because I said the President's wife looked like a
floozie? Because I never said that.

GUIDE

And this is our local guide to the archaeological site of
Megiddo – Mister . . .

*And it's Hastur. Who is not going to let anyone else upstage
him.*

HASTUR

I'm Hastur . . . La Vista . . . I'm an archaeologist . . .
which one of you is the ambassador?

TAD DOWLING

Thaddeus Dowling, at your service, my wife Harriet . . .

*But Hastur has ignored him, and the proffered handshake,
and made straight for Warlock.*

HASTUR

An honour! You must be Warlock.

WARLOCK

You smell like poo.

HASTUR

Funny boy. Always love a good joke, me. I've heard a
lot about you.

WARLOCK

I've heard you smell like poo.

But Hastur has noticed something . . .

HASTUR

. . . Where's the dog?

TAD DOWLING

So, Professor La Vista. I understand from our briefing that

Tel Megiddo was part of Tiglath-Pileser's administrative centre. The Assyrian kings fascinate me . . .

HASTUR

You. Shut up. Where's the dog? Why doesn't the boy have a dog?
 (to Warlock)
Do you hear voices? What are they saying? What are they telling you?

WARLOCK

The voices . . . in my head all say . . . that you smell like poo.

Hastur bites his fist in anger. It bleeds black blood.

439 INT. A CINEMA – DAY

Crowley is sitting alone, in a run-down cinema. The lights are out and a film is on. We can hear Carl Stalling-style cartoon music.

He's waiting for the end of the world. Out of time. Out of hope.

He smiles, despite himself, at the antics of something cartoony on the screen that we cannot see.

We see from his POV, preferably stop motion, but if not, people in costumes: THREE BUNNIES, dancing, holding up signs saying SATURDAY, MORNING and FUN TIME.

Then one of the bunnies jerks and pulls off its head. In the costume is Hastur.

HASTUR

What the, what the HEAVEN is going on, Crowley? What have you done?

CROWLEY

Mmm. Hastur. Hey. Not following you. How do you mean?

HASTUR

The boy called Warlock. We brought him to the fields
of Megiddo. The dog is not with him. The child knows
nothing of the great war. He is not our master's son.
He said I smelled of poo.

CROWLEY

You can see his point—

*On the screen, the cartoon Hastur, overcome with fury,
thrusts his fist into a bunny, which dies.*

HASTUR

You're dead meat. You're bloody history.

CROWLEY

Obviously the way you smell is a sensitive topic.

HASTUR

Stay where you are. We're coming to collect you.

*Hastur vanishes from the screen. The only surviving bunny
looks sadly at the dead bunny. He takes off his hat in respect.
Then he looks out of the screen, as if he doesn't know what
to do next, and waves sadly.*

A shot of the cinema seats. Crowley has left already.

440 INT. JASMINE COTTAGE, BEDROOM – DAY

*Newt opens his eyes. He rubs his head. Everything hurts. His
shoes have been taken off ...*

*At the foot of the bed is Anathema. She holds up his wallet
and his witchfinding kit. Opens a card ...*

ANATHEMA

You are Witchfinder Private Newton Pulsifer.
Apparently all magistrates are enjoined to give you as
much dry kindling as you need to burn any witches,
hags or beldames you discover.

NEWT

I'm not actually a real witchfinder. There aren't really any witches. I'm really . . . I'm a computer engineer. I just needed something to get me out of the house.

ANATHEMA

I'm Anathema Device. I'm really a witch. And here, you should read this. It will save time.

The storm is rising outside the cottage. Rain lashes the windows. Newt is looking at a card. We can see it has a prophecy typed up on it, and then notes in various hands annotating it. (See the book for examples.) Anathema has put all the cards, in a card-box, on the bed.

NEWT

(reading)
'When Robin's blue chariot inverted be, three wheels in the skye, a man with bruises be upon thy bed, achinge his head for willow fine . . .'

ANATHEMA

That's you. Your car crash. And the aspirin. Have you ever heard of Agnes Nutter?

NEWT

I'm afraid not.

ANATHEMA

She was an ancestress of mine. One of your ancestors burned her at the stake. Or tried to.

NEWT

Ancestors?

ANATHEMA

Thou-Shalt-Not-Commit-Adultery Pulsifer. It was a religious family. Ten children, named after the ten commandments. Covetousness Pulsifer, False-Witness Pulsifer . . .

NEWT

If I was called Adultery Pulsifer, I think I'd want to
hurt as many people as possible.

ANATHEMA

I think he just didn't like women. Your family obviously
has a tendency to burn mine. I took your matches . . .

NEWT

I'm not going to burn anybody!

ANATHEMA

I know. Agnes would have warned us if you were. She
wrote all of these prophecies in a book, published in
1655.

NEWT

She knew I was going to crash my car?

ANATHEMA

Yes. No. Well, yes. My family has been figuring
out Agnes's *Nice and Accurate Prophecies* for four
hundred years now. You could say we're professional
descendants.

NEWT

So how many prophecies are there?

Anathema points to the card box.

ANATHEMA

Several thousand. It averages out at about one
prophecy a month – more now, in fact, as we get closer
to the end of the world.

NEWT

And when is that meant to be?

Anathema looks over at the clock. Newt catches her glance.

NEWT (CONT'D)

Oh, come on! The world isn't really going to end today.

ANATHEMA

The end of the world starts here in Tadfield. This afternoon. According to Agnes. I just can't find it.

NEWT

It?

ANATHEMA

The Antichrist. The Great Beast. I've been searching for it. It's impossible to find.

She hands him a card.

NEWT

Where the Hogge's back ends the Young beast will take the world and Adams's line will end in Fire and Darkness . . . Hogge's back . . . Hang on. Hog's Back Lane . . . Adam Young?

Anathema looks at him like she's been hit.

ANATHEMA

What did you say?

NEWT

Adam Young. He lives at 4, Hogback Lane.

ANATHEMA

How did you . . . ? I should have . . . I didn't see that . . .
 (to Newt)
Adam. That's crazy . . . He's so sweet . . . He and his friends carried you here. He's the sweetest kid in the village. He's not the Beast at the end of the world . . .

CUT TO:

441 EXT. HOGBACK WOOD – DAY

Adam is leading the kids into Hogback Wood . . . they aren't entirely in control of where they are going.

ADAM

Come on.

PEPPER

Adam. We all have to go home for lunch.

ADAM

There's no point to going home.

BRIAN

But, my mum said I had to be there by one.

ADAM

It doesn't matter. That's all done now.

WENSLEYDALE

But we don't actually want to go with you.

ADAM

You do.

We can hear a weird whispering, as if of distant voices . . .

WHISPERY VOICES

. . . make it better . . . start again . . . tear it down and start again . . .

ADAM

You know why you're all coming with, Wensley? Because there's nowhere else to go. What's the point? What's going to be left when we grow up? Everywhere you look, there's all this environment going on. Everything's being killed or used up and no one takes it seriously. Everyone thinks somehow it'll all get better again. Where's the sense in that?

BRIAN

Adam. This is all wrong. I'm not going with you.

ADAM

But you are.

Brian realises it's true. They are all walking with Adam whether they want to or not.

WENSLEYDALE

It isn't actually funny.

PEPPER

Wensley's right. It's a stupid game. You're being weird.

ADAM

It's our job to make it . . . start again . . .

WHISPERY VOICES

(undercurrents all though this)

. . . make it better . . . start again . . . tear it down
and start again . . . make it . . . better world . . . start
again . . . from the beginning. Start again . . . from the
beginning . . .

PEPPER

What does that even mean? 'Start again?'

ADAM

Make it better. Do it right this time. That would be
good, wouldn't it? If we just burned it all up. And
started again. Right, Dog?

*Dog whines. He shakes his head. He does not want to go
back to Hell.*

442 INT. BENTLEY – LONDON STREETS – DAY

Crowley is driving. Fast. Angry. Radio Four is playing.

ANNOUNCER

. . . another chance to hear the late Sir Terry Pratchett's
musical selections on *Desert Island Discs*. And . . .

(slips into Hellvoice without missing a beat)

DAGON

Crowley, the troops are assembled, the Four Beasts are

riding. But where are they riding to? Something has gone wrong, Crowley. We trust you have a perfectly reasonable explanation for all this.

CROWLEY

Absolutely. Perfectly reasonable.

And he spies – no, it can't be – Aziraphale, walking disconsolately back to his bookshop.

Crowley pulls the car around, with a screech of brakes. He gets out of the car, at a rush, slamming the door behind him.

Meanwhile, the radio keeps talking, to nobody. We cut back to it intermittently . . .

DAGON

Your explanation, and the circumstances that will accompany it, will provide a source of entertainment for all the damned of hell, Crowley. Because no matter what agonies the damned are suffering, Crowley, you will have it worse. Crowley? Are you listening? Crowley?

In the street, Crowley grabs Aziraphale. Crowley thinks about something for a moment. Comes to a decision.

CROWLEY

I'm sorry. Apologise. Whatever I said. I didn't mean it. Work with me, I'm apologising here. Yes. Good. Get in the car.

AZIRAPHALE

What? No!

CROWLEY

Forces of Hell. They've figured out that it was my fault. We can run away, together. Alpha Centauri. Spare planets up there. Nobody will notice us.

Aziraphale shakes his head.

AZIRAPHALE

Crowley, you're being ridiculous. I'm quite sure that if I can just reach the right people, I can get all this sorted out.

CROWLEY

There aren't any right people. There's just God. Moving in mysterious ways and NOT TALKING TO ANY OF US.

AZIRAPHALE

Well, yes. That's why I'm going to have a word with the Almighty, and then the Almighty will fix it.

CROWLEY

That won't happen.
 (beat)
You're so clever. How can somebody as clever as you be so stupid?

Aziraphale decides not to be offended by this.

AZIRAPHALE

I forgive you!

Crowley jumps back in the car.

Aziraphale shrugs. Sets off again down the pavement when there is a sound of a car hooting. He turns round to see Crowley leaning out the window. Crowley's shouting.

CROWLEY

I'm going home, angel. I'm getting my stuff. And I'm leaving. And when I'm off in the stars, I, I won't even think about you!

Aziraphale looks hurt. A PASSER-BY stops to console him.

PASSER-BY

I've been there. You're better off without him.

443 EXT. A CARPARK – DAY

There is nothing in the carpark but a GLEAMING RED MOTORBIKE.

A red helmet sits on the seat, and red gloves. One of the gloves is on the ground.

And there are three friends talking — JACKIE and her BOYFRIEND, and their MALE FRIEND. They are happy, and the woman and her boyfriend are very much in love. She's possibly even showing her engagement ring to the friend.

A figure in scarlet walks over to the bike. It's WAR, wearing the red hair we saw her in as a war correspondent. She puts on one of the gloves, looks around for the other.

Both the boyfriend and the friend have noticed, and they race towards the fallen glove, trying to be the one who gets it to War.

The friend gets there first; the boyfriend stamps on his hand to grab the glove but . . .

Jackie elbows him hard in the face and sends him flying as she snatches the glove from his hand and tosses it to War.

War catches it, smiles a thank you, and puts it on.

Then War puts on her helmet and drives her bike away, while in the background the three former friends continue to beat each other senseless.

444 EXT. CROWLEY'S FLAT – DAY

Crowley pulls up outside the flat.

RADIO VOICE
 Crowley. Stay where you are. You will be collected.

He scans the street. No sign of anyone following.

445 INT. CROWLEY'S FLAT – DAY

He's through the door of his flat, checking his watch, talking to himself . . .

CROWLEY
 They'll be here any moment . . .

He picks up a plant mister, and mists a green plant with it.

446 INT. CROWLEY'S FLAT, KITCHEN – DAY

He gets a large plastic bucket from under the sink. He's still got the plant mister. He puts it into his jacket pocket.

447 INT. CROWLEY'S OFFICE – DAY

He looks at the framed Mona Lisa sketch hanging on the wall. Reaches up for it.

The Mona Lisa swings open, revealing a safe. Crowley is turning the dial. He looks nervous. The door opens.

He reaches into the safe, takes out two arm-length rubber gloves, and a big rubber apron. Puts them on, hurrying like someone stressed in a caper movie.

Crowley takes out the dusty Thermos flask – it's the tartan Thermos flask that Aziraphale gave him in Episode Three. Then gets the tongs from the safe.

448 EXT. CROWLEY'S FLAT – DAY

Hastur and Ligur ring the doorbell.

449 INT. CROWLEY'S OFFICE – DAY

He takes the top of the Thermos off, using the tongs.

It's a careful procedure. If he sweated, he would sweat now. The doorbell rings.

450 INT. CROWLEY'S FLAT – DAY

The last drop of water drips from the Thermos into the bucket.

The sound of the front door being knocked down, downstairs . . .

Crowley winces. Then he carefully opens the office door.

451 INT. CROWLEY'S OFFICE – DAY

Crowley is standing on a chair and carefully balancing the bucket on top of the door, which is about eight inches ajar.

We hear a muffled old lady scream from downstairs. Crowley looks sympathetic.

Then Crowley scans the room: a desk with a telephone with answering machine attached. Chair behind it. He takes the plant mister from his pocket. Sprays a green and luxurious plant with it. A drop of water glistens in ECU. Then he puts the mister down on the table.

452 INT. CROWLEY'S FLAT

The main door is kicked open. Ligur and Hastur walk in, Ligur in front.

HASTUR
 Crawleeeee . . .

LIGUR
 We only want a little word with you . . .

HASTUR
 We know you're here somewhere . . .

LIGUR
 Crawleeee . . .

453 INT. CROWLEY'S FLAT – DAY

Crowley is settling himself behind the desk. He's removed the apron already. Now he's pulling off the PVC gloves. He looks nervous.

He moves the plant mister so it's next to him on the table. Then he puts on a relaxed and casual face.

CROWLEY
In here, people.

454 INT. CROWLEY'S FLAT – DAY

And Ligur is in front. He pushes forward into Crowley's office . . .

455 INT. CROWLEY'S OFFICE – DAY

In slow motion, the bucket on the top of the door falls, comically, onto Ligur's head.

Ligur peels and flares like a lump of burning sodium. Oily brown smoke oozes from him, and he screams. Then he crumples, folds in on himself, and what's left lies glistening on the burnt and blackened circle of carpet, looking like a handful of mashed slugs.

Crowley is relaxed.

Hastur is standing in the open doorway, looking at the remains of Ligur in horror.

CROWLEY
Hi.

HASTUR
Holy water. I can't believe even a, a demon would . . .
Holy water . . . He hadn't done nothing to you!

CROWLEY
Yet.

Crowley raises the green plastic plant mister, and sloshes it around threateningly.

CROWLEY (CONT'D)
Go away.

HASTUR
You don't frighten me.

In extreme close up. A drip of water on the nozzle slides slowly down the side of the plant mister.

CROWLEY
Do you know what this is? This is a plant mister, cheapest and most efficient on the market today. It can squirt a fine spray of water into the air. It's filled with holy water. It can turn you into that. Now go away.

The drip reaches Crowley's fingers. Hastur is watching this.

HASTUR
You're bluffing.

CROWLEY
Maybe I am. Maybe I'm not. Ask yourself. Do you feel lucky?

Hastur gestures and the plant mister dissolves, soaking Crowley.

HASTUR
Yes. Do you? Time to go, Crowley.

The phone on Crowley's desk rings. Crowley is desperate . . . In the background, we can hear Crowley's voice on the outgoing message:

CROWLEY (V.O.)
Hey, this is Anthony Crowley. You know what to do. Do it with style.

CROWLEY

> Don't move. There's something very important you
> need to know before you disgrace yourself.

Aziraphale's voice comes from the machine . . .

AZIRAPHALE (O.S.)

> Um. It's me. Listen . . .

Crowley quickly picks the phone up.

CROWLEY

> Hello? I . . . uh. This isn't a good time. I've got an old
> friend here.

AZIRAPHALE

> But—

*Crowley puts down the phone. Then he smiles like a
lighthouse burning or a TV quizmaster. He addresses the
room, like someone talking to hidden cameras.*

CROWLEY

> Well, you have definitely passed the test! You are ready
> to start playing with the big boys!

HASTUR

> You've gone mad.

CROWLEY

> The Lords of Hell had to know that you were
> trustworthy before we gave you command of the
> Legions of the Damned, in the War ahead. And
> Hastur, Duke of Hell, you've come through with flying
> colours!

Hastur isn't certain that Crowley's bluffing . . .

*Crowley pulls out his mobile phone. Hits a button, and it
starts to dial . . .*

CROWLEY (CONT'D)

> I wouldn't expect you to believe me, Duke Hastur. But

why don't we talk to the Dark Council. Let's see if they
can convince you . . .

HASTUR
You're calling the Dark Council?

*We hear Crowley's mobile phone dialling and being put
through. And then he looks at Hastur and says:*

CROWLEY
I am! And they say . . . So long, Sucker . . .

And he's gone.

The phone clatters to the desk.

*Hastur screams, hatred and anger. And then he's gone too.
And we can hear the phone on the desk ringing.*

GOD (V.O.)
You're probably wondering where Crowley has gone.
Demons aren't bound by physics.

456 ANIMATION

We are looking at a schematic diagram of an angel.

GOD (V.O.)
Over the years a huge number of theological man
hours have been spent debating the question:
How many angels can dance on the head of a pin?

*Next to the angel design appears a large pin. It moves about
in a 360-degree animation.*

GOD (CONT'D)
To answer it, we need information. Firstly, angels don't
dance. It's one of the distinguishing characteristics that
marks an angel. So, none.

*And then the schematic diagram of the angel changes to a
schematic diagram of Aziraphale.*

GOD (CONT'D)

>At least, nearly none.

457 INT. GENTLEMAN'S CLUB – DAY – 1890s

Unmoving camera. Scratchy black and white, an ancient silent movie – What the Butler Saw-style – with a piano soundtrack. Aziraphale and MALE DANCERS, doing a gavotte together. (I'd use the music of Gilbert and Sullivan's 'I am a Courtier Grave and Serious' from The Gondoliers.)

All the dancers are Victorian men, tall and short, fat and thin, young and old. Aziraphale looks ridiculously pleased with himself.

GOD (CONT'D)

>Aziraphale had learned to gavotte in a discreet gentlemen's club in Portland Place, in the late 1880s. After a while he had become fairly good at it, and was quite put out when, some decades later, the gavotte went out of style for good. So providing the dance was a gavotte, the answer is a straightforward *one*.

The angel schematic is replaced by a demon schematic. The demon (which could be Crowley, or Hastur) is disco-dancing very badly.

GOD (V.O.)

>Then again, you might just as well ask how many demons can dance on the head of a pin. They're of the same original stock, after all. And at least demons dance. Not what you'd call good dancing, though.

There is a pin. The demon stays the same size as the pin seems to come towards us, getting huger and huger . . . And now it's back to reality:

GOD (CONT'D)

>For demons, or for angels, size and shape are simply options. So, if you look from really close up, the only

problem about dancing on the head of a pin is all those big gaps between electrons.

We are looking at Crowley's phone, falling from his hand. And we SLAM into the mouthpiece of the phone . . .

GOD (CONT'D)
That's where Crowley has gone. That's where Hastur is following. Right now they are both travelling incredibly fast through the telephone system. Which means that Hastur, Duke of Hell, is now trapped on a tape inside Crowley's antique telephone answering machine.

And inside the phone, still moving fast, we are in the INTERNET.

458 INT. THE INTERNET

It's unbelievable. We are looking at the internet – or a pictorial/animated representation of what the internet might look like from the inside. It's all images zooming past at incredible speed – there's PORNOGRAPHY and CAT PICTURES, there's someone FACE-TIMING THEIR MUM, there are NUMBERS like The Matrix and what appears to be THE COMPLETE WORKS OF SHAKESPEARE going by . . . And a whooshing soundtrack of music and voices, and something's coming towards us . . . A tiny black dot getting bigger . . .

It's Crowley! He looks like he's having too much fun. He's zooming towards us . . .

He glances, worried, back over his shoulder . . .

HASTUR
CROOOOOOOWWWWWWLLLLEEEYYYYYYY!

And Hastur is behind him, heading towards him.

HASTUR (CONT'D)

You can't escape me! Wherever you come out, I'll come out too!

And Crowley looks slightly worried now.

In the distance we can still hear a phone ringing. The phone on Crowley's desk.

Hastur looks triumphant. The gap is closing. Crowley looks TERRIFIED . . .

And then we realise Crowley is counting.

CROWLEY
(to himself, silently)
Three . . . two . . . one . . .

459 INT. CROWLEY'S OFFICE – DAY

Crowley, out of breath and disarrayed, appears beside the desk again.

As he does, the answering machine on the phone on his desk clicks on.

CROWLEY (V.O.)

Hey, it's Anthony Crowley. You know what to do. Do it with style.

And we hear a voice coming out of the answering machine . . .

HASTUR

Crowley? Where are you, you little runt? I heard your voice. It's dark in here. Where am I? Oh no. You wouldn't dare. You SNAKE!

And Crowley presses OFF on the answering machine. He grins. There's a rumble of THUNDER . . .

460 EXT. A SOHO STREET – DAY

*Grey weather gusting. Aziraphale is heading down the street,
looking harried and as if he is carrying the weight of the
world on his shoulders. Which he is.*

*Three angels step out of the shadows. Michael, Uriel and
Sandalphon. They are all wearing sharp suits. Michael is in
the lead.*

MICHAEL

Hello, Aziraphale.

AZIRAPHALE

Oh. Michael. Sandalphon. Uriel. Hello, um.

MICHAEL

We've just been learning some disturbing things about
you – you've been a bit of a fallen angel, haven't you?
Consorting with the enemy . . . ?

AZIRAPHALE

I – I – I haven't been consorting. Just exchanging
information. Trying to stop this all from happening.

SANDALPHON

You know how we treat traitors in wartime?

AZIRAPHALE

I'm not a—

URIEL

Terrible choice. Don't think your boyfriend in the dark
glasses can get you special treatment in Hell. He's in
trouble too.

MICHAEL

Aziraphale, it's time to choose sides.

AZIRAPHALE

I've actually been giving this a lot of thought. The whole
choosing sides thing. What I think is, there obviously
has to be two sides. That's the whole point. So people

can make choices. That's what being human means.
Choices! But that's for *them*. Our job, as angels, should
be to keep all this working, so *they* can *make* choices.

URIEL

You think too much.

*Michael nods, smiles, beatifically, and Sandalphon punches
Aziraphale, hard, in the solar plexus. Aziraphale goes down.
He's out of condition.*

*Uriel reaches down, hauls Aziraphale up and slams him
against a wall. Blood on Aziraphale's lips.*

AZIRAPHALE

You . . . mustn't. Why would you *do* this? We're the
good guys.

MICHAEL

You've been down here too long.

Aziraphale takes a few steps away from them.

AZIRAPHALE

I have to warn you, I – I'm going to take this entire
interaction up with . . . a higher authority.

*A gust of huge wind blows newspapers past them and
dustbins blow over . . .*

Distant heavenly horn sounds.

URIEL

You really think upstairs would take your call? You're
ridiculous.
 (he looks up)
Oh, this is great, it's starting . . .

*The angels vanish in a burst of light and a little heavenly
music.*

Aziraphale wipes the blood from his lips.

AZIRAPHALE
(resolutely not swearing)
You. You *B . . . AD* angels.

461 EXT. HOGBACK WOOD – DAY

The storm is rising. Adam is sitting where he usually sits, but now it's like a throne.

The other kids are gathered around like courtiers. It's not good . . . Adam is in his own world. The whispering satanic voices are still whispering.

Dog is miserable and whining. The expressions on the faces of Pepper and Wensleydale and Brian are hurt and scared.

PEPPER
Adam. We want to go home. I'm hungry. Please . . .

Adam is almost entirely unaware of them as people. He is their lord, lecturing them.

ADAM
Seems to me it'd serve everyone right if all the nuclear bombs went off and it all started again, only properly this time. And then we could sort everything out.

PEPPER
If there's all these bombs going off, people get killed. Speaking as a mother of unborn generations, I'm against it.

ADAM
You'd all be fine. I'd see to that. It'd be wicked, eh, to have all the world to ourselves. Wouldn't it? We could have amazing games. We could have War with real armies.

WENSLEYDALE
But there wouldn't actually be any people. They'd all be dead.

ADAM

Oh, I'm going to make us some new people.

BRIAN

Adam, please let us go home. I want my mummy and my daddy.

ADAM

No. I'll make you new mummies and daddies.

The wind is howling around them.

BRIAN

Please! Adam!

PEPPER

Adam? What are you doing?

And Dog is howling . . .

ADAM

I've got friends coming soon. You'll like them. They are a lot like you. They're going to help me make it all stop.

WENSLEYDALE

Actually, Adam, please, I can't move. I don't like this game.

ADAM

You wait. It's going to be *wicked*.

462 EXT. TADFIELD LANE – DAY

There's a storm brewing. The sky is darkening. The trees are whipping back and forth.

463 INT. JASMINE COTTAGE, BEDROOM – DAY

Newt and Anathema. He's pulling on his clothes, and he seems quite determined.

NEWT

Um. Why 'Nice and Accurate' prophecies? They don't seem very nice to me.

ANATHEMA

Nice as in exact or precise.

NEWT

Ah. Look, I don't think the world is really going to end. Why don't we, um. Go for a walk, and get to know each other.

ANATHEMA

I'm psychic. Trust me. It's true. But I don't get it. There isn't any evil here. Something loves this place, so powerfully that it shields and protects it. How can anything bad start here? But this is where it starts.

NEWT

Okay. So we find this Adam. And then what do we do?

ANATHEMA

Stop him. He's bringing Armageddon.

NEWT

So we . . . ask him nicely to stop?

ANATHEMA

I don't know. Agnes doesn't say. She goes off on stuff about you and me.

NEWT

Like what?

ANATHEMA

Stupid stuff. You don't want to know. Hogback Lane isn't far from here . . .

Newt hesitates, then puts on his Witchfinder Army jacket . . .

464 INT. JASMINE COTTAGE, FRONT ROOM – DAY

They are heading for the front door. We hear the sound of a howling wind outside.

NEWT

 Sounds like the weather's turning bad.

ANATHEMA

 She did say he bringeth the storm.

Newt opens the front door. It's whipped open. Through the open door we can see a TORNADO is hitting Tadfield.

Newt, in front of Anathema, shouts as the wind whips him forward, and pulls him up.

Anathema, thinking quickly, grabs the archway around the door.

ANATHEMA (CONT'D)

 Hold on!

NEWT

 I'm not an idiot.

Behind them, a small tree is pulled up, and spirals off into the sky.

NEWT (CONT'D)

 You don't get tornadoes in England.

ANATHEMA

 Prophecy 691. We do today. The wind should drop in
 a few seconds, then redouble. We'll have less than a
 minute to get inside the house and under cover before it
 starts again. Got it?

NEWT

 I don't bel— yeah, got it.

The wind drops. Anathema catches Newt. They hurtle into the house and slam the door behind them.

465 INT. JASMINE COTTAGE, BEDROOM – STORM, DAY

Newt and Anathema come in at a run.

NEWT

> Under the bed!

And as they slide under the bed at a rush, all the windows of Jasmine Cottage burst inward from the wind. It's scary . . . And Anathema and Newt are getting physically closer together . . .

NEWT (CONT'D)

> This is insane. Tornadoes don't happen here. Did Agnes say what we're meant to do next?

One of the cards in the air falls down into Anathema's hands.

She looks at it, shrugs, hands it to Newt. We hear Agnes's voice:

AGNES NUTTER (V.O.)

> *Lette the wheel of Fate turne, let harts enjoin, there are othere fyres than mine; yet when the whirl wynd whirls, reach oute one to anothere.*

NEWT

> 'reach out to one another . . .' She means . . . ? I'm not sure that I've ever . . .

ANATHEMA

> You must have.

NEWT

> Nope. The world is about to end, and I've never robbed a bank, I've never had a parking ticket, I've never eaten Thai food, I've never been abroad, I've never learned to play a musical instrument, I've . . .

ANATHEMA

> Never kissed a girl?

Newt looks like he's going to protest. Then he shakes his head in agreement.

NEWT
　　Not even once.

A huge CRASH, sounding like part of the cottage is blowing down . . .

And they, involuntarily, REACH OUT FOR EACH OTHER. Hold each other tight.

They look at each other, startled. And then they move together, and their lips meet as we pull away . . .

466　EXT. JASMINE COTTAGE FROM ABOVE – STORM, DAY

We see Jasmine Cottage from above. And we are pulling up and away, now looking at Tadfield, now southern England, now the whole of the UK, still centred on Jasmine Cottage and we . . .

DISSOLVE from the reality of the satellite view to AN ANCIENT AND STAINED AND RATHER TORN AND TAPED-UP MAP, with a pin in it where Jasmine Cottage would be.

467　INT. SHADWELL'S FLAT – DAY

The pin goes PING! And flies out of the map.

Shadwell looks puzzled. He leans down, picks up the pin, pushes it into the map once again.

Outside, the thunderstorm is just beginning to rumble. Madame Tracy comes in, with tea.

MADAME TRACY
　　Made you a cup of tea.

Shadwell says nothing. Stares at the map and the pin.

MADAME TRACY (CONT'D)

 I made it just the way you like it. Nine sugars and condensed milk.

SHADWELL

 Awa' wi' ye, ye murrain plashed berrizene.

Madame Tracy blushes.

MADAME TRACY

 Oh, Mr Shadwell. You say the nicest things.

Shadwell realises that he may have done something bad . . .

SHADWELL

 I sent him into the jaws of doom.

MADAME TRACY

 Who?

SHADWELL

 Private Pulsifer. He's just a lad. I let him go alone. I should have gone with him.

MADAME TRACY

 He's just having a nice day out.

Shadwell shakes his head and points to the pin. It's glowing red-hot. A wisp of smoke is coming out from the place the pin goes in.

MADAME TRACY (CONT'D)

 That's . . . unusual.

SHADWELL

 I'm a bad man and a worse Witchfinder Sergeant. I canna believe I let him go. I should go to him.

MADAME TRACY

 There's the train to Tadfield.

SHADWELL

 I can't get there on my bus pass . . . There aren't the funds for a train ticket . . .

Madame Tracy reaches into her cleavage and removes a small roll of banknotes. She counts out twenty-five pounds. Shadwell ignores it.

SHADWELL (CONT'D)

I will not travel on the wages of harlotry and ghost-raising.

MADAME TRACY

You'll need an extra five pounds for a sandwich and a coffee . . .

SHADWELL

(*mutters rapidly under his breath to avert temptation*)
There shall not be found among you any one that useth divination, or an enchanter, or a witch. Or a charmer, or a consulter with familiar spirits, or a wizard, or a necromancer. For all that do these things are an abomination unto the LORD.

Madame Tracy doesn't know what to say. And then the pin explodes from the map, which begins to burst into flame.

Shadwell throws his tea at the map, putting out the flame. Madame Tracy puts her money back into her cleavage.

MADAME TRACY

If you won't take it from me, what about one of those nice men who call up?

SHADWELL

Mister Crowley won't pay in advance. I think he's mafia. But the southern pansy in the bookshop might be a soft touch. Aye. He's got money . . . Even now young Pulsifer could be suffering unimaginable tortures at the hands of the daughters o' night. I cannot imagine what he's going through.

468 INT. JASMINE COTTAGE, BEDROOM – STORM, DAY

A hurricane is going through the bedroom, cards and everything else flying through the air. And under the bed, Newt and Anathema are making out, passionately and urgently. Newt suddenly pulls back and says:

NEWT
But shouldn't we, have dinner or something first . . . ?

ANATHEMA
Shhh . . . No time . . .

And she kisses him again.

469 INT. SHADWELL'S FLAT – DAY

Shadwell grabs an ancient and unpleasant hat, tips out the cigarette ends and puts it on his head. He nods.

SHADWELL
We cannot leave our people in there. They could be doing all manner of things to him, right this moment!

MADAME TRACY
I don't think it'll be the end of the world if they do, Mr S.

But he's slammed the door.

470 INT. JASMINE COTTAGE, BEDROOM – DAY

Anathema and Newt are making love under the bed, while prophetic filing cards blow around the room. Arms and legs can be seen coming out from under the bed, holding on to the bedlegs. It's very PG and very passionate.

471 INT. HOGBACK WOOD – STORM, DAY

Adam is now standing above the others and is talking. Pepper is angry, and Wensleydale and Brian are whimpering.

As we pull back, we realise that Adam is standing ON THE AIR, about a foot or two above the others.

WENSLEYDALE
We. Please. Adam. We have to go home.

ADAM
This is your home! Here! With me. You don't have to go home or go to school or anything. Or do anything you don't want to do, ever again.

Brian looks from Wensleydale to Pepper . . .

PEPPER
Adam! Stop it! Stop it, stop it, stop it!

Adam gets angry, and a little scared . . .

ADAM
Shut up! Stop talking! You all have to stop talking now! Everybody! Stop talking!

There's a sparking around their faces. And now they have no mouths . . .

472 EXT. SHADWELL'S FLAT – DAY

The bad weather has started. Shadwell's hat blows off. He looks worried. He picks up his hat.

He gets on a bus . . .

473 EXT. AZIRAPHALE'S BOOKSHOP – DAY

Rain splashes the outer window. Aziraphale hangs up a CLOSED sign.

474 INT. AZIRAPHALE'S BOOKSHOP, BACK ROOM – DAY

Aziraphale pulls back a rug. There's a circle painted on the wood under the rug, a cabalistic circle filled with symbols.

He grabs some candelabras, lights the candles, puts them around the circle. Then he stands with his hands together.

AZIRAPHALE

Hello. This is the Principality Aziraphale. I'm looking for . . . um. A Higher Authority. Is there anybody there?

A moment of silence. We hear a knock on the door in the background.

AZIRAPHALE (CONT'D)
 (calls out)
We're closed!
 (to the circle)
This really is frightfully important. I'm prepared to take this all the way to the top.

And suddenly the circle flares, and fills with light. And a HUGE FACE appears, filling the room.

AZIRAPHALE (CONT'D)
I need to speak to the Almighty.

METATRON
Speak, Aziraphale.

AZIRAPHALE
Is that . . . am I speaking to . . . God?

METATRON
You are speaking to the Metatron, Aziraphale. To speak to me is to speak to God. I am the voice of the Almighty.

AZIRAPHALE
Well, yes. But you're the voice of the Almighty in the same way a presidential spokesman is the voice of the president. I actually need to speak directly to God.

METATRON
What is said to me is said to the Almighty.

Aziraphale does not believe this.

METATRON (CONT'D)
　Well, Aziraphale?

AZIRAPHALE
　I want to complain about the conduct of some angels.
　But the important thing is, the Antichrist. I know who
　he is, I know where he is.

METATRON
　　(flatly, unimpressed)
　Good work, well done.

AZIRAPHALE
　So there doesn't need to be any of that nonsense with
　a third of the seas turning to blood or anything. There
　needn't be a war. We can save everyone.

METATRON
　The point is not to avoid the war, it is to win it.

AZIRAPHALE
　Ah. Hmm. What sort of initiating event will precipitate
　the war?

METATRON
　We thought a multi-nation nuclear exchange would be
　a nice start.

AZIRAPHALE
　　(hopelessly)
　Very imaginative.

*And we look through the open door to the back room, all the
way through the bookshop, to the front door, and the open
letterbox, and close in on a pair of angry eyes. SHADWELL's.*

*And then REVERSE the shot: we see the bookshop, and
beyond that, Aziraphale talking to a giant head in a roomful
of light . . .*

METATRON
>You also wished to complain about the poor conduct of some angels?

AZIRAPHALE
>Not really much point, now.

METATRON
>The battle commences, Aziraphale. Join us.

AZIRAPHALE
>In a jiffy. Two shakes of a lamb's tail. Just a couple of things left to tie up.

METATRON
>We will leave the gateway open for you, then. Do not dawdle.

AZIRAPHALE
>Jolly . . . jolly good . . .

The Metatron vanishes. But the etherial light that fills the circle does not completely vanish. There's a weird, musical humming noise that lingers too.

AZIRAPHALE (CONT'D)
>Is, um, anyone still there?

No answer. Aziraphale carefully walks around the circle. He picks up the telephone from the desk, and dials.

475 EXT. AZIRAPHALE'S BOOKSHOP – DAY

CLOSE UP on Shadwell's hands, using his skeleton key on the lock.

476 INT. AZIRAPHALE'S BOOKSHOP – DAY

Aziraphale is on the phone. We hear it ringing.

We hear the TING of a shopbell, as someone opens the door, very quietly. But Aziraphale doesn't notice.

We hear the phone being answered.

CROWLEY (V.O.)
> Hey.

AZIRAPHALE
> Hello. I know where the Anti—

CROWLEY (V.O.)
> This is Anthony Crowley.

AZIRAPHALE
> I know who you are, you idiot, I telephoned you!
> Listen . . .

CROWLEY (V.O.)
> You know what to do. Do it with style.
>> *(BEEP)*

AZIRAPHALE
> Um. It's me. Listen . . .

There's a click. It might be easier for people to follow the chronology if we CUT BACK TO Crowley and Hastur, in the scene we have seen, as Crowley says . . .

477 INT. CROWLEY'S OFFICE – DAY

CROWLEY
> Hello? I . . . uh. This isn't a good time. I've got an old
> friend here.

AZIRAPHALE
> But . . .

478 INT. AZIRAPHALE'S BOOKSHOP – DAY

But there is a roar from behind Aziraphale, and he drops the phone.

Shadwell is advancing.

SHADWELL

You foul fiend! In league with the forces of darkness!

AZIRAPHALE

No! Sergeant Shadwell . . . ?

SHADWELL

You monster. Seducing women to do your evil will!

AZIRAPHALE

I think perhaps you've got the wrong shop.

SHADWELL

You are possessed by a DEMON! And I will exorcise
you with bell, book and candle!

AZIRAPHALE

Yes, fine, but please, keep away from the circle. It's still
powered up . . .

SHADWELL

BELL!

*He slams his hand down on the little hotel-style ding-for-
service bell. It DINGS.*

AZIRAPHALE

I'm honestly not a demon. I don't know what you think
you saw, but . . .

Shadwell picks up the copy of The Nice and Accurate
Prophecies *and slams it down on the table.*

SHADWELL

BOOK!

*Shadwell sees the candles burning around the circle. He
heads for them, but Aziraphale's body blocks him . . .*

AZIRAPHALE

Please! You *must* keep away from the circle . . .

Frustrated in his attempt to get the candle, Shadwell pulls an

ancient zippo-style cigarette lighter out of his pocket, flicks it alight and thrusts it at Aziraphale . . .

SHADWELL
Practically a candle!

AZIRAPHALE
Look, the circle is still on, and it would be very unwise for you to step into it without proper precautions, whatever you think you've seen just don't cross the circle, you stupid man . . .

SHADWELL
By the powers invested in me as a duly appointed Witchfinder, I charge ye to quit this place and return henceforth to the place from which ye came, and deliver us from evil, returning nae more!

And Shadwell puts away his lighter and sticks out a pointing finger. Aziraphale is working hard to keep Shadwell from stepping into the circle.

And then . . . Aziraphale looks like something bad has happened.

He looks down.

We see that he is himself STANDING IN THE CIRCLE OF LIGHT. Shadwell is pointing his finger at Aziraphale, like a gun. Aziraphale swears for the first time in 6,000 years.

AZIRAPHALE
Oh . . . fuck.

The humming noise becomes a loud rushing noise, and Aziraphale VANISHES. The light goes out in the circle. There's nothing left but the flickering candles . . .

SHADWELL
Hello? Hello?

He reaches out his left hand, and lowers his right hand with

its pointing finger, as if it's just shot someone. He never expected such a thing to happen.

A beat and he panics, and runs, slamming the door HARD behind him.

The slam of the door makes a burning candle fall over. The burning candle rolls into a pile of Aziraphale's papers, which begins to burn . . .

And over that we hear children singing Buddy Holly's 'Everyday', Langley-School-music-project-style, as we . . .

FADE TO BLACK.

EPISODE FIVE

THE DOOMSDAY
OPTION

501 EXT. SOHO – STORM, DAY – PRESENT DAY

Storm clouds so dark it might as well be night. The city is alive with the clanging of fire engines and police sirens.

Crowley is driving towards us, and he's angry. And he's scared. But he's Crowley, so he's trying as hard as he can to play it cool.

We hear an engaged telephone tone, and the message THE NUMBER YOU HAVE CALLED IS CURRENTLY BUSY; *or something similar.*

502 INT. AZIRAPHALE'S BOOKSHOP – DAY

We see a telephone off the hook, and hear a repeated recorded message on the lines of: 'If you wish to make a call, please hang up and dial again.' Smoke is drifting past it.

503 INT. CROWLEY'S BENTLEY/EXT. AZIRAPHALE'S BOOKSHOP – DAY

Crowley gives up on the phone. He drives past a fire engine, and then sees Aziraphale's bookshop. Efficient FIREFIGHTERS are unrolling hoses, getting ready to storm the building, from which smoke is pouring.

Crowley's car rides up onto the pavement and pulls up with a screech of brakes. He gets out, and is intercepted by a firefighter.

FIREFIGHTER

Are you the owner of this establishment?

CROWLEY

Do I look like I run a bookshop?

FIREFIGHTER

Appearances can be deceptive. I, for example . . . Hey!
You can't go in there!

*Crowley has pushed his way through the firemen, reached the
door, and as he reaches it, it OPENS without him touching
it, to reveal an inferno inside . . .*

FIREFIGHTER (CONT'D)

Stop him!

Crowley walks inside.

504 INT. AZIRAPHALE'S BOOKSHOP – ON FIRE

*Smoke fills the place. One wall is already burning. Crowley is
trying, still, to play it cool . . .*

CROWLEY

Aziraphale! Aziraphale! Where the Heaven are
you? You idiot. Aziraphale! For Go— for Sa— for
SOMEBODY'S SAKE, where ARE you?

We hear rumblings as things fall . . .

*Crowley looks around desperately. Behind him a window
smashes . . .*

*A firehose spurts water through the window, into the inferno,
and straight into Crowley.*

Crowley is knocked backwards, into the flames.

*Out of the fire, he gets to his feet . . . His hair is a mess. His
dark glasses have been knocked off, revealing his real eyes,
yellow and slitted like a snake's. His face is filthy. His clothes
are burned and ripped, and he is angry and upset.*

CROWLEY (CONT'D)
> *(on the verge of tears)*
> Aziraphale?

He picks up dark glasses and puts them on. They are melted, and the glass is shattered, and they are ridiculous.

CROWLEY (CONT'D)
> Right. I'm done. I've had it. I don't care about any bloody angels or humans or anyone. I hate you all. Somebody killed my best friend, and I don't even care who did it. Bastards, all of you.

And he looks down, and sees . . . The Nice And Accurate Prophecies of Agnes Nutter, *where it was thrown by Shadwell. It hasn't caught fire.*

He reaches out for it, picks it up.

CUT TO:

505 EXT. HOGBACK WOOD – STORM, DAY

Hogback Wood. Pepper, Wensleydale and Brian are frozen, literally unable to speak. They have no mouths. Adam's eyes are closed. He's talking like a statesman . . .

ADAM
> It's a bad world. But we can fix it. And it doesn't matter that you three aren't my friends any more. I've got better friends than you'll ever be.

He opens his eyes and they are gently glowing. He smiles.

ADAM (CONT'D)
> My new friends will be together soon. They're coming here. And then we make everything better.

TITLES SEQUENCE

506 EXT. SOHO – STORM, DAY

With a crash, Aziraphale's bookshop building tumbles in on itself. Obviously, nobody inside could have survived.

The police are pushing the onlookers back.

The firefighter is talking to the other firefighters. He's dazed . . .

FIREFIGHTER
 . . . I couldn't stop him. He just ran in there. Must have been mad, or drunk, I don't know. Just ran in there. Horrible way to die. He just . . .

And then, standing there, in front of the inferno, we see Crowley, with ruined dark glasses. Ripped suit and filthy and everything. And he looks like a grown-up among children. He's carrying the book.

The police officers look at him, and don't say anything. The firefighters don't say anything.

Crowley looks down at his car. Bricks and smouldering wooden joists have fallen across the front. Cops and such are standing between Crowley and the car.

They look at him.

They get out of the way. He takes off his ruined sunglasses. Looks at a cop with his snake eyes.

CROWLEY
 I shouldn't litter, should I? I mean, I probably should litter, I'm a demon after all, but nobody's really keeping score any more.

He drops the destroyed sunglasses in a bin on the pavement. He walks over to the Bentley. Opens the door. Gets in, with the book.

The car reverses off at enormous speed, swings around a fire engine, and off into the stormy darkness.

Since Crowley appeared, nobody has spoken or said a single word. It's been perfectly quiet.

POLICE OFFICER
> *(numbly)*
> Weather like this, he ought to have put his headlights on.

FIREFIGHTER
> *(just as numb)*
> Especially driving like that. It could be dangerous.

And there is a blinding FLASH OF LIGHTNING.

507 INT. BENTLEY – STORM, DAY

And a CRASH OF THUNDER, and we are driving through London with Crowley.

GOD (V.O.)
> Crowley had lost Aziraphale, and the world was ending
> in a few hours. He was in Hell's bad books. Not that
> Hell has any other kind. He had nowhere to go.

The glove compartment is opened. It contains nothing but dark glasses.

Crowley reaches in and takes a pair, puts them on.

508 EXT. SHADWELL'S FLAT – DAY

The storm is coming, but not quite here. Right now it's just a little rain and it's gusting. And Shadwell, stumbling towards us. His left hand is holding his right hand at the wrist as if it might go off. His gaze is on his right hand, as if he's sure that if he keeps looking at it, it won't explode. He's in shock.

He reaches the front door, then realises he would need his key to get in. He rings the doorbell with his left hand. Then he collapses against the wall.

CLOSE UP on the door as it opens, and Madame Tracy is dressed in her most occulty clothes. She is ready for the seance and expecting company.

MADAME TRACY
> *(in occulty tones)*
> Enter, seekers after wisdom, and together we shall part the veil . . .

Then she registers what she is looking at: nobody. She looks around the doorframe. Sees Shadwell holding his hand.

MADAME TRACY (CONT'D)
> *(normal)*
> Mr Shadwell? What have you done to your hand?

SHADWELL
> Get away from me, woman. I dinna know me own power.

MADAME TRACY
> Are you all right, dear?

SHADWELL
> I canna be responsible. The southern pansy. I saw it. I saw him. I pointed it at him, and – BABOOM!

MADAME TRACY
> What on Earth happened?

SHADWELL
> Aye. That's just it. Nothing on Earth. *Nothing on Earth.* What would you say . . . if I told you that this hand had just exorcised a demon, clean off the surface of the Earth . . . ?

MADAME TRACY
> I'd say that I think somebody needs a nice cup of tea, and a little lie down.

She takes his arm and starts leading him up the stairs.

509 INT. SHADWELL'S FLAT – DAY

Shadwell is almost delirious.

SHADWELL
 But young Newt. He's still out there. In thrall to
 heathen ways and lubricious occult wiles. There could
 be women there . . .

And Madame Tracy pushes him into her flat.

510 INT. MADAME TRACY'S FLAT – DAY

The table is set for a seance. It's a very spooky, fancy, low-rent medium's room.

MADAME TRACY
 I hope he'll know what to do about them. And I'm
 sure he wouldn't like to think of you getting yourself
 worked up into a state.

She looks around.

MADAME TRACY (CONT'D)
 You can't be in here. Mrs Ormerod and them will be
 here any moment. Come on . . .

And she pushes him through into . . .

511 INT. MADAME TRACY'S BEDROOM – DAY

Her private bedroom space. It is very pink. There are photos on the wall of a very sexy young lady in and out of a bikini holding a beach ball, in a photographer's studio in London, in black and white. This was young Madame Tracy. There are stuffed toys around, and discreet handcuffs, pink glittery whips and suchlike. It is a very sweet and homelike fluffy pink den of iniquity.

MADAME TRACY
 You lie down and I'll make you a nice cup of tea.

SHADWELL
 But—

MADAME TRACY
 You won't be any use to young Newt in this state.

SHADWELL
 Aye. A bit of a lie down. Indeed.

He sits on the bed. Still looking at his hand.

SHADWELL (CONT'D)
 (whispering)
 Nobody's ever done what I've done. Not Hopkins. Not
 Siftings. Not Dalrymple. I'm the ultimate weapon. I'm
 the Doomsday Option. I'm . . .

He looks around in horror. The stuffed toys stare back at him.

SHADWELL (CONT'D)
 What kind of a place is this?

512 INT. HEAVEN – ETERNAL NIGHT

*We are in Heaven. It's a very abstract sort of place, white
walls open to the night sky, and everything is in a mad
bustle. A QUARTERMASTER ANGEL, bossy and angry,
and directing ANGELS to their places, is in charge. Dressed
in clothes that seem vaguely military. There are other
ANGELS doing his bidding.*

*The planet Earth, no bigger than a globe, is spinning slowly
in a glass box in the room, like a piece of art.*

*AZIRAPHALE MATERIALISES: he's dressed in white
(all his clothes on Earth have been replaced with perfectly
tailored, laundered, gleaming white versions of the same). He
looks winded and upset.*

QUARTERMASTER ANGEL
 You! You're late!

AZIRAPHALE

Yes. Um. Actually, I didn't mean to be here. Yet. Still sorting things out. On Earth.

The quartermaster isn't interested. Is checking things in a file on a clipboard.

QUARTERMASTER ANGEL

Aziraphale, isn't it? Principality, angel of the Eastern Gate. Your whole platoon is waiting for you.

The quartermaster angel is handing Aziraphale a tin hat and a war kilt.

QUARTERMASTER ANGEL (CONT'D)

Aziraphale, Aziraphale . . . ? Why is that name so familiar?

Aziraphale looks innocent. The Quartermaster looks through papers.

QUARTERMASTER ANGEL (CONT'D)

Hang on. Aziraphale. You were issued with a—

AZIRAPHALE

Flaming sword, yes, I know. It's not my fault . . . she was having a very bad day and I . . .

QUARTERMASTER ANGEL
 (interrupting)
You were issued with a body. Where is it?

Aziraphale looks down at himself. He's slightly transparent.

AZIRAPHALE

I'm afraid I hadn't actually prepared for stepping into the transportation portal, you see. And the body discorporated.

QUARTERMASTER ANGEL
Discorporated?

AZIRAPHALE

It was six thousand years old.

QUARTERMASTER ANGEL

I count them all out, and I count them all in again.
And then you turn up, late for Armageddon, no
flaming sword, not even a body, you pathetic excuse
for an angel . . .

AZIRAPHALE

I suppose I am, really. I mean . . . I have no intention of
fighting in any war.

*All angels on the floor turn and look at the angel who has
said the unsayable.*

QUARTERMASTER ANGEL

Don't be a coward.
 (more quietly)
You get into position, right now, and I won't say
anything more about the body you discorporated. We
can take the sword out of your celestial wages.

AZIRAPHALE

I was in the middle of something important. I demand
to be returned.

QUARTERMASTER ANGEL

Without a body? That's ridiculous.

Aziraphale stops and thinks. What an excellent idea!

AZIRAPHALE

It is?

QUARTERMASTER ANGEL

Obviously. What are you going to do? You can't
possess them.

AZIRAPHALE

Demons can.

QUARTERMASTER ANGEL

You aren't a demon. You're an angel.

AZIRAPHALE

How does one navigate? Oh well. I'll figure it out as I go.

QUARTERMASTER ANGEL

What are you—?

And Aziraphale closes his eyes. He reaches for the Earth in a box, and pushes his hands against the side of the box . . .

And he's GONE.

The angels look at where he was, then, doubtfully, look at the quartermaster.

QUARTERMASTER ANGEL (CONT'D)

What are you lot looking at? Don't you know there's a war on?

513 EXT. HOGBACK WOOD – STORM, DAY

Adam is ignoring the three frozen kids. He's talking to Dog.

ADAM

They're getting ready. They're getting ready to ride. And then it all goes away.

Dog starts whimpering.

ADAM (CONT'D)

It's good. It's good, Dog. They messed it all up. I'm doing the right thing. The voices said so.

Dog backs away.

The storm is finishing, but the sky is blood red.

ADAM

My friends are on their way. It'll be a world just for us. We'll get rid of everything stupid and start all over again. Won't that be awesome?

His friends mouthlessly stare at him.

ADAM (CONT'D)
> Say something!

Pepper raises a finger to the place where her mouth used to be.

A tear runs down her face.

ADAM (CONT'D)
> Stop it! Stop crying! This is fun! We're having fun!
> This is the best day of all.

And Adam levitates. His eyes are glowing.

ADAM (CONT'D)
> You have to smile. I can make it happen! Mouths back.
> Smile. SMILE!

And the kids' mouths are back on their faces. Now they have huge Joker-style smiles.

A tear runs down Brian's grinning face.

514 INT. MADAME TRACY'S FLAT – DAY

Madame Tracy opens her bedroom door. She's holding a mug.

MADAME TRACY
> Here you go. Nice cup of—

She looks down. Shadwell is fast asleep on her bed. He's still got his boots and raincoat on.

She looks at him with . . . well, with love. It's probably easier to love Shadwell when he's asleep.

Then she backs out of the door.

515 INT. JASMINE COTTAGE, BEDROOM – DAY

Newt is in a post-coital rosy glow, in bed. Newt has a soppy smile on his face. Anathema is getting dressed.

The storm has abated a little . . .

NEWT

That was. I mean. That was. You were . . .

ANATHEMA

The earth moved for everybody, then.

NEWT

Yes. You know . . . I'd never actually, that was my first
time . . .

ANATHEMA

I'd never have known.

But she says it nicely.

NEWT

So. Um. Seeing the world's ending . . . Can we do it
again?

ANATHEMA

We don't have time. The storm's dying down. We have
to get going. And Agnes said we only did it this once.

NEWT

She never. She bloody . . . you can't tell me she
predicted that.

*Anathema looks down. Cards blew all over the room earlier,
but the right card is sitting waiting for her now. She picks it up
and tosses it to him. Then she starts picking up the cards . . .*

Newt reads it.

NEWT (CONT'D)
 (reading)
'You go, boy! May fortune be with you!' 'Anathema,
my descendent, I trust he will be fine of feature and
manly of—' oh my dear lord.

ANATHEMA

Get dressed.

She starts to pick up the cards. He starts pulling on his clothes.

NEWT

We need to visit Adam Young. And stop him.

ANATHEMA

I'm not sure about that any more. Agnes doesn't tell us to. If there's a card with instructions, I don't know which it is.

NEWT

What do you mean, 'Agnes doesn't tell us to'? Don't you ever just *do* things? To see how they'll turn out?

ANATHEMA

Not important things, no. And we now have maybe an hour to go until there's nothing anyone can do. I'm not going to waste a second of it. Come on.

And Newt looks somehow cockier. He's growing up. He tosses a balled-up sock into the air and catches it.

NEWT

You can't let a 400-year-old witch tell you what to do.

ANATHEMA

I've spent my life trying to figure out what she wanted me to do. She's never failed me. Sometimes I fail her. And . . . I can't kill an eleven-year-old boy.

NEWT

Not even to save the world?

Anathema shakes her head ruefully.

516 INT. PUB – STORM, DAY

A London pub. Crowley is waiting for the end of the world, and has decided to drink himself into oblivion while he waits. He has two empty bottles of Talisker in front of him, along with the copy of The Nice and Accurate Prophecies of Agnes Nutter. *And a glass.*

BARMAN *(in his fifties) is reading the newspaper, when not serving.*

CROWLEY

Same again.

The barman impassively puts another bottle of Talisker in front of him. Crowley begins talking when the barman approaches.

CROWLEY (CONT'D)

I never asked to be a demon. I was just minding my own business one day and then, looky here, it's Lucifer and the guys, they say, hey, Crowley, my man, we're just on our way to discuss the whole job conditions and career advancement thing, so, okay, the food hadn't been that good lately, I'd got nothing on for the rest of that afternoon, next thing I know I'm doing a million-light-year freestyle dive into a pool of boiling sulphur.

There's a high-pitched noise. Crowley sways, catches himself.

The bar now looks odd, like an old polaroid.

The very solid Crowley is joined by a translucent Aziraphale.

CROWLEY (CONT'D)

Aziraphale? I'm trying to get drunk. Failing. But you know me. Indefatigable. Are you here?

AZIRAPHALE

Good question. Not certain. Never done this before. Can you hear me?

CROWLEY

Of course I can hear you.

As they talk, Aziraphale shimmers and fades a lot. He isn't looking at Crowley – more looking around as if he's wondering where Crowley is . . .

AZIRAPHALE

Afraid I rather made a mess of things . . . did you go to Alpha Centauri?

CROWLEY

No. I changed my mind. Stuff happened. I lost my best friend.

AZIRAPHALE

I'm so sorry to hear it. Listen. Back in my bookshop there's a book I need you to get.

CROWLEY

Your bookshop isn't there any more.

AZIRAPHALE

(profoundly hurt)
Oh.

CROWLEY

I'm really sorry. It burned down.

AZIRAPHALE

All of it?

CROWLEY

Yeah. What was the book?

AZIRAPHALE

The one the young woman with the bicycle left behind. *The Nice and Accurate Prophecies of . . .*

CROWLEY

Agnes Nutter. Yes. I took it. Souvenir.

AZIRAPHALE

You have it? Oh. Look inside. I made notes. It's all in there. The boy's name, address. And everything else. I worked it all out.

Crowley opens the book. There are notes on scraps of paper in Aziraphale's neat handwriting, with ADAM YOUNG,

4 HOGBACK LANE, TADFIELD, *and a small map of the village of Tadfield. And then AIRBASE circled.*

CROWLEY

Look, wherever you are, I can come to you. Where are you?

AZIRAPHALE

I'm not really anywhere yet. I've been discorporated. You need to get to Tadfield Airbase.

CROWLEY

Why?

AZIRAPHALE

World ending. That's where it's all going to happen. Quite soon now. I'll head there too. I just need to find a receptive body. Harder than you'd think.

CROWLEY

(sotto voce)

Not going to go there . . .

AZIRAPHALE

I do need a body. Pity I can't inhabit yours. But angel, demon . . . We'd probably explode. So I'll meet you in Tadfield. And we're both going to have to get a bit of a wiggle-on.

CROWLEY

What?

AZIRAPHALE

Tadfield. Airbase.

CROWLEY

I heard that. It was the wiggle-on.

But Aziraphale has vanished. The pub is normal again. Crowley looks around as if trying to make sense of the world.

517 EXT. SHADWELL'S FLAT – STORM, DAY

The storm is raging outside, and Madame Tracy uses all her strength in holding open the door.

MADAME TRACY
> *(in occulty tones)*
> Enter, seekers after wisdom, only if you are willing to part the veil and receive wisdom from those who have gone before and you better come in quickly because the door's going to blow off.

MRS ORMEROD
> You don't have to ask us twice!

There are three of them. MRS ORMEROD, an elderly battleaxe in a green hat, MR SCROGGIE, a colourless gentleman in his sixties, and JULIA PETLEY, who ought to be a cheerful, blonde, Adele-like hairdresser, but who has come over a bit gothy, and so has dyed her hair black and is wearing dark velvet colours and lots of silver jewellery. Mrs Ormerod's umbrella has blown inside out.

MRS ORMEROD (CONT'D)
> We are here to receive your wisdom, Madame Tracy.
> *(to umbrella)*
> Cheap rubbish, just look at it.

518 INT. MADAME TRACY'S FLAT – DAY

As they come in through the door . . .

MADAME TRACY
> Julia, dear. I see your vibrations are particularly strong today.

JULIA
> Oh. Thank you.

MADAME TRACY
> Mister Scroggie, you sit over there, on my right.

He nods. Outside, a RUMBLE OF THUNDER.

MADAME TRACY (CONT'D)
Just the weather for a seance, isn't it?

JULIA
Did you have them do it special? The weather? With your psychicness?

MADAME TRACY
No, dear.

MRS ORMEROD
They're waiting for us. Our Ron, and the spirits. They're waiting.

MADAME TRACY
And we're all looking forward to hearing what they have to say. After we've all had our tea. And, um, made our donations.

Julia looks confused.

MADAME TRACY (CONT'D)
Twenty five pounds, love. It's not for me. It's for my spirit guide.

Mrs Ormerod hands over an envelope, as Julia opens her gothic handbag.

MRS ORMEROD
You'll find it's all in there.

519 INT. AIRPORT – DAY

GOD (V.O.)
Aziraphale had to find a host to inhabit. The Four Horsemen needed to come together for their final ride.

Famine reaches the immigration official.

IMMIGRATION OFFICER
 Purpose of your visit to the UK?

FAMINE
 I ride to where the end of the world begins.

IMMIGRATION OFFICER
 Sounds like fun.

520 EXT. MOTORWAY CAFÉ PARKING LOT – STORM, DAY

*The storm is starting: it's blustery. A newspaper blows
across. A red motorbike pulls up. War gets off, and walks in
to the café, pulling off her helmet.*

521 INT. MOTORWAY CAFÉ – STORM, DAY

*Video game noises. War walks into the café. There are a
HANDFUL OF PEOPLE in there, and a LADY behind the
counter.*

*In the back of the room, a TALL DARK FIGURE is playing
a video game.*

WAR
 Four cups of tea, please. One of them black. And a
 cheese sandwich.

CAFÉ LADY
 You take a seat. I'll bring it over for you. Four of you,
 are there?

WAR
 There will be. I'm waiting for friends.

CAFÉ LADY
 You're better off waiting in here. It's hell out there.

WAR
 No. Not yet.

*And the café door opens. The wind blows into the café, and
BLACK/FAMINE walks in, helmet off. He's wearing black
leathers.*

522 EXT. MOTORWAY CAFÉ – STORM, DAY

*In the carpark, Famine's black bike is parked next to War's
red bike.*

523 INT. MOTORWAY CAFÉ – STORM, DAY

Famine walks over to where War is sitting:

FAMINE
> Hello, War. Been a long time.

WAR
> Mmm. Famine. Feels funny, all of us finally getting
> together like this.

FAMINE
> Funny?

WAR
> We've spent all these thousands of years waiting for
> the big day, and now it finally comes. Like waiting for
> Christmas. Or birthdays.

FAMINE
> We don't have birthdays.

WAR
> I didn't say we do, Famine. I just said that was what it
> was like.

Café Lady comes over with a tray . . .

CAFÉ LADY
> Here's your teas. But we're all out of cheese. And
> bread. And things to eat . . .

FAMINE
> *(to War)*
> Sorry. Not sorry.

524 EXT. MOTORWAY CAFÉ – STORM, DAY

A dirty motorbike pulls up in a cloud of black smoke. The exhaust backfires as it comes to a halt, and a pool of black oil drips from the engine.

Pollution gets off the bike and crisp packets and sweet wrappers blow past on the storm. They park by the other three.

525 INT. MOTORWAY CAFÉ – STORM, DAY

WAR
> Weather looks a bit tricky down south.

FAMINE
> Looks fine to me. We'll have a thunderstorm to ride in. You'll see.

WAR
> That's a relief. It wouldn't be the same if we didn't have a good thunderstorm. Any idea how far we've got to ride?

Pollution enters. The crisp packets blow in and swirl around as the door opens, then the packets fall to the floor.

POLLUTION
> A hundred miles.

WAR
> I thought it'd be longer, somehow.

POLLUTION
> It's not the travelling. It's the arriving that matters.
> Any sign of him yet?

And the tall dark figure stops playing the video game, and walks over to us . . .

526 EXT. MOTORWAY CAFÉ – STORM, DAY

There is a fourth bike next to the other three. Death's . . .

527 INT. MOTORWAY CAFÉ – STORM, DAY

WAR
　When did you get here?

DEATH
　I NEVER WENT AWAY.

FAMINE
　Your tea is getting cold, Lord.

WAR
　It's been a long time.

POLLUTION
　But now we ride.

DEATH
　YES. NOW WE RIDE.

528 EXT. SHADWELL'S FLAT – STORM, DAY

Outside the wind howls. A rubbish bin blows over and paper bags blow down the street.

529 INT. MADAME TRACY'S LIVING ROOM – STORM, DAY

Inside, Madame Tracy lights a candle. There are some big old mirrors around the room in old frames.

MADAME TRACY
　Now we will link hands. And I must ask for complete
　silence. The spirit world is extremely sensitive to vibration.

MRS ORMEROD
　Ask if my Ron is there.

MADAME TRACY
I cannot control the spirits.

Thunder. Lightning.

MRS ORMEROD
Right.

MADAME TRACY
I need absolute silence.

Madame Tracy glances at her watch.

Absolute silence. Madame Tracy's head lolls.

MRS ORMEROD
She's going under. Nothing to be alarmed about. She's just making herself a Bridge to the Other Side. Her spirit guide will be along soon.

Madame Tracy looks irritated, but masks it. (In the book we have Geronimo as her fake spirit guide. I'd like a female voice, as it makes the Aziraphale stuff better.)

MADAME TRACY
Oooohhhh . . . Are you there, my spirit guide?
 (then, as Irish little girl)
Ah, begorrah, tes me. Little Colleen O'Leary.

MRS ORMEROD
Colleen died in Dublin in 1746 when she was nine years old. But she was very psychic.

MADAME TRACY
Colleen died in . . . Yes. Hello Colleen. Thank you for coming. We have a new seeker after truth with us in today's circle.

MRS ORMEROD
That's you, dear.

MADAME TRACY
> *(as Colleen)*
> Faith and would you believe it? 'Tes the lovely Julia
> Petley?

JULIA
> Hello.

MRS ORMEROD
> Hello, Colleen, dear. Is my Ron there? I've got so much
> to tell him. For a start, the guttering over the shed's
> come loose, but I spoke to our Cindi's latest, who's a
> jobbing builder, and he'll be over to see to it on Sunday,
> and ohh, that reminds me . . .

MADAME TRACY
> *(Colleen)*
> So many poor blessed souls waiting here in the
> afterlife . . .
> *(as herself)*
> Now Colleen wants to know if there's anyone named
> Mr Scroggie here?

MR SCROGGIE
> Actually that's my name.

MADAME TRACY
> Colleen wants to know if you ever knew anyone named
> John.

MR SCROGGIE
> . . . No.

MADAME TRACY
> It could be Jim. Or Tom. Or Steve. Or Dave. The
> connection to the spirit world is a bit vague . . .

MRS ORMEROD
> I need to tell Ron about our Krystal's wedding.

MR SCROGGIE

> I knew a Dave in Hemel Hempstead.

MADAME TRACY

> That's what he's saying. Hemel Hempstead. He wants
> you to know he's doing very well beyond the veil.

MR SCROGGIE

> I saw him last week walking his dog and he looked
> perfectly healthy.

JULIA

> People go very suddenly. It's like my mum. One day
> she was fine. And then the next she just sat down, and
> then she was gone.

MRS ORMEROD

> Your mum can bloody well wait her turn, Julia Petley.
> I've been coming here for seven years and I do have
> seniority. Tell my Ron . . .

MADAME TRACY

> Something's . . . coming through.

*Another flash of lightning and a rumble of thunder. All the
candles flicker weirdly. Madame Tracy seems disturbed.
She's twitching.*

MRS ORMEROD

> Is it our Ron?

MADAME TRACY

> No. It's something real, it's . . .

*And Aziraphale comes through! He's speaking through
Madam Tracy's mouth. If possible, this is going to work
with no voice treatment or special effects, because Madame
Tracy is going to be an absolutely remarkable actor who
can play Aziraphale-using-her-face-and-body-and-voice
incredibly well . . .*

MADAME TRACY/AZIRAPHALE

*Sprechen sie Deutsch? Parlez-vous français? Wo bu
hui jiang zhongwen?*

MRS ORMEROD

Is that you, Ron?

MADAME TRACY/AZIRAPHALE

Ron? Not Ron. Definitely not.

MRS ORMEROD

I want to speak to Ron Ormerod. He's rather short,
balding on top. Can you put him on, please?

MADAME TRACY/AZIRAPHALE

There does appear to be a spirit of that description
trying to get our attention. Very well. I'll hand you
over, but you must make it quick. I am attempting to
avert the Apocalypse.

Madame Tracy jerks. The candles flare up.

*The people at the seance are looking thrilled. This is
something new.*

*Now she's sounding like Ron . . . stammering, northern,
nervous . . .*

MADAME TRACY/RON

H-hello Brenda.

MRS ORMEROD

Ron? That's you. But you sound like . . . you . . .

MADAME TRACY/RON

I am me, Brenda. It's c-cold here.

MRS ORMEROD

Right. So. I went to our Krystal's wedding last
weekend, that's our Tracy's eldest, and we're all sat
down, and they start serving Korean food. Well, I can
take a joke as well as the next woman—

MADAME TRACY/RON
 Brenda.

MRS ORMEROD
 I'm just getting to the good bit. So, I hold up the kim
 chee and I say, what do you expect me to do with this
 then? Whereupon, without even the grace to look
 ashamed . . .

*This is huge. Madame Tracy's eyes have rolled up in her
head. Full-on special effects – room darkens, candles flare,
voice booming, terror and darkness – as the ghost speaking
through her says*

MADAME TRACY/RON
 (effects on voice)
 BRENDA!

Mrs Ormerod and the other seancers are terrified . . .

MRS ORMEROD
 Yes, Ron.

MADAME TRACY/RON
 (still some echo and effects on the voice)
 You never let me guh-get a wuh-word in edgewise
 when we were married. Now I'm dead, there is only
 one thing I want to tell you.

MRS ORMEROD
 (slightly less cowed)
 You've never spoken to me like this before . . .

*One final burst of candleflare and lightning in the darkness
as Ron says . . .*

MADAME TRACY/RON
 I don't cuh-care about the ku-kim chee. I never did.

MRS ORMEROD
 Ron! Remember your heart condition!

MADAME TRACY/RON
> I don't have a heart any longer. Remember? Anyway, Brenda?

MRS ORMEROD
> Yes, Ron?

And the room fills with ectoplasmic bursts and light as Ron says . . .

MADAME TRACY/RON
> Shut up.

And he's gone. Madame Tracy as Aziraphale snaps her fingers and the lights go back on.

MADAME TRACY/AZIRAPHALE
> Wasn't that touching? Right. Lovely meeting you all. Out. Show's over. World to save. Can't lollygag.

MR SCROGGIE
> That was very good value. Very entertaining.

And now Madame Tracy/ Aziraphale is pushing them into the hallway . . .

MRS ORMEROD
> You haven't heard the last of this. And neither has our Ron.

The door slams behind them.

530 INT. MADAME TRACY'S KITCHEN – STORM, DAY

The kettle is whistling. Madame Tracy walks past a mirror on her way to turn it off.

From her POV: Aziraphale is in the mirror, copying her every movement.

She stops. Walks back to the mirror. Looks in it. Aziraphale from the mirror smiles sheepishly and wiggles his fingers at her in a hello.

*Madame Tracy pours tea from a comedic teapot into two cups.
She puts two sugars into one of the cups. Then hesitates.*

MADAME TRACY/AZIRAPHALE

No sugar for me, please.

*She sits at the kitchen table, props up the mirror in front of
the teapot. She takes a slurp of the tea with sugar. Then in the
mirror we see Aziraphale, looking expectant.*

MADAME TRACY

Right. I want an explanation. And it had better be good.

531 EXT. TRAFFIC JAM – STORM, DAY

TITLE CARD: **1 HOUR AND 43 MINUTES TO THE END OF THE
WORLD**

GOD (V.O.)

Crowley is currently stuck in a traffic jam as he tries to
get out of London to find Adam.

*The rain is pouring down so hard that we can barely see out.
Horns are sounding.* Gardeners' Question Time *is on the
radio . . .*

RADIO VOICE

Gardeners' Question Time coming to you from Tadfield
Gardening Club. Last here in 1953, and as the team will
remember it's a rich Oxfordshire loam in the east of
the parish, rising to chalk in the west, the kind of place
I say, don't matter what you plant here, it'll come up
beautiful . . .

Crowley isn't listening. And then Hell takes over the radio . . .

BEELZEBUB (V.O.)

*The war has begun, Crowley. We note with interest that
you avoided the forces we empowered to collect you.*

CROWLEY
Possibly a slight mix-up . . .

BEELZEBUB (V.O.)
*We will win this war. And as long as there is one
demon left in hell, Crowley, you will wish you had
been created mortal. Mortals can hope for death. All
you can hope for is the mercy of Hell.*

CROWLEY
Yeah?

BEELZEBUB (V.O.)
Just our little joke.

The blaring of horns gets louder . . .

532 INT. POLICE CAR ON MOTORWAY – STORM, DAY

A police car. One of our police is talking to base . . .

POLICE #1
I know what it sounds like. But we have to close
down this whole stretch of motorway. At least as far
as the Tadfield junction . . . I TOLD you. It's raining
fish . . . No, that's not an expression like 'raining cats
and dogs' . . .

As LIVE FISH FALL FROM THE SKY onto the windscreen.

533 INT. BENTLEY – STORM, DAY

Crowley is in his Bentley. HE KNOWS. It is happening.

RADIO VOICE
It's official. This is the biggest traffic jam in England's
history.

CROWLEY
Why?

In memory he hears:

SATAN (V.O.)
> *What you did to the M25 was a stroke of demonic genius.*

CROWLEY
> No! Oh no. No no no no no no no!

GOD (V.O.)
> The traffic jam is being caused by problems on the M25, the freeway that circles London. Crowley had a lot to do with the design of the M25 back in the 1970s.

534 FLASHBACK. EXT. A MUDDY FIELD – NIGHT – 1970s

Crowley is in wellies. He's also dressed like it's the seventies. It's night. He's got a piece of paper on a clipboard, along with a compass.

He picks up a flag, and hauls it across the field. Checks with his clipboard. Moves it a final couple of inches, lining it up exactly. We see a diagram of M25 Odegra on his clipboard. Then he grins.

CROWLEY
> M25, you are now going to be the dread sigil, *Odegra*. It means, 'Hail the Great Beast, Devourer of Worlds'. And you're a motorway. Brilliant.

535 INT. MADAME TRACY'S FLAT, BEDROOM – STORM, DAY

Shadwell's eyes open. He takes in the mirrored ceiling, the stuffed animals, the fluffy pinkness of it all.

536 INT. MADAME TRACY'S FLAT

Shadwell wanders, looking lost, through the flat, following voices towards the kitchen.

He stops at the kitchen doorway, flattens himself against the wall, hand making a gun with his two fingers, and listens.

We can hear two voices: Madame Tracy's and Aziraphale's.

MADAME TRACY (O.S.)
So what exactly do you propose we do about this?

AZIRAPHALE (O.S.)
Given the circumstances, we are both going to have to be extremely flexible . . .

Shadwell has heard enough.

537 INT. MADAME TRACY'S KITCHEN – STORM, DAY

Shadwell bursts into the kitchen to defend Madame Tracy's honour.

SHADWELL
Get your hands off her, you . . .

He looks around. There's nobody there. Only Madame Tracy, looking at a mirror propped up on her table, in which we see reflected Madame Tracy.

SHADWELL (CONT'D)
Where is he?

MADAME TRACY
Who?

SHADWELL
Some southern pansy. I heard him. Making lewd suggestions.

Madame Tracy's POV: Aziraphale is in the mirror.

MADAME TRACY/AZIRAPHALE
Not just *A* southern pansy, Sergeant. *THE* southern pansy.

The voice is 100% Aziraphale's. Shadwell is shaken. But he points his hand at her, like a gun.

SHADWELL

Demon? You know what this is? Four fingers. One thumb. Now you get out of this gud woman's head before I blast ye to kingdom come.

MADAME TRACY

That's the trouble, Mr Shadwell. Kingdom come. It's going to. Mr Aziraphale has been explaining it. Now, you have a nice cup of tea, and listen to him.

SHADWELL

I'll no listen to a demon's hellish blandishments!

Madame Tracy reaches out and pats his shoulder.

MADAME TRACY

You old silly. Nine sugars, isn't it?

Shadwell, slowly, lowers his finger.

538 EXT. M25 TRAFFIC JAM – STORM, DAY

GOD (V.O.)

As Adam came into his power, the world welcomed him in ways not even Crowley had expected.

On the M25 motorway, cars are stopped in the storm. A car door opens . . .

HORACE

I can't hold it in!

NORA

Well, what if the traffic starts moving again? It's the M25. You can't just stop and have a widdle by the side of the road.

HORACE

I can and I will. Hail the Great Beast.

NORA

> What did you say, Horace?

HORACE

> Hail the Great Beast . . .

NORA

> Devourer of Worlds . . .

The noise of honking horns and cars and people shouting out of their windows begins to form words. A low repeated chanting.

CHANT

> Hail the Great Beast, Devourer of Worlds. Hail the
> Great Beast, Devourer of Worlds . . .

Pull back: the surface of the M25 is a bright red, burning vision of Hell.

GOD (V.O.)

> The M25 had become, unexpectedly, a burning
> magical ring of fire that surrounded London. Nobody
> was getting in or out. Crowley had made it. Now
> Crowley was trapped inside it.

High aerial shot of London: we can see the M25 around it, and then it ignites: it's a glowing symbol . . .

539 INT. BENTLEY – STORM, DAY

Crowley. He's angry. He's frustrated. And he's figuring this one out . . .

CROWLEY

> Right. M25 is now an impassable burning ring of
> infernal fire. And that's my fault. Come on. Tadfield.
> Tadfield. Tadfield. I can do this. North. Pick up the
> M40 at Denham.

540 EXT. TRAFFIC JAM – DAY

The Bentley pulls out of the traffic onto the hard shoulder.

541 INT. TELEPHONE SALES OFFICE – STORM, DAY

A telephone marketing company call centre. Rain is flooding down the windows. At each desk is a human being with a headset and a computer making the calls. We move down a line of them. Then we meet LISA. She's having a bad day . . .

LISA

Mr Biggs, I'm calling about the car accident that was not your fault that you were involved— bugger.
 (next call)
Mrs Blore, I'm calling about the car accident you were recently involved in. You are eligible for compensation. Oh for Heaven's sake . . .

On her desktop screen, we can see little pop-up texts turning up: Got one out of the bath! *And:* He's Swearing Now . . .

They hang up. She starts again . . .

And now Lisa's screen, which is throwing up the names of people being called, says on it, Anthony Cowwley, London, W1.

542 INT. CROWLEY'S OFFICE – STORM, DAY

We see Crowley's desk. The phone rings, once, twice. And the black answering machine appears to catch the call . . . The red light is flashing

HASTUR (V.O.)
 (whispery)
Yes?

543 INT. TELEPHONE SALES OFFICE

Lisa goes happily into her spiel . . .

LISA

Hello, Mister Cowwley. We are calling about the
accident you had . . .

HASTUR (V.O.)
(whispery)
It wasn't an accident, Lisa. And this isn't Crowley.

LISA

Um. How do you know my name?

HASTUR (CONT'D)

I know lots of things, Lisa. I should be grateful to you
for setting me free, shouldn't I? I should thank you
personally and meet your friends . . .

LISA

I'm . . . I'm putting the phone down.

HASTUR

Too late . . .

*It's been getting darker and darker in the space. And now
something comes out of her phone headset.*

It's a MAGGOT.

*It falls on the desk, onto a piece of paper, and wriggles.
Another few maggots fall.*

Zoom in on Lisa's face as she screams . . .

*Pull back, and there are skeletons in the seats, where there
were people.*

And a huge single MAGGOTTY THING, that BELCHES.

And becomes Hastur, but a slimier, more goopy Hastur.

HASTUR (CONT'D)
I needed that.

544 INT. MADAME TRACY'S LIVING ROOM – STORM, DAY

Madame Tracy is talking to Shadwell, who is drinking his tea with condensed milk. He is sitting at the table where she had the seance. She is standing.

When we are looking from Madame Tracy's POV we can see Aziraphale reflected in the mirrors, standing next to Madame Tracy.

From Shadwell's POV, the mirrors show only him and Madame Tracy.

SHADWELL
 So there's really an Antichrist?

MADAME TRACY/AZIRAPHALE
 The Antichrist is alive on earth at this moment, Sergeant. He is bringing about Armageddon. I am sure that you can see that the imminent destruction of the world is not something any reasonable person would permit. Am I correct?

SHADWELL
 Aye.

MADAME TRACY/AZIRAPHALE
 The Antichrist must be killed, Sergeant Shadwell. And you are the man to do it.

SHADWELL
 I don't know about that. The Witchfinder Army . . . we just kill witches.

MADAME TRACY/AZIRAPHALE
 And I am sure you've killed lots of them.

SHADWELL
 We . . . lll . . . Early days. This Antichrist of yours. How many nipples does he have?

MADAME TRACY/AZIRAPHALE
 Oh. Um . . .

We see Aziraphale crossing his fingers under the table.

MADAME TRACY/AZIRAPHALE (CONT'D)
> Oodles of them. Pots of nipples. Nipples everywhere.

SHADWELL
> Then I'm your man.

MADAME TRACY/AZIRAPHALE
> What weapons do you have, Sergeant?

Shadwell holds up his fingers.

MADAME TRACY/AZIRAPHALE (CONT'D)
> Anything more substantial?

SHADWELL
> I've got pins. And the Thundergun of Witchfinder Colonel Dalrymple. It'll fire anything. Silver bullets.

MADAME TRACY/AZIRAPHALE
> That's werewolves.

SHADWELL
> Garlic.

MADAME TRACY/AZIRAPHALE
> Vampires.

SHADWELL
> Bricks.

MADAME TRACY/AZIRAPHALE
> That should do nicely.

Shadwell wanders off.

MADAME TRACY/AZIRAPHALE (CONT'D)
> Now. We need to get to Tadfield. I trust you have a reliable mode of transportation.

MADAME TRACY
> I do indeed.

Madame Tracy goes to the kitchen cupboard. Pulls out two ancient motorbike helmets. She puts on the pink one as Shadwell reappears, holding a huge, ancient blunderbuss gun we've seen on the wall in a display case in his flat.

MADAME TRACY (CONT'D)
You don't point that big thing at me, dear. Now, pop this on.

Holds out the green helmet.

545 EXT. SHADWELL'S FLAT – STORM, DAY

The door to the flat opens, and Madame Tracy manhandles an ancient scooter, like a Triumph Tina, out onto the street.

MADAME TRACY
You'll have to hold on to me very tight. Won't that be nice? Oh, I am naughty.

SHADWELL
De'il ding a divot aff yer wame wi' a flaughter spade.

MADAME TRACY
I don't think there's any call for language. Right. Hold tight.

And she starts the scooter. It is not made to carry two people. It goes PUTT-PUTT-PUTT-PUTT and carries them extreeeeemely slowly off down the street.

Madame Tracy's POV: she looks into the bike's mirror. And there's Aziraphale, with a pink motorbike helmet looking back at us.

And we PULL BACK and up from Madame Tracy into an AERIAL SHOT OF LONDON . . .

The M25 is a giant, burning ring of pure, demonic light around the city.

And we head down . . .

546 EXT. NEAR WALL OF FLAMES – STORM, DAY

The Bentley is covered with dust from the fire.

Crowley has pulled up the Bentley on the hard shoulder beside a traffic jam that stops at a simple wooden NO ENTRY roadblock. Beyond the wooden roadblock is a curtain of light that's glowing with evil energy.

547 INT. BENTLEY – STORM, DAY

In the car. Crowley is frustrated . . .

CROWLEY

Come on. Come on. There has to be a way across it.

He grabs The Nice and Accurate Prophecies, *starts flicking through it.*

CROWLEY (CONT'D)

Burning roads? Did you predict this, Agnes? Why isn't there an index?

He turns a page . . .

A hand reaches out, takes the sunglasses from Crowley's face and breaks them in half.

Without any effects or fanfare, Hastur is sitting on the seat next to Crowley.

HASTUR

You'll never escape London. Nothing can.

CROWLEY

Hastur. How was your time in voicemail?

HASTUR

Joke all you like. There's nowhere to run, Crowley.

Crowley starts driving forward. Slowly at first . . .

CROWLEY

Aren't you meant to be lining up, ready for battle around now?

HASTUR

Hell will not forget. Hell will not forgive. You're done. Do you think you can get across *that*? That's not Hellfire. That's the real deal. There's nowhere to go.

Crowley sighs. The car keeps moving forward . . .

CROWLEY

Let's find out.

HASTUR

Why are you driving? Stop this thing.

CROWLEY

You know, the thing I like best about time, is that every day it takes us further away from the fourteenth century. I really didn't like the fourteenth century. You would have loved it, then. They didn't have cars back in the fourteenth century. Lovely clever human people, inventing cars and motorways and windscreen wipers. You've got to hand it to them, haven't you?

He guns the engine. They start heading along the hard shoulder, past the stopped cars, faster and faster.

HASTUR

Stop this. It's over. You're doomed. Whatever happens, you're doomed.

CROWLEY

Then I'll never have to fill out another compliance report again, will I? See? The day's already got better.

HASTUR

Is that a joke? You know I don't like jokes.

Crowley slams the Bentley forward: he drives around the police roadblock and heads into the curtain of fire . . .

In the car, everything is starting to smoke.

548 EXT. THE WALL OF FLAMES – STORM, DAY

The Bentley drives into the glow of the M25.

549 INT. BENTLEY – STORM, DAY

Hastur, in the front seat, looks down at his hands and he realises they are burning . . . He's BURSTING INTO FLAMES.

HASTUR
 Stop it. You'll discorporate us both!

Crowley starts to laugh. Everything in the car is filling with smoke.

HASTUR (CONT'D)
 This isn't funny.

CROWLEY
 Come on! If you've got to go, then go with style.

Crowley drives deep into the flames.

Crowley just grins. He's holding it together. Hastur's burning . . . Everything is burning . . . Hastur can't take it. Crowley is holding it together by effort of will.

HASTUR
 I hate you.

And Hastur is gone.

550 INT. BENTLEY – IN FLAMES – STORM, DAY

Inside the Bentley, everything is now burning. Crowley's concentrating, hard . . .

CROWLEY

> You . . . are my car. I've had you from new. And you
> are not . . . going to burn . . . Don't even think of it . . .

And inside the car, the flames subside and vanish. Crowley's all messed up: smudges of soot on his face, his hair a mess, his suit interestingly ripped.

His sunglasses are gone.

He reaches out and turns on the car stereo. It's loud and pounding music.

Everyday, it's a gettin' closer . . .

GOD (V.O.)

> Crowley has something no other demons have,
> especially not Hastur. An imagination. Right now he is
> imagining that he is just fine, and that a ton of burning
> metal, rubber and leather is a fully functioning car. He'd
> started the journey in his Bentley and he was damned if
> he wasn't going to finish it in his Bentley as well.

551 EXT. POLICE ROADBLOCK ON M40 – STORM, DAY

Beyond the flames . . . on the other side of the burning M25 are our old friends, Officers Fred and Julia . . .

OFFICER FRED

> The boffins are on the way. But in the meantime,
> nothing's getting out of London.

OFFICER JULIA

> Are you sure about that?

Because coming towards us is the Bentley. It's in flames. And then it's gone up the motorway . . .

Fred and Julia stare in shock.

OFFICER FRED

> That's, um . . .

OFFICER JULIA
> Right now, that's someone else's problem.

OFFICER FRED
> He was waving.

552 EXT. M40 MOTORWAY – STORM, DAY

The drums and heavy metal guitars of Hell continue to pound as we see Crowley, a crazed speed demon driving a burning car . . .

> CUT TO:

553 EXT. HOGBACK WOOD – RED SKY, DAY

Adam is still floating in the air. His friends are on the ground. His eyes are a bit glowy.

ADAM
> I'm . . . I'm sorry I made you all shut up. I'm going to make it so you can talk again. And we'll play a game.

> CUT TO:

554 EXT. THE MOTORWAY – STORM, DAY

Motorbikes, driving in the storm down an empty motorway. We hear the roar of engines, and the storm. And they come . . .

In the front is Death. Then War.

Then Famine.

Then, moments later, Pollution.

And then it gets quiet. Unearthly quiet.

555 EXT. THE SKY ABOVE HOGBACK WOOD – RED SKY, DAY

We hear SCREAMING. We are looking at Adam smiling.

Pull back to realise that Adam is floating high in the air.

ADAM

But this is a good game!

Pull back further to see that the other three are also several hundred feet above the ground. And they aren't enjoying it. They are terrified.

PEPPER

NO! Adam Young! Put us DOWN.

WENSLEYDALE

Actually, now.

BRIAN

I don't like this.

ADAM

I was going to show you the whole world. I'm going to make you happy!

PEPPER

Down! Now!

They crash to earth. Adam floats down.

They don't know what's happening.

ADAM

Come on. We'll still be friends. When all the people have gone. You can rule the world that's left. Wensley, you'll get America. And Pepper, you can have Asia and Russia. Brian, you get Europe and Africa . . . and Dog, you can have Australia. To run about in. See? And I'll make new people and you can tell them what to do and armies that fight each other, and, and . . .

Dog howls sadly . . .

Pepper squats to stroke Dog.

PEPPER

So we'd rule the world. But what about you, Adam?

ADAM
> What?

PEPPER
> What bit are you going to have?

Adam looks taken aback.

ADAM
> Tadfield. From Hogback Wood to the Dip and from
> the Old Quarry up to the pond. I'll be here . . . same as
> always . . .

WENSLEYDALE
> On your own?

ADAM
> . . . I don't want to go anywhere else.

PEPPER
> And this is our Hogback Wood too. We don't want to
> go to America or Asia.

*Dog makes a whining noise that sounds a bit like 'or
Australia'.*

ADAM
> You will do as I say.

PEPPER
> Or what? You've already taken our mouths and frozen
> us here. We can't get away.

WENSLEYDALE
> Actually, he could kill us.

PEPPER
> Yes. You could do that.

ADAM
> You aren't frozen any more. You can go anywhere you
> want. See? And you can talk. I don't care where you go.

Pepper considers this.

PEPPER
 Goodbye, Adam.

BRIAN
 Goodbye, Adam.

WENSLEYDALE
 Actually, yes. Goodbye, Adam.

ADAM
 What do you mean, 'Goodbye'?

The three Them begin to trudge away. Adam watches them go, and then floats after them.

PEPPER
 Stop following us.

ADAM
 I'm not following you.

PEPPER
 We aren't your friends any more. We don't like you.

ADAM
 I don't care.

But he does. That struck deep.

BRIAN
 So what happens to us, Adam? Do we get to die now along with everyone else? Or are you going to kill us first?

Adam doesn't say anything. He stops following them.

And then the coup de grace. Dog is following the Them. Adam watches them go.

ADAM
 Dog! Come back! DOG!

But Dog runs on with the kids.

We hear the satanic voices whispering, trying to repair this.

WHISPERY VOICES
> *(whispering)*
> Let them go. You have the world. You have the power.
> You have the glory.

556 EXT. TADFIELD VILLAGE GREEN – RED SKY, DAY

The three terrified children are running across the village green, with Dog running with them.

There's a CRASH, and Adam is hanging in space above the green in front of them. He's really angry.

And we see a hundred emotions chasing themselves across his face. And then, racked with emotion, he says . . .

ADAM
> Give me back my dog.

PEPPER
> He's not your dog. He's his own dog. And I don't think
> he likes you any more.

WENSLEYDALE
> You're really scary. And you aren't our friend.

BRIAN
> You're not anybody's friend. You're going to burn all
> this away. Why? Because some adults mucked things
> up? That's a reason to fix it. Not destroy it.

And Dog yaps at Adam.

We close in on Adam's face – he looks from one of his former gang to the other, in increasing panic. He's getting upset . . . the cocky Antichrist is being replaced by a small, scared boy, who has just lost the thing that was most important to him. His gang.

ADAM
> Come back . . . Please?

And the Them just shake their heads. Even Dog shakes his head.

Adam convulses, floating in the air, throws himself into a pose that's half Superman and half Crucifixion, and he SCREAMS. It's a superhuman, echoing scream . . .

SHOTS of Newt and Anathema, of Mr and Mrs Young, people in Tadfield, looking up and HEARING SOMETHING . . .

Hogback Wood SHAKES as the child screams . . .

Adam drops to the earth. He's not floating in space. His eyes aren't glowy. He's unconscious.

Brian nervously picks up a cricket bat someone has thoughtfully left on the green, and raises it over Adam's head. He's going to hit him.

PEPPER
 Quick! Before he starts again!

Dog goes over to Adam and starts to lick his face. Pepper notices this.

She shakes her head at Brian. Brian lowers the cricket bat slowly.

Adam opens his eyes . . . The GLOW HAS GONE.

ADAM
 I'm . . . I'm sorry . . . I wasn't . . . I don't think I was
 thinking straight . . . but I am now . . .

Adam gets to his feet.

ADAM (CONT'D)
 Friends?

He puts out his hand, facing down. The others look at him, hesitantly. Then Pepper walks back, reaches out her hand, puts it on top of his.

Then Wensleydale's hand goes down on Pepper's. Then Brian's on Wensleydale's. They're a gang.

557 EXT. CROUCH END HIGH STREET – STORM, DAY

Madame Tracy and Shadwell, on the motorscooter, are puttering incredibly slowly through the streets of London.

SHADWELL

Can ye no slow this hellish contraption down, woman?

Shadwell is holding on to his thundergun and wobbling slightly with every movement.

MADAME TRACY

Mr Shadwell, if you don't hold on to me tightly, you'll fall off, and I can't be held responsible.

SHADWELL

Let me adjust my weapon then.

Madame Tracy giggles at this. Shadwell looks miserable. He puts an arm around her. She reaches around and yanks it so that he is actually hugging her, the Thundergun between them.

558 INT. JASMINE COTTAGE – RED SKY, DAY

Anathema is in the kitchen. She's putting together a basket of things they might need to save the world, including her cards and the breadknife.

Newt comes running in . . .

NEWT

I've got it.

ANATHEMA

Oh yes?

NEWT

If Agnes tells you what to do . . . and we have to get this right . . . then you need to just pick a card. Any card.

ANATHEMA

Don't be silly.

NEWT

I'm not. I've had a good idea for the first time in my
whole life.

ANATHEMA

I'm not following you.

NEWT

Well, if Agnes is right, and we're doing all this because
she's predicted it, then any card picked right now has
got to be the relevant one. That's logic.

ANATHEMA

It's nonsense.

NEWT

You're here because Agnes predicted it. You say I'm
here because she predicted it. Pick a card. Any card.

Anathema gives him a look. She knows this is crazy, but . . .

NEWT (CONT'D)

'*When the skies are crimson seen . . .* ' – well, she got
that bit right – ' *. . . then ye both must stand between
the world of life and the world of war, where the iron
bird lands no more.*' See?

ANATHEMA

It could be talking about us. The iron bird lands no
more . . .

NEWT

I guess an iron bird could be a plane. But where don't
they land?

ANATHEMA

There's an American airforce base outside of town.
They don't land planes there any more. I met some
of the guys who work there in the village pub. But

why would we go there? All they've got left in there
is communications technology. Computers and stuff.
Nothing explosive at all . . .
> (and then she realises what she's said)
Oh my god.

559 EXT. A LONDON STREET – STORM, DAY

The scooter is going very verrrrry slowly down the road.

MADAME TRACY/AZIRAPHALE
> Dear lady. How fast would you say this contraption
> is currently moving? Because it seems to me we could
> make better time walking . . .

MADAME TRACY
> It doesn't go very fast when it's just carrying me. It
> would take a miracle to get past ten miles an hour.

MADAME TRACY/AZIRAPHALE
> Miracles. Yes. Right. Hold on extremely tightly,
> Sergeant Shadwell, if you'd be so kind.

*Madame Tracy's face. She's grimacing as she performs her
miracle.*

*The scooter wobbles. A blue light surrounds it, then it rises,
rather gracefully, until it's a few feet above the ground.*

And, oddly, it seems to be moving backwards . . .

*And then we hear a loud TWANG, as if a pulled-back elastic
band were released . . .*

And the scooter goes into a Star Trek/Star Wars-*style zoom
forwards while everything else becomes lines . . .*

*And we can see Madame Tracy enjoying it, while Shadwell is
closing his eyes and shuddering . . .*

560 EXT. POLICE ROADBLOCK ON M40 – STORM, DAY

A HANDFUL OF SCIENTISTS have joined Officers Fred and Julia.

The scientists have some fancy machines, hooked up to laptops, and are scanning the M25. Some of them also have satellite views of the M25 on their laptops, and we can see it's glowing . . .

TWO OF THE SCIENTISTS are telling off Officers Fred and Julia.

SCIENTIST 1

>Everything you are telling us is ridiculous. The temperature immediately above the M25 right now is somewhere in excess of 750 degrees . . .

SCIENTIST 2

>Or minus a hundred and fifty.

SCIENTIST 1

>Or minus 150. It's probably just a mechanical error. The point is, we can't even get a helicopter over the M25 without winding up with helicopter McNuggets. So how in hell could a vintage car drive over it unharmed?

OFFICER FRED

>I never said it was unharmed.

SCIENTIST 1

>You said the driver waved at you.

OFFICER JULIA

>The car was burning. But it just kept driving.

SCIENTIST 2

>Do you have any idea how impossible that is?

OFFICER JULIA

>Of course we do. We're not stupid.

A SOUND, like glass harmonicas. They look around, puzzled. Then they look up . . .

Madame Tracy's motor scooter breaks through the M25 forcefield and heads towards them.

CLOSE UP on Madame Tracy for a moment, having the time of her life, and Shadwell, terrified.

Everyone on the ground is looking up at it, horrified, confused and amazed.

OFFICER FRED
I mean, it's more likely than that, for a start.

MADAME TRACY
Yahooooooo!

And she's gone.

OFFICER JULIA
I wonder where they're all going.

CUT TO:

561 EXT. ABOVE M40 MOTORWAY – STORM, DAY

Madame Tracy, with Shadwell holding tightly behind her, on a slightly wobbly scooter zooming at about 100 mph across the sky.

CUT TO:

562 TADFIELD STREETS – STORM, DAY

R. P. Tyler leaves his house with his poodle, Shutzi. There's a low roaring of motorbike engines. The Four Horsemen of the Apocalypse pull up in the road in front of him.

He looks nervous.

Then Famine, Pollution and War raise their visors. Death's stays ominously down.

FAMINE

I'm afraid we're lost. The signposts must have blown down. We're looking for the airfield.

R. P. TYLER

Take the second right, only it's not exactly right, it's on the left but you'll find it bends round towards the right eventually, it's signposted Porrit's Lane, but of course it isn't Porrit's Lane, you look at the Ordinance Survey map, you'll see it's simply the eastern end of Forest Hill Lane, you'll come out in the village, go past the Bull and Fiddle and you can't miss it.

FAMINE

I'm not sure I got that.

DEATH

I DID. LET US GO.

Shutzi the poodle wails and scurries away at the sound of Death's voice.

Tyler looks: Pollution is eating the last crisp from a plastic packet. And then carefully drops it on the floor.

TYLER

Young . . . person. Is that your litter?

POLLUTION

It's not just mine. It's everybody's.

And the bikes roar off.

563 EXT. TADFIELD VILLAGE GREEN – RED SKY, DAY

Adam is walking around on his own, Dog following him at a distance. Adam looks haunted, as if he's thinking about what he's done.

PEPPER
Adam. What have you done?

ADAM
I . . . don't know. But whatever I've started, we have to
stop it.

He looks very small and alone.

ADAM (CONT'D)
We need our bicycles. Meet back here in five minutes.

PEPPER
Where are we going?

Adam is thinking.

PEPPER (CONT'D)
Adam! After we get our bikes, where are we going?

ADAM
The end of the world. It's not far.

564 EXT. A BIG CITY — NIGHT

*A large city, at night. The street lights are going out. Then
the traffic lights go out. Then the tall buildings go dark, and
there's nothing but the shape of the city, and the stars above:
no light pollution . . .*

*We pan up into the star-filled, gorgeous sky. And see . . . our
ANGELIC ARMY exiting the skyscraper.*

*Standing in the skyscraper, watching them leave, is the angel
Gabriel. The angel Sandalphon beside him.*

GABRIEL
Right. So. This is the big one. Everyone accounted for?

SANDALPHON
All present and correct, your glory. Well . . .

GABRIEL

 Well what?

SANDALPHON

 We're still missing Aziraphale. He . . . Um. He just buggered off.

GABRIEL

 When we've won the war, triumphed over the forces of Hell, he'll find out what we do to traitors. Sound the advance . . .

And the trumpets of Heaven ring out.

565 EXT. HELL

The smoky plains of Hell. The ARMY OF DEMONS looks like the army of angels, only with more variety of dress, number of limbs, and body shapes.

At front is Dagon: Lord of the Files, Master of Torments. Standing next to him is Beelzebub, who looks like Jeff Goldblum in the later acts of The Fly *only much, much worse.*

BEELZEBUB

 Ssszo. It beginnnzz. And we are all accounted for.

DAGON

 Er. More or less. We've lost Ligur, and um, Crowley.

BEELZEBUB

 What happened to Ligur?

DAGON

 Crowley did.

BEELZEBUB

 Well, when the war isssz won, and the angelsss are dead, and the universsse issss ourszs . . . then Crowley will find out what we do to traitorrrsss . . . Szzzound the advance.

The drummers of Hell begin to bash their instruments. And the thumping drums and heavy metal guitars of Hell ring out.

CUT TO:

566 EXT. TADFIELD STREETS – DAY

Newt and Anathema are driving in Dick Turpin, Newt's battered little car. Anathema has her arms full of the cards with the prophecies on them, and she's been putting them into order. There is storm damage everywhere as they go.

We linger for a moment on the last prophecy of all, 5004: 'When alle is ſayed and all is done, ye must chooſe your faces wiseley, for soon enouff ye will be playing with Fyre.'

Handwritten notes around it say things like '1976 – Could this be a reference to the oil crisis?'

ANATHEMA
 . . . 5003, 5004, and here's 1011 goes in there and we're done . . . Left here.

Newt is cockier, more adult, than before.

NEWT
 Do you think that a witch who died 400 years ago actually predicted how we were going to break into an American airbase without being killed?

ANATHEMA
 Yup.

They pass the signpost to the airbase.

NEWT
 Are you sure? Because they have serious people with extremely big guns guarding these places, and if we don't get shot trying to break in we'll spend the last minutes before the world ends in a little room without windows and—

ANATHEMA

I think you're getting yourself overexcited.

NEWT

I'm not. I'm getting quite calmly worried about being shot and then put in a cell and waterboarded and shot again . . .

They are at the front of the airbase.

ANATHEMA

'Behind the Eagle's Nest a grate ash hath fallen.'

NEWT

That's all?

ANATHEMA

You know, most of my family thought it was something to do with the Russian Revolution. Go straight on, then turn right at the next road.
 (beat)
And don't worry. Agnes would definitely have told me if someone was going to shoot you.

567 EXT. AIRBASE – RED SKY, DAY

There's a manned checkpoint. The (American military) GUARD on duty is reading a book. It's very quiet here.

A little way back down the road, the Four Horsemen of the Apocalypse pull up on their bikes.

Death pulls back his helmet visor, revealing the death's head skull inside.

DEATH

THIS IS THE PLACE.

War looks around, unimpressed.

WAR

Is this all there is? I thought it would be more

impressive somehow. All those thousands of years waiting, just for a ride of a hundred miles.

DEATH

IT IS ENOUGH.

WAR

Let's crash through the barriers.

DEATH

NO. WE GO IN, WE DO THE JOB, WE GO OUT, WE LET HUMAN NATURE TAKE ITS COURSE.

They start their bikes, and head towards the guard box. Looking from the guard box: the Four Horsemen of the Apocalypse are driving towards the guard box. The guard hears the bikes and looks up from his book.

The guard's POV: he sees an illusion, cast by the Horsemen. There's a black staff car with a US flag on it, with four people in it.

The Four Horsemen are now dressed as generals: War, US Army; Death, US Airforce; Famine, US Marines; and Pollution, an admiral.

Death doesn't look like a skeleton any longer. He looks human and magisterial.

The guard comes out, and is standing in front.

DEATH (CONT'D)

SURPRISE INSPECTION, OFFICER.

GUARD

I wasn't informated of any surprise inspection . . . sir.

FAMINE

If you had, it wouldn't be a surprise, would it?

GUARD

Can I . . . Can I see some kind of identification, sir?

We see Famine hold up an empty motorbike-gloved hand. Guard's POV: General Black is showing him ID.

GUARD (CONT'D)
Very good, sir.

WAR
Don't tell them we're coming, officer. We want it to be a surprise.

The gates are opened and the staff car drives in.

As it gets through the other side of the gates, and out of the guard's field of vision, it becomes the Four Bikers once again.

Pollution looks at the guard, and simply waves, creepily.

568 EXT. LANE BEHIND AIRBASE – DAY

Newt and Anathema pull up in the car. The high, barbed wire, PLEASE KEEP OUT fence has been knocked down by a fallen tree.

NEWT
'Behind the Eagle's Nest a grate Ash hath fallen.' She's on the money there.

They get out of the car. Anathema is getting witchier. It's something intangible, helped by hair, make-up and costume: she's more occult than she's ever been.

Newt pats his car.

NEWT (CONT'D)
Nice going, Dick Turpin.

ANATHEMA
You really do call your car Dick Turpin?

NEWT
Yes!

ANATHEMA
 I bet you're hoping one day someone's going to ask
 you why.

NEWT
 Um. Maybe.

ANATHEMA
 Right.

She walks over the fallen fence.

NEWT
 It can't be that easy. It really can't. There's going to be
 cameras and guards and . . .

*Anathema points to the camera, crushed by the fallen tree.
They walk over the fallen fence. Anathema looks up at the
buildings of the airbase: she's caught the psychic scent of the
Horsemen.*

NEWT (CONT'D)
 Where are we going?

ANATHEMA
 There.

NEWT
 How do you know?

ANATHEMA
 (witchy but certain)
 Everything in my life. Everything that Agnes wrote down
 in the book 400 years ago. Everything . . . it was all
 leading me here. Now. With you.
 (beat)
 I *KNOW.*

NEWT
 And we're going to stop them, how exactly?

*But Anathema is already running towards the
communication centre.*

ANATHEMA
Oh! Come on!

569 EXT. TADFIELD STREETS – RED SKY, DAY

Here comes Adam, with Dog riding in a makeshift box on the handlebars of the bike.

And Pepper comes down her street on her red bike and meets him.

Then Brian and Wensleydale, on their bikes. Wensleydale's is sensible, black, and well kept. Brian's is white and grubby . . .

PEPPER
It's stupid them calling it a military base. I went up there on that open day. They didn't even have guns and things. Just lots of radios and satellite dishes and stuff.

BRIAN
Yeah. It was all knobs and dials. Stupid. What are your new friends going to do here?

ADAM
I suppose they could patch into the worldwide military net, and issue orders to all the computers to activate all automated systems and start fighting.

WENSLEYDALE
Actually that would be quite difficult.

ADAM
Not really. Not if you're them.

570 EXT. AIRBASE – RED SKY, DAY

The Four Horsemen, now wearing biker gear once more, walking through the semi-abandoned airbase. Perhaps we can see their bikes parked behind them. They are following the signs to the communications centre.

WAR

It's not really what I was hoping for. The Four Button-Pressers of the Apocalypse.

FAMINE

This is just the overture.

POLLUTION

I thought we'd be starting somewhere exciting. Washington or Moscow or somewhere . . .

DEATH

IF ARMAGEDDON IS ANYWHERE, THEN IT IS EVERYWHERE. THE GEOGRAPHY IS IMMATERIAL.

He snaps his fingers. A door opens. It says, COMMUNICATIONS CENTRE. RESTRICTED ZONE.

TITLE CARD: **31 MINUTES TO THE END OF THE WORLD**

571 EXT. TADFIELD STREETS – DAY

(A note on the weather: the storm is over, and the sun is out, and the red sky has finished. However, if we get a long shot of the sky, we can see that the storm is going on elsewhere: lightning is flashing; there are huge clouds, etc. It's just in Tadfield that the eye of the storm means that everything is a perfect August evening.)

Here comes R. P. Tyler, the Youngs' neighbour, and chairman of the local Residents Association. He's a small, self-important man, with a small self-important dog, Shutzi, on lead.

Now the Them come cycling down the street.

TYLER

Hoy! You! STOP! I say stop!

The kids brake.

TYLER (CONT'D)

Adam Young. I thought it was you. And the rest of you. Do your parents know that you're out?

WENSLEYDALE

Actually it's not like there's a law against being out. I mean, you can't get sent to prison for 'being out'.

Dog makes its eyes glow red and growls at Shutzi, the Tylers' poodle.

ADAM

Dog, get away from Mr Tyler's rotten old poodle.

Dog comes reluctantly away. Pepper sticks out her tongue at Tyler.

TYLER

Where are you four troublemakers going this evening? Don't stick your tongue out at me, young lady, or I shall have words with your mother—

BRIAN

We're going to the airbase.

ADAM

If that's all right with you. I mean, we wouldn't want to go there if it wasn't all right with you.

They cycle on . . .

TYLER

Adam Young! Don't think I won't talk to your father!

572 INT. COMMUNICATIONS CENTRE – DAY

The space we are in looks functional rather than impressive.

Some desks, a wall of screens, lots of knobs and buttons and such. We aren't trying to impress, although there are lots of things on the screens. This isn't a control centre. It's worse. It's a hub.

A HANDFUL OF MEN AND WOMEN are working, although one of them is doing a crossword, and one of them is down on the floor, working on some wiring and computers.

MAN ON FLOOR
Can someone pass me the screwdriver?

It's put into his hand by Death. The man does a double-take.

MAN ON FLOOR (CONT'D)
Who the hell are you?

DEATH
I AM NEITHER OF HELL NOR HEAVEN.

And Death touches the man on the head. He falls unconscious . . .

The Horsemen walk among the workers, who pass out.

POLLUTION
What's so special about this place anyway?

FAMINE
It's a classified communications hub. Everything comes through here. They've made it so they don't even have to fight any more. Machines can do it for them.

Pollution sits down at a vacated chair and idly presses some keys. A wisp of smoke curls up from the keyboard and a small alarm begins to beep insistently.

WAR
People still need to kill. They want the killing to happen. Cleanly. They just don't want to get their hands dirty. So they build machines, and machines to control machines. The machines do the aiming, and the flying. They even find the targets. Can you believe that? Machines will do it all.

DEATH

EXCEPT THE DYING. WHEN IT COMES TO
SOME THINGS, MACHINES WILL NEVER
REPLACE PEOPLE.

Death is looking at the room like visiting royalty.

DEATH

AND . . . WHAT EXACTLY ARE THOSE?

POLLUTION

Relays. I'm introducing viruses into each system. The
global internet is responding to even the simplest
request as a denial of service attack.

DEATH

HOW . . . INTERESTING.

*War and Famine are at consoles . . . talking to each other,
privately, so Death doesn't hear them.*

WAR

Nearly there. I can feel it happening. Another five
minutes, and the whole world will be at war.

FAMINE

And as the war begins, the famine comes, and the
pollution.

WAR

You know . . . even if there was no more war. No famine.
No pollution. *He's* always going to be here, isn't he?

*This said inclining her head towards Death, on the other side
of the room.*

FAMINE

Always.

Death looks up.

DEATH

HE IS COMING.

Pollution opens their hands. Something that looks like a squiggly blue light is in them. They blow gently, and the thing goes into the computers, and the screens all start showing different versions of LOCKED, *and* DEFENCE SEQUENCE INITIATED, *and* RETALIATION PROTOCOL STARTED.

POLLUTION
We're in business.

573 ANIMATION OF A GLOBE

The world as a filigree ball of light . . .

GOD (V.O.)
They are taking charge of the electricity. All of it. And, under their rule, it is coming to life. They're fusing relays, they're closing switches, they're turning off the lights. They are in control.

We see a little blue twinkle, and then the filigree starts to grow dark . . .

The Four Horsemen look less human, more like ideas incarnate . . . We look at them: Famine, Pollution, War and, monstrous and skeletal, Death itself. Then War says:

WAR
Let's get this show on the road.

She spits on her hands, then slams them against a wall of screens. She arches her back, breathes out ecstatically . . .

574 EXT. NEBRASKA – DAY

A military silo in Nebraska, seen from the air . . .

575 INT. SILO CONTROL ROOM – DAY

The two-man crew are lounging at their consoles — the world is at (more or less) peace. The COMMANDER is

doing a crossword. The CREWMAN is listening to music through headphones and rocking out.

The commander taps him on the shoulder, and the crewman reluctantly takes out an earbud.

COMMANDER
Seven Letters. A rhythmic insectile grouping. Fourth letter is a T.

CREWMAN
Obvious.

COMMANDER
Don't tell me! Just give me a clue. How is it obvious?

CREWMAN
The Beatles. Rhythm is a beat . . .

COMMANDER
I said don't tell me!

He hears a click, and looks up. Across his console, switches are closing; lights are turning from green to red.

Two handles, one by the crewman, one by the commander, both clunk around by themselves, going into ARMED position.

COMMANDER (CONT'D)
What the heck?

576 INT. SILO – DAY

Inside the silo, vapour begins to wreathe a missile.

577 INT. SILO CONTROL ROOM – DAY

The commander taps a control panel. A few more lights turn red.

CREWMAN
Did you really just say 'What the heck'?

COMMANDER
Get me Stratcom cyber command. Something's happening.

MONTAGE, possibly stock footage: missiles being deployed, silo tops moving aside, missiles rising; nothing being fired yet, but they are ominously waiting.

578 EXT. TADFIELD STREETS – DAY

R. P. Tyler is walking his poodle. There is a PUT-PUT-PUT noise and he turns.

Madame Tracy and Shadwell, on the motor scooter. Shadwell is holding the Thundergun, and has his eyes closed.

MADAME TRACY
Hello, dear. I think we're a bit lost.

TYLER
Where are you going?

MADAME TRACY
We're actually looking for someone.

MADAME TRACY/AZIRAPHALE
His name is Adam Young.

We can see Aziraphale's face reflected in the moped's rear view mirror, in Madame Tracy's pink crash helmet.

TYLER
That boy. Aye. He and the other little monsters are going to the airbase.

MADAME TRACY
Boy? You never mentioned that he was a boy. How old is he?

MADAME TRACY/AZIRAPHALE
He's eleven.

MADAME TRACY
 Eleven?

MADAME TRACY/AZIRAPHALE
 Airbase. It's that way?

TYLER
 Yes, then second right, only it's not exactly right, it's
 on the left but you'll find it bends round towards the
 right eventually . . .

*But Madame Tracy has already accelerated. Shadwell looks
back at Tyler with disdain.*

SHADWELL
 Drivelling whey-faced southern pillock.

579 EXT. RUSSIAN SUBMARINE – DAY

*Deep water. There's a sonar pinging as a Russian submarine
goes past.*

580 INT. RUSSIAN SUBMARINE – DAY

*A RUSSIAN COMMANDER enters the command centre.
Worried-looking CREW MEMBERS are at consoles with
slightly archaic equipment. But then, all the equipment
should feel a little archaic.*

The Russians speak in Russian, with subtitles.

RUSSIAN COMMANDER
 (in Russian)
 What exactly is happening?

RUSSIAN CREWMAN
 (in Russian)
 Coded message from the Kremlin. I think we're at
 war.

RUSSIAN COMMANDER
 (in Russian)
Who with?

RUSSIAN CREWMAN
 (in Russian)
Who do you think?

RUSSIAN COMMANDER
 (in Russian)
Ukraine?

RUSSIAN CREWMAN
 (in Russian)
Keep going . . .

RUSSIAN COMMANDER
 (in Russian)
Uzbekistan?

RUSSIAN CREWMAN
 (in Russian)
Everybody.

581 INT. COMMUNICATIONS CENTRE – DAY

In this dark room, lit by computer lights, War, Pollution and Famine no longer look quite as human. Pollution's skin is glistening; Famine and War have become inhuman personifications: War is scarred, while Famine seems thinner and fanged . . . (Practical effects here, not CGI.)

WAR
 It's begun. Nuclear codes delivered. Everything is set into motion for the final countdown. The sword is raised, and ready to strike.

POLLUTION
 It's not just nuclear destruction . . . it's chemical too . . . And my favourite standbys are all chemical.

Say what you like, plutonium may give you grief for thousands of years, but arsenic is for ever.

FAMINE

The war. The pollution. And then the winter. I like winter. So clean. So hungry.

582 EXT. TADFIELD VILLAGE GREEN – DAY

Mr Tyler and Shutzi walking. Tyler sniffs the air. Something is burning . . . yes . . . and there's smoke . . . and he turns.

A huge gust of smoke as Crowley winds down the window on the Bentley.

CROWLEY

Hey. Excuse me. Sorry to bother you.

Tyler turns. He sees a burning car, and Crowley, a scorched wreck with yellow snake-eyes, leaning out.

CROWLEY (CONT'D)

I've managed to get slightly lost. Tadfield Airbase?

583 FREEZE ON TYLER'S FACE

GOD (V.O.)

There are some things it is very difficult to say. What R. P. Tyler truly wants to say is . . .

TYLER

Your car is on fire!

GOD (V.O.)

. . . But he can't. I mean, the man must know, mustn't he? Perhaps it's some kind of practical joke. So he says . . .

TYLER

You might have taken a wrong turn. Signpost blew down. Easy mistake to make. So, second right . . .

He FREEZES.

GOD (V.O.)
 . . . when what he wants to say is . . .

TYLER
 Young man, your car is on fire and you're still sitting in
 it and frankly it's in no fit condition to drive!

CROWLEY
 Right. Got it. Terrific.

Tyler has to say something and—

TYLER
 Young man!

CROWLEY
 Yes?

Tyler looks at us and tries to say it, but can only say . . .

TYLER
 Very unusual weather, for the time of year.

CROWLEY
 I'm afraid I hadn't noticed.

And as he reverses off, Tyler says, in an explosion of anger . . .

TYLER
 That's probably because your stupid car is on fire!

584 EXT. TADFIELD LANE – DAY

TITLE CARD: **17 MINUTES TO THE END OF THE WORLD**

*A peaceful scene: hedgerows and birds. Perhaps some rabbits
hopping on the verge. Then Crowley's Bentley, on fire, comes
around the corner, heading straight for us.*

*Inside the smoke-filled car is Crowley, his face tormented:
his snake-eyes are glaring. He's holding the car together with
his mind.*

585 EXT. AIRBASE GATE – DAY

The GUARD ON THE GATE's POV. Shadwell has taken off his helmet and he is pointing a finger at us.

SHADWELL
 D'you see this finger, laddie? This finger could send
 you to your maker!

And the guard looks desperately at Madame Tracy, who is delivering the kind of one-woman two-person performance that gets you Emmys and BAFTAs.

The Thundergun is propped up against the scooter.

MADAME TRACY/AZIRAPHALE
 It really is vitally important that we speak to whoever
 is in charge here—

MADAME TRACY
 He's telling the truth, I'd know if he weren't—

MADAME TRACY/AZIRAPHALE
 Will you please stop interrupting, I am trying to—

MADAME TRACY
 I was just trying to put in a good word—

MADAME TRACY/AZIRAPHALE
 I understand, but I really must—

GUARD
 Will you please be quiet? Both of you. I mean, ma'am
 . . . I must respectfully ask you to . . .

And at this moment, a burnt-out Bentley pulls up, still sputtering with flame, trailing smoke.

A sudden CRASH DOWN – but the blackened hulk of a car is still holding together, just.

Crowley stumbles out into the world, along with a cloud of smoky blackness.

Falls down. Gets up again.

CROWLEY
You wouldn't get that sort of performance out of a
modern car.

*Snake-eyes, in a wrecked suit, messed up hair, and smuts and
smudges all over his face.*

He is still holding The Nice and Accurate Prophecies of Agnes
Nutter, *although now it's a blackened charcoal wreck of a
book.*

MADAME TRACY/AZIRAPHALE
Crowley?

CROWLEY
Hey. Aziraphale. I see you found a ride. Nice dress.
Suits you.

MADAME TRACY/AZIRAPHALE
This young man won't let us in.

CROWLEY
Leave it to me, army human. My friend and I have
come a long way, and . . .

There is a click. The barrier goes up.

GUARD
Which one of you did that?

Shadwell looks at his finger in amazement . . .

*. . . as four kids on bikes zoom through. (Dog is in Adam's
basket.)*

GUARD (CONT'D)
Okay. Those kids are in trouble. And so are you
people. Don't move.

*He presses a red alert button. An alarm sounds. Then he
raises his gun, for the first time, and points it at them.*

586 INT. COMMUNICATIONS CENTRE – DAY

WAR

 All the chickens are coming home to roost.

FAMINE

 No more chickens.
 (looks around)
 Shouldn't he be here by now?

POLLUTION

 Our Lord, our master. Our friend. He's all we've been
 waiting for. When he joins us, we will be complete.

WAR

 And then the world will finally be ours.

DEATH

 THE WORLD IS ALWAYS OURS. BUT HE IS
 CLOSE . . .

587 EXT. COMMUNICATIONS CENTRE – DAY

GOD (V.O.)

 Adam didn't know what was going to happen next, but
 he did know what he had to do.

The four Them get off their bikes.

WENSLEYDALE

 So what are these people like?

ADAM

 Dunno.

PEPPER

 Are they grown-ups?

Adam nods. Dog jumps up, to attract their attention . . .

BRIAN

 Seems to me, when we go up against grown-ups they
 always win.

SOLDIER (O.S.)
What the hell are you kids doing here?

There are SEVERAL SOLDIERS, and guns pointed at the kids. And now a red alarm light has started flashing and a whooping noise has started.

ADAM
It's all right.

SOLDIER
Listen, kid. You're on military property—

ADAM
I think you all need to go to sleep now. All you soldiers. So you don't get hurt.

The soldier looks incredulous, and then as one, they slump to the ground.

PEPPER
How did you do that?

Adam brushes away the question. He faces the building with the Four Horsemen in it, and says,

ADAM
I'm here.

588 INT. COMMUNICATIONS CENTRE – DAY

We hear Adam's 'I'm here' echoing. Each of the Four Horsemen has heard it, and stops doing what they were doing.

CLOSE UP on Death, as he raises his head and looks at us, revealing his death's head skull, and says:

DEATH
HE'S HERE. EVERYTHING ENDS NOW. TIME IS OVER.

FADE TO BLACK.

And over the credits, the pounding, crazy-ass, heavy metal Hell-chords transmute into a world-ending metal version of 'Everyday'.

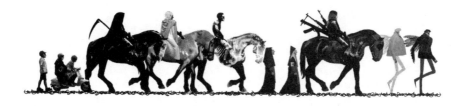

EPISODE SIX

THE VERY LAST DAY
OF THE REST OF THEIR
LIVES

601 INT. HELL'S COURT

A dark room, with a few spotlights. We are in Hell, in the Place of Trials. Very, very formal and ritualistic: two demons, Hastur and Dagon, enter and walk on each side up to a dais, as if they are prosecutor and defender. They are standing.

Then Beelzebub enters and goes to the only seat, between Hastur and Dagon.

The front of the hall contains the dais for Hastur and Dagon, and Beelzebub's high seat.

The rear of the hall contains only, rather oddly, a claw-footed bathtub, and behind that, although currently in darkness, a lift (elevator) door.

The USHER of Hell, a small and loathsome creature, bangs its staff on the ground and announces:

USHER
 The trial of the demon Crowley, beginning with evidence and ending with utter obliviation, is in session. Beelzebub, Lord of the Flies, presiding. All rise.

Hastur and Dagon step forward.

BEELZEBUB
 Bring in the traitor.

A gate opens. As Crowley is walked in by DEMON GUARDS, the walls and ceiling of the room we are in become transparent: we realise that we are in a cube, and that all the walls and the roof are covered with spectators, all demons, naked and clothed, all nightmarish: their faces press against the glass, hungrily . . .

Crowley looks slightly less cool than usual. He is, however, still wearing the snappiest of suits, and the coolest of dark glasses.

He glances around. We watch him take a deep breath, and then:

CROWLEY

Hey guys. Nice place you've got here.

HASTUR

Not for you it won't be.

CROWLEY

Could do with some pot plants. Maybe a coffee table.

BEELZEBUB

Silencczze. The prisoner will approach.

CROWLEY

Love to. So. Four of us. Rubber of bridge? Barbershop quartet?

BEELZEBUB

The trial of a traitor.

CROWLEY

Lord Beelzebub. You are . . .

BEELZEBUB

I am the judge.

HASTUR

I am the prosecutor.

CROWLEY

And so Dagon here is defending me?

DAGON

> 'Fraid not. I'm just here in case there's anything you did they forgot.

BEELZEBUB

> But we built this place for you ssspecially. It will be your placze of trial. And it will be your placze of desssztruction.

CROWLEY

> Guys. You shouldn't have gone to all the trouble. What appears to be the problem?

BEELZEBUB

> Duke Hastur? Would you like to begin?

And we rewind to Crowley arriving at the airbase, eighteen hours earlier.

TITLE CARD: **18 HOURS EARLIER**

TITLE CARD: **THE LAST DAY OF THE WORLD**

TITLE CARD: **LATE SATURDAY AFTERNOON**

602 EXT. AIRBASE GATE – DAY

A burnt-out Bentley pulls up, still sputtering with flame, trailing smoke.

A sudden CRASH DOWN — but the blackened hulk of a car is still holding together, just.

Crowley stumbles out into the world, along with a cloud of smoky blackness.

Falls down. Gets up again.

CROWLEY

> You wouldn't get that sort of performance out of a modern car.

Snake-eyes, in a wrecked suit, messed up hair, and smuts and smudges all over his face.

He is still holding The Nice and Accurate Prophecies of Agnes Nutter, *although now it's a blackened charcoal wreck of a book.*

MADAME TRACY/AZIRAPHALE
Crowley?

CROWLEY
Hey. Aziraphale. I see you found a ride. Nice dress.
Suits you.

MADAME TRACY/AZIRAPHALE
This young man won't let us in.

CROWLEY
Leave it to me. Army human, my friend and I have
come a long way, and . . .

There is a click. The barrier goes up.

GUARD
Which one of you did that?

Shadwell looks at his finger in amazement . . .

. . . as four kids on bikes zoom through. (Dog is in Adam's basket.)

GUARD (CONT'D)
Okay. Those kids are in trouble. And so are you
people. Don't move.

He presses a red alert button. An alarm sounds. Then he raises his gun, for the first time, and points it at them.

The Bentley explodes into a smouldering pile of burning wreckage.

Crowley is more concerned about his car. He's heartbroken, and isn't paying attention to the guard.

CROWLEY

Ninety years, and not a scratch. Now look at you.

MADAME TRACY/AZIRAPHALE

Crowley. He's got a gun. He's pointing it. Do something.

Crowley holds up his hand, to indicate he can't be interrupted now.

CROWLEY

I'm having a moment here.

MADAME TRACY/AZIRAPHALE

Crowley! I'm the nice one! You can't expect me to do the dirty work.

Shadwell is still bothering the guard.

SHADWELL

I'm gonna count tae three. Then, I use my finger.

GUARD

Ma'am, I'm giving you all five seconds to vacate this area . . .

There is a POP! And the guard has vanished. Shadwell looks at his finger. He shakes his head. Crowley is finishing his moment.

CROWLEY

(to the car)

Rest in peace. You were a good car.

(to Aziraphale)

Nice job on the soldier.

MADAME TRACY/AZIRAPHALE

Oh, I do hope I haven't sent him somewhere unpleasant.

CROWLEY

Aren't you going to introduce me to your new body?

MADAME TRACY/AZIRAPHALE

Oh. Yes. Right. Madame Tracy, this is Crowley.

He's . . . Well, we're sort of business associates.
Crowley, Madame Tracy.

MADAME TRACY
Charmed, I'm sure.

And now, responding to the alarm, several jeeps filled with American soldiers are heading towards us.

CROWLEY
Okay! I've got to get over the car thing. I'll deal with
them.

SHADWELL
Never fear, laddie. I've got a finger.

MADAME TRACY/AZIRAPHALE
You may need to brandish your weapon, Sergeant
Shadwell. We are here to lick some serious butt.

CROWLEY
Kick, Aziraphale. It's kick butt. For Heaven's sake. I
can't believe I said that.

603 EXT. ADAM YOUNG'S HOUSE – DAY

Mr Young is outside the house. He is polishing his car – the same green Morris Traveller he had in the first episode.

Tyler strides up, officiously.

TYLER
Hoy. Young.

MR YOUNG
Yes?

TYLER
Your son. Adam.

MR YOUNG
 (wearily)
What's he done now?

TYLER

> I just saw him and his little gang of cronies cycling to the airforce base. If you think that armed guards and whatnot will put up with your son's tomfoolery, I for one do not.

MR YOUNG

> Adam wouldn't . . .

TYLER

> You saw what he did to my begonias.

And then, as a parting shot, he adds, he feels, humorously:

TYLER (CONT'D)

> Don't blame me if your son starts World War Three!

TITLES SEQUENCE

604 EXT. AIRFIELD BY COMMUNICATIONS CENTRE – DAY

Adam is in front of the Them.

Death leads the Four Horsemen towards them. The feeling here is spaghetti western. This is the shootout and the showdown.

GOD (V.O.)

> In a handful of moments, the missiles will fly. The forces of Heaven and Hell will attack. And everything depends on one small boy. Silence holds the bubble of the world in its grip.

605 EXT. AIRBASE – DAY

Newt and Anathema are running through the airbase. They aren't being shot, because all the soldiers they pass are fast asleep.

NEWT

> Where exactly are we going?

ANATHEMA
 Sshh.

Ahead of them, a door opens. The Four Horsemen come out. ANATHEMA VISION: we see the Horsemen through Anathema's eyes, and their auras are black, purple, pulsing things, like migraines onscreen.

Anathema screws up her eyes, puts her hand up to shield them, as if looking at the Horsemen hurts her eyes.

Newt pulls her back against the building to avoid being seen. Anathema points to the open door the Horsemen came through.

ANATHEMA (CONT'D)
 In there.

Newt looks puzzled.

NEWT
 Really?

Anathema is certain.

They go inside.

606 INT. COMMUNICATIONS CENTRE – DAY

Newt and Anathema look around at the screens and the room, at the unconscious workers.

NEWT
 Those people. Do you think they were terrorists?

ANATHEMA
 In a very nice and accurate way. Yes. You should have seen their auras.

NEWT
 Was there a problem with them?

ANATHEMA

Negative auras. Like black holes. I don't think they were entirely human.

There are SCREENS with upset people on them, mouthing silently.

NEWT

If only we knew what they were saying.

Anathema picks up a remote control and turns the volume up.

SCREEN 1

We no longer have control of the Agni Six nuclear launch protocols. I think we've been hacked!

SCREEN 2

Nuclear strike orders implemented. Against Belgium. Are you sure this is a good idea?

SCREEN 3

(German)
Please put me through to someone who can fix this. All of our instruments are frozen.

SCREEN 4

Look, we're trying to turn off the controls, but there's some kind of satellite override in place.

SCREEN 2

Are you sure this is a good idea?

Anathema presses the remote again and mutes the screens.

ANATHEMA

They're saying it's the end of the world.

NEWT

Yes, I got that.

607 EXT. AIRFIELD BY COMMUNICATIONS CENTRE – DAY

Death is talking directly to Adam.

DEATH
> IT HAS BEGUN.

ADAM
> I didn't ask for it to begin.

DEATH
> YOU DID NOT HAVE TO ASK. YOUR VERY
> EXISTENCE DEMANDS THE ENDING OF THE
> WORLD. IT IS WRITTEN.

*A jeep is swerving across the airfield, driven by Crowley.
Madame Tracy and Shadwell are in the back. Shadwell is
holding the Thundergun. The jeep pulls up.*

DEATH
> YOU COULD FINISH THIS FOR THEM WITH
> ONE THOUGHT. YOU CAN MAKE THE WORLD
> ANEW.

CROWLEY
> That's him. The curly one. Shoot him. Save the world.

DEATH
> YOU'RE PART OF US, NOT THEM. NO ONE
> WILL DISOBEY YOU. IGNORE THIS NONSENSE.
> A WORD FROM YOU AND I WILL END THEIR
> LIVES.

SHADWELL
> But he's . . . he's only a wee bairn . . . You can't just . . .

MADAME TRACY/AZIRAPHALE
> Oh for Heaven's sake. Give me that.

*Madame Tracy's body animated by Aziraphale takes the
Thundergun. But Madame Tracy is not convinced.*

MADAME TRACY

You can't just kill children. Perhaps we should wait a bit.

CROWLEY

Until he grows up? Shoot him, Aziraphale.

There is a struggle going on between Aziraphale and Madame Tracy for control of the body. The gun is pointed at Adam, then up into the air, then back again.

MADAME TRACY

No!

We can see expressions chasing each other across Madame Tracy's face.

MADAME TRACY/AZIRAPHALE

Madame, for the greater good, he has to . . .

CLOSE UP on the finger closing on the trigger.

A huge explosion as the Thundergun is fired – up into the air. Madame Tracy has control of the body.

MADAME TRACY

I'm . . . Sorry. I couldn't let you do it.

And now Adam is staring at Madame Tracy.

ADAM

Why did you do that?

MADAME TRACY

Well, dear . . .

ADAM

Excuse me, why are you two people?

MADAME TRACY/AZIRAPHALE

Ah. Long story. You see, I was in my bookshop . . .

ADAM

It's not right. You should go back to being two separate people again.

*And Aziraphale is there in the flesh, standing next to
Madame Tracy. He is wearing a bright tartan bowtie and a
tartan cummerbund. Madame Tracy gives a little shudder of
ecstasy as he is removed.*

MADAME TRACY
> That made me all tingly.

*She looks at Aziraphale, and is, frankly, disappointed.
Aziraphale is prodding himself to make sure he's solid.*

608 INT. COMMUNICATIONS CENTRE – DAY

*Anathema and Newt are in the communications centre. The
screens have started to fuzz and we can see on them various
missiles preparing to fire, satellites readying, and scenes of
terrible things about to happen . . .*

ANATHEMA
> We're at war. Everyone's at war. But we have to be able
> to do something.

NEWT
> We aren't in a movie. There's no handy red wire to cut
> to make the countdown stop. And there isn't even a
> proper countdown . . .

ANATHEMA
> You're a computer engineer. These are computers.
> Make them stop.

NEWT
> It doesn't work like that!

ANATHEMA
> Agnes. You got any ideas?

She grabs a card randomly.

NEWT
> You can't shut down twenty-first century technology
> with a seventeenth-century random prediction.

ANATHEMA

'He is not what he says he is.' Agnes, you aren't trying. What does that even mean?

Newt looks guilty.

NEWT

I don't know.

ANATHEMA

What? Tell me!

NEWT

I think it's about me.

Anathema looks at him and makes a 'we don't have much time – go on?' gesture.

NEWT (CONT'D)

I'm . . . not really a computer engineer. I want to be. I'm actually just . . .

ANATHEMA

Just what?

NEWT

Just the opposite. I'm rubbish with computers. When I try and make them work, they break. I'm sorry. We're doomed.

609 EXT. AIRFIELD BY COMMUNICATIONS CENTRE – DAY

GOD (V.O.)

It was time to decide who friends were. So the Antichrist, three human children and a former hell-hound faced Death and three monsters who came from the mind of humanity.

ADAM

The thing is, they're not actually real. They're just like nightmares, really.

War steps forward. She looks at the Them.

WAR

Little boys. With your toys. I am war. You were made to serve me, to live in me and die in me.

Pepper looks at her and doesn't like her.

PEPPER

I'm not a boy. And my mum says war is just masculine imperialism executed on a global stage.

War holds out the flaming sword, so it gets close to Pepper's face . . .

WAR

A little girl. Run away and play with your dolls, little girl.

And now Pepper is angry.

PEPPER

I do not – endorse – everyday sexism.

War raises her sword, as if she's about to slice Pepper into two.

Pepper stamps, as hard as she possibly can, on War's foot.

And War, taken by surprise, drops the flaming sword on the ground.

It crashes onto the tarmac. War steps towards it.

But Pepper's faster than War. She grabs the sword as if she's not afraid to use it. And now War takes a step back.

PEPPER (CONT'D)

I can play with dolls or not play with dolls. Just as I can play with swords or not play with swords. But War is stupid.

WAR

Put that down, child.

PEPPER

Yeah?

WAR

Yes. I will not be mocked.

War reaches out a gloved hand toward the blade, as if she's going to wrench it away from Pepper. Pepper jerks the blade back, away from her.

PEPPER

You will, you know. We're Adam's real friends. Not you lot. You're a joke.

CROWLEY

(quietly)

Didn't that used to be your sword?

AZIRAPHALE

I do believe it was.

War is getting closer to Pepper . . .

PEPPER

Adam? What do I do?

ADAM

Just say what you believe, Pepper.

War, impatient, grabs the blade with a gloved hand. She shouldn't have done that.

PEPPER

I believe in peace, bitch.

GOD (V.O.)

Swords are dangerous if left lying around. And weapons can be used against the people who brought them.

The sword flares up – and the flames engulf War herself . . . And then War seems to get sucked into the blade.

ADAM
>Drop it, Pepper. Quick!

Pepper drops the sword. It clangs to the tarmac.

Brian picks it up.

Brian points the sword at Pollution . . .

BRIAN
>I believe in a clean world.

And Pollution is also engulfed in flame (but the black smoke of an oil fire burning) and sucked into the sword.

GOD (V.O.)
>Soon there was nothing left of Pollution but the acrid stench of oil and burning trash.

A black cloud of smoke, and as it clears, Pollution's crown falls to the tarmac with a clattering noise.

Famine looks worried. He glances up at Death, who does nothing.

Wensleydale picks up the sword.

Famine looks around desperately. He backs away, looking terrified.

WENSLEYDALE
>And I believe in food. And a healthy lunch for everybody. Actually, it's a really good thing.

Dog growls, and goes for Famine's ankle.

The sword flames once more in Wensley's hand.

GOD (V.O.)
>The bite of a mere dog should not have bothered a creature like him, but Dog was still a hell-hound, and dogs like bones.

And then Famine's gone, and the silver scales he was given fall jingling to the tarmac.

Wensleydale drops the sword on the tarmac by the crown and the scales.

610 EXT. HELL

(Or possibly the woods outside Tadfield. Perhaps a nice, grassy meadow: we see DEMON CREATURES pushing up out of the ground.)

And Beelzebub is similarly ready for action . . . Dagon's shouting to the demons assembled . . .

BEELZEBUB
Any moment now. Encourage the troops, Dagon.

DAGON
Right! Listen up! Any moment now, we'll be going over the hill, up against the army of angels. Now, all you were angels once. And we fought in the glorious revolution. And we lost. But that was then. We've had thousands of years to get tougher, smarter, and more dangerous. I want all of you to repeat after me, we're tougher!

A SPIDERY DEMON says:

SPIDER DEMON
Tougher . . . Smarter!

A VERY VERY STUPID THING THAT LOOKS LIKE IT'S MADE OF ROCKS AND EVIL says, not very intelligently:

ROCK THING
Smaaarrrterrr . . .

Beelzebub looks alarmed.

BEELZEBUB
Something is happening. Something's wrong.

611 INT. COMMUNICATIONS CENTRE -

Anathema stops and thinks. Then she grins.

ANATHEMA
 We're idiots. Look. Repair it.

NEWT
 What?

ANATHEMA
 Get this computer room working better. Right now.
 You say every computer you try and fix dies. So fix it.

NEWT
 And speed up nuclear armageddon?

ANATHEMA
 Could you? Speed it up?

NEWT
 Easy. If I actually wanted to get these computers
 working better, I'd just click on this disk defragmenter
 and, and . . .

*There is a clicking. A sad whirring like something running
down . . .*

Red lights start going out and turning green.

GOD (V.O.)
 All over the world, people who had been wrestling with
 switches found that they had switched, circuit breakers
 opened, computers stopped planning World War Three
 and went back to idly scanning the stratosphere.

612 EXT. AIRFIELD BY COMMUNICATIONS CENTRE – DAY

*It's a summer's evening. As this sequence goes on, the light
starts to fade.*

Adam is facing Death – it's High Noon.

ADAM

Death. This all has to stop now.

We look over the things on the ground between Death and Adam: the crown, the scales, the sword. Death smiles, but then, Death always smiles.

Death's black wings open.

DEATH

IT HAS STOPPED. BUT THEY WILL BE BACK. WE ARE NEVER FAR AWAY. I AM CREATION'S SHADOW. YOU CANNOT DESTROY ME. THAT WOULD DESTROY THE WORLD.

It bows to Adam. Then it looks at Aziraphale and Madame Tracy and Crowley, and says:

DEATH (CONT'D)

GOOD DAY, GENTLEMEN.

MADAME TRACY

Cheek!

PEPPER

Cheek!

GOD (V.O.)

Death opened wings of night, wings that were shapes cut through the matter of creation into the darkness beneath, in which distant lights glimmered, lights that may have been stars or may have been something entirely else.

There is a thunderclap and it is gone.

AZIRAPHALE

There. You see Crowley? It's as I've always said, at bottom . . .

CROWLEY

It isn't over. Nothing's over. Both Heaven and Hell still want their war.

613 INT. COMMUNICATIONS CENTRE – DAY

Anathema and Newt are walking out of the communications centre . . .

ANATHEMA
You fixed it.

NEWT
 (semi-sad)
I broke it.

ANATHEMA
Same thing. You're amazing.

And Newt stands taller, and prouder.

614 EXT. AIRFIELD BY COMMUNICATIONS CENTRE – DAY

CROWLEY
You. Boy. The Antichrist. What's your name again?

Anathema and Newt heading towards us out of the communications centre.

ADAM
Adam Young.

CROWLEY
So. Your friends all got together and saved the world. Well done. Have a gold star. It won't make any difference.

ANATHEMA
You! You were the men in the car. You stole my book.

CROWLEY
Book girl! Catch!

Crowley tosses her the charcoal remnants of Agnes's book. A much-burned page flutters out as the book is tossed, and blows over to Aziraphale, who catches it, and glances down at it.

The fragment says: When alle is ſayed and all is done, ye must chooſe your faces wiseley, for soon enouff ye will be playing with Fyre.

ANATHEMA
What's going on out here?

CROWLEY
Long story. No time.

ANATHEMA
Try me.

Aziraphale pockets the fragment, and steps forward.

AZIRAPHALE
Ah, okay, so, in the beginning, in the Garden, there was, well, *he* was a wily old serpent and *I* was technically on apple tree duty . . .

Crowley touches his finger to his lips. Aziraphale shuts up. Anathema sees Adam.

ANATHEMA
Hi, Adam. Hi, Pepper. Hi, you two.

ADAM
Hello, Anathema. You just stopped them blowing up the world, didn't you?

ANATHEMA
I guess. My boyfriend here did the tricky bit.

Newt starts to make a self-deprecating shrug, then realises what she just said.

NEWT
Boyfriend?

Pepper shakes her head at this unfortunate news.

PEPPER
Another deluded victim of the patriarchy.

Shadwell is looking meaningfully at Newt, and then at Anathema. He is beckoning with a finger. Newt looks nervously at Shadwell.

Madame Tracy nudges Shadwell hard. She approves of Newt and Anathema.

And there is a CRACKLE of lightning. A LIGHTNING STRIKE! But when it's over, there's A FIGURE OF PURE LIGHT STANDING ON THE TARMAC.

It is Gabriel!

A moment, and he is FULLY HUMAN, brushing the dust off his excellent suit, checking his watch.

There is a lurch, and everyone is thrown to the ground. A crack in the earth, and through it rises Beelzebub.

For a moment, Beelzebub is the hellish, fly-like creature we've encountered so far, and then, suddenly, it's COMPLETELY HUMAN.

Both Gabriel and Beelzebub are wearing nice suits: political enemies.

CROWLEY

Lord Beelzebub. What an honour.

BEELZEBUB

Crowley, the traitor.

CROWLEY

Not a nice word.

BEELZEBUB

All the other words I have for you are worse. Where is the boy?

GABRIEL

That one. Adam Young. Young man: Armageddon must restart, right now. A temporary inconvenience is not going to get in the way of the ultimate good.

Gabriel and Beelzebub are both addressing their pitches directly to Adam. Armageddon has stopped and they want him to kickstart it again.

BEELZEBUB

As to what it standz in the way of, that has yet to be decided. But the battle must be decided now, boy. That is your deztiny. It is written. Now: start the war.

ADAM

You both want to end the world, just to see whose gang is best?

GABRIEL

Obviously. That's the Great Plan. The entire point of the creation of the Earth . . .

BEELZEBUB

I've got this. Adam, once this is over, you're going to get to rule the world. Don't you want to rule the world?

We look at Anathema and Newt, holding hands. At Shadwell and Madame Tracy. At the Them. At Crowley and Aziraphale. They worry about what answer Adam will give.

ADAM

It's hard enough having to think of things for Pepper and Wensley and Brian to do all the time so they don't get bored. I've got all the world I want.

GABRIEL

You can't refuse to be who you are! Your birth and destiny are part of the Great Plan.

Crowley is rubbing his forehead, defeated. And then he realises that Aziraphale has stepped forward.

AZIRAPHALE

Excuse me. You keep talking about the Great Plan.

GABRIEL

Aziraphale. Maybe you should just keep your mouth shut.

AZIRAPHALE

Only, I'm not clear on one thing. Is this the Ineffable Plan?

BEELZEBUB

The Great Plan. It is written. There shall be a world and it shall last for six thousand years and end in fire and flame . . .

AZIRAPHALE

Yes, that's the Great Plan all right. Just wondering if it's the Ineffable Plan as well.

GABRIEL

(baffled)
It's the same thing, surely?

Crowley starts to smile. He realises what Aziraphale is doing . . . He steps in.

CROWLEY

(to himself)
You don't know.
(to Gabriel)
Be a pity if you thought you were doing what the Great Plan said, but actually, you were going directly against God's Ineffable Plan.

Now he and Aziraphale flank Adam.

CROWLEY (CONT'D)

Everyone knows the Great Plan. But the Ineffable Plan is, well, it's ineffable, isn't it? By definition, we *can't* know it.

BEELZEBUB

But it iszz written!

GABRIEL

God does not play games with the universe!

Crowley and Aziraphale look at him with pity.

CROWLEY

Where have you *been*?

Neither Gabriel nor Beelzebub seem exactly assured now. They step together to consult.

GABRIEL

(*quietly*)

I'm going to need to talk to . . . head office. How I'm going to get ten million angels to stand down from war footing doesn't bear thinking about . . .

BEELZEBUB

(*quietly*)

No? You ought to try to get ten million demons to put down their weaponsz and go back to work.

GABRIEL

(*quietly*)

Well. At least we know whose fault this is.

And they both glance at Crowley and Aziraphale. Aziraphale gives them a happy wave. Crowley sighs at this.

GABRIEL (CONT'D)

(*to Adam*)

Young man?

ADAM

Yes.

GABRIEL

You were put on this earth to do one thing and one thing only. To end it. You're a disobedient little brat. I hope someone tells your father.

BEELZEBUB

Someone will. And your father . . . will not be pleased.

They vanish. Dust blows across the airfield.

MADAME TRACY
　　Weren't they odd?

ADAM
　　I want to go home.

WENSLEYDALE
　　Actually, I want to go home too.

Aziraphale is humbled and amazed that they survived.
Crowley drops to his knees. He's in sudden, stabbing pain.

CROWLEY
　　No. No no no no nono no no no. NOOOOO!

AZIRAPHALE
　　What's happening? I can feel something . . .

CROWLEY
　　They did it. They told his father.

AZIRAPHALE
　　Oh no.

CROWLEY
　　And his satanic father . . . is not happy . . .

The tarmac starts to shake and shudder. Everyone is
staggering.

NEWT
　　Perhaps it's a volcano.

ANATHEMA
　　There aren't any volcanoes in England. It's really angry,
　　whatever it is. I can feel it . . . it's getting closer . . .

A huge judder and they are thrown to the ground . . .

Pepper and Brian and Wensleydale hold hands. They look at
Adam. He reaches out and holds Pepper's hand.

SHADWELL

What's happening?

AZIRAPHALE

Well, you can call me an old silly, but it looks like the Devil's coming. Satan himself.

SHADWELL

That's the way it is, then?

Shadwell waves the Thundergun. He stands in front of Madame Tracy.

SHADWELL (CONT'D)

Anyone who wants to hurt the Hoor of Babylon is gonna have to get past me!

MADAME TRACY
(pleased)
Ooh, Mr Shadwell!

Crowley turns to Aziraphale.

CROWLEY

Right. That was that. It was nice knowing you.

AZIRAPHALE

We can't give up now.

CROWLEY

This is Satan himself. It isn't about Armageddon. This is personal. We are fucked.

Aziraphale picks up the sword from the ground, and holds it awkwardly, as if it might go off. He's not threatening Crowley with it, just making his point that he can do dangerous out-of-character things if he needs to.

AZIRAPHALE

Come up with something, or . . . Or I'm never going to talk to you again.

Crowley nods. That one hurts. What the hell. Crowley snaps his fingers . . . and time stops.

615 EXT. THE TIMESTOP BUBBLE – EVENING

We are transported. We are inside Adam's head, or perhaps inside Crowley's. We could be on the airstrip, or a meadow, or a London Street, and it could be any time of day, but there are only three people here now: Adam and Crowley and Aziraphale.

Crowley and Aziraphale have wings now. Aziraphale's are well- groomed. Crowley's were once white but have seen better days.

Crowley runs his hands through his hair and puts on a new pair of sunglasses.

CROWLEY

Adam! Listen: your father's coming to destroy you. Probably to destroy all of us.

ADAM

My dad? He wouldn't hurt anybody.

CROWLEY

Not your earthly father. Satan. Your father who is no longer in Heaven. He's coming. And he's angry.

ADAM

So what do you want me to do about it? Fight him?

Adam is close to us, looking at us. Crowley and Aziraphale are some distance away, seen over his shoulders. All in focus. The effect is that we have an angel on one shoulder and a demon on the other.

CROWLEY

I don't think that fighting him would do any good. You're going to have to come up with something else.

ADAM

But . . . I'm just a kid.

AZIRAPHALE

That's not a bad thing to be, Adam. You know, I
was scared you'd be Hell Incarnate. I hoped you'd be
Heaven Incarnate. But you aren't either of those things.
You're better than that. You're HUMAN incarnate.

And now Crowley and Aziraphale are beside him.

CROWLEY

Adam. Reality will listen to you, right now. You can
change things. And when I start time, you'll have to
do it fast.

AZIRAPHALE

And whatever happens . . . for good or for evil, we're
beside you.

*Aziraphale holds up the sword, this time like he means it. It
WHOOMPFS into white flame, cleanly and beautifully.*

*And they are: an angel and a demon, with a boy between
them.*

CROWLEY

I'm going to start time. You won't have long to do
whatever you're going to do . . .

Crowley pulls out the tyre iron from his pocket.

616 EXT. AIRFIELD – EVENING

And they are back on the airfield again.

*The ground is splitting and shaking and rumbling, and lava
is dribbling between the cracks . . .*

CROWLEY

And do it quickly . . . Because he's . . .

Adam is holding Aziraphale's left hand and Crowley's right hand.

There's a HUGE EXPLOSION, as if something in front of them has appeared, as if a bomb has been dropped . . .

A HUGE DEMONIC SHAPE made of smoke is appearing on the grass.

SATAN

Where's my son? You?! You're my rebellious son? Come here.

Adam walks forward.

ADAM

You're not my dad. Dads don't wait until you're eleven to say hello. And then turn up to tell you off.

SATAN

What?

ADAM

If I'm in trouble with my dad . . .

Another explosion knocks everyone down. Red smoke is everywhere . . .

We can make out a face, THE FACE AND UPPER BODY OF SATAN, LOOKING DOWN AT US, monstrous and enormous on the airfield.

ADAM (CONT'D)

. . . then it won't be you. It's going to be the dad who was there. You're . . . not . . . my . . . dad . . .

A struggle of wills. Adam's face is clenched with effort . . .

SATAN

What did you say?

AZIRAPHALE

You can do it!

CROWLEY

Say it, Adam.

SATAN

Come here!

We close in on Adam's face and then on his eyes. This child is Power Incarnate.

ADAM

You're not my dad. You never were.

Something happens to the nature of reality.

SATAN

No! No, no, no, no, no, no, nooooooo!

And the figure of Satan dissolves back into smoke.

And through the smoke we can see Mr Young's car, pulling up.

AZIRAPHALE

That's not really his father . . .

CROWLEY

It is. It is now. And it always was. He did it!

Mr Young gets out of the car as the smoke clears. Crowley and Aziraphale are wingless.

MR YOUNG

Adam? Adam? Oh, for Heaven's sake. Where is he? Adam! Where are you?

Mr Young surveys the gathered people. Aziraphale and Crowley, Shadwell and Madame Tracy, Anathema and Newt . . .

MR YOUNG (CONT'D)

Would anyone here care to explain to me what exactly is going on?

GOD (V.O.)

But Adam rarely did what his father wanted.

And the kids are on their bikes, cycling away into the distance . . .

617 INT. PEPPER'S BEDROOM – NIGHT

Very rapid CUTS: Pepper's not-girly bedroom is empty. Then she's in bed.

618 INT. WENSLEYDALE'S BEDROOM – NIGHT

Wensley appears in his bed in his bedroom with encyclopedias in it. He takes off his glasses.

619 INT. BRIAN'S BEDROOM – NIGHT

Brian appears in his bed. He reaches into the bed and pulls out an open packet of crisps.

620 INT. ADAM YOUNG'S BEDROOM – NIGHT

Deirdre Young opens the bedroom door. She looks at Adam, asleep in his bed, with a fond smile on her face.

Adam is faking being asleep. He does a small snore for verisimilitude.

621 EXT. TADFIELD CENTRE – NIGHT

Later. It's now real night. We are in the town centre.

Crowley and Aziraphale are sitting on the bench. They are sharing a bottle of 1921 Châteauneuf-du-Pape (as seen in Episode One) . . . they look perfectly normal . . .

Aziraphale has a cardboard box next to him on the bench.

AZIRAPHALE
 I'm sorry about the car. I know how much you liked it. Perhaps if you concentrated really hard . . .

CROWLEY

It wouldn't be the same. I had it from new, you know.

AZIRAPHALE

I do. Yes.

Aziraphale is playing with the burned 'playing with Fyre' paper fragment from the book.

AZIRAPHALE (CONT'D)

It all worked out for the best. Just imagine how awful it might have been if we'd been at all competent.

CROWLEY

Point taken. What's that?

Aziraphale hands him the fragment.

CROWLEY (CONT'D)

So that was the final one of Agnes's prophecies?

AZIRAPHALE

As far as I know.

CROWLEY

And Adam's . . . human again?

AZIRAPHALE

Again, as far as I can tell. Yes.

The International Express van drives past . . .

CROWLEY

Angel. What if the Almighty planned it this way all along? From the very beginning?

Aziraphale takes a swig, wipes the bottle top, and hands it back.

AZIRAPHALE

Could have. I wouldn't put it past Her.

CROWLEY

From what I remember, and we were never actually on what you might call speaking terms, she wasn't exactly

one for a straight answer. She'd just *smile*, as if She knew something that you didn't.

AZIRAPHALE
Well, She *is* God. That's sort of the point.

The International Express man, who died earlier that morning, is none the worse for wear, and approaches them.

INTERNATIONAL EXPRESS MAN
You've got the . . . um?

Aziraphale presents him with the cardboard box.

AZIRAPHALE
Didn't want them falling into the wrong hands.

The International Express man takes the box. Inside is the coronet and the scales. Then he looks at his clipboard.

INTERNATIONAL EXPRESS MAN
Excuse me, gents. There's meant to be a sword here.

They look around. Then Aziraphale says:

AZIRAPHALE
Sitting on it.

He drops the sword into the box.

INTERNATIONAL EXPRESS MAN
Good thing you were here, really.

AZIRAPHALE
It's nice to have someone who recognises our part in saving the . . .

INTERNATIONAL EXPRESS MAN
I need someone to sign for it.

AZIRAPHALE
Oh. Right.

Aziraphale signs. The International Express man puts the box away, then he opens the door of his van.

INTERNATIONAL EXPRESS MAN
Do you believe in life after death?

AZIRAPHALE
I suppose I must do.

INTERNATIONAL EXPRESS MAN
Yeah. If I was to tell my wife what happened to me today, she wouldn't believe me. And I wouldn't blame her.

He drives off.

AZIRAPHALE
There it is.

A green country bus/coach is pulling up.

AZIRAPHALE (CONT'D)
It says Oxford on the front.

CROWLEY
Yeah . . . but he'll drive to London. He just won't know why.

AZIRAPHALE
I suppose I should get him to drop me off at the bookshop.

CROWLEY
It burned down, remember?

Aziraphale looks like he's going to cry. He nods. They get onto the bus.

CROWLEY (CONT'D)
You can stay at my place, if you like.

AZIRAPHALE
I don't think my side would like that.

CROWLEY
You don't have a side any more. Neither of us do. We're on our own side.

And the Tadfield bench is left empty as the bus drives away.

622 BLACK SCREEN: TITLE CARD: **SUNDAY**

GOD (V.O.)
> Adam had rebooted reality. He had changed the past
> and changed the present. So, on Sunday, people woke
> to find a world that was almost – but not entirely – the
> one that they used to inhabit.

623 EXT. CROWLEY'S FLAT – DAY

*Crowley comes out of his flat. He's dressed in a perfect suit,
although uncharacteristically, and subtly, his tie is tartan.*

*He looks depressed. Then he notices something odd: parked
outside the flat is HIS BENTLEY. As good as new. Better,
even . . .*

He raises an eyebrow. And walks past it. He waves a TAXI.

624 EXT. AZIRAPHALE'S BOOKSHOP – DAY

*The bookshop looks unburned. In fact it looks just like it did
before. Only cleaner.*

625 INT. AZIRAPHALE'S BOOKSHOP – DAY

*Aziraphale is walking through the bookshop, impressed. All
the books are clean and beautiful.*

GOD (V.O.)
> Although, people who were dead were now alive, and
> things that were broken had now been miraculously
> restored.

*He stops at a shelf covered with beautiful first editions of
boy's books: the* William *books by Richmal Crompton, and
suchlike. All in beautiful shape.*

AZIRAPHALE
That shelf's new.

TITLE CARD: **THE VERY FIRST DAY OF THE REST OF THEIR LIVES**

626 EXT. ADAM YOUNG'S HOUSE – DAY

Mr Young is sitting outside the house on his deckchair, reading the Sunday paper. (He's probably a Telegraph *reader.)*

R. P. Tyler coughs. He's walking his dog.

TYLER
Morning, Young.

MR YOUNG
Good morning, Mr Tyler.

TYLER
It's about last night. I . . . I remember I came and talked to you about your son. I remember something was happening, but . . . I don't remember what it was.

MR YOUNG
Adam is confined to the house. And I've stopped his pocket money for the next two weeks.

TYLER
Good. Good! . . . What, exactly, did he do?

MR YOUNG
I don't think that's any of your business.

627 INT. ADAM YOUNG'S BEDROOM – DAY

Adam, and Dog, are in his bedroom. It's, for once, amazingly tidy.

ADAM
I tidied it! Mum!

Mrs Young looks in.

MRS YOUNG
Was that so hard? I can see the carpet. Now you just have to keep it clean.

ADAM
Can Dog and me go outside?

MRS YOUNG
You know what your father said.

ADAM
He said even if he didn't know why I was in trouble, I would.

MRS YOUNG
And . . . was he right?

A beat. Then Adam nods.

MRS YOUNG (CONT'D)
Can you explain it to me?

Adam shakes his head.

MRS YOUNG (CONT'D)
Well, you can go into the garden. Give Dog a little exercise. But that's all.

Adam brightens up. He hugs her.

ADAM
Thanks, Mum! Come on, Dog.

And he and Dog scramble down the stairs . . . Mrs Young looks at him go, with love on her face.

628 EXT. ADAM YOUNG'S HOUSE – DAY

Mr Tyler is walking away. Mr Young gets up from his deckchair, and calls after him.

MR YOUNG
Hoy! Tyler.

Tyler looks around, surprised.

MR YOUNG (CONT'D)
Just in case you were in any doubt. I'm proud of my son.

629 INT. JASMINE COTTAGE, BEDROOM – DAY

The bedroom, which was wrecked the last time we saw it, is tidied and nice. No trace of the storm.

Newt is in bed. He opens his eyes to the birdsong. He rolls over. Anathema is still asleep. He kisses her and she opens her eyes sleepily . . .

NEWT
Good morning.

ANATHEMA
Good morning. I'm going to regret asking this, but . . . I'm going to ask. Why *is* your car called Dick Turpin?

NEWT
Dick Turpin was a famous highwayman. It's a sort of joke.

ANATHEMA
Yes?

NEWT
It's called Dick Turpin because everywhere it goes it holds up traffic.

ANATHEMA
I regret asking.

NEWT
I thought I'd make us both breakfast.

ANATHEMA

That would be nice . . . It's so weird. I've lived all my
life according to Agnes's prophecies. And now there
aren't any more prophecies. I can do whatever I like.
I'm like a train that got to the end of the tracks and
still has to keep on going.

NEWT

From now on, you'll head into the future with
everything coming as a surprise. Just like the rest of
us.

ANATHEMA

It . . . it's just odd. I feel a bit lost.

NEWT

It's called being human. You'll get used to it.

Newt heads for the door.

ANATHEMA

Witchfinder Private Not a Computer Engineer. Did we
save the world yesterday?

NEWT

I don't know.

ANATHEMA

You were a pretty good witchfinder, though. I mean,
you found me, didn't you?

And she settles back into the bed.

630 EXT. ST. JAMES'S PARK – DAY

A really beautiful day. We are looking at it from above . . .

*Then we move down into the park. A CHILD is eating an
ice-cream. A happy family of TOURISTS – MUM, DAD,
and THREE SMALL CHILDREN go past. A TALL
FIGURE is feeding the ducks.*

Several PARK KEEPERS are walking through the park. They have a large van with them, full of deckchairs, and are taking deckchairs out of the van and putting them out.

The British secret agent from the first episode is talking to the Russian agent, sitting on a park bench, pretending to read newspapers and pretending not to talk.

BRITISH AGENT

As far as the British Government is concerned, the apparent appearance of the legendary beast known as the kraken was a mass hallucination.

RUSSIAN AGENT

There were a number of mass hallucinations in our country too.

BRITISH AGENT

Yes, but this one ate our trade delegation.

Aziraphale and Crowley are in line at an ice-cream van. Crowley's made it to the front.

CROWLEY

A strawberry lolly. And a Mr Whippy with a flake.

He hands the ice-cream to Aziraphale.

AZIRAPHALE

How's the car?

CROWLEY

Not a scratch on it. How's the bookshop?

AZIRAPHALE

Not a smudge. Not a book burned. Everything is back just as it was. Have your people been in touch yet?

Crowley shakes his head.

CROWLEY

Yours?

AZIRAPHALE
Nothing.

CROWLEY
Do you understand what happened yesterday?

AZIRAPHALE
Well, I understand some of it. But some of it, well . . .
it's just a bit too . . .

TALL FIGURE
INEFFABLE.

*It is Death. He nods at them, and fades away. Crowley
watches him go. Turns his attention away from Aziraphale . . .*

CROWLEY
Funny seeing him here. It's meant to be bad luck.

He pauses for a reply.

CROWLEY (CONT'D)
I said it's meant to be . . . ?

He looks around. Aziraphale is nowhere to be seen.

*Nearby: the PARK KEEPERS, whom we now recognise as
angels, are bundling Aziraphale, with his mouth taped up,
and hands zip-tied behind him, into their deckchair truck.*

URIEL
Renegade angels all tied up with strings.

SANDALPHON
These are a few of our favourite things.

Crowley sees this, and starts to run after them . . .

CROWLEY
Hey! Stop! Stop them!

A large mum TOURIST says:

LADY TOURIST
What's wrong, love?

CROWLEY
My friend! They're kidnapping my friend!

LADY TOURIST
Bad luck, dear.

And she swings back and brings down a crowbar on the back of Crowley's head. It would have killed a human . . .

He sways . . .

CROWLEY
Not a problem. Everything's tickety-boo.

Crowley's POV: everything gets swimmy, and then he falls. Crowley falls to his knees.

Crowley's POV: the lady tourist is now transformed into Hastur in a wig. Her husband is Dagon; their children are monstrous tiny adults, Don't Look Now-*style.*

The van with Aziraphale in it drives away, and Crowley tries to crawl after it.

And then he collapses.

And the screen goes black.

631 INT. HEAVEN – DAY

We are high up in a really nice office block with a fantastic view of the world. Beautiful decor.

GABRIEL
Ah. Aziraphale. So glad you could join us.

AZIRAPHALE
You could have just sent a message. I mean, a kidnapping, in broad daylight . . .

GABRIEL
Call it what it was. An extraordinary rendition. So. With one act of treason, you averted the war.

As we've pulled back, we can see that Aziraphale is tied to a chair.

AZIRAPHALE

Well, I think the greater good demanded . . .

GABRIEL

Don't talk to me about the greater good, sunshine.
I'm the Archangel Fucking Gabriel. The greater good
was we were finally going to settle things with the
opposition once and for all.
 (to angels)
Any word from our new associate?

There are other angels standing around.

URIEL

He's on his way.

GABRIEL

You're going to like this, Aziraphale. Bet you didn't see
this one coming.

632 INT. HELL

*Crowley is in chains, and standing, lonely, in the centre of
the box.*

HASTUR

. . . and the murderer of a fellow demon, a crime I saw
with my own eyes!

CROWLEY

Is there anything I can say in my defence?

HASTUR

That's a very good question, Crowley.

DAGON

Objection. It's a stupid question. There's nothing you
can do or say, traitor. You've done it all.

BEELZEBUB

> Objection suzzstained. Creatures of Hell, you have
> heard the evidence against the demon known as
> Crowley. What is your verdict?

*Through the glass, we see hundreds of DEMONS, naked
flesh and slug-flesh, tentacles and faces, a nightmare world,
watching the proceedings. And the mouths open, and we hear
a chant of . . .*

DEMONS

> Guilty! Guilty! Guilty!

Beelzebub smiles at Crowley.

BEELZEBUB

> Do you have anything to szzay before we take our
> vengeance on you?

Crowley shrugs.

CROWLEY

> What's it going to be then? An eternity in the deepest
> pit?

*Hastur, Beelzebub and Dagon smile and shake their heads in
unison.*

HASTUR

> We're going to do something even worse. We're
> deleting you, as painfully as we can. Letting the
> punishment fit the crime.

The little usher creature shouts:

USHER

> Send for the Method of Execution!

We hear the DING! of a lift door.

*Lift doors open at the back of the hall. And the angel Michael
steps out. The angel is wearing white robes, and holding a
glass jug, filled with water.*

CROWLEY

The archangel Michael? That's . . . unlikely.

DAGON

It's diplomacy. You ought to approve of that.
Cooperation with our old enemies.

HASTUR

Oy. Wank-wings. You brought the stuff?

Dagon, Beelzebub and Hastur seem very nervous. So does the little usher.

ARCHANGEL MICHAEL

I did. I'll be back to collect it . . .

HASTUR

You, um . . . Ought to do the honours. I've seen what that stuff can do.

Michael pours the jug of water into the bath. It's apparently inexhaustible: the water flowing from the small glass jug fills the bath.

CROWLEY

That's holy water.

ARCHANGEL MICHAEL

The holiest, yes.

BEELZEBUB

It'sz not that we don't truszt you, Michael, but obviously we don't truszt you. Hazstur, test it.

Hastur leans over and grabs the little demonic Usher, who flails, terrified.

USHER

What? What did I do?

HASTUR

Wrong place. Wrong time.

Hastur tosses the usher into the bathtub.

It's as if a lump of sodium has been dropped into water. It flares and sputters, and the usher SCREAMS before vanishing.

BEELZEBUB
 Demon Crowley, I sentence you to extinction by holy water. Have you anything to say?

CROWLEY
 Well, yes. This is a new suit, and I'd hate to ruin it. Would you mind if I took it off?

HASTUR
 Keep making jokes, funny man.

But Crowley has removed his jacket, and is undoing his tie . . .

633 EXT. SHADWELL'S FLAT – DAY

The motor scooter is parked and chained up outside the house.

634 INT. SHADWELL'S FLAT – DAY

Shadwell is sitting in his grimy bedsit, reading a book. It's an ancient demonological text, although someone has drawn glasses and moustaches on all the demons. He looks like a man with a lot on his mind. There is a knock on the door.

SHADWELL
 (warily)
 Just leave the plate outside the door.

The door opens. It's Madame Tracy. She looks . . . well, she looks normal. Not like a medium. Not like a sex worker. Not like an eccentric. Just rather off-puttingly normal.

MADAME TRACY
 Hello, Mr S.

SHADWELL
Aye, Jezebel?

MADAME TRACY
I was just thinking, after all we've been through in the last two days, seems silly for me to leave a plate by the door, so I've laid a place for you at the table.

SHADWELL
In your den of iniquity?

MADAME TRACY
That's right, dear.

635 INT. JASMINE COTTAGE – DAY

There's a ring at the doorbell. Newt opens it, to see GILES BADDICOMBE standing on the doorstep: a middle-aged solicitor. Baddicombe gives a smile. He's holding a cardboard box, and has a notebook in his hand.

BADDICOMBE
Hello. Mister
 (checks notebook)
Pulzifer?

He hands Newt his card.

NEWT
Pulsifer. Yes.

He looks down. The card says
 Giles Baddicombe
 Robey, Robey, Redfearn and Bychance
 Solicitors
 13 Demdyke Chambers, PRESTON.

BADDICOMBE
I have the peculiar honour of bringing you and Mrs Pulsifer a small bequest.

NEWT

There isn't any Mrs Pulsifer. I mean, there's my mum, but she's in Dorking.

BADDICOMBE

How odd. The letter is quite specific. Can I come in?

He walks in, puts the package down.

NEWT

Coffee?

BADDICOMBE

I mustn't. To be honest, we're all very interested in this. Mr Bychance nearly came down himself, but he doesn't travel well these days.

NEWT

I have no idea what you're talking about.

BADDICOMBE

The bequest. It's what's in the box. With the letter. My firm has had it for over 300 years. I don't know the full details because I joined the firm only fifteen years ago, but . . .

636 EXT. AGNES NUTTER'S TIME – DAY – 1650s

FLASHBACK. Virtue Device knocks on a door. A very young lawyer, ROBEY, opens the door.

VIRTUE

Master Robey? This is for you, from my mother. And this, with it, for safekeeping.

She hands him a package tied with twine, and a sealed note.

637 INT. ROBEY'S ROOMS – DAY – 1650s

Robey opens the sealed note, breaking the seal. A gold coin

falls out. He opens the package and inside it is a brand new metal box.

He looks at the box and then he smiles . . . He reads the note hungrily.

GOD (V.O.)
> The letter contained a gold coin, certain instructions and five interesting facts about the next ten years which would ensure that he was able to pursue a very successful legal career. All he had to do in return was see that the box was carefully looked after for rather more than three hundred years, and then be delivered . . . here on this particular Sunday morning.

638 INT. JASMINE COTTAGE – DAY – PRESENT DAY

Baddicombe shrugs.

BADDICOMBE
> We've been looking after it for three hundred years. And, um . . . Well, here it is.

Anathema has come downstairs. Newt has finished opening the box that the thing was in. It's an ancient metal box.

ANATHEMA
> It's from Agnes.

NEWT
> Are you sure?

ANATHEMA
> I recognise the style. Hello. I'm Anathema. Well . . . Let's see what's inside.

BADDICOMBE
> We've had bets in the office . . .

ANATHEMA
> Would you like to open it?

BADDICOMBE
 I say. That would be something to tell my
 grandchildren.

He opens the box.

BADDICOMBE (CONT'D)
 That's odd.

*He takes out an envelope, addressed to GYLES
BADDICUMBE. He opens the envelope. An ancient coin
falls onto the table. He reads a note.*

BADDICOMBE (CONT'D)
 Excuse me. I, um . . .

White-faced, he takes the coin and runs out of the door.

*A glance out of the window shows him driving away. Newt
picks up the letter from the table, and reads . . .*

NEWT
 *Here is A Florin, lawyer; nowe, runne faste, lest thee
 Worlde knoe the Truth about yowe and Mistreſs
 Spiddon of the councille's Towne planning department.*

*Anathema reaches into the box. There is a yellowing
350-year-old manuscript. And she reads the front page, in a
handwriting we recognise.*

ANATHEMA
 *Further Niſe and Accurate Prophecies of Agnes
 Nutter, Concerning the Worlde that Is To Com. Ye
 Saga Continueſ!*

She looks at Newt and bites her lip. He looks at her.

639 INT. MADAME TRACY'S FLAT – DAY

*At the table where the seance was held. There are flowers on
the table and a tablecloth, and Mr Shadwell and Madame
Tracy are sitting concluding their dinner. Nothing has been*

said for a while, but the dinner was good. Shadwell dabs his lips with a serviette.

MADAME TRACY

I know it's wicked, but . . .

She produces a bottle of Guinness, and pours it for Shadwell, who is impressed.

She sips her tea as he slurps his stout.

MADAME TRACY (CONT'D)

You know. I've got a tidy amount put away. Sometimes I think it might be nice to move out of London. Get a little bungalow. And they say that two can live as cheaply as one . . . and it would be nice to have a man around . . .

Shadwell suddenly realises what he's being asked.

SHADWELL

I . . . I don't think Private Pulsifer is ever coming back. I'm the only witchfinder left.

MADAME TRACY

Well, you found me, love. I'm not much of a witch, but I'll have to do. Now what?

SHADWELL

Now . . . I pop the question . . . ?

MADAME TRACY

Well, go on, then.

Madame Tracy nods.

SHADWELL

Aye. How many nipples ha' ye got, Jezebel?

MADAME TRACY

Retired Jezebel, Mr S. Just the two.

SHADWELL

Well, then. That's all right.

640 INT. HEAVEN – DAY

Aziraphale is tied to a chair. The angels in nice suits are arranging a circle of stones on the nice floor in front of them. It's a circle just big enough for someone to stand in.

AZIRAPHALE
So we're waiting for somebody?

No answer. They ignore him.

AZIRAPHALE (CONT'D)
Nice stones. What are they for?

URIEL
Barbecue.

AZIRAPHALE
What fun. I love a barbecue.

In answer we hear the DING of a lift (elevator) door.

And here is the DISPOSABLE DEMON. He's looking around as if this is not somewhere he would ever choose to be. He's holding a metal pan, with a cover on it.

DISPOSABLE DEMON
Nice view. You don't get this view down in the basement.

SANDALPHON
You got the thing?

DISPOSABLE DEMON
Oh yes. Tit for tat deal. This is a first.

He takes the top off the metal pan, with a flourish. Flames are burning in the pan – weird-coloured flames, burning hard.

Look at Gabriel and the other angels – some of them step back, or avert their glance. This is scary.

Only Aziraphale seems unfazed.

Demon puts the pan of fire on the stones. It flares up.

DISPOSABLE DEMON (CONT'D)
> Can I . . . Can I ask a favour . . . can I hit him? I've
> always wanted to hit an angel.

SANDALPHON
> Go for it.

*Demon heads over to Aziraphale. Who looks up at him,
unafraid.*

And demon has second thoughts.

DISPOSABLE DEMON
> I . . . should be getting back. I'll come and pick up the
> Hellfire in, what, an hour?

URIEL
> Barbecue will be over and done by then.

*The pillar of Hellfire is burning, and the angels are no more
comfortable with it than the demons are with the holy water.
It's terrifying for them.*

*Two of the angels, Uriel and Sandalphon, pull their flaming
swords.*

*(NB: the burning swords are burning with a very different
kind and colour of flame to the Hellfire. And they do not
have to burn.)*

*Uriel walks over to Aziraphale with his sword out. We think
he's going to stab Aziraphale, but no . . .*

Uriel cuts the rope that ties Aziraphale to the chair.

URIEL
> Up.

Aziraphale gets up. Brushes himself down. Adjusts his bowtie.

AZIRAPHALE
> I don't suppose I could persuade you to reconsider . . . ?

The angels in the room are impassive.

AZIRAPHALE (CONT'D)
 We're meant to be the good guys, for Heaven's sake.

GABRIEL
 And for Heaven's sake, we make an example of a
 traitor. Into the flame.

And Aziraphale walks forward. Reluctantly. This is so hard.

He takes a deep breath. He's almost at the flame . . .

AZIRAPHALE
 Right. Well, lovely knowing you all. May we meet on a
 better occasion.

GABRIEL
 We won't. It's Hellfire. It will destroy you absolutely
 and utterly and for ever. Now shut your stupid mouth
 and die.

*Aziraphale steps into the flames and is engulfed by burning
Hellfire.*

641 INT. HELL

*The walls and roof of the court of Hell are transparent,
and dozens of demons are staring in at us: they look
HORRIFIED.*

*What does it take to drop the jaws of demons? Beelzebub
and Dagon and Hastur also look terrified, revolted . . . And
we follow their glance to . . .*

THE BATHTUB.

*In which, wearing nothing but his underpants and, oddly
enough, his socks (but his feet are out of the bath, resting
on the far edge) is Crowley. He doesn't actually have a
newspaper and a cigar, but damn, he's enjoying himself in his
bath . . .*

CROWLEY
> I don't suppose that anywhere in the nine circles of
> Hell there's such a thing as a rubber duck? No?

He waves at Beelzebub.

642 INT. HEAVEN – DAY

*And in Heaven the angels are watching, with horror, as
Aziraphale stands in the flame, without burning.*

He's standing in it like a man taking a much-needed shower.

*He takes a deep breath and breathes out a huge gout of
Hellfire into the room.*

The angels back away in terror . . .

GABRIEL
> It's worse than we thought.

643 INT. HELL

Beelzebub is having the same thoughts.

BEELZEBUB
> He's gone native. He isn't one of us any longer.

644 INT. HEAVEN – DAY

Uriel is terrified, but he's asking the question . . .

URIEL
> What IS he?

645 INT. HELL

*Beelzebub watches as Crowley enjoys himself by taking
handfuls of water and dripping them over the side of the
bath, where they flame and flare and burn through the
floor.*

CROWLEY

So you're probably thinking, 'If he can do this, I wonder what else he can do'? And very, very soon, you're all going to get the chance to find out.

HASTUR

He's bluffing. We can take him. One demon against the whole of Hell, what's he going to do?

BEELZEBUB

Shut it! We have to get him out of here. He's going to causze a riot.
(she looks at the demons staring at this through the walls)
What are you all looking at? Nothing to see! Nothing to szee here!

The glass goes black, and the demons vanish.

There is a DING! *The lift doors open. The angel Michael is holding his empty jug.*

MICHAEL

I came to bring back the . . . OH LORD.

Crowley gets out of the bath.

CROWLEY

Michael. Duude. Do us a quick miracle, will you? I need a bathtowel?

Michael looks desperately at the demons, then, nervously hands a miraculous bathtowel to Crowley, who starts towelling off. Crowley looks at Beelzebub and co. He starts to do up his shirt.

CROWLEY (CONT'D)

I think it would be best for everyone if I were left alone in future. Don't you?

Beelzebub and Hastur and Dagon all nod. Crowley looks at Michael, who nods too.

Crowley picks up the rest of his clothes.

CROWLEY (CONT'D)
Right.

646 INT. THE LOBBY OF THE HEAVEN AND HELL BUILDING – DAY

The lift doors DING open. Crowley, finishing getting dressed – doing up his tie perhaps – walks out into the lobby.

A moment later, another DING, and Aziraphale, looking very pleased with himself, gets out.

They look at each other. Then Crowley and Aziraphale walk out of the building together.

AZIRAPHALE
 (sotto voce)
Now THAT was playing with fire.

647 EXT. TADFIELD HILLSIDE – DAY

Newt is at the top of a hill. He's leaning in with a box of matches. Drops one towards us and a fire starts.

Pull back. A bonfire is burning in a small circle of stones. We're on a hill outside Tadfield.

NEWT
Are you sure?

Anathema steps into shot.

ANATHEMA
Yes. I'm sure. I know what I'm doing. I just don't like it.

NEWT
Technological marvels could be revealed.

ANATHEMA
You'd probably just break them.

She takes the manuscript, and picks up the title page, and is about to drop it into the fire. Then she hesitates.

NEWT

> Think of it this way. Do you want to be a descendant all of your life?

And she drops the title page into the flames.

We look at it blackening, as another page joins it. And another.

Newt and Anathema, laughing, drop the pages in.

The smoke wreathes up from the bonfire, and for a moment we see Agnes Nutter, in the smoke, looking down at her descendants, and smiling. She's happy . . .

648 EXT. ADAM YOUNG'S HOUSE – DAY

Adam's in the back garden. He looks gloomy. A PSSST! is whispered from behind the fence.

Pepper's head pops up. So does Wensley's and Brian's.

PEPPER

> Your mum said we can't talk to you. So we came round the back.

Adam shrugs.

BRIAN

> Adam. What happened last night?

ADAM

> Just stuff. Doesn't matter. All I try and do is help, and now I'm stuck in the garden.

WENSLEYDALE

> How long until they let you out?

ADAM

> Years. Years and years, I expect.

PEPPER

What about tomorrow?

ADAM

Tomorrow will be all right. They'll have forgotten by then. They always do.

PEPPER

There's a circus in Norton. We were going to go over on our bikes and watch them set up.

ADAM

You should go. I'll be fine.

They go.

He sits for a moment on his own. Dog is sitting looking up at him. Adam looks around. Then an idea occurs to him.

He looks at the hedge, which is impenetrable.

ADAM (CONT'D)

Dog. Get away from that hedge, because if you went through it, then I'd have to chase you to catch you, and I'd have to go out of the garden, and I'm not allowed to do that. But I'd have to . . . if you went an' ran away.

There's a beat. There's now a hole in the hedge, of a size that a boy and a dog could get through. Dog looks up at him. And then he's off, through the hole and away into the field beyond the house . . .

Adam grins, delighted.

ADAM (CONT'D)

Dog, you bad dog! Stop! Come back here!

And he runs after him.

649 EXT. TADFIELD FIELDS – DAY

And Dog runs ahead, and Adam, delighted, runs after him, laughing.

Pull back.

GOD (V.O.)
Something told him that something was coming to an end. Not the world exactly, just the summer. There would never be one like this. Not ever again.

Newt and Anathema are on the hill having their bonfire.

Adam pauses for a moment, and looks up at the smoke from the bonfire.

Agnes Nutter in the smoke sees Adam, and winks at him. Anathema and Newt wave at the small boy, and he waves back, and then runs, with Dog at his heels . . .

Then we see his hand snatch AN APPLE from a tree.

R. P. TYLER (O.S.)
Oy! You, boy, Adam Young, get away from my apples! I'll tell your father!

And he's still running. Eating his apple with joy.

GOD (V.O.)
He couldn't see why people made such a fuss about people eating their apples, but life would be a lot less fun if they didn't. And there never was an apple, in Adam's opinion, that wasn't worth the trouble you got into for eating it.

A boy and his dog. Having the best day of their lives.

650 EXT. BERKELEY SQUARE – DAY

Aziraphale and Crowley, sitting on a bench in Berkeley Square, in the garden. It's a beautiful day.

AZIRAPHALE
Do you think they'll leave us alone, now?

CROWLEY

At a guess, they'll pretend it never happened. Right. Is
anyone looking?

Aziraphale raises his hands to his temples, and concentrates.

AZIRAPHALE

Nobody. Right. Swap back, then.

GOD (V.O.)

It was just like Agnes had told them. They were playing
with fire, and would need to choose their faces wisely.
And so they had.

*Crowley and Aziraphale hold hands. We watch as they
MORPH: Crowley becomes Aziraphale and Aziraphale
becomes Crowley.*

CROWLEY

A tartan collar? Really?

AZIRAPHALE

Tartan is stylish. So. Agnes Nutter's last prophecy was
on the money.
 (confiding, pleased with himself)
I asked them for a rubber duck! And I made the
archangel Michael miracle me a towel.

CROWLEY

They'll leave us alone. For a bit. You ask me, both sides
are going to use this as breathing room before the big
one.

AZIRAPHALE

I thought that was the big one.

Crowley shakes his head.

CROWLEY

For my money, the really big one will be all of us
against all of them.

AZIRAPHALE

What? You mean Heaven and Hell against humanity?

Crowley shrugs. They start to walk away through the garden . . .

CROWLEY

Time to leave the garden. Let me tempt you to a spot of lunch.

AZIRAPHALE

Temptation accomplished. What about the Ritz? I do believe a table for two has just miraculously come free.

651 INT. THE RITZ HOTEL RESTAURANT – DAY

A pianist is playing gentle dinner music . . .

Crowley and Aziraphale are eating in the restaurant. They are enjoying the things of the world. A waiter is filling their glasses.

AZIRAPHALE

I like to think none of this would have worked out if you weren't, at heart, just a little bit, a good person.

CROWLEY

Or if you weren't, deep down, just enough of a bastard to be worth knowing. Cheers. To the world.

AZIRAPHALE

To the world.

Glasses clink. We hear birdsong over . . .

GOD (V.O.)

Perhaps the recent exertions had had some fallout in the nature of reality because, while they were eating, for the first time ever, a nightingale actually did sing in Berkeley Square. Nobody heard it over the noise of the traffic, but it was there, right enough.

And as the screen goes black we head into the credits, and a voice sings . . .

SONG
> *That perfect night, the night we met,*
> *There was magic abroad in the air.*
> *There were angels dining at the Ritz*
> *And a nightingale sang in Berkeley Square.*
>
> *I may be right, I may be wrong,*
> *But I'm perfectly willing to swear*
> *That when you turned and smiled at me*
> *A nightingale sang in Berkeley Square . . .*

FADE TO BLACK.

END CREDITS

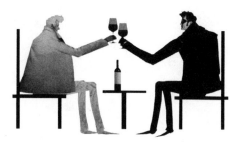

THE
REGRETTABLY–DELETED–
OTHER–FOUR–HORSEMEN–
OF–THE–APOCALYPSE
SEQUENCE

It is a rule of film-making that, no matter how much money you have and no matter how much time you have, you never have enough money and you never have enough time. The first casualty of budget and time was the Other Four Horsemen of the Apocalypse. We had cast them (they were funny, and huge. And actually gloriously scary-looking), but then, a few days before our read-through, we needed to shave several days off the schedule along with a healthy amount off the budget, and I gritted my teeth and began to cut. This is what I cut. You can make it in your head . . .

EXT. UK MOTORWAY – RAIN – DAY

War, in red leathers, on a red motorbike, pulls off the motorway. She stops outside a service station/café.

EXT. THE HAPPY PORKER CAFÉ – STORM, DAY

War stops her bike, dismounts. There are four big battered Hells Angels motorbikes parked there already.

The weather is nasty: gusting and raining, an ice-cream sign is spinning.

A BUSINESSMAN, leaving the café with a CLIENT. They are talking happily.

War takes off her red helmet; shakes out her long auburn hair like someone in a shampoo commercial or a sixties James Bond film . . .

The businessman turns his head to look, while still walking, and smashes his face into a plank sticking out from the back of a lorry. Blood drips from his cheek onto the client, who takes a step back, repulsed, and then stamps on the businessman's foot.

The businessman takes a swing at the client, and we watch them fighting in the background as we follow War into the café . . .

INT. THE HAPPY PORKER CAFÉ

It's empty. There's a bored CAFÉ LADY behind the counter. There are four HELLS ANGELS in the back of the café, all of them huge, filthy and dangerous, with four varieties of interesting facial hair. They are called PIGBOG, GREASER, SKUZZ and, biggest and nastiest, BIG TED. They are gathered around another BIKER who is still wearing his motorbike helmet. This biker is wearing a long black coat, with a bat-winged hourglass picked out in rhinestones on the back.

He's a lot cleaner than the others, but we should initially assume he is one of them.

The other biker is playing an ancient TV-screen arcade video trivia game with BLEEPS and BLOOPS.

We can see the categories: General Knowledge, History, Films & TV, Sports.

The other biker hits Films & TV: which film won the most Academy Awards? (Options: RETURN OF THE KING, GONE WITH THE WIND, THE GODFATHER, ALL ABOUT EVE.)

PIGBOG
> It's D. *The Godfather* must have got more Oscars than *Gone with the Wind.*

SKUZZ
> *Titanic* got lots of Oscars.

GREASER
> It's not on the list, Skuzz, you tosspot.

The other biker's gloved hand presses the A (RETURN OF THE KING) *option. The screen gives a* RIGHT ANSWER *flash, and 'you win'-style BLEEPS.*

BIG TED
> He's good.

PIGBOG

I'll give him that, Big Ted. He's good.

War is over at the counter.

WAR

Cup of tea, please. And a cheese sandwich.

The café lady bustles into tea-pouring action. Outside the rain gets nastier.

CAFÉ LADY

You on your own then, dear?

WAR

Waiting for friends.

CAFÉ LADY

You're better off waiting in here. It's hell out there.

WAR

No. Not yet.

Pigbog is talking to Greaser. Pigbog has LOVE and HATE tattoed on his knuckles.

PIGBOG

Thass a new one: 'How many times has England been officially at war with France since 1066?'

GREASER

Twenty? Nah, s'never twenty . . . Oh. It was.

Greaser has FISH and CHIP tattooed on his knuckles.

We notice that the winnings, many pound coins, are sitting uncollected in the tray under the screen.

EXT. THE HAPPY PORKER CAFÉ – STORM, DAY

In the carpark, Famine's black bike pulls up next to War's red bike.

INT. THE HAPPY PORKER CAFÉ – STORM, DAY

SKUZZ

Pop music, current events, general knowledge and . . . war?

BIG TED

I'm hungry. Get us a steak and kidney pie.

And the café door opens. The wind blows into the café, and BLACK/FAMINE walks in. He's wearing black leathers.

Famine walks over to where War is sitting.

FAMINE

Hello, War. Been a long time.

WAR

Mmm. Famine. Feels funny, all of us finally getting together like this.

FAMINE

Funny?

WAR

We've spent all these thousands of years waiting for the big day, and now it finally comes. Like waiting for Christmas. Or birthdays.

FAMINE

We don't have birthdays.

WAR

I didn't say we do, Famine. I just said that was what it was like.

GREASER

What do you mean, you haven't got any steak and kidney pies?

CAFÉ LADY

I thought we did, but we don't.

GREASER
Well what have you got?

She looks around.

CAFÉ LADY
Pizza.

Greaser looks at Big Ted. Ted thinks then nods. Pigbog says:

PIGBOG
No anchovies.

SKUZZ
Or olives.

Nods of agreement all around.

BIG TED
Yeah, all right. Just no anchovies. Or olives.

The café lady's been pottering behind the counter, and she is triumphant, if a little baffled.

CAFÉ LADY
I can definitely do you pizza. I've got anchovy and olive pizza.

GREASER
Nothing else?

CAFÉ LADY
You could peel off the anchovies. And the olives.

And it's odd: the boxes of sweets, the sandwiches, the pies that were there when we went in have now all gone.

We can see the video screen reflected in the biker's black mirrored visor. He's still winning. Pigbog and Skuzz are puzzled . . .

PIGBOG
I never knew that about the Irish Potato Famine.

SKUZZ

> I never knew that about the 1969 San Francisco dope famine.

EXT. THE HAPPY PORKER CAFÉ – STORM, DAY

A dirty white motorbike pulls up in a cloud of black smoke. The exhaust backfires as it comes to a halt, and a pool of black oil drips from the engine.

Pollution gets off the bike and crisp packets and sweet wrappers blow past on the storm.

INT. THE HAPPY PORKER CAFÉ – STORM, DAY,

The trivia game continues. We see the screen: War, Famine, Celebrity Gossip, Pop Music *are the categories.*

WAR

> Weather looks a bit tricky down south.

FAMINE

> Looks fine to me. We'll have a thunderstorm along any minute.

WAR

> That's good. It wouldn't be the same if we didn't have a good thunderstorm. Any idea how far we've got to ride?

And at this point Pollution enters. The crisp packets are swirling around them as they open the door, then the packets fall to the floor.

FAMINE

> A few hundred miles.

WAR

> I thought it'd be longer, somehow. All that waiting, just for a few hundred miles.

POLLUTION

It's not the travelling. It's the arriving that matters.
(to the café lady)
Four teas, please. One of them black.

CAFÉ LADY

Four of you, are there, dear?

POLLUTION

There will be.
(to Famine and War)
Any sign of him yet?

The video screen categories are now War, Famine, Pollution *and* Pop Trivia 1962–1979

Question: What Year Did Elvis Presley Die? A) 1981, B) 1977, c) 1974, D) 1991

SKUZZ

It's B.

PIGBOG

Go on. 1977. That was the year Elvis died.

GREASER

Same year as Marc Bolan.

SCUZZ

And Bing Crosby.

BIG TED

Definitely 1977. Go on. Press the button. It's the jackpot question.

But the biker is not moving.

PIGBOG

Press it.

And then the extremely tall, extremely thin biker in black says, without taking off his helmet, in a dark, huge voice that seems to echo through the room . . .

BIKER

> I DON'T CARE WHAT IT SAYS. I NEVER LAID A
> FINGER ON HIM.

*He turns away, leaving his winnings behind him, and heads
over to the three by the window. They are looking up, happy
to be a team again.*

RED

> Hello, boss. When did you get here?

BIKER

> I NEVER WENT AWAY.

*The biker sits down next to them. He doesn't remove his
helmet.*

*Pigbog, Greaser, Big Ted and Scuzz look at each other
meaningfully. Something is happening and they don't know
what it is. And they don't like it.*

BIG TED

> So you're Hells Angels, are you? Cos you look like
> weekend bikers to me.

GREASER

> Big Ted doesn't like weekend bikers.

PIGBOG

> He also doesn't like anchovies.

SKUZZ

> Or olives. None of us do. What are the odds?

BIG TED

> Skuzz, shut up. So you're . . . Hells Angels?

FAMINE

> That's right.

WAR

> We're the originals. The old firm.

POLLUTION
> Others promise. We deliver.

BIG TED
> You, you can shut your mouth. You're not Hells
> Angels. There's no women angels for a start.

WAR
> There's me.

BIG TED
> Yeah? Well, what chapter are you from?

*At this the biker, who hasn't said anything, turns and gets up
. . . and up . . . and is now looking down at Big Ted and the
others.*

And then it lifts its visor.

*There is a skull inside the helmet. It doesn't look like Death
in the Discworld movies. It looks like a skull, with some
intelligence in the tiny lights in the darkened eye sockets. This
is AZRAEL, ANGEL OF DEATH: the Fourth Horseman of
the Apocalypse.*

DEATH
> REVELATIONS. CHAPTER SIX.

FAMINE
> Verses two to eight.

*The Four Horsemen of the Apocalypse look at the bikers,
and the bikers look away first. This is the first time we've
really seen the Four Horsemen together and there is
something otherworldly and very scary about them.*

Then Big Ted says, tapping his leather jacket . . .

BIG TED
> You're on our logo.

DEATH
> I GET EVERYWHERE.

The Four Bikers are not smart enough to be properly afraid.
Then Big Ted says . . .

BIG TED
What kind of bike are you riding?

EXT. THE MOTORWAY – STORM, DAY

Motorbikes, driving in the storm down an empty motorway.
We hear the roar of engines, and the storm. And they come . . .

In the front is Death. Then War.

Then Famine.

Then, moments later, Pollution.

And then it gets quiet. Unearthly quiet.

And, riding together, behind the Four Horsemen, are the
four Hells Angels. They are wearing the kinds of helmets that
don't have visors.

PIGBOG
It's gone all quiet.

SKUZZ
Pigbog, can you hear me?

PIGBOG
Course I can hear you.

SKUZZ
Greaser, can you hear me?

GREASER
Course I can.

SKUZZ

Big Ted, can you—

BIG TED

Yes!

SKUZZ

It's quiet!

BIG TED

I can hear that it's quiet.

PIGBOG

Why's it quiet, then? How can we hear each other?
That's just weird.

GREASER

I fink it's because we are now mystical beings. Cos we
are now the other Four Horsemen—

PIGBOG

Bikers!

GREASER

The other Four Bikers of the Repocalypse!

Pause.

PIGBOG

So what are we then? They're Famine and War and
P'llution and Death . . .

BIG TED

I am War!

PIGBOG

You can't be War, Big Ted. She's already War. Pick
something else.

BIG TED

I am Grievous Bodily Harm. GBH! GBH!

SKUZZ

Can I be Embarrassing Personal Problems?

INT. NARRATOR'S WORLD

The narrator has models of the Four Horsemen. And behind them, a board.

We can see written on the board, FOUR HORSEMEN (crossed out) BIKERS OF THE APOCALYPSE: Famine, War, Pollution, Death.

The narrator is writing up the others:

NARRATOR
. . . Grievous Bodily Harm, Embarrassing Personal Problems, Greaser and Pigbog riding towards Tadfield and the Apocalypse.

EXT. MOTORWAY – STORM, DAY

Again: WIND AND BIKE NOISE! The Four Horsemen riding. They seem less human now: their helmets are full face, but eyes burn like lights behind them.

Then QUIET!

GREASER
I'll be Cruelty To Animals.

PIGBOG
I'll be People Taking Selfies.

BIG TED
People Taking Selfies? You can't be People Taking Selfies. What kind of a Biker of the Repocalypse is People Taking Bleedin' Selfies?

SKUZZ
Here. I want to change mine. Can I be Things Not Working Properly Even After You Thumped Them?

BIG TED
Yeah. All right. But YOU can't be People Taking Selfies.

PIGBOG

 Then I want to be Really Cool People.

GREASER

 Really Cool People?

PIGBOG

 Yeah. I hate them. 'I'm so post-hipster I don't even use
 apps any more and I drink beer with no alcohol in it.'
 I bloody like the alcohol. Nobody drinks lager for the
 taste.

SKUZZ

 Can I change again? I could be No Alcohol Lager.

BIG TED

 No, you can't. You've already changed once.

SKUZZ

 I don't see why he can be Really Cool People and I
 can't be No Alco—

BIG TED

 Shut it!

INT. NARRATOR'S WORLD

*Now the Narrator's dolls have been replaced with a huge
crystal ball, in which we see the action, or a screen, as the
bikers ride past . . .*

NARRATOR

 Death and Famine and War and Pollution rode toward
 Tadfield. And Grievous Bodily Harm, Cruelty To
 Animals, Things Not Working Properly Even After
 You've Given Them A Good Thumping But Secretly
 No Alcohol Lager, and Really Cool People travelled
 with them.

EXT. MOTORWAY – STORM, DAY

We see a MOTORWAY CLOSED sign flashing.

Police cars have their lights on. There are hazard signs up. Orange traffic cones, and beyond that, roadblocks.

There's an overturned lorry blocking the motorway. And behind it, there's an enormous pile of fish. Like a huge hill of fish, that the lorry hit before overturning.

There's a stressed police sergeant trying to deal with things, calling home.

SERGEANT

 I appreciate that. But I asked for a bulldozer. I've got about forty tons of fish blocking the road. And a lorry.

And here come the Four Bikers of the Apocalypse.

SERGEANT (CONT'D)

 Jesus! STOP THEM! No, you can't! I can't look . . .

The sergeant covers his eyes. The constable near him watches something happening that we can't see . . . We hear WHOOSH noises.

CONSTABLE

 They didn't hit it.

SERGEANT

 What do you mean, they . . .

DEATH (O.S.)

 YOU GO ON AHEAD.

But here come the OTHER Four Bikers . . .

The cops are watching this time. We see their expressions, and hear the carnage, as the bikers hit the fish pile and the lorry . . .

A tumbling of fish.

And we follow the Sergeant's glance . . .

CLOSE UP on Skuzz, on his back under his bike in a pile of fish.

SKUZZ
My leg. I can't move my leg!

CONSTABLE
Well, you're luckier than your friends.

Skuzz glances over. The other three bikers are very dead . . .

Skuzz gestures for the constable to lean in.

SKUZZ
(quietly)
Listen. The Four Horsemen of the Apocalypse.
They're all bastards.

CONSTABLE
He's delirious, sarge.

SKUZZ
I'm not. I know who I am. I'm People Covered In Fish.

CREDITS

NEIL GAIMAN

is the bestselling author and creator of books, graphic novels, short stories, film and television for all ages, including *Neverwhere*, *Coraline*, *The Graveyard Book*, *The Ocean at the End of the Lane*, *The View from the Cheap Seats*, *Norse Mythology* and the critically acclaimed, Emmy-nominated television adaptation of *American Gods*. The recipient of numerous literary honours, Neil has written scripts for *Doctor Who* and worked with authors and artists including Terry Pratchett, Chris Riddell and Dave McKean, and *Sandman* is established as one of the classic graphic novels. In 2017, he became a Goodwill Ambassador for UNHCR, the UN Refugee Agency. As George R. R. Martin says: 'There's no one quite like Neil Gaiman.'

Take a tour behind the scenes with your ultimate guide to navigating Armageddon

Featuring character profiles and in-depth interviews with the cast and crew, stunning stills photography of the stars and locations, and a fascinating insight into costume boards and set designs

GOOD OMENS
The Nice and Accurate Prophecies of Agnes Nutter, Witch
Written with Terry Pratchett

Available in Paperback, Audio, and eBook

According to *The Nice and Accurate Prophecies of Agnes Nutter, Witch*, the world will end on a Saturday. Next Saturday, in fact. So the armies of Good and Evil are amassing, the Four Bikers of the Apocalypse are revving up their mighty hogs, and the world's last two remaining witchfinders are getting ready to fight the good fight. Atlantis is rising, frogs are falling, tempers are flaring. Everything appears to be going according to Divine Plan. Except that a somewhat fussy angel and a fast-living demon are not particularly looking forward to the coming Rapture.

"The Apocalypse has never been funnier."
—Clive Barker